Praise for *The Art of Looking*

"If you've never understood contemporary art, or fear you've understood it all too well, then this book is ready to be your secret friend. In lucid prose that has the loft of poetry, Lance Esplund lifts the burden of 'art appreciation' to reveal that the subject of all great art is how it appreciates you for the way you look at it. His own encounters with exemplary work—by Joan Mitchell, James Turrell, and Marina Abramović among others—are related in terms so complete, courageous, and physically convincing they make you want to see art as he has seen it, a giant step toward seeing it for oneself."

—Douglas Crase, author of *The Revisionist*

"*The Art of Looking* is a wonderful book, filled with remarkable insights about experiencing whatever it is that we mean by the word 'art.' Whether it is Balthus and the Me Too Movement or walking through Richard Serra's enormous curving rust colored sculptures—there is always something new and exciting to be discovered."

—Robert Benton

THE ART OF LOOKING

THE ART OF
LOOKING

HOW TO READ MODERN
AND CONTEMPORARY ART

LANCE ESPLUND

BASIC BOOKS

New York

Basic Books
Hachette Book Group
1290 Avenue of the Americas, New York, NY 10104
www.basicbooks.com

Printed in the United States of America
First Edition: October 2018
Published by Basic Books, an imprint of Perseus Books, LLC, a subsidiary of Hachette Book Group, Inc. The Basic Books name and logo is a trademark of the Hachette Book Group.

The Hachette Speakers Bureau provides a wide range of authors for speaking events. To find out more, go to www.hachettespeakersbureau.com or call (866) 376-6591.

The publisher is not responsible for websites (or their content) that are not owned by the publisher.

Library of Congress Cataloging-in-Publication Data
Names: Esplund, Lance, author.
Title: The art of looking : how to read modern and contemporary art / Lance
 Esplund.
Description: First edition. | New York : Basic Books, 2018. | Includes
 bibliographical references and index.
Identifiers: LCCN 2018026754 (print) | LCCN 2018028114 (ebook) |
 ISBN 9780465094677 (ebook) | ISBN 9780465094660 (hardcover : alk. paper)
Subjects: LCSH: Art, Modern. | Art appreciation.
Classification: LCC N6490 (ebook) | LCC N6490 .E798 2018 (print) |
 DDC 709.04—dc23
LC record available at https://lccn.loc.gov/2018026754

ISBNs: 978-0-465-09466-0 (hardcover); 978-0-465-09467-7 (ebook)

LSC-C

10 9 8 7 6 5 4 3 2 1

To Evelyn

CONTENTS

Contents

INTRODUCTION

THE LANDSCAPE OF ART HAS CHANGED DRAMATICALLY during the past one hundred years. We've seen Kazimir Malevich's *Black Square* (1915), an abstract painting comprising a single black square within a white ground, and Marcel Duchamp's infamous *Fountain* (1917) (fig. 10)—a hand-signed porcelain urinal. Midcentury brought us the Abstract Expressionist "drip" paintings of Jackson Pollock, as well as Pop art, which featured Andy Warhol's pictures of Marilyn Monroe, Campbell's soup cans, and Chairman Mao. With the rise of neo-Dada and Conceptualism, we saw Piero Manzoni's *Artist's Shit* (1961), a series of ninety sealed tin cans, each purportedly containing 1.1 ounces of Manzoni's own excrement. In 1971, Chris Burden, in his performance artwork *Shoot*, was voluntarily shot in the arm with a .22 caliber rifle. In 2007, Urs Fischer, for his installation *You*, took a jackhammer to Gavin Brown's enterprise gallery, in New York City, to create a giant crater in the cement floor. And uptown, in 2016, at the

1

Solomon R. Guggenheim Museum, the artist Maurizio Cattelan replaced a porcelain toilet in one of the public restrooms with the interactive sculpture *America*—a fully functional replica of a toilet, cast in 18-karat gold.

Is it any wonder that the art-viewing public is bewildered, even intimidated? What are they to make of the range of possibilities offered in galleries and museums? Are Henri Matisse, Pablo Picasso, and Pollock old hat? Is the art of the past century meant primarily to baffle, shock, and provoke us? Are Modern and contemporary artists speaking only to an elitist art-world few or creating inside jokes? Or is the joke, perhaps, on us? And if viewers don't bother to queue up to use Cattelan's *America*, or to see a Jeff Koons, Kara Walker, or Gerhard Richter retrospective, are they missing out? Or is something else afoot? Today's viewers might rightly wonder: Has the public always felt uneasy about and out of step with the art of their time? Or is all the confusion and apprehension a sign of something new and very recent—something exclusive to the experience of today's contemporary art?

The answers to these questions—just like the art under discussion—are complex and manifold. People have had to grapple with the revolutionary art of their contemporaries throughout history: the jarring, naturalistic sense of space introduced during the Renaissance in the early fourteenth century was just as unsettling and revolutionary as the jarring, antinaturalistic sense of space of Cubism, which upended the Renaissance's approach in the early twentieth century, or the jarring objectlessness of Conceptual art in the late twentieth century. It's important to understand that art, despite its

relationship to its time, is a language unto itself—a language that exists beyond its particular era. That language continually evolves and reinvents itself—even often quotes itself. But there are also qualities specific to Modern and contemporary art that are unique.

Definitions of the word "art"—as well as of many of the different terms used to classify art's periods, movements, and "isms"—are now fluid and open to discussion. Whether any given movement is truly "modern"—as in recent—is therefore often up for debate. One could argue, for example, that the twentieth-century movement Surrealism, fueled in part by the workings of the artist's unconscious, reached its zenith in the fantastical religious narratives created by the Netherlandish painter Hieronymus Bosch (1450–1516); or that the Modern movements Expressionism and Cubism were in ascendance already in the angular elongations and fractured spaces of the Spanish painter El Greco (1541–1614); or that some of the most inventive abstract art was created by medieval nuns and monks, or by the ancient Egyptians. In this book, I'll shed some light on these issues, and perhaps make these movements more approachable, by illuminating the similarities between recent and past art.

It's useful to discuss terminology, because there is such a wide range of work being done—and such a wide range of opinions, philosophies, agendas, and approaches around art. By "Modern," I'm referring primarily here to artworks made since 1863, when Édouard Manet exhibited his scandalous painting *Le Déjeuner sur l'herbe* (*The Luncheon on the Grass*) (fig. 1) in the *Salon des Refusés*, after it had been rejected by the academy

of the official Paris Salon. *Le Déjeuner sur l'herbe*, a painting in which a nude woman, looking at the viewer, picnics with a couple of dandies, was among the first artworks that provocatively and self-consciously questioned and poked fun at the hallowed traditions and conventions of painting. In this case, it was through, among other things, its subject, which transformed the classical nude from goddess and muse into floozy, if not prostitute, and its willfully slapdash paint-handling. But we could start earlier, with the gritty Realist paintings of Gustave Courbet, or later, with Picasso's and Georges Braque's Cubism. Modern art incorporates not only Manet's Impressionism, but also those groundbreaking movements Realism and Cubism, as well as Symbolism, Fauvism, Expressionism, Surrealism, Dadaism, and abstraction, among many others. To be a Modern artist means not so much belonging to a particular era or movement as taking a particular philosophy and stance in relationship to art and art-making.

Modernism in its early days represented liberation and independence. Modernists created radical new modes of artistic expression. They embraced new materials, technologies, artistic innovations, and subject matter—including photography, the assembly line, the machine aesthetic, kinetics, plastics, abstraction, Expressionism, refuse, reinforced concrete, and steel—the same material that was allowing for the creation of the vertical skyscraper and the modern city. They were inspired by the art of other cultures—such as the flat space, active patterns, and everyday subject matter of Japanese prints, and the spare, rectilinear organization of Japanese architecture; the pared-down forms of so-called primitive masks and totems; and the

exoticism of other non-Western societies. Modernists, free to focus on whatever they wished, also looked inward, embracing not just the nightclub, the brothel, and the racetrack, but themselves, their culture—both lowbrow and highbrow—and art itself: how they felt about being in an increasingly unfamiliar world that was changing and speeding up at an exponential rate, that was becoming increasingly global, and being flooded with new art, new cultures, new technologies and inventions, and new ideas, leaving behind the old and the familiar.

Modernists rejected a lot of what they saw as outmoded and academic. They no longer believed that art needed to be about mythology and religion, or kings and queens. They no longer believed that art needed to mirror the world, or that perspective needed to be the organizing principle of a picture (why not organize, instead, in accordance with the artist's feelings, or why not let the artwork be the subject of itself?). Modern artists didn't believe, necessarily, that a sculpture must be separated and elevated on a pedestal, or that a sculpture must be conceived and built out of an accumulation of masses (why not incorporate the pedestal, as in a primitive totem, so that it is integral to the work, equal to and inseparable from it—as in the Modernist sculptures of Constantin Brâncuși and Alberto Giacometti?).

Modernists sought to liberate pedestal, sculpture, mass, and even the stationary artwork itself: space—void—was transformed, by the Cubists, into volume; and the stationary object could be freed to move and interact among the viewers—as in the mobiles of the American Modernist sculptor Alexander Calder. But Modernist artists, acknowledging and honoring

newfound technologies and modes of thinking and feeling as well as the primacy of individuality, didn't reject the past out-of-hand. They willingly and excitedly embraced the new—alongside tradition—in order to speak in the present by reinventing the past, and thereby further the tradition of art. The radical French Realist painter Gustave Courbet, a pioneering figure of Modernism in the 1800s, said, "I have simply wanted to draw from a thorough knowledge of tradition the reasoned and free sense of my own individuality. To know in order to do: such has been my thought. To be able to translate the customs, ideas, and appearance of my time as I see them—in a word, to create a living art—this has been my aim."

Courbet's stance continues to be that of many artists working today. It's essential to keep in mind that Modern artists were not merely reacting to the modern world and embracing every new material and technology that came their way. They were and are individualists who honor what they think and feel and the path their art naturally takes. It matters little that Modern artists embraced new materials and technologies and subjects. What matters is what those artists did and continue to do with those newfound things. Although, for instance, the relativity of space and location experienced in Picasso's and Braque's Cubism has been aligned with the relativity of Albert Einstein, Cubism was not illustrating an idea about physics or about the nature of the universe; it was born out of the formal interests and inner needs of its creators—their independence and individuality. The fact that Modern art and modern science sometimes took similar trajectories, though intriguing, really is beside the point.

Art and artists make their own paths. Artists, despite their alignments, can be movements unto themselves. Modern art is wide ranging and omnivorous—a movement encompassing the provocative representational paintings of Manet, the abstract weavings of Anni Albers, the Surrealist and figurative art of Giacometti, the fluorescent light installations of Dan Flavin, and the Minimalist sculptures of Donald Judd, as well as the land art of Robert Smithson and Maya Lin's Vietnam Veterans Memorial. Despite the popular belief that Modernism is over and dead, there are plenty of contemporary artists who consider themselves Modern artists.

It's necessary to keep in mind that art history is fickle. Artists go in and out of fashion. Some of the past artists we celebrate today were virtually unheard of for decades, and even centuries. And it is usually artists who resurrect artists. We are still in the throes of the Modernist era. We have yet to get enough distance to see Modernism objectively, let alone many of today's fashionable contemporary artists, some of whom art history will consign to the rubbish heap. And there are also many underappreciated contemporary artists who are virtually unknown and who will be celebrated by future generations.

WHAT IS "CONTEMPORARY art," anyway? Although it may seem like it would be a simple matter to state a basic definition, for many artists, art historians, curators, and art critics, that is not the case. I once participated on a panel titled "What Makes Contemporary Art Contemporary?" Among the definitions and requirements bandied about were these ideas: that contemporary art, to be designated "contemporary"—"relevant"—must

address contemporary political and social issues; that it must be engaged with the latest technology and with globalization; that it must be multimedia, must be revolutionary, and must question, appropriate, and depose the art and artists of the past—especially the "Modernists." Some panelists argued that contemporary art began with Pop art or Conceptualism or Postmodernism; or circa 1945, or 1970; or that it could only include art made since 1990, or 2000. One person suggested that a contemporary artist was anyone born since 1950. Another said that a work of contemporary art, by definition, must have been completed "today," or maybe "yesterday"—and by someone under the age of thirty. Even more recently, I encountered the idea that today's most important contemporary artists don't necessarily make art objects at all; rather, they are closer to first-responders and activists, resorting, when and if necessary, to guerrilla tactics in order to address emergency crises, assist victims of natural disasters, counter social injustice, or instigate change. Following in their footsteps, some contemporary curators have shifted their role from organizing exhibitions to organizing curatorial activism.

I do not believe that art today has to be one thing or another, or that a contemporary artist must have an agenda. I do believe that the best artists have a position—something to say, and the creative means to say it well. This might be a feeling about the qualities of light in a sunset, the weight and color of an eggplant on a table, the sense of loss in the myth of Orpheus and Eurydice, or contemporary politics. I'd much rather see an inventive still-life painting or landscape than a derivative and uninteresting work of politically driven performance art. Likewise, I'd

rather spend time with an engaging multimedia installation than a banal, uninspired landscape, video, or abstraction. I define "contemporary art" as any art being created by living or recently deceased artists—generally speaking, any artist, young or old, who is working currently, whatever the mode and materials and subjects.

The term "Postmodern" in art is often used interchangeably with "contemporary" or "Modern," but Postmodernism is actually a subset of movements in contemporary art. Like Modernism, Postmodernism is extremely eclectic and embraces diverse and contradictory positions. It has affected all of contemporary culture, from architecture, literature, music, theater, and dance to philosophy and criticism. Like Modernism, Postmodernism is about liberation—albeit liberation from what are seen as the shackles and ideals of Modernism.

Although Postmodernism has its roots in the nineteenth century, most scholars see it as flourishing after the mid-twentieth, as a reproach to the individualism and bravado of artworks by Abstract Expressionists such as Willem de Kooning and Pollock, and to the then dominant less-is-more postwar aesthetic of the International Style in architecture, which had produced impersonal, minimalist boxes of concrete, glass, and steel—machines for living. But many others believe Postmodernism began around 1915, with the birth of Duchamp's "Readymades"—store-bought or mass-produced objects exhibited as works of art—because Postmodernism, like Modernism, is defined less by a time period than by an artist's philosophy.

Practitioners of Postmodernism operate as if Modernism were over, or were dying embers needing once and for all to

be extinguished. Others see the Postmodernism movement as Modernism's death rattle, or last hurrah. Postmodern art, for our purposes, refers to any art made as a rebuke to Modernism. Postmodernism, which sees Modernism, and especially formalism, as bankrupt (I'll address the fallacy of this belief in later chapters), embraces irony, humor, theory, and pluralism. Self-conscious and self-referential, it is art that willfully critiques, if not makes fun of, other "Art"—art with a capital "A." Postmodernism takes an anti-aesthetic, nihilistic stance, one that denies that there is any discernible or hierarchical value in anything, that believes there are no such aesthetic distinctions as "good" and "bad," "less than" and "greater than." The Postmodernists assert that all art is subjective, that there are no truths—only interpretations—and that the Modernists' so-called values and qualitative judgments are insignificant and unmeasurable. They maintain that meanings and rankings are elitist inventions—holdovers from the old regime—and that discussing and valuing the formal properties in a work of art, and believing that a Rembrandt or a Picasso or a Pollock might be better than some random scribble, is a load of hooey.

Adherents to the Postmodernist philosophy believe in the importance of leveling the playing field and value inclusivity— they embrace everything, high and low, equally with open arms, especially chance, ugliness, disharmony, and kitsch. They choose the freedom and messiness of irrationality over what they see as the restrictive, puritanical rationality of Modernism. The Postmodernists seemingly imagine Modernism to be much purer and less messy and omnivorous than it actually is. And they want to mess it all up, if not tear it down.

Many Postmodernists believe that the participatory viewer is as important as, if not sometimes more important than, the artist, and that the intention of the artist is meaningless. This anti-formalist, anti-aesthetic position has led to movements such as Process art, which values impermanence and perishability—and in which an object, such as a hay bale, might just be left outside to weather the elements—and Conceptual art, in which the idea or concept is prized above the finished artwork, and in which, occasionally, the art object never materializes. At times in Conceptual art, the viewers themselves must create, or merely imagine—conjure in the mind's eye— the unrealized "artwork" or artistic "act."

Like Modernist artists, however, Postmodern practitioners represent a broad range of approaches and artists. Postmodernists embrace irony, Conceptualism, and deconstructionism. They also resort to appropriation—in which artists borrow, if not steal, and reuse the work of other artists. Appropriation artists include Richard Prince, who, in photographing and altering vintage cigarette advertisements, repurposed the Marlboro Man; Christian Marclay collaged together thousands of film and television clips for his twenty-four-hour-long looped video montage *The Clock*, from 2010. Postmodernists also embrace nostalgia for the academic art against which the Modernists originally rebelled. In Postmodernism, what was once considered "bad" or tasteless is now considered "good"—if only for the reason that it goes against Modernism's notions of "good" and "bad." And it is worth noting that Postmodernism, which displaced Modernism in the 1980s and 1990s, is the current reigning ideology in galleries, museums, art history programs, and art schools.

Postmodernism—as well as a lot of contemporary art and artists—prizes rebellion. Oftentimes, in fact, we are told that one of the main functions of contemporary art is to challenge and prod us and to be revolutionary. The art of the past two centuries has often been groundbreaking, challenging, and provocative, and the birth of Modernism coincided with the birth of the Industrial Revolution and violent revolutions in the United States and France. Modern artistic innovations were often jarring, intentionally or not. When you are familiar only with figurative sculptures of bronze and marble, a kinetic abstract mobile by Calder can positively provoke you. And sometimes, in order to be heard, artists who were ignored by the establishment have had to embrace revolutionary tactics. Too often, though, the notions of innovation and revolution have been misunderstood to be the rallying cry of Modern and contemporary art, their *raison d'être*. Because some of the greatest Modern art, completely new, was shocking and revolutionary, it is now believed that art's job is to upset the status quo.

If we approach art with the belief that it must be *this* and not *that*, then we risk missing out on a lot of worthwhile Modern and contemporary art. We also limit our understanding of what art is. And if we believe that *our* contemporary art is more important and relevant to us than the art made a decade ago, or a century or a millennium ago, we take a position of false superiority, a stance that, as it increasingly cuts us off from our histories, distances us from ourselves. When we consistently focus on the new, we embrace the next thing out of habit, not necessity. And when provocation is expected in art, provocation becomes rote—no longer provocative—and art and artists

assume the role of bully. Bucking the status quo becomes the status quo, with last year's "revolutionary" model always being rotated out to make room for this year's "revolutionary" model. If we blindly accept that the latest art is better and more relevant than earlier art, each time we embrace the next fashionable thing we leave something of what came before, and once mattered to us, behind.

THE ART OF LOOKING acknowledges the interconnectedness between the art of the past and the art of the present. It recognizes that Modern and contemporary artists are in dialogue with, recycle, and reinvent the art of the past. Although my focus will be on how to navigate Modern and contemporary art, I want to encourage you to engage with all art—not just the art of the past century or decade—at the deepest level, and to see that the art of the recent past and of the present can open us up to the art of the past. I also want to encourage you to develop your aesthetic judgment—your critical mind and eye—and to begin to trust yourself and to see art the way artists see art.

Though there are differences among philosophies and emphasis, the art of the present and the art of the past share many of the same elements and much of the same language. With that in mind, I've interspersed art from many periods and cultures throughout the book in order to underscore the continuum of art's language. I've used paintings for the majority of my examples because painting is among the oldest and most consistent and prevailing forms of visual art; it also contains the majority of art's universal elements: color, line, movement, form, shape, rhythm, space, tension, and metaphor. These same elements

can also be found in contemporary assemblages, works of performance art, and sometimes even Conceptual art. When you encounter an artwork that is new and different, it is worthwhile to look for its similarities with more familiar works, rather than focusing only on what is unique or seemingly revolutionary. By grounding yourself in the larger language of art, you may find that those things that initially seemed strange might not be as unfamiliar as you at first thought.

I've organized *The Art of Looking* into two sections. The first section is "Fundamentals." In its five chapters I relate my own experience of first coming to art, and I explore the elements and language of art, the use of metaphor in art, and the value of marshaling your powers of both subjectivity and objectivity when engaging with works of art. In Chapter 5, after we've explored how to approach the art of all eras, I discuss the nature of Modern and contemporary art and touch on how Postmodernism came into being.

The second section of the book, "Close Encounters," is devoted to close readings of a variety of individual works of Modern and contemporary art: painting, sculpture, video, installation, and performance art. These eclectic works show the range of deep and surprising experiences viewers can have when engaging with art. My close readings in these ten chapters are in-depth analyses of how I have looked at, thought about, and experienced art.

I'm well aware that in doing close readings of artworks, we are in danger of injuring the delicacy and intricacy—the mystery—of an artwork's inner life, and of introducing the proverbial rock on which so many of those who interpret artworks

are commonly wrecked. But please bear with me and follow along in these chapters, as it is precisely in the navigating and interpreting of an artwork's intricacies—and in identifying, reading, and attempting to glean what, exactly, its forms and pathways are doing, where they're taking us, and why—that an artwork unfolds and reveals its inner life.

We are seeking questions and possibilities, not answers. Art is less concerned with answers than with inspiring you to expand and deepen your experience—to feel and think. In sharing my experience of artworks, I'm not suggesting that they are definitive. I present one set of possibilities and responses. As you follow along with me, check in with yourself, just as I have done and continue to do, to get closer to the truth of the work and to the truth of your own responses. Start with your eyes and your gut feelings. Then pose questions: to the artwork, to me, and to yourself. Ask yourself if your responses and experiences jibe with mine. Ask yourself what you think: where the artwork takes you and what thoughts it inspires, because it is great to have feelings about something, to have likes and dislikes, but it is even better to know why—to think in accompaniment to feeling—to reach a place, in your experience of an artwork, where feelings and ideas support, inspire, and further one another, where they fuse.

The concluding chapter, "Looking Further," addresses the changing nature of art museums, the pitfalls of the use and intrusion of technology to interact with art, and the role and importance of the artist. I also make some suggestions about how to keep your bearings while navigating art's evolving landscape.

The Art of Looking is by no means exhaustive, encyclopedic, or even absolute (there are no absolutes). What I have written here is what I know to be true for me, and what I have gleaned and believe from a lifetime of looking at art. The book is more of an impassioned primer on the subject—some ideas that you can try on, take, and run with—than a comprehensive text on Modern and contemporary art. No book of this size and scope can hope to be all-encompassing. (Much more—in terms of artists, movements, philosophies, genres, and "isms"—has been left out than included.) My focus here is on grounding you in art's fundamentals and on empowering you to look and think for yourself—to help you to discover your own passions. Once you've gotten enough of your own footing with art, you'll begin to trust yourself and your experience. My goal has been to help you learn to have faith in your own eyes and heart and gut, and to feel confident reading works of art on your own—that is, to help you begin to think like an artist. This is not a book of art history, or about the art market. It is not a collection of greatest hits. Nor is it a rundown of the most important, groundbreaking, expensive, revolutionary, or shocking artworks of the past century or decade. Although I expend a great deal of time and energy here telling you what I personally think and feel about works of art, I do not aim to convince you that my way of seeing is the only way of seeing, or that the art I love is the art you should love—that the art I've assembled on my personal altar is the art that should grace your altar. Rather, my aim is to familiarize you with the language of art, to help you open up to art that might be unfamiliar, to engage further with the art that interests you already—whether it is

Modern, contemporary, or ancient—to begin to assemble your own personal altar.

My goal is to give you some tools so that you can get out and go to work. Think of *The Art of Looking* as a guide to help you to hone your skills of perception and to home in on the truth of your experience. You do not have to agree with or share my tastes in art, or even see what I see. It is more important that you begin to see and to feel for yourself in front of works of art. I cannot give you my experience or love of art. You must come to and love art on your own. And it is essential that you get out and see artworks in the flesh, because there is absolutely no substitute for the face-to-face encounter with art.

Many people tell me that they don't know how to look at art, that they are afraid they are not sophisticated enough and will see or focus on the wrong things, that they will miss what's important, and that they feel intimidated by art (especially Modern and contemporary works). They fear that instead of getting closer to a deep experience and understanding of art, their encounters will merely expose their ignorance and further alienate them from art. Others are quick to point out that they know what they like and don't like, and that when it comes to art, they don't need any experts or art critics to tell them what to look at and how to look. These are all valid feelings that most of us share to one degree or another. But it's crucial to realize that great art is extremely generous, welcoming, and encouraging. It's a gift. And it needs to be approached with the curiosity of a child. Great art, offering countless doorways— one of which was made just for you—invites you in. Great art tells you in clear language everything you need to know and

takes you everywhere you need to go. And it's also important to remember that the experience of art, although we can all share in it, is ultimately—like your experience of love—yours and yours alone.

When I send my college students to the museum, I remind them that art offers a personal, one-on-one encounter, not unlike a first date, during which one needs to be open enough to be able to take in what art has to say. For the encounter to be successful, there should be flirtation, seduction, and chemistry—a back-and-forth. There also has to be a level of trust, self-awareness, and self-confidence going in. You need to know something about your own truths before you attempt to know those of another. It's imperative to be mindful of your own prejudices. With art, as in courting, you should ask questions and listen closely to the responses; you should be curious, patient, and attentive. And you shouldn't make snap judgments, or assume immediately that an artwork is "not your type." Otherwise—as in dating—you might miss out on meeting kindred spirits or the love of your life.

SECTION I
Fundamentals

ENCOUNTERING ART

WHEN I WAS THIRTEEN, MY PARENTS GAVE ME AN enormous art book for Christmas. It was an illustrated tome of Leonardo da Vinci's paintings, drawings, and inventions. Inside were large color pictures of *The Virgin and Child with St. Anne* (fig. 3), the *Mona Lisa*, and *St. John the Baptist*, as well as an impressive *Last Supper* centerfold. The book included drawings of nature, anatomy, innovative weaponry, and flying machines—all of which were very cool. I admired and pored over their details. But what I remember most was that the paintings and drawings didn't move me, and the secret shame I felt because I knew that Leonardo was considered among the greatest artists of all time. What did it say about me, about art, and about Leonardo, if I wasn't excited by his work?

What did interest me at that time was practicing martial arts, listening to music, acting in plays, and making my own paintings and drawings. I was proud of the tightly rendered pencil drawings I copied from black-and-white photographs,

and the painstakingly detailed paintings I made of friends, cars, and rock stars. But I knew somehow they weren't art, even though I had no idea what art really was or what my own work was lacking. I sensed back then that my own pictures, though time-consuming to make, came too easily; that art required something greater, *other*. My high school teachers, and, later, my college professors, continued to encourage me to make artworks about whatever held my interest. But Leonardo—indeed, all art—remained beyond my grasp. I know now what those early photorealistic pictures of mine, though meticulous, were missing. They were illustrative, flat, and formless. They had no structure, light, rhythm, or music. They lacked poetry, liftoff, life. I was a mere copyist back then, not an artist.

In my art history classes, I learned about art in terms of periods and styles, symbols, mythologies, historical contexts, and innovations. I was told that, among other innovations, Leonardo was famous for perfecting atmospheric perspective, a method in which distant forms are softened and given less detail and saturation, providing the hazy illusion of increasing atmosphere from foreground to background. I also learned about the revolutionary Dutch abstractionist Piet Mondrian, who, four hundred years after Leonardo, was famous for paring painting down to the rudimentary elements of vertical and horizontal and the primary colors red, yellow, and blue, along with black and white. But I eventually realized that it was neither Leonardo's innovation toward a more believable naturalism nor Mondrian's revolutionary leap toward an elementary abstraction that made these artists extraordinary.

The truly great artists are not great because they include all the requisite symbols in their work, or because they produce believably accurate renditions of men, women, plants, and animals, or because their work is radical. I came to understand that great representational artists, such as Leonardo, aren't imitating nature so much as they—like the great abstract artists, such as Mondrian—are transforming their experience of the world around them. It's an artist's ability to transform experience that sets him or her apart. I came to understand that artists are poets, not copyists, and that what matters in a work of art isn't the *what*, but the *how*.

IT TOOK A long time for me to have my first real experience— my first relationship—not with the *subject* of an artwork but with the artwork itself. It took me a long time to get out of my own way—to see, honor, and unearth the truth of a work of art. The reason I had not been interested in that book of Leonardo's paintings had been that his pictures of saints, or of a group of men eating supper at a long table, didn't interest me. The reason I hadn't cared much for Mondrian's abstract, flat, colored rectangles was that I felt no real connection to them, besides relating his art to the patterned colors decorating the Partridge Family's bus. I didn't realize then that any subject—Christian saints, classical gods, bowls of fruit, or Modern abstractions— could be thrilling in the hands of a true artist.

The work of art that changed everything for me was Paul Klee's 1928 abstract painting *Howling Dog* (fig. 2). I saw it on a college road trip, and I was mesmerized. *Howling Dog* was not the first great painting I had seen face to face; and, at roughly

eighteen inches high by twenty-two inches wide, it was far from the largest work of art I had encountered. But it was the first painting I experienced—the first artwork, and the first image, with which I formed a relationship, through which I took a journey. *Howling Dog* was the first artwork to inspire me. Paul Klee had died in Switzerland in 1940 at the age of sixty, but his *Howling Dog* spoke with a startling immediacy to me, a kid who'd grown up in the American Midwest a generation later. Art has that kind of power. It leaps across borders, continents, decades, and even centuries.

I came to Klee's *Howling Dog* because of my affection for animals. I was seduced and held, however, not by the painting's subject, but by its icy oranges, whites, greens, and gray-violets, later telling a friend that looking at it felt "like an eye massage." Klee's picture both enchanted and perplexed me. On the one hand, I was enamored by its color, by its cool light, and by the way it evoked both a picture *of* things in nature and, overall, the sense that I was looking into an aquarium—that it suggested not merely a picture but also an object, a living universe. But I was also intrigued by the power of its seduction. Why, I wondered, did this painting hold me in a way that others hadn't? While appreciating the picture's comical forms, frigid light, and strange beauty, I began to wonder what it was all about: Why was *Howling Dog* closer to a child's finger painting than to the defined, realistic forms of Leonardo and Michelangelo? Can an artist paint like a child without making a childish painting? Klee's picture inspired me to think and to ask questions; to begin a dialogue, a give-and-take; to communicate further with an artwork because it had already spoken to me.

Howling Dog is an abstract painting that has recognizable imagery. The picture is a swirling mixture of color into which Klee has drawn a wiry, white dog with a crisscross of lines evoking waves, as if his howls had pierced through the surface of the painting and were reverberating, like the effect from stones thrown into a pond. The dog and its barbed, wavelike yelps overlap, as if they are all intertwined as a single living organism; the howls, which ripple and unfurl out of the dog, are larger than the animal and seem to have taken on a life of their own. I wondered: Were the painting's colors being stirred by the dog and its howls? Or had the full moon moved the colors to whirl and the animal to wail? Were the starry howls dancing in supplication to the moon? Or was the dog, tethered to its cries, being walked by its own wails? Eventually, I decided that Klee's radiant moon was both cause and spectator of this show, in which the echoing howls—with their canine eyes, ears, and mouths—mirror the dog itself as they seemingly bark back at it.

As I swam in *Howling Dog*'s colors, I began to understand that Klee's taut, muscular line had dynamism and volume, and that it incised and swelled within the flat plane, which was paradoxically airy, liquid, and solid; that Klee's line was not merely resting on the surface, but served as energy and skeletal structure to the body and skin of the painting; that Klee had transformed the canvas into a cosmos, a living organism; that his line rises and falls, opens and closes, expanding and contracting the picture, breathing like bellows. And I realized that these bellow-like swells seemed to breathe air and life not just into the dog and its howls but also into the painting as a whole. Klee had painted not just a dog baying at the moon—or

something to imply that one dog's howls inspire many. He had given form and humor and life to the exponential sounds of the howls: their reverberations stirring the air, revolving around the moon, and puncturing the quiet night and the wide-open mouth of the moonlit sky.

PAUL KLEE's PAINTING taught me that engaging with art is a full-body experience: one in which color, form, space, weight, rhythm, timbre, and structure are felt as much as they are seen. Art, before it is understood to represent a sunset, the Virgin, or an abstract form, begins by striking within us physical and emotional chords. *Howling Dog* opened me up to what is possible in a work of art. It taught me as much about color, drawing, and space as I was learning in my art classes; it was an immersion in how an artist explores his theme. Klee opened up for me not just the world of abstraction, but the world of art.

Klee's *Howling Dog* had jumpstarted my interest not just in Paul Klee, but in all painting. My visceral experience with his twentieth-century abstract painting of a dog baying at the moon allowed me to appreciate and understand Leonardo's sixteenth-century representational painting *The Virgin and Child with St. Anne* (c. 1503–1519). Just as in Klee's painting I was drawn to swim in its cool colors, so I was lured by Leonardo's serene light, and its ability to move over, permeate, and seemingly emanate from solid forms. I realized that both Klee and Leonardo were masters of invention and color—of light— and that their paintings breathed. Just as Klee gives sound a color, a form, and energy, so, too, Leonardo brings forms to life—so they are haloed, glowing from within.

In *St. Anne*, I recognized characters, attributes, and symbols. But I realized that identifying and naming those things is a very small part, and only the beginning, of the experience Leonardo had created for me. I saw that his pyramidal figure grouping became a mountain, rising to the heavens; that the Virgin's symbolic blue robe, though solid, was as diaphanous as the sky; and that the beautiful landscape and tree, compared to the family, were toy-like. I saw the grouping of the Christ Child with his mother, grandmother, and the lamb as forms flowing out one from another, like a set of nesting dolls. I noticed that the Christ Child rocked to and fro, held tightly back, yet also simultaneously offered forth by his mother. Christ is lodged like a cork in a bottle, as if ready for launch; yet he also pulls away from his family and embraces the sacrificial lamb. I recognized that the child was making a leap of faith; that he had stepped through and merged with the lamb, lifting it off the ground—as if the two were already in ascension. And I realized that the child's piercing step through the lamb was also an act of self-sacrifice—that the sweep of his leg was like the stroke of a sword, severing the animal's head. I began to understand how Leonardo had been exploring themes of love, familial connection, grace, sacrifice, and redemption. And I was reminded of what friends of mine had said about motherhood: that bearing a child is like having your heart outside of your body; like shooting an arrow into the world. You aim as best you can, but once the arrow flies, anything can happen.

Looking at art is an extension of looking at the world. But the world of art is not a likeness of that world. Art is a world

unto itself. We all use our eyes to identify and classify things around us. When we look at an artist's work, we are glad to recognize a dog, a mother, a child, a tree, an apple, even a flat red rectangle. We can't help comparing what the artist has offered us with what we see in the world around us. The problem is that all too often, after acknowledging the artist's subject, and the strangeness or beauty or "accuracy" with which the artist has realized that subject, we stop. This has been increasingly true since the dawn of photography, when the myth took hold that the objective eye of the camera—believed to be the ultimate truth—had supplanted the less-than-accurate eye of the artist. The truth is that when we've taken in the relationship between the work of art and the world as we know it, we've only begun to experience what the artist has accomplished.

Artists are poets. And an artwork is a meditation on a theme. Artists seek to formulate and incite particular emotional and cognitive responses. They want to expand our imaginative awareness. They do this in many ways, beginning with the invention and manipulation of forms, colors, and rhythms. They create unexpected allusions and analogies. When Mondrian, one of the greatest Modern painters, builds a composition out of hundreds of tiny rectangles in *Broadway Boogie Woogie* (1943), we suddenly see that totally abstract forms can be orchestrated so as to evoke the propulsive rhythms, visceral excitement, and complex structures not only of boogie-woogie jazz but also of the modern city. We see that Mondrian, whose colored rectangles paradoxically remain flat yet push toward us, is also a unique master colorist, albeit one with a different voice from that of Leonardo or Klee.

Like all poets, artists employ metaphors. Metaphor, I be-
lieve, is an essential key to our understanding of Modern art—
indeed, of all art. "Metaphor" comes from the Greek word
metapherin, which means to transfer the weight or meaning of
one thing to another thing. The purpose of metaphor is to ex-
pand and to help clarify the theme of an artwork. In written
poetry, metaphor is a device, an act of comparison, or trans-
posal, through which the poet, to express his or her feelings
about something—and through the fusion of the qualities of
one thing with another—puts one word or phrase in place of
another word or phrase. Consider the presence of a lily in a pic-
ture of the Virgin. In Christian art, the lily symbolizes Mary's
chastity and purity. If an artist merely depicts a lily near the
Virgin—treating it as just a sign—that lily is limited to its sym-
bolic meaning. We understand but don't necessarily experience
the lily and its import and connection to Mary. If, instead, the
artist treats the lily's petals—and, perhaps, the Virgin's robes—
similarly, and imbues those things with erotic qualities that
alert us to the fact that the flower functions as the sexual organ
of the plant, we are made not only aware of what the lily stands
for, but also of what the Virgin—in remaining celibate, pure—
has physically sacrificed. We see the Virgin as girl, goddess,
selfless mother, and flower.

In the poetry of visual art, as in written poetry, when em-
ploying metaphor the artist is not so much saying, for instance,
that Eve moves *like* a serpent as that Eve *is* a serpent. You can
see this very clearly in the fragmentary low-relief sculpture of a
reclining nude Eve (c. 1130) by the French Romanesque sculp-
tor Gislebertus, originally carved for the Cathedral of Saint

Lazare at Autun, France. Gislebertus is working metaphorically when he pushes us to move beyond the discrete identities of Eve and the serpent to a third realm where their identities are bridged, fused, and a new being is born—neither Eve nor serpent, but somehow a joining of the two, as she sinuously undulates, as if swimming horizontally across the rectangle—as if passing before us like a dream. Eight hundred years later, Giacometti explored similar metaphoric territory in *Reclining Woman Who Dreams* (1929), a Surrealist bronze sculpture in which the woman's head is spoon, oar, and anchor, and her snaking body is flying carpet, waves, and the undulating dreams on which she travels. The artist, in other words, takes the elements of the known world and merges and transforms them into something new and unexpected—something previously unknown and unimagined.

Through metaphor, art, wonderfully and paradoxically, allows for things to be more than one thing simultaneously, and for our feelings about those things to conflate and collide and to contradict one another. In Gislebertus's *Eve*, for example, we might first notice the watery qualities of her hair, body, and limbs, the way they heave, and the serpent's-mouth-like grip of Eve's hand on the fruit, as being more flowing and snake-like than human; or that Eve's breasts are as fruit-like (round, firm, ripe, and enticing) as the forbidden fruit itself. Gislebertus's *Eve* is fully nude and much more naturalistic than most twelfth-century carved relief figures (radical departures for a Romanesque cathedral), but it is his ability to fuse—beautifully, believably, and metaphorically—the qualities of woman, flora, and serpent in *Eve* that sets this work apart.

In art, metaphoric invention trumps naturalism. In Barnett Newman's two purely abstract paintings *Adam* (1951–1952) and *Eve* (1950), the artist, eschewing figuration, employs flat vertical rectangles, stripes, and reddish and purple hues of earth, fruit, and body as the only references to the Garden of Eden, the Trees of Knowledge and Life, and the human form. Newman doesn't need literal vines, a snake, human figures, the roundness and plumpness of fruit, or the narrative awakening of self-awareness, seduction, and eroticism, or an angel expelling the couple from Paradise with a sword. Once we know his theme, his colors and forms and movements are evocative of these things: Genesis, striving, and desire; snake, vine, tree, and rib; the reddish flush and heat of sexuality and shame; the sense that separation, temptation, expansion, repetition, evolution, and free will have—all been set in motion.

In *Adam*, Newman's single vertical red band toward the center of the canvas wavers or buckles slightly near its base, as if it is being born and is hesitant in its ascent and lateral progression—or as if it has experienced a seismic shift or break, and is unsure of its next step and its direction. This sense of arrest, of being lodged and bent, or buckled or broken, yet still held within the plane, reminds me of Leonardo's *St. Anne*, of the ambivalent and arrested Christ Child still held by and looking back at his mother; it is also evocative of Adam's leg and foot in Masaccio's fresco *The Expulsion of Adam and Eve* (c. 1424–1427), in the Brancacci Chapel in Florence, Italy. In *Expulsion*, Adam appears to be pulling his wedged foot out of the Garden of Eden's shrinking, narrow gateway before it becomes completely stuck there or is severed. To exit Paradise,

Adam's rubbery leg impossibly bows and twists; his forward movement changes suddenly from diagonal to lateral—as if his body has been physically altered during the Expulsion, or as if Adam, reborn, has had to become a new being in order to turn toward and reunite with Eve. Masaccio makes us not just see but also feel and experience the changes and violence of the Expulsion: the passageway out of the Garden of Eden becomes a closing door, a world disappearing, the jaws of a trap.

For the artist, the creative space of metaphor is a liberated space—a space where imaginative play is possible. Metaphor is the key to understanding the work of all great artists. Metaphor creates a bridged space, where we can associate, mix, compare, transpose, and fuse a whole range of perceptions and feelings. It is this *other* space of metaphor—this fertile field of the imagination—that is the space of art. The artist invites us into this inventive space, and as viewers we begin to share in the imaginative experience. In written poetry, the metaphors build word by word, stanza by stanza—through reading and through time. In the poetry of visual art—a painting, for example—the metaphors, which certainly unfold and reveal themselves through time and exploration—through our *reading* of the artwork—are available to be comprehended all at once. But it is only through our experience of their buildup that the metaphors come to fruition.

When looking at a work of art, it's important to resist the urge to try to name the *things* we see (which unnaturally forces the artwork, especially a work of pure abstraction, to bend to the will of our first impressions and expectations). If I had attempted to hold Klee's *Howling Dog* to the standards of life, to

name every form, I would have dismissed it, either because I couldn't identify certain forms or because sounds can't be seen. Likewise, the forms and colors in Newman's *Adam* and *Eve* would have left me puzzled, frozen at the starting line. I'm suggesting, instead, that we first allow our minds to wander, to free-associate; to begin to sort out our feelings about what we're seeing—*reading* and *experiencing*—in the artwork; to engage with an artwork's mood, forms, movements, and light; and to let the work's identities and elusive meanings trail behind, just as we do when listening to music or reading poetry. I'm not suggesting that artworks are not designed to convey specific meanings—far from it—great artworks are clear, precise. I'm suggesting that the way to get to know a work deeply occurs as much through what we feel as through what we think.

When I first started looking at art, as a child and young adult, I didn't realize that all artists are poets and that they employ metaphors. I didn't realize that works of art have formal and poetic values of their own, values that ultimately transcend social and religious beliefs and the times and the places in which the artists live. I mistakenly believed that artists were slaves to what they saw before them, serving the motif. I mistakenly believed that I knew something about what a portrait or a still life was about simply because I could identify a head, a table, a pheasant, or the flowers and fruit. And I believed back then that Modern and contemporary art were the most esoteric and difficult types of art to understand, and that abstract art was beyond my comprehension. I eventually discovered, however, that Modern and contemporary art, far from being

33

impenetrable or that much different from earlier art, could unlock and open doorways into the art of the past. I realized that I could come to Gislebertus's *Eve* through Giacometti's *Reclining Woman Who Dreams*, or to Giacometti's *Reclining Woman* through Gislebertus's *Eve*.

Artworks exist in a realm beyond the popular terms and "isms" often used to describe and classify them. Although these terms—ancient, Modern, and contemporary; Classicism, Impressionism, and Conceptualism—help to locate the origins of a work and ground us in relationship to it, such categorizations can color or muddle the truth of our experience. It was Picasso, that most famous of Modern artists, who put it best when, in 1923, he said: "To me there is no past or future in art. If a work of art cannot live always in the present it must not be considered at all. The art of the Greeks, of the Egyptians, of the great painters who lived in other times, is not an art of the past; perhaps it is more alive today than it ever was." Picasso was stressing that art survives the fickleness of fashion. Through his own completely new and radical art, he reignited our interest in numerous past artists and periods, expanding art's pantheon. Picasso's neoclassical pictures of the 1920s—no less than the art of the Italian Renaissance—opened a new doorway into Greco-Roman Classicism.

Picasso was not alone in forging a fresh vision of the past. Modern artists stress the importance of inwardness, personal experience, immediacy, directness, essences, and pure formal values in their work. They encourage us to engage with art as a personal, one-to-one encounter, rather than, for example, as part of a congregation being led by a single voice of authority

in a church. By employing the title *Untitled*, a Modern artist can stress that we disengage just a little from the subject of an artwork, and that we instead appreciate and focus on the work's formal power and emotional presence—that is, that we experience the forms in the work before we identify and name them. Modern artists encourage us to appreciate not only the uniqueness, timbre, and poetry of the individual artistic voice but also the qualities born out of our subjective responses.

Modern artists, in their quest to make their art about themselves and their personal experiences and feelings, help to open us up to past artists' personal feelings. Modern art, with a range of expression as infinite, inclusive, and inventive as the far-ranging personalities and creative impulses of Modernism's many artists, allows us to rediscover artists long abandoned by fashion and art history.

Through Modern art, we are able to see and appreciate some of the art of the past as if for the first time, and we are able to learn from, and to reinvent, what were once thought to be lost traditions. We are made aware that artists from different eras and cultures can share a temperament or a voice. We are able to see, through the pared-down forms of Modern art—such as those in the smooth, egg-like figurative essences of the Romanian sculptor Brâncuşi—that new art can relate to art from any era: Brâncuşi's interpretation—evocation—of the essences of a bird and its movement through space relates to ancient Cycladic idols, to the Hellenistic *Winged Victory of Samothrace*, and to African tribal masks. We see that works from other cultures that the West once dismissed as primitive or too simplistic, or childish or abstract, were in fact beautiful, pure expressions

that got to the essence of form—the heart of things—and that Modern Western artists were just catching up.

Through the work of countless artists, I came to realize that art is not a mirror, but an exploration. It was Paul Klee who gave us one of the keys to all art when he wrote that "art does not reproduce the visible; rather, it makes visible." Once I grasped this essential truth in the work of Modern artists, I was able to discover the same truths in old masters and ancient artists, in abstractionists and representational artists. I began to see that all art *makes* visible what the artist chooses to reveal—but also, that the positon of the artist is humble, and that the artist, no matter how visionary, as Klee reminds us, "does nothing other than gather and pass on what comes to him from the depths. He neither serves nor rules—he transmits." Once I was able to let go of my old ways of approaching and navigating art—to get out of my own way—the world of art opened up to me and I began to understand what art is about, and how, perhaps, to make it. I began to see and to think and to feel as artists see and think and feel. I began to be able to come to art without demands, and to let art, in turn, come to me.

I realized that the key to looking at and appreciating art is to slow down and to take my time, to retrain my eyes, heart, and mind not to react in familiar, well-worn ways, but instead to take in what's actually there: not to look for what I expect to see based on what I already know, but to open myself up to a new language and to new ways of seeing, and to be patient, to ask questions, and to experience works of art in terms of nuances and possibilities. I came to understand that art has its own terms and rules of engagement—its own language—and

that this complex language—like those of mathematics and music—often has little or nothing to do with the appearance of the world outside of art.

And after I'd had that first authentic, deep encounter with an artwork—and had begun to comprehend what its forms were doing and why—new doorways opened. I was able to begin to recognize when, in fact, I encountered other compelling works of art, art that was worthy of my time, that fed rather than merely pleasing, provoking, or befuddling me—work that moved and enriched me enough to want to return to it again and again.

THE LIVING ORGANISM

A N ARTWORK IS A LIVING ORGANISM. IF YOU VISUALLY break down a work of art into its various components and systems, you will begin to understand how each of its elements functions and how those elements work together in harmony, just as you would if you were learning gross anatomy or dissecting a body. In this way, you can begin to see not just what an artwork looks like, but how it's structured, what its elements and systems do, how they interrelate, and how they contribute to the life of the artwork as a whole.

You can begin to understand that there are correlations between a living body and a work of art, and that every element, in concert, plays its part; that, just as cells are the building blocks of an organism's life, so, too, an artwork's elements are the building blocks of its life. Essential to the life of an organism, such as a human body, are the tensions among ligaments and muscles, the circulation of fluids, the strength and density of bone, the functions of organs, the elasticity and porousness of skin,

the rhythms of breathing and heartbeat. Those interdependent elements of the body, if they are not purposeful, healthy, and working together, could become useless, if not dangerous—malignant—to the organism as a whole. So, too, an artwork's unique, interdependent elements (its points, lines, movements, shapes, forms, colors, structures, energies, tensions, light, and rhythms) must be present, healthy, functional, and purposefully fused—working together in harmony, subservient to the greater whole—in order for that work of art to have life.

LET'S BEGIN, FOR example, with the smallest element in a picture: the point, or dot. Context, of course, matters. The point, or dot, could represent a head, the pupil of an eye, a location, the big bang, a black hole, a universe, or the entry point of a knife penetrating flesh. It could also be a freckle, a moon, a period, a seed, a germ, a kiss, or the birth of an idea. It can also, of course, be not just one but many of these things simultaneously.

A number of points connected together make up a line. A line that moves, changes directions at right angles, and returns to its point of origin could become the shape of a rectangle or a square. The determination of a horizontal rectangle, which moves primarily sideways, is different from that of a vertical rectangle, which strives upward or downward; the purposeful-ness of a rectangle is different from that of a square, which has a sense of stasis, rightness, arrival, and fixity not evident in rectangles. But a line need not change directions at right angles, or angles of any type. A single point that moves into a curving line and then comes back to meet and join its own

point of origin could be a circle, which seems never to be at rest, and which, depending on its context and environment, might be considered as another, though larger or closer, single point.

If a new dot is generated at the intersection of two lines, as in the meeting point of the horizontal and the vertical lines in a cross, that point is created through the active collision or merging of two opposing forces. It is a point that, because of its origin in the impact of horizontal and vertical, like an impregnated egg, is charged—a point that has the potential to grow and to radiate energy, like a starburst, not just in two dimensions but in all directions, like the light from a sun.

In different artworks that explore different subjects, that crossing of vertical and horizontal energies and the resultant meeting point at their intersection will mean different things, even though their formal elements and dynamics remain similar. In artworks depicting the crucifixion of Christ, for example, that point of intersection on the cross represents not just the collision and binding together of vertical and horizontal energies, but the reunion of man and God: the horizontal representing man, or the earth-bound plane, and the vertical representing God, ascendance, and spirituality. In the Christian cross, the intersection of horizontal and vertical represents the exact point where the physical and spiritual planes meet and fuse, the point where horizontal and vertical transcend themselves and return back to the *point* of origin—to genesis. The circle, or point, has in fact been used in many cultures like a metaphoric seed for eternity. It is an all-encompassing form with no beginning or end, or can symbolize both beginning

and end simultaneously—timelessness, the infinite. A mere point, then, in the hands of an artist, can become deeply symbolic and metaphoric.

Paul Klee suggested that a line is a point going for "a walk...a point, shifting its position forward." In representational works, we often experience a line as designating some particular thing or place: a strand of hair, the horizon, the contour of a form, such as the edge of a cheek or an apple. But a line can also represent abstract ideas about boundary, meeting place, energy, fusion, and fission. A line can be a spine or a vein. It can be lightning, or stress, or striving. When two forms meet and press against each other, they create a new line—a juncture, an offspring—out of the encounter and merging of their two separate boundaries: new life and energy generated out of interface. Each element in a work of art has the potential, through relationships and contact with other elements, to foster new forms and life—to convey a sense of growth and transformation; to convey that the artwork, though its forms might be literally unchanging, is not *fixed*, but continually in motion, interaction, creation. These are the qualities and energies and actions we notice and therefore make happen in an artwork through the acts of looking and experience.

Consider the deceptively simple works of the American Minimalist artist Fred Sandback (1943–2003), in which Sandback's line registers as edge, latent energy, and incision. Minimalism, which took off in the 1960s, gave rise to artists who worked with the barest of elements and materials. Sandback's signature medium was string, and he used it sparingly.

42

He sculpted open space, stretching colored yarn wall to wall, floor to ceiling, or floor to wall—horizontally, vertically, diagonally—to create the illusion of solid, transparent planes that rhythmically torqued, activated, and divided space. His fuzzy lines of colored yarn sculpted void into volume, and vibrated the air, as if the empty white room had been sliced and sectioned and plucked like strings.

I LIKE KLEE's description of a line as a point going for a walk, and his description, too, of a drawing as a line going for a walk. These ideas remind us of the creative actions, interactions, and intentions that make up a work of art. They stress that the elements of a work of art have determination, resolve—that they are going somewhere and with good reason—that a work is not static, but is moving, changing, thriving. Klee's analogies show that the artist's composition is a combination of energies and interrelationships, built up one element—one building block—at a time. Our eyes follow the pathways that an artist has created for us; we make the same moves and experience the same relationships and interactions that the elements do, and arrive where they arrive.

In representational painting, a line is not necessarily just what it depicts, but a complex journey. Consider the path of Mona Lisa's smile. To reduce that mouth to a mere smile is to deprive it of its mystery and power and the places it takes us. If you follow the line formed where her upper and lower lips come together, you'll notice a variety of widths, densities, pressures, and speeds. These subtle shifts slow us down as we try to follow and interpret her mouth's expression.

Notice how the line curls upward on her left, suggesting that Leonardo's subject is pleased to see us. But that smile also turns inward—into her face, as it rises—so that it appears to be pulling back and away from us, as if reacting to our presence, as if retreating. At the opposite end of that line, on the right side of Mona Lisa's face, the smile stops abruptly, as if hitting a wall. And at the middle of her smile, where the lips are fullest, her whole mouth seems to betray a reticent ambivalence. Her lower lip shifts slightly off-center, to her left, as if changing course.

The line of Mona Lisa's mouth perpetually rises into a smile, yet it also perpetually settles into a frown. Lingering in the "in between," it suggests deliberation, indifference, and disregard. And her mouth does not act alone. The elements of the picture all play their parts. The mouth's ambiguities, working in tandem with the rest of the painting, inspire infinite chase. Although Mona Lisa's head is in three-quarter view, parts of her face, such as her eyes, gaze frontally in an impossible manner. We sense a head in motion—a personality responding to the world. Do her eyes meet ours? Is she turning toward us, or away? Her gaze comes from above, from over her shoulder and beyond those folded arms—with their restless fingers and zigzagging lines traversing scarlet sleeves—which barricade our advances. Those eyes perpetually drift to her left, as if focused elsewhere. Like the line of her smile, Mona Lisa's eyes moor us to the peripheral, suspending us in anticipation.

FORMS IN GREAT representational artworks such as the *Mona Lisa* do not behave the same way as objects in the real world.

And you must not expect them to. But those complex forms in an artwork often inspire the kinds of complex responses we experience in life. In representational art, transmutations, or distortions (and I mean this in no way pejoratively or to suggest falsehood, irrationality, or trickery), are essential and purposeful. Representational artists, responding to the world, interpret, alter, conflate, and reinvent forms to their metaphoric advantage. (No one's mouth or head can behave the way Mona Lisa's mouth and head do.) The key is not only to be aware of those distortions, but to expect them to be there and to ask questions about why they're there: What are they doing? What possible poetic purposes do they serve? How do they add up to convey, as in the *Mona Lisa*, a compelling personality? You have to assume that the artist created every element for a reason, and that no essential elements are missing. I'm reminded of a story about the Modernist French painter Albert Marquet (1875–1947), who, alongside his best friend, Matisse, was one of the original Fauves—or "Wild Beasts"—painters who, for pictorial and emotional effect, used invented heightened color at the turn of the twentieth century. Later, Marquet, among Modernism's greatest perceptual colorists, became a stalwart Realist who created beautiful, spare, naturalistic, light-filled seascapes, painting them in quick, one-shot creative bursts in direct response to the motif. One day, after Marquet rapidly completed a painting of an aqueduct, another nearby painter skeptically asked, "Did you get *all* of the arches?" "I don't know," Marquet replied. "I didn't count them."

In representational painting, it's critical to expect an artist not to copy the world, but to interpret and reinvent it. It's also

essential for the artist to have control, and to have something specific to say. Marquet was not concerned with getting all of the arches in his picture. He was concerned with capturing on his canvas something much more important, intangible, and difficult—the exact light he experienced before him: its color, pressure, weight, density, temperature, moisture, and airiness. It's important for the viewer to think about whether an abnormality in a painting—a table plane that tilts upward; a figure that feels formless, or weightless; a distant mountain that appears to advance and to loom in the foreground; a sense that the space between two objects is closing and collapsing; unnatural, heightened colors, or missing "arches"—is intended by the artist or not. It's essential to take an artwork at face value.

First, you need to recognize whether the subject of a painting, such as Mona Lisa, has palpable weight, form, and volume, and if there is a sense of space and air and atmosphere around her; and then, if you realize that she doesn't have weight, or that there is no sense of space around her, to discern whether this oddity was the artist's intention, for metaphoric purposes, or if the artist lacked the skill to create form: tactility, naturalness, space, movement, tension, cohesion, life.

When Leonardo makes Mona Lisa's head almost too large for her shoulders, and advances the landscape behind her so that the sky and ground feel like they are part of her, and slightly unreal—as if the dreamy workings of her imagination had been unfurled—and he snakes that tiny roadway so that it seems to originate from her and to move through her, to traverse her shoulder, and to merge her with her surroundings,

and when he dissolves her abdomen into smoky, inky darkness, he is not deficient, but poetic. Leonardo paints his subject, surrounded by and emanating light, with weighted, believable form and human presence. But he gives us much more. He suggests that she is both advancing and retreating, materializing and disappearing; that she is woman, mountain, sky, and spirit; that she is right here and present yet also distant, unreachable, dissolving, up-and-away in the clouds; that she is serene and sublime, an ideal subject for portraiture and a muse for art—that she is the origin of beauty and poetry and light, the origin of the world.

THE MORE YOU begin to understand about what an artwork's elements are doing—and can do—the more you'll begin to realize what is possible in art. You'll begin to know what to look for and what to expect from artworks. You'll compare every portrait's smile and every landscape to those in the *Mona Lisa*. You won't expect every artist to be Leonardo (artists, after all, are unique), but you'll expect artists to invent and orchestrate forms that convince and move you, and that take you to places as deep and high as the places Leonardo takes you. And you'll begin to look at painted portraits, whether by Picasso or Rembrandt or Giacometti or Leon Kossoff, for a sense of form, a sense of purpose and light, for a sense of contradictions, movements, and interactions—for metaphors—not some kind of bean-counting, photographic fidelity.

You'll see that Picasso and Giacometti and Leonardo and Rembrandt, despite their very different voices and artworks,

are doing the same kinds of things metaphorically and taking you to the same depths and heights. And you'll look for and expect an artwork's elements to do much, much more than just describe things. In portraits, you'll be on the hunt for elements that appear to marshal and orchestrate themselves, gathering forces, and fusing into a believable, contradictory, and complex personality. And you'll expect these multifaceted qualities and this level of metaphoric gestalt not just in portraits, landscapes, still lifes, and figure busts, but also in abstractions, videos, performances, and assemblages. You'll look in each artwork for a unique, compelling, and convincing voice. You'll begin to expect more, see more, search for more, and find more.

You'll begin to see how subtle pressures and spatial shifts operate and move you through an artwork, not just vertically and horizontally but also from front to back, in depth, and from inside to outside. You'll notice when a brushstroke, shape, form, or line has spatial tension. You'll experience the implied sightlines that connect form to form to form; that an artist can get you to leap from one point to another (as in the spatial arabesque of Mona Lisa's smile, which pushes into and penetrates as it moves across and defines the volumes of her face; or in the line of that erotic, mysterious roadway, which seemingly penetrates and moves through and over her arms and torso, fusing figure and surroundings). You'll learn how artists transform their materials: how a heavy marble or bronze or stone sculpture can paradoxically seem to defy gravity, to feel much weightier on the top than on the bottom, to feel buoyant, to appear transparent in places, to seem as if its forms were in

motion and malleable despite the sculpture's resolute hardness and stillness.

As in dancing, you'll learn to let the artist lead you. And as you move through an artwork, letting your eyes hop and glide from form to form, you'll begin to pick up on the rhythms and melodies of the artwork. You'll begin to feel your own eyes dancing through the artwork's elements: moving faster here, slower there, pausing, and resting; traversing long, lyrical arcs and feeling the rat-a-tat-tat effects—as in Mondrian's *Broadway Boogie Woogie*, Byzantine mosaics, and the checkerboard patterns of abstract medieval manuscript pages—of staccato pulses. You'll understand why the language of art and the language of music share so many of the same terms: tone, rhythm, melody, speed, timbre, color, line, and dynamics—and that tone is not just about shades of light to dark, but may imply the emotional pitch of an artwork, or the physical state—the muscle tone—of its body. Maybe you'll begin to experience and to describe elements of art as you do food: acidic, sweet, buttery, bitter, underdone, and overdone. Like me, maybe you'll occasionally find yourself tapping out the rhythms of movements and forms in artworks, or trying to contort your body, as you stand before figure sculptures and paintings, into the odd and impossible positions depicted in them.

If you accept that these forces are at work, you'll begin to sense not just palpable things in a picture, but also the palpable space in which those things exist: a sense of distance and atmosphere and air between one form and another; a sense that those spaces are not only open and navigable, but charged with

light and energy, and that those spaces, like the forms themselves, seem to breathe and provide air, that they are believable, purposeful—alive. As you encounter more and more great paintings, you'll begin to sense the marked differences between an artist who actually achieves and delivers form and light on the canvas and one who merely implies—illustrates—form and light. You'll begin to see that light—color—in a painting is not about how much white or black is added to a hue, but about qualities and degrees of warmth and coolness, translucency and opacity, about weight, tone, color, and timbre, envelopment and reflectivity; that light can be harsh or inviting, and can affect us deeply; that it is emotionally, perhaps even spiritually, expressive.

CONSIDER THE WORK of Wassily Kandinsky (1866–1944), the Russian painter and professor who wrote a number of groundbreaking books. These included, in 1912, *Concerning the Spiritual in Art*, in which he spoke about art as coming from an inner necessity, and as having both physical and retinal as well as spiritual impact. Kandinsky was a master at the Bauhaus, a German art school, operational between 1919 and 1933, that embraced and unified all aspects of fine and applied arts—architecture, industrial, interior, and graphic design as well as painting, sculpture, ceramics, photography, bookbinding, and weaving—and practiced traditional crafts alongside art designed for mass production by the machine. Its best-known proponents include the architects Marcel Breuer, Walter Gropius, and Ludwig Mies van der Rohe and the artists and designers Anni and Joseph Albers, Herbert Bayer, Lyonel Feininger,

Johannes Itten, Paul Klee, El Lissitzky, László Moholy-Nagy, Oskar Schlemmer, Jan Tschichold, Theo van Doesburg, and Piet Zwart. At the Bauhaus, the model for all departmental art schools since, Expressionism, Constructivism, figuration, kinetic sculpture, photograms, and pure abstraction existed side by side. The sheer breadth and variety of creative genius and revolutionary ideas there is staggering. Much of what Kandinsky and Klee contributed in both art and theory has yet to be digested—let alone fully explored.

Abstraction was Modernism's Renaissance. Kandinsky, who was among the handful of Europeans who invented abstraction in the early years of the twentieth century, gave his pictures the qualities and movements of music. Unlike many of his contemporaries, Kandinsky didn't arrive at pure abstraction through Cubism, in which the visible world was interpreted, almost scientifically, in terms of pure formal relationships and spatially fractured. In the painted Cubist portrait by Georges Braque *Man with a Guitar* (1911), the room, the space, the architecture, the figure, a guitar, and even the sounds of music all become interchangeable, equally palpable and immaterial, equally tangible and intangible. The painting is not purely abstract (it is of a man playing a guitar), but to navigate it is to let go of the three-dimensional world we know outside of art and allow yourself to travel the rhythms and forms of the music and of the thoughts and movements of the musician, as much as the forms and spaces of the man, his environment, and his guitar. It's necessary not only to allow for the empty, airy port, or sound hole, of the guitar to be cinematically repeated—as if, like the guitarist himself, it were in motion and in many places

simultaneously—but also to see that the guitar's port in places has become convex and more solid than the guitar and the guitarist, and that the guitar port, the strings, the music, and the guitarist have all merged.

Kandinsky, instead of trying on Cubism, began his trip to abstraction by interpreting the landscape, albeit through the kaleidoscopic, fairy-tale lens of a fabulist, but he moved quickly away from using lines and forms descriptively. Kandinsky employed linear, spatial arabesques—lines not merely resting on the surface but expanding and contracting, moving into space and back again—to turn space into something elastic, malleable, and unpredictable.

In Kandinsky's early landscape-based abstractions from 1911, line, color, and shape free themselves from acting as descriptive nouns into becoming active verbs, forces, and energies: contours and colors mix and dissolve, suggesting stained glass and children's finger painting; a horse and rider are expressed as a lyrical bolt of lightning. By the time he paints the purely abstract masterpiece *Black Lines* (1913), all sense of the landscape has vanished: color, shape, volume, space, and line are completely independent, free agents, and his spatial arabesques simultaneously remain on the surfaces of his flat picture and also transform that flat surface into a stretchy membrane, as if the painting were made of rubber or taffy, or could be poked and twisted, or even turned inside out, like the surface of a balloon. Kandinsky gave his lines, forms, and shapes pictographic immediacy and energy. Sometimes, as in the later masterpieces *Blue World* (1934), *Striped* (1934), *Succession* (1935), *Thirty*

(1937), *Various Parts* (1940), *Sky Blue* (1940), and *Various Actions* (1941), his forms feel as if they are painted or incised hieroglyphs, while they also suggest unfamiliar creatures and microscopic organisms, as well as veins and jolts of electric current. They look like signs and symbols, yet feel alive and in motion.

In his mature work, Kandinsky's pictorial elements were set completely free of descriptive reference to identifiable sources in nature. Eschewing representational description, Kandinsky embraced becoming and transformation. He no longer painted a bird, but its flight; no longer the horse, but its gallop; no longer the trees, clouds, animals, and stars, but, seemingly, nature's urges, movements, interactions—energies and essences.

Kandinsky purified art into its essentials. In his painting *Dominant Curve* (1936), for example, he broke nature down into its purest elements and dynamics: emissaries for the universe's forces and actions, its genesis and re-genesis. It's as if we were experiencing the very building blocks of the universe being imagined, diagrammed, symbolized, born, then regenerating, and taking flight. Here, Kandinsky gives us the experience of nature's essences and movements and interactions. He allows us to experience not only the nature of nature, but the nature of picture-making. He brings us up close and inside, as witnesses—in art and life—to the genesis of genesis.

KANDINSKY ACKNOWLEDGED THAT every form and color and movement in an artwork has an effect on us, and that those elements all contribute to the physical and emotional—even spiritual—effect of the whole. Kandinsky was also an early

proponent of synesthesia, believing that an artwork's shape, movement, or color, in the right proportion, could stimulate a sensory experience beyond that of sight, such as a sound, a physical feeling, or a taste: that one might hear the blunt sound of red or the melodic flow of blue, or have his or her tongue pricked by the acidity of yellow. He acknowledged that every element in an artwork is equally important, and must be inwardly purposeful and in service to the whole, like separate cells in an organism; that "form" refers not to shape or volume, but to structure, tension, cohesion, life.

An artist must be in control of his or her universe. And an artist must convey a sense of that universe as an organic totality—a sense that every form is equally important and necessary. In two-dimensional works, the forms are often referred to as "positive space," and the background, or space and air around those forms, as "negative space." I prefer the terms "figure" (for the forms) and "ground" (for the space, such as the white ground of the drawing paper surrounding those forms). These terms are not perfect, but they affirm the positive presence of form even in the white space of a drawing. In an artwork, such as a painting or drawing, there are no negative or formless areas (despite what some may assert to the contrary), unless the artwork has an actual hole in it (and even then, it is filled with air); every element—including the so-called empty white space of a piece of paper surrounding a figure's head—contributes to and fuses with the rest of the picture. If a form or area of an artwork is not helping or contributing to the artwork, then it is hurting the artwork. If there is no tension or interaction between a head and its surrounding space, then the

head feels separated from its environment, and both the head and the environment become lifeless. Even in the *Mona Lisa*, where we are transfixed by her countenance, no element of the picture is actually given priority, any more than one brick in a wall is given priority over another. Remove a few bricks, and the wall—the artwork—collapses, dies.

This fusion of figure and ground is also clearly evident in Matisse's flat, abstract paper cutouts. In *Icarus* (fig. 4), for example—which he created for his book *Jazz* (1947)—the dreamy black figure of Icarus seems simultaneously to fly, fall, swim, drift, rotate, and ascend within the airy blue ground of the cutout. Matisse is working with flat, single-colored shapes, but those flat shapes, because of how they are cut (drawn), convey a sense of volume and movement, even of twisting in the flat plane.

Notice how Matisse provides us with multiple viewpoints all at once: we are below Icarus, looking up, as he flies above and falls toward us; we are above Icarus, watching him drop; and we are alongside him, plunging and soaring. Matisse, seemingly, embeds us in his flat world. Icarus is surrounded by darting, prickly, yellow forms that suggest stars, birds, flowers, and barbs—the piercing rays of light that melted his wax wings. His arms resemble those wings, and the yellow stars flash like sparks in the blueness. See how Icarus's black body and the yellow spurs seem simultaneously to dart through and change direction in space; how they appear to rotate; how Icarus and those stars tend to swell and then to flatten in the blue. The paper forms (the figures) are flat, just like the blue ground, but they appear to move and to twist, which activates the flatness

of that ground plane. Notice how Matisse swaps figure and ground: how the black boy opens as void and then surges into volume; how blue flits among water, airy backdrop, and solid; how Icarus seemingly snaps and billows like a ship's sail, his belly full of air, and then appears suddenly to melt and to fall endlessly into the sea, his black silhouette blank and hollow, both body and grave.

EVERY ARTWORK PROVIDES us with a window, or a viewpoint, that opens up a unique world the artist wants us to see—to venture into. And the metaphor of the window—especially since the Renaissance, when the invention of perspective gave us deep, natural spaces that convincingly re-created the three dimensions of our own reality—is often used to describe the illusionistic space of paintings. And sometimes a picture will open deep into space as if with a view into another world.

This experience of a space seeming to open within a flat surface is one of painting's essential metaphors. Flatness is a given (it's where a picture begins and ends), and space has to be created within the flatness, but without completely disavowing that flatness. Painters must acknowledge and use flatness as an essential element of and force within the picture. Otherwise, they are breaking the picture's back.

Painting, which began on walls before it was applied to the movable walls of wood panels and canvases, to some extent has always been a form of decoration. Pictures require flat support, and that support must be honored and also employed to its best advantage and exploited for its strengths. Painting, then, needed both to reaffirm the flatness of the wall and also,

seemingly miraculously, to defy that flatness. Painting could not become a form of mere trickery. To do so would be to fool—not engage—the viewer with what is possible in painting. This is part of the magic and allure of paintings: they are both flat and spatial simultaneously. We acknowledge these facts in painting and drawing, and we take pleasure in the ways that artists create and orchestrate space, whether it is the mysteriously deep space of a Renaissance painting by Jan van Eyck or the mysteriously flat space of a Mondrian. And the more painters acknowledge and expand our experiences of a picture's flatness, and of the subsequent dichotomies in our sense of space and flatness, the more magical a picture becomes.

Painters realize that in order for us to experience the metaphor of the opening in flatness they must reinforce that metaphor repeatedly. They must remind us of the flatness, as they also take us into depth. So painters move us back and forth in space, reinforcing our sense of the flat picture plane even as they open that flatness and make it malleable. The plane remains visibly whole yet also flexible, capable of inward and outward motion, expansion and contraction, being open and being closed, as if the flat surface has been transformed by its painted forms and light and has been given an ability to change and to move. Painters treat the flat space as if it were elastic— making it a realm in which they can move us deeply inward, then back outward, and then into the middle ground, and back once again to the picture plane where we started.

Great painters are able to treat the spatial realm of a picture as if it were taffy that could be twisted and pulled and stretched, yet never actually broken. To break it, of course,

would be to break the spell. It is in this way that painters create mutable space within the flat plane, reinforcing the experience of flatness opening and becoming spatial, and simultaneously closing and becoming flat. It is in this way that the artist honors where we actually are (face to face with the flatness of the picture plane and the artifice of space) while also honoring the mysterious realm that a painting opens up to us—the realm of art.

To DEFINE THIS paradoxical experience of both flatness and spatial depth in painting, Hans Hofmann (1880–1966), a renowned German American abstract painter and an influential teacher of many of America's most celebrated midcentury artists, came up with the English term "push and pull," which he also referred to as "movement and countermovement," "force and counterforce," and "plasticity." Plasticity refers to the sense of the fusion of all the elements in a picture, but it also acknowledges that picture space is pliable. Hofmann's shorthand term "push and pull" describes exactly the dynamic interplay between flatness and depth in a painting or drawing. And this paradoxical experience of flatness and depth happens in both abstraction and representation. "Push and pull" is not new. It is just as important in prehistoric cave paintings of bulls, in ancient Egyptian wall paintings of deities, and in Renaissance paintings of Christian saints as it is in Modern abstract paintings.

In great paintings, every color has luminosity, but every color also has elasticity and a spatial presence and location in relationship to, and dependent upon, every other color. These

colors all pressure inward and also press outward against the perceived front plane of the canvas. When you look at a painting, imagine not just a front plane, a middle plane, and a background plane, but an infinite number of transparent planes (like windows) layered in the space; and then imagine, further, that these planes, though parallel to the front picture plane, can warp and twist and connect diagonally, and that forms and colors can seem to exist in and connect and merge the locations of these planes; and, even further, that those forms can bridge and exist in numerous planes—or locations, spaces—simultaneously.

Even in an abstract painting made of colored rectangles, no two shapes of different sizes (even if they are the same hue) can really seem to exist in the exact same spatial location relative to each other. Larger forms will tend to advance, perhaps, and smaller forms will tend, perhaps, to recede. Or the opposite can happen. Other qualities besides size—such as brightness, intensity, opacity, translucency, density, warmth, and coolness, and especially location relative to other elements—all contribute to how we read where, exactly, a color or form is in relationship to another color or form, and to how we experience the rhythmic pulse and speed and dynamic "push and pull" of those forms as they seem to shift within the spatial universe of the picture.

We can experience the visceral dynamics of "push and pull" in Hofmann's painting *The Gate* (1959–1960) (fig. 5). Here, Hofmann's color shapes are heavy with opacity and *impasto*—thickened paint, which feels as if it has been troweled onto the canvas. The speed of the colored shapes feels at

first to be somewhat sluggish, as if forms are still congealing. Yet Hofmann gives those forms various speeds and levels of elasticity. The large golden-yellow rectangle dominating the upper third of the composition feels very much embedded deep within the various greens surrounding it, but also feels as if it were suspended far in front of the greens. It punches forward. And if we try to focus only on the golden-yellow rectangle, to discern its spatial location in the picture (if it is closer to us or farther away from us than the large, horizontal, electric-red rectangle beneath it), we must take into account how the surrounding colors affect our experience of it. We must allow the colored forms to "push and pull" us through the painting.

Just below the golden-yellow rectangle is a darker blue swath of color, which tends to pull the bottom of the yellow rectangle above it closer toward us. This gives us the sense that the flat yellow rectangle exists in multiple locations, or that it is not completely flat and parallel to the picture plane, but bending toward us at its base. We feel that the yellow rectangle is farther back in space, or deeper in space, than the red rectangle below it, but it also seems to be plying itself forward, as if to connect to the red.

We sense that each colored form in *The Gate* has, if not that exact dynamic pliability of the yellow rectangle, then the potential to behave in similar ways, since Hofmann has demonstrated that that particular sense of "push and pull" is evident in at least one of his rectangles. Through economy, he nurtures possibility, as well as a sense of becoming. There is a sense here in *The Gate*, just as there is when you see only one flower having bloomed on a bush, that all of the other buds will, or at least

can, also blossom. Each form seems to be stepping forward and/ or back in space; the forms all seem to be competing, perhaps, for frontality. If we try to ascertain which of Hofmann's forms is actually the closest to us in space and which is the farthest away, we find we are muscling in and out through the picture space—moving back and forth, where the painted forms move. The forms in Hofmann's picture breathe, open, and close, exert pressure forward and backward, and even at times swing in space, exploring the metaphors not only of window, but of gate.

HOFMANN'S *GATE*—PUSHING and pulling, exerting its will on us—feels alive. His notion of "push and pull," which refers to more than spatial dynamics, gets at the heart of what living is: the forms are interacting and struggling within the universe of the picture, just as we interact and struggle within our own universe. His art speaks to us because it behaves like us. Hofmann's "push and pull," like that dynamic experienced in nearly every great artwork, expresses the tension at the core of all human existence: the experience of being physically alive in tension against the fact that you are one day going to die. Yet his Modern notion of an artwork as a living organism is as ancient as art itself—an essential element not just in visual art but in all visual communication.

The ancient art of Chinese calligraphy, which evolved through pictographs from pictures into abstract signs, fully embraced this metaphor of the living organism. Inspired by the claw marks of animals and the footprints of birds, Chinese calligraphy retains the vestiges of its pictorial origins in the living body: bones, meat, muscle, and blood. Calligraphy's

bones comprise its authority, structure, and size. Its *meat* is represented by the proportion of the marks and characters in relation to one another. Its *muscle* refers to its inner spirit and vital force. And the characters' *blood* is conveyed through the texture, movement, weight, and fluidity of the ink. These are all elements present in any great painting or drawing, no matter when or where it was made.

In Chinese characters—shorthand action pictures—as in all pictorial art, the focus is as much on what they resemble and represent as it is on their dynamics: how well they function and live, and move and flow through the page. Although Chinese calligraphy is a purely pictorial (as opposed to alphabetic or phonetic) language, those characters must convey not their subjects' appearance but their *life*.

The Chinese character for "dawn" is a rising sun felt in tension against a horizon line; "sees" is an eye with running legs—emphasizing the motion, the act, of *seeing*. When a calligrapher paints the character for "sky," it could be airy, light, diaphanous, dark, brooding, bright, promising, still, active, or stormy. The character for "man," two legs in motion, could convey his posture, gait, speed, health, personality, and philosophy—even his misgivings, or the opposing winds, he experiences on his journey. In *The Chinese Written Character as a Medium for Poetry*, written by Ernest Fenollosa and edited by Ezra Pound, we are reminded that in nature there is no such thing as a pure noun or a pure verb: "The eye sees noun and verb as one: things in motion, motion in things." Traditionally, Chinese calligraphy is considered the highest art form in China, and when Chinese calligraphy rises to the level of art, we have a sense not of

seeing pictures, or of reading signs, but rather—as in all great art—of experiencing dynamic, living forms and forces in tension among one another, working out their own fates. There is a sense of "push and pull"—among each character's strokes of the brush, among boundaries, figure, and ground, and among the other characters.

THE MIDCENTURY AMERICAN Abstract Expressionists took the elements and qualities of calligraphy to heart. In Pollock's "drip" paintings—which are very much akin, in language and spirit and dynamics, to Asian calligraphy—form, content, and expression are fused. Chinese calligraphers work within an invisible grid, giving each character's elements a sense of proper placement, scale, and structure, a presence in relationship to the boundaries of its invisible square. It might surprise people to learn that Pollock drew a grid on his large canvases, which he laid out on the floor, before he dripped and flung paint across their surfaces.

Employing the grid, Pollock created an internal structure within which to move and to which he could respond. He was using the canvas like a jazz musician improvising, within a structure, on a theme, but he was just as concerned as earlier painters had been—including the Renaissance artists, who were designing large frescos—with the underlying organization and structure of his compositions, and how the smaller moves related to the larger moves.

The grid gave Pollock a map, a sense of location, and a way to work out the propulsive rhythms of his dynamic splatters and linear strokes. Every time Pollock's flung lines and drips

of paint hit up against the edge of a smaller, internal rectangle on his grid, he was responding also to the corresponding outer edge of the canvas's frame. In this way, as Pollock kept track of where he was within a smaller, internal rectangle, he was also keeping track of the relationship of his marks to the whole. Far from moving haphazardly, mindlessly flinging line by line of paint across the canvas, Pollock, with each stroke, was orchestrating a part-to-whole symphony.

In his frieze-like *Autumn Rhythm (Number 30)* (1950) (fig. 6), a canvas roughly seventeen feet wide by nine feet tall, Pollock moves us dynamically across and through the plane. He immerses us in a web of sweeping, swelling, whiplashing strokes of black, white, brown, and deep turquoise blue that roll us laterally across the mural while pushing and pulling within the space. In *Autumn Rhythm*, Pollock's flung and dripped lines are not only lines—they are the bones, energy, and blood of the painting. And those lassoing, interlacing lines build to create the tendons and muscles of the forms as well as the painting's interwoven skin. They all build to amass the increasingly dense, yet open and airy, frontal presence, pressure, and light of the painting—which radiates toward us. Pollock's spots and looping, clashing drips have elasticity. Performing spatial arabesques, they build up the layered surface as they also reach back and forth—push and pull—into space.

Existing on, in front of, and within the ever expansive picture plane, Pollock's percussive brushstrokes create an illusion of opening a depth among the painted marks and the canvas ground—a space flat yet layered—as lines, color, forces, and ground all interweave, becoming nearly indistinguishable. The

painted lines and ground plane compete with one another, vying for frontality. The weightier, denser, and more congested Pollock's marks become, the more active, the lighter, and the more open and free the painting feels overall—the more it seems to defy gravity and to take flight.

Chinese calligraphy, from the outset, embraced the idea that "form" (or the artwork's visual and material elements) and "content" (or its meaning), by their very nature, are inseparable. (Try, in Leonardo's *Mona Lisa* or Pollock's *Autumn Rhythm*, or the Chinese character for "dawn," to separate which marks are the forms and which are the content.) Still, people often believe that an artwork can be broken down into its form, on the one hand, and its content, on the other. This kind of separation, of course, is impossible. In art, every form is expressive. Each form, then, has meaning as a representation and as an expressive structure. Forms in art exist to explore and express meaning. Meaning—content—cannot exist without form. And if an artwork's forms are muddled or unclear or ambivalent, so, too, will be the content they convey.

In his essay "On Perfection, Coherence, and Unity of Form and Content," the art historian Meyer Schapiro reminded us that when you encounter two paintings of the same subject—portraits of the same sitter, for example, each made by a different artist—they will convey different content. Although their subject, if both painters are working from the sitter at the same time, remains constant, we will experience two different artistic *interpretations* of that subject—two different types and qualities of forms, and therefore, two different kinds of content. Schapiro wrote: "In a representation every shape and color

is a constituting element of the content and not just a rein-forcement. A picture would have another meaning if the forms were changed in the slightest degree." Form and content, then, are fused. As the artwork's forms are experienced, content un-folds and reveals itself—begins to live inside the viewer. The clearer, more expressive, and more complex an artwork's forms, the clearer, more expressive, and more complex the artwork's content.

As LIVING BEINGS, we feel, consciously or not, that ever-present existential tension between life and death. And we relate to and sense in an artwork its own tensions and movements and vital-ity, its will to live—its ability, for instance, to defy the down-ward pull of gravity or to strive vertically against the opposite tension of horizontal. We sense that an artwork's forms en-deavor to move, to assert themselves, to change and grow—to move within, affect, and break free from the binding flat plane or the solid marble.

I do not mean to imply that every artwork is about the struggle between life and death; or that every vertical line is a symbol or metaphor for life and every horizontal line rep-resents death; or that every artwork is a metaphor for a human being. This would give unwarranted narrative symbolism to every artwork. I mean that an artwork's forms and dynamics are felt as living forces; that we, as living organisms, relate to artworks that relate to us and express themselves in kind. It is neither important nor necessary, usually, to name and identify the symbolic meanings of those dynamics, but it is important to feel them and to understand how they operate on and relate

to one another in an artwork, how they build into and contribute to and fuse as an organic whole. It's important, I believe, to begin to ascertain what the elements of a work are doing and why the artist created them and put them there. It is in these ways that we move beyond the mere physical, or formal, aspects of an artwork's elements and get to something closer to the artwork's philosophy—its *raison d'être*.

HEARTS AND MINDS

O̲U̲R̲ ̲H̲E̲A̲R̲T̲S̲ ̲A̲N̲D̲ ̲M̲I̲N̲D̲S̲ ̲P̲L̲A̲Y̲ ̲E̲S̲S̲E̲N̲T̲I̲A̲L̲ ̲R̲O̲L̲E̲S̲ ̲I̲N̲ ̲H̲O̲W̲ we experience works of art, how we assess what is beautiful and harmonious, and how we understand what artworks are saying. It is art's ability to communicate with us through our feelings *and* our thoughts—as well as our conscious and subconscious minds—that brings an artwork alive both privately and communally. Great works of art speak to each of us individually as well as to all of us collectively.

This paradoxical ability among art's many mysteries is what makes it possible for a work of art to communicate universally. A great work of art connects to us first as human beings, but is broad and inclusive enough to address the group. It may seem as if a work is speaking both for me and to me. A great work speaks generally but also privately and confidentially, as if the artist, who may have died thousands of years ago, had planned for me, had recognized me from afar and was communicating directly with me—as if the artwork had been waiting there

patiently for me, like an ancient seed, ready to take root. It is in this way that art erases distance and time; that art, through your experience of and connection to it, communicates with you and unlocks within you what was previously unknown and inaccessible. This is the experience that leads you to feel that an artist—who takes you to the core of yourself—might know you more intimately than your friends or your lovers do, or members of your own family.

We learn from birth to be sensitive to the world, to distinguish things, and to prefer some things over others—to develop and fine-tune our rationality alongside our personal tastes. Along the way, of course, personal experience colors and clouds our objective view of the world. We tend, perhaps, at least initially, to favor paintings that use our favorite colors, despite how well an artist has used those colors. The key is to recognize when this is happening: when, for instance, we dislike a seascape simply because we prefer the forest, or dislike abstract pictures and sculptures because we feel we don't understand them—perhaps because they seem at first to say little about the world with which we are familiar, with nameable objects we can hold onto. These are subjective experiences, experiences of the heart—which are quite different from our objective, mindful experiences.

Both our hearts and our minds are essential to our engagement with art. We need to be feeling and intuiting. But we also need to be discerning, discriminating, and rationalizing the experience of viewing a work of art. And we need to know the difference between the two: to know when the

heart is confusing the mind, and when the mind is blocking the workings of the intuitive heart. To experience art fully, one must develop, fine-tune, and explore the far reaches of all of the senses, and feel and think deeply. Yet, as one nurtures one's subjectivity and objectivity, one must also find a delicate balance between those two poles of experience. This is especially important when confronting some of the most unexpected and unfamiliar formulations of Modern and contemporary artists.

YOUR SUBJECTIVE SIDE (or heart) comprises all the things that make you uniquely *you*—your interests, memories, likes, dislikes, tastes, preferences, ancestry, and personal story. It encompasses your whole history. It might include your fondness for the color red over green, for the taste of oranges over apples, for representational art over abstraction, for landscapes over seascapes. These are subjective preferences driven by your personal feelings.

Maybe you almost drowned as a child and have had an aversion to lakes, ponds, and rivers ever since, so that any body of water, even when depicted in a great seascape painting, causes personal anxiety. Perhaps you are a pacifist, so you won't look at battle scenes, or you are not a Christian, and therefore pass by works of Christian art, which you believe cannot speak to you personally. Equally subjective, of course, would be your preference for all (or only) battle scenes, because you are a military history buff, or for Christian-themed art over other religious artworks—Buddhist bodhisattvas, Egyptian tombs, African tribal totems, Islamic mosques—simply because your faith is

at odds with the myths and tenets behind them. A religious preference might make you lavish the same attention and affection on any depiction of Christ (good or bad) simply because of its subject. In all of these cases, your responses are irrational, fueled primarily by your subjective self—your heart.

The art historian E. H. Gombrich said he didn't think there were "any wrong reasons for liking [a work of art]," but "there *are* wrong reasons for disliking a work of art." I think he was suggesting that we can have all sorts of personal reasons—reasons of the heart—for being drawn to a work of art. Maybe a portrait by an old master reminds you of your grandfather, or a beach scene by Vincent van Gogh takes you back to a childhood vacation. But Gombrich was suggesting that it would be a shame if we missed out on a work of art that was capable of speaking to us in deep and unexpected ways simply because of an initial resistance to its subject matter or style. Gombrich was cautioning us against being drawn only to works of art that seem to reaffirm our personal interests and preferences, and which seem familiar, over artworks that may at first seem odd, or challenging. A person's feelings about a work's subject or color or what-have-you should not have to do all the heavy lifting. A work of art should not act first merely as a trigger, then merely as a mirror, and then merely as a receptacle for the viewer's personal preferences and feelings. The work of art should be allowed to open itself up to the viewer, and the viewer should be open to it in turn—it may give the viewer something that he or she didn't have before. This is art's gift. But one must do the work required to receive it. Sometimes, an artwork is at

first experienced as beautiful and soothing (appealing to our hearts), and, seduced, we are glad to enter; but before long—yet after it's too late—we discover that the artwork's deeper truths, though beautifully expressed, begin to sting us. And this is also one of art's gifts—because truth, no matter how painful, has a beauty all its own. Seduction and misdirection are among art's many guises.

Consider some great works of art, such as Matisse's abstract mural *The Dance* (1930), which he painted for the main gallery of the Barnes Foundation collection, now in Philadelphia. In this work, eight large, ecstatic female nudes fall, fly, ascend, and tumble across three lunettes like goddesses or acrobats, both affirming and—swelling and billowing in places into volumes—opening the flatness of the wall. They are nearly abstract, suggesting angels and clouds; although there is no clear narrative, Matisse's nudes are beautiful and hypnotic. Consider a carved bodhisattva, which inspires the viewer to contemplate the nature of being heavily grounded and yet weightless, seemingly levitating, and in which solid stone, in places, looks as soft and transparent as silk. Or consider similar qualities in great depictions—from ancient to contemporary—of Christ's crucifixion, in which it feels as if Christ is both firmly nailed to the cross and floating there before us, hovering as if in flight, his loincloth snapping like a wind-whipped flag, his fingers and toes fluttering like the wings of a bird, his body seemingly stretched between this world and the next. There may be very little about these imaginative artworks that feels familiar, like part of your everyday experience, and that reaffirms your own

personal beliefs. But if you allow yourself to approach them with an open mind, you will find that they work on you in mysterious ways, and that they all speak to various aspects of being human.

IN ORDER TO allow this to happen—to open yourself up to new art—you must use your objective mind, not just your subjective heart. Here, the abilities of the mind represent the capacity to reason—for example, to understand that two plus two equals four, that a picture is vertical or horizontal, that one color is red and another green, that a flat, black rectangle is darker and denser and cooler and appears to sit farther back in the space of a painting than an adjacent flat rectangle of white, or vice versa. Your preferences for black over white, red over green, or landscapes over seascapes have nothing to do with the objective facts your mind is able to discern in an artwork.

The art critic Clement Greenberg wrote that, when looking at art, you need to "distance yourself" from your subjective, or private, self so that you can become as "objective" as you are "when reasoning." Writing about Modern and contemporary abstract art in the mid-twentieth century, Greenberg was aware that many people regarded it as overly subjective—as a matter of the artist simply inscribing the workings of his or her heart onto paper or canvas or into metal or stone without much regard for the thoughts and feelings of viewers. Greenberg was urging people to approach art with all their powers, not only of feeling but also of thinking. He wanted to help people open their minds to all the experiences that Modern and contemporary art offers. He wrote: "The greater—or 'purer'—the

distancing...the more accurate your taste or your reasoning becomes." To become more "objective," he continued, means to become more "impersonal, [but] the pejorative associations of 'impersonal' are excluded here. Here, in becoming more impersonal, you become more like other human beings—at least in principle—and therefore more of a representative human being, one who can more adequately represent the species." To get closer to the objective truth of an artwork—that which is intrinsic and, dare I say, absolute—Greenberg contended that the viewer must let go of as much of his or her "selfishness" as possible.

Greenberg had a point. He was aware that Modern and contemporary art were very often criticized for their subjectivity, and indeed, that the artists were criticized for their selfishness, as if they were working with little concern for how their works—which often looked very different from the art of the past—would be received and experienced by viewers. Greenberg knew that what he was advocating flew in the face of a popular notion: the idea that every subjective viewpoint was equally valid, that an artwork's function—indeed, its *raison d'être*—was to be a blank slate on which each viewer could write his or her own personal story, and that viewers could see and glean whatever their hearts wanted, despite an artwork's objective truths.

His point was that this particular kind of selfishness in viewers denies, or at least confuses, the story that each artwork has to tell. Greenberg wanted people to be able to appreciate the uniqueness and greatness of a Picasso or Pollock painting, or perhaps of a masterful, abstract welded metal sculpture by

David Smith—which, at first glance, might suggest to some viewers that it belonged not in a museum but in the junkyard. Of course, it is true that each Modern artist has begun with his or her own subjective feelings and thoughts. But, clearly, so, too, have Giotto (1266–1337) and Giorgione (1478–1510)—artists in whom we feel the full expression of feeling and thinking. The Modern artist, no less than the old masters, aims to give those subjective feelings an objective form—the form of a work of art, which can speak broadly and universally. And if the meaning of the work isn't going to be misunderstood, overlooked, or dismissed, then the person standing in a gallery or a museum before that work—before something unexpected and peculiar and even, perhaps, seemingly offensive—must be open-minded enough to allow the artist to communicate fully.

When a viewer treats an artwork too selfishly, he or she prioritizes personal experience over universal experience. The viewer not only closes himself or herself off from the work personally, but denies what the work is actually saying, what it objectively is. When this happens, the viewer also denies the shared and universal experiences he or she might otherwise enjoy in viewing and learning about art. Artworks do not exist in a vacuum. Our experience of one artwork opens us up to the experience of other artworks. To close ourselves off from one work or artist is to close ourselves off from all of them in a way that prevents a truly enriching experience.

One of the most rewarding experiences an artwork can offer is that of personal, private engagement—especially when one viewer's one-on-one experience is confirmed by another viewer's own personal engagement. It is particularly satisfying and

edifying when I see artworks with students and colleagues, or with my wife, who is an artist, and we come to a work of art together. Often, my wife and I can look at the same artwork at the same time and each have a unique experience. Yet when we share and discuss what we saw in the artwork and what we felt—and how the various forms and colors in the work functioned, how those elements, working in relationship to one another, affected us personally—we usually find that we have seen and experienced many of the same things. The same thing often occurs with my students. Our subjective experiences, we discover, were objective experiences. By pointing out various qualities other viewers have not yet noticed, we can enhance each other's experience. And it is through this three-way dialogue (among the artwork, the individual viewer, and other viewers) that the work of art opens up not just privately but communally—and exponentially.

An artwork, after all, is not just there to highlight and to heighten the artist's own experience any more than it is there merely to reaffirm the individuality of the artist or the viewer; it is there to heighten *all* experience—both private and shared, both the individual experience and universal experience. In this way—through the specific, charged, deep, and private experience of one artwork—viewers get closer, if they're honest, to feeling what others feel. They get closer not just to art and to poetry and to the artist, but to other people, to what it means to think and to feel deeply, not just alone, but as a community. The private experience of art opens us up to the larger experience of seeing, feeling, thinking, reflecting, and living in other times and cultures. The more deeply one engages with

art—even when alone, face to face with a single work of art—the more deeply one engages with life and with what it means to be human. Even if you do not, as Greenberg said, "become more like other human beings" when viewing great art, you might discover the same things that others have discovered in a particular work of art. Being alone with a drawing or a sculpture, or an installation or performance or assemblage, might help to narrow the gap between you and the artist who made it, and between yourself and other people.

THE DYNAMIC RELATIONSHIP between the heart and the mind is deeply embedded in the story of Modern art. It is true that Modern and contemporary artists have often prioritized their feelings. But it is equally true that they want to make sense of their feelings—they want to use the mind to understand and illuminate the heart.

This complex dynamic can be seen in the work of the Impressionists—Claude Monet, Pierre-Auguste Renoir, Camille Pissarro, and their cohort—and in the radical work they were doing in the third quarter of the nineteenth century. The Impressionists, working directly in the landscape, were fascinated by their subjective experience. These artists were influenced by the shifting light, the unpredictable and uncontrollable weather, the flora, insects, and fauna, and their own shifting moods. How the world affected them began to take priority as a subject in and of itself. But at the same time, they wanted to represent their sensations in a rational, logical way. Out in the landscape, the Impressionists, doing away with deep space and closed contours, portrayed the world as so many

radiant bits of colored light. This approach was in part because that's how light affected them. Monet famously wanted to ensnare that bright light on his canvas. The Impressionists wanted to show how nature actually looked, felt, and impressed itself upon them. They followed their hearts as they looked out at the world. But there was a mental discipline in the way they proceeded and in the compositional structures they created to express their feelings and their personal visions. You might say they were reasoning with their sensations.

This complicated dance between the heart and the mind continued in the work of the artists who followed, the Postimpressionists, a group that included van Gogh, Paul Cézanne, and Matisse. Both van Gogh and Matisse let their hearts as much as their eyes dictate the colors in their paintings, but it was thoughtful study that showed them how to organize those intense colors into compositions. They recognized that strong feelings needed strong structures. Cézanne, who wanted to paint the truth of his experience of nature, eventually painted not just what he saw but the *experience* of seeing. He used crystalline touches of color, like so many little flashing sensations, to give us the sense of our eyes in motion: the act of seeing life from multiple changing viewpoints and perspectives. In doing so, he hoped to bring the viewer closer than ever before in art to the existential truth of experience. Cézanne thus devised a science of seeing—but while intuiting and reasoning in equal measure. For all these reasons, he is now called the father of Modern art. He brought us somewhere new and fostered something new.

After Cézanne, movement, emotion, and anxiety—a world being lived, not merely seen, depicted, presented, and

interpreted—became vital subjects for art. Artists working in the cities were inspired by the innumerable changes and quickening pace of urban life. It was not a leap for the Cubists—particularly Picasso and Braque—taking Cézanne's language further, to create a bridge between representation and abstraction.

Embracing Cézanne's fractured elisions, spatial ambiguities, simultaneous multiple viewpoints, and geometric simplifications, the Cubists conceived of form, space, location, and time not as fixed—as if seen from a single vantage point—but as if all were relative and in flux, each element moving and changing within the structure of a work. Like the Impressionists, the Cubist and abstract artists used their minds to make sense of what their hearts told them. In the great Cubist paintings of the modern city by the French artist Fernand Léger, the speed and onslaught of signage, lights, noise, architecture, movement, and people fused into ordered, classical cacophonies. All of the great Modern artists, including even the Expressionists—those who most notably began and ended with the untamed workings of the heart—have understood that expressive, wild feeling, no less than deep thought, is a form of communication that must be *composed* by the artist in order to be received by the viewer. The great Expressionists realized that a human cry is a form of communication as valid a subject for art as anything else, although they also knew that a cry—in and of itself—does not necessarily rise to the level of great art. If you wanted a viewer to spend time contemplating the meaning, expressiveness, individuality, and universality of a cry, and communicate

something significant about that cry to the viewer, then you must do more than just scream into his or her ears.

It's IMPORTANT TO remember that even though Modern and contemporary artists often make work that is primarily (or initially) personal—unlike earlier artists, who, under strict guidance, were given the jobs of telling religious stories, painting official portraits, and the like—that doesn't mean their goals are entirely personal. They are communicating something they believe to be vital, something about what they think and feel. The deeply personal is thus shared. They endeavor, by moving deeply into themselves, to channel something true for all. Moreover, just because a work is primarily (or initially) personal and overtly Expressionistic does not mean there is no forethought, design, or intent behind it. The viewer encountering the piece and contemplating its meaning can move beneath the expressive, personal, perhaps even off-putting surface to unearth and divine something that is universal.

The psychologist Sigmund Freud believed that art communicates not just through the heart and mind, but also in ways that neither the artist nor the viewer is consciously aware of. He believed that an essential part of the art-making process, and of the communication between artist and viewer, occurs at the subconscious level. Freud contended that creating art is an act of transformation and transfiguration, a process during which—through the unique and commanding ability of the artist to mold particular materials to his or her own satisfaction—both conscious and subconscious aspects of the artist's inner psyche,

including his or her fantasy life, take physical form, and that likewise, when viewers experience these forms (those fantasies made real), they do so in both the conscious and subconscious realms. Through art, the artist's subconscious communicates—bridges—with the viewer's subconscious, awakening and revealing hidden truths. Freud believed that art's process of transfiguration, connection, and revelation had the power not only to provide profound pleasure, in the form of feelings, thoughts, and contemplation—and to inspire deep gratitude and admiration of artists by viewers—but also to relieve anxieties in the artist and the viewer alike. This mysterious power both to awe and to calm, and to give our daydreams physical form, was among art's primary purposes, in his view, and explained why we are driven to return to art again and again.

Artists depend on the viewer bringing his or her personal and impersonal experiences, thoughts and feelings, and fantasies and daydreams to an artwork. They know their works of art, which came to them, in part, through processes and from places they cannot always identify, will affect and speak to the viewer in kind. Artists are aware that people cannot always keep up with every thought and feeling they have while experiencing a work of art; that art, like life, can move through us quickly. When artists sculpt lovers entwined, or paint fruit in a bowl, or an onslaught of abstract forms, they expect the work of art to awaken both personal memories and shared appetites—to remind viewers of those times they held someone in a passionate embrace, or had their appetite whetted before biting into a ripened peach, or became excited by the pure dynamism of abstract shapes and forms. Great artists know what excites

and holds our interest. They acknowledge that a vertical form inspires different emotions than a horizontal or a diagonal form, that a grouping of related objects nestled comfortably together can, depending on the details, inspire a sense of familial belonging or a sense of claustrophobia.

When a great abstract artist arranges colored geometric shapes on a canvas, he or she is aware that, if given time to explore the composition, viewers will respond to those shapes in similar ways and reach similar conclusions about them—about what those shapes are doing and how they affect the viewer intellectually and emotionally. This is the case in *Rhythm Color* (1967)—among other pictures—by Sonia Delaunay, the pioneering Ukrainian-born French painter and designer. Nearly every shape in the painting seems to strive for pure Euclidian geometry and pure primary color, seeking to exist as an unadulterated, uninterrupted rectangle, circle, or triangle. And yet each shape also feels hindered by another: half-circles overlap or bisect the rectangles and triangles; rectangles and triangles overlap and bisect the circles; many of the forms feel like half-starts—pushed against, cut in half, unhinged, or jarred and slipped out of position. And the primary colors feel threatened, intermixed: pure yellow is tinged lime, black affects white, the introduction of yellow compels red toward orange, and white gives opacity and body to pure blue.

At the center of the painting, the right angles of two black forms press toward each other, but they do not touch. Instead, they are separated ever so slightly—as if the center of the painting, expanding, cannot hold, or as if, as much as they would like to, they cannot come together. Those forms are so close to

each other, and yet so far away. There is enormous tension between them. Have they avoided a collision, or are they pulling apart? It seems similar to the tension between two people who have had an argument—like when you go to bed angry with your spouse. You feel misunderstood, separated, and yet remain so close physically that you can sense the other person's body heat and hear his or her breathing. That small gap between the two of you feels—emotionally and psychologically—as broad as the Grand Canyon.

To those who would argue that artists do not think about these things—that they are merely painting the fruit they see before them in a bowl or mindlessly arranging abstract colored shapes on a canvas—I would reply that some, of course, do not. But I would also argue that the great ones do. To experience a bowl of fruit painted by Jean-Baptiste-Siméon Chardin, or Cézanne, or Picasso, or Matisse, or to experience abstract works by Kandinsky, Robert and Sonia Delaunay, Klee, Mondrian, or Ellsworth Kelly—in which rotund fruits, or pure abstract colored shapes, appear to nuzzle and roll, to rub and press against, and to turn toward and away from one another, and in which one form begins to levitate and another feels nudged, suggestively, from behind—is to think and feel your way toward exactly what the artist is communicating.

In works by these artists, you begin to see and to sense not merely a bowl of fruit, or an abstract arrangement of colors and forms, but a dynamic universe, a gathering of relationships and forces. And you begin to feel not, exactly, that a story is being told, but that a number of individual forms are responding, merging, and interacting with one another, that one form is

nearly bruised, while another is blushing, and that still others are sweating, and that sometimes, perhaps, those fruits are altering or even lifting the bowl and table themselves, or penetrating and altering the walls of the room—that an abstract arrangement of marks and colors can align to create their own cosmos.

In some representational paintings, we sense that there are interchanges and relationships not just among things like pieces of fruit and bowls, but also among the inhabitants of a place and the interiors—as in Édouard Vuillard's tightly woven sitting rooms, in which Edwardian families, inextricably separated and yet fused, feel knitted and knotted together like the patterns of the wallpaper's flowers and vines. Or in the gardens and interiors and bathrooms of Pierre Bonnard, which become psychedelic collisions of fantasy and domesticity where figures, flora, and fauna achieve an exalted, fever-pitch patchwork of color and light suggesting brilliant sunsets, annunciations, flashing precious gems, and infernos.

The artist may acknowledge that some of these things we experience in works of art we might at first find difficult to believe and will keep to ourselves: we will think that we are inventing things and seeing only what we want to see (that our fantasies and daydreams are getting the best of us), that our responses and impulses are farfetched, that we are discovering something that is not actually there—that we are being too subjective. Artists plant the seeds, hiding them in plain sight, so that we feel as if we—and we alone—are the ones to bring those seeds to fruition. Artists are aware, however, that if they make your search worthwhile, you will tend to the

gardens they have planted for you. They know you will nurture your experience and bring it and the artwork to life. You will be inspired to move from the general to the specific, and your thoughts will spark feelings, and your feelings, thoughts; you will move through the personal and arrive at the universal.

Artists expect that their work will ignite your imagination and emotions as much as your rationality. They believe that if you are encouraged and rewarded, you will dig deeper and free-associate. They count on this in fact. Artists compose their artworks in order to keep the personal and the universal, the conscious and the subconscious, in ascendance. They trust us to take pleasure in the act of looking closely, personally, with our hearts, and in setting our daydreams free. Artists know that, eventually, if we have been honest with ourselves about what we are truly seeing and feeling, our minds will follow. And they trust that if we honestly take in what is before us with our eyes, mindfully and rationally, then our feelings won't be far behind, and that those feelings will reaffirm the truths of what we see.

four

ARTISTS AS STORYTELLERS

A RTISTS ARE STORYTELLERS. THEY HAVE SOMETHING TO
say. People often think of artists as illustrators of stories or
ideas, and many of them are, but because artists are poets, their
artworks are not literal tellings of those stories. As artists learn
from the work of other artists, among the principal stories artists
tell is that of the ongoing story of art.

Artists might explore an ancient myth, the experience of a
kiss, the disasters of war, unrequited love, or the tension be-
tween two rectangles—but no matter what their subjects, they
are all speaking with the same vocabulary and the same ele-
ments of art. Because the language of art evolves, art changes
with time and comes to us through the voices of different art-
ists. But art is a language not just of growth and change but of
reinvention and recycling.

As artists learn their craft and explore their themes—whether
they're working in painting or bronze or with garbage or blood,
and whether they're working abstractly, representationally, or

Conceptually—they revitalize and extend art's vocabulary. A painting or sculpture, or a performance or collage, tells the story not only of its subject, but of the artist and his or her era; it speaks to its genre and contributes to the larger story and language of art.

To grasp the breadth of that story, especially how it relates to the development of Modern and contemporary art, it's necessary to comprehend that although art has taken on an almost infinite range of subjects, materials, and forms, the elements and language of art remain basically unchanged. A contemporary sculpture, say, of a shark floating in a glass tank of formaldehyde, by Damien Hirst, and an ancient one, say an Assyrian sculpture of a deity-king, both deal with the same elements—for example, scale, weight, form, color, mass, texture, movement, buoyancy, contrast, energy, power, and humor. They both communicate something to the viewer, although they might address and explore art's language in varying ways, or to different purposes, and even with varying degrees of success. With some fluency in the language of art, the viewer can comprehend what each work is communicating, how it is communicating it, and even how well it is communicating it. It's important to see how the language of art—whether it is being spoken in a Brooklyn studio today or was initially spoken in a cave forty thousand years ago, and has been preserved for us to see today—is the same. The art of the past can speak to us now, just as much as the art of the present, once we begin to understand that language, and the art of the present can speak to and help to illuminate the art of the past. Fluency in art's language

grants us access not only to one artwork and its story, but to the whole world and story of art.

ABSTRACTION IS OFTEN considered a Modern invention—and certainly, abstraction was reborn in the early twentieth century—and yet abstract art existed alongside representational art in Paleolithic caves. Throughout history, representation and abstraction have generally alternated as modes of artistic expression, based on how a society felt toward the outside world. This is a point the art historian Wilhelm Worringer made in his groundbreaking book *Abstraction and Empathy: A Contribution to the Psychology of Style*, first published in 1908.

Although Worringer's book was the first serious assessment of what would become known as Modern art, it did not address Modern and abstract art per se. Worringer completed the text, as his doctoral dissertation, in 1906 (Picasso invented Cubism around 1907). Worringer was attempting to come to grips with why the artists of some cultures, such as ancient Greece and Rome, and some periods, such as the Renaissance, worked representationally, while others—the artists of ancient Sumer and Egypt, and of the Byzantine era and the Middle Ages, as well as of many primitive cultures—worked abstractly.

Worringer realized, while studying the ethnographic objects in the collection of what is now Paris's Musée de l'Homme, that those earlier pared-down and abstract primitive artworks must have been thought of as beautiful and functional by their societies, and that we were wrong to force our own post-Renaissance European preferences about what art should or shouldn't look

like on art from other cultures, just because their artworks differed from the representational art we valued and called beautiful. Worringer, alongside many Modern artists, was questioning long-held received beliefs about aesthetics, psychology, sociology, and what was and wasn't beautiful—what was and wasn't "art."

In accepting and acknowledging the mastery of those primitive objects—as Picasso did while looking at the same artworks in the same museum—Worringer came to believe that they were admirable works of abstract art and expressed a worldview, just as the representational art of the Renaissance also expressed a worldview. Worringer classified these two stylistic polar opposite views as abstraction and empathy. He argued that when we are comfortable in the world and our surroundings—as people were in ancient Greece and Rome and during the Renaissance—we tend to want to empathize with the world: to idealize it, and to re-create the look, and especially the three-dimensional space, of that world in our artworks; we want to make objects that objectify our delight in the self. And when we feel uncomfortable, uncertain, and anxious in the world—as people did in ancient Egypt, during the European Middle Ages, and during the Modernist era—we tend toward a will to abstract from that world: to create artworks that suppress the look and space of our surroundings, that honor our inner unrest; these eras produce a state of alienation that we might describe as "an immense spiritual dread of space."

The ancient Egyptians focused their whole lives on building their tombs in preparation for the afterlife, and ancient Egyptian artists worked basically abstractly for over three

thousand years. Ancient Egypt was the epitome of a culture focused elsewhere, living in a state of unrest. The art historian Erwin Panofsky, discussing the Egyptians' obsession with the afterlife, wrote: "If we were, God forbid, sociologists, we might say that the entire Egyptian civilization tended to be 'death-oriented' rather than 'life-oriented'; Diodorus of Sicily expressed the same contrast much better in the sentence: 'The Egyptians say that their houses are only hostelries, and their graves their houses.'" This existential feeling of discontent and unrest reared its head again during the Industrial Age, when Modern European artists didn't actually *invent*, but rather *re-invented*, abstraction.

THE DUTCH PAINTER Mondrian, a key innovator of Modernist abstraction, distilled the elements of art to their barest minimum: horizontal, vertical, the right angle, and the colors red, yellow, blue, black, and white. Mondrian's extremely spare painting *Composition with Blue (Schilderij No. 1: Lozenge with 2 Lines and Blue)* (1926) (fig. 7), at the Philadelphia Museum of Art, is a square oriented like a diamond. Generally referred to as *Composition with Blue*, it is an abstract painting that is insistently flat, and with only a few elements—a field of white intersected by two black lines and a triangle of blue—but it is extremely energetic and complex.

The painting's flat surface only faintly suggests overlapping between the two black intersecting lines, one moving vertically on the left side of the painting and one stretching horizontally through the lower third of the white ground. The small triangle formed by their intersection and the lower left diagonal edge of

the canvas is a deep, cool, primary blue. The rest of the composition's forms are stark white. These white and blue forms and black lines lie flat and deny spatial depth, implying that each element is equally frontal, then more frontal, and then even more frontal still. When you spend time looking at Mondrian's whites, it begins to seem like instead of the black lines being incised within the white ground, the white forms are expanding, overtaking, and pushing aside a diminishing black or even blue ground. It's as if the white is not a ground at all, but the closest element of the picture—like a white liquid spreading across the canvas. The tensions among what is on top, what is below, and what is incised *within* the painting's ground plane is up for grabs, evolving equally, and those tensions vary depending on what precisely you are looking at—where your eyes are moving—within the painting.

At the outer edges of *Composition with Blue*, the black lines seem like they are on top of the white, but as you move inward, the large, home-plate-shaped white form begins to feel as if it were rotating and diving, like a missile, toward the right angle of where the vertical black line meets the horizontal black line. Here, at this dynamic point in the painting, white tends to swell, to muscle, to press against, and to overpower the black right angle.

Depending on where you are looking within Mondrian's painting, each form, its sense of flatness and volume, and its directional movement (up, down, left, right, diagonal, in, out) varies. In places, we feel that the flat plane is bulging and breathing, that it is a taut, elastic membrane elbowing its way around and through the composition—that Mondrian's flat,

painted plane is a living thing. This is especially true when each form is considered by itself amid the others. The blue triangle, despite its small size and dark color, exerts a diagonal, upward pressure against the black right angle at its apex, like a propulsive engine launching the larger white home-plate form.

Mondrian's blue triangle has the expansive energy of a star-burst, yet it acts as both the painting's keystone and its center-beam balance point. Mondrian keeps us off balance, moving, trying to right ourselves and his composition. Moving through the expanse of the flat field, it's impossible, really, to find a center—attempting to do so is a futile longing that leaves us either floating in white space or being pulled constantly else-where, everywhere.

Composition with Blue has a sense of dynamic equilibrium—not only of arrest of movement vertically, horizontally, and diagonally, and not just an arrest of spatial depth, but also a sense of circular movement against the *en pointe* balance of the canvas's bottom point. The painting, as if standing on tiptoe, pirouetting, feels as if it were pulling to its right and then its left, as if it were rising, and as if it were plunging straight down, diving like a bird of prey.

We feel in this painting the vertical and horizontal pres-sures exerted on the black lines, particularly the farther those lines extend away from the intersection. To help counter this effect, Mondrian made the horizontal black line a little wider, or thicker, than the vertical black line. This slows its move-ment horizontally while giving it the appearance of swelling and advancing slightly toward us, and of beginning to widen from line into plane—into a rectangle. Like the other forms,

the black lines give the painting increased movement and flex. Mondrian's machine-like lozenge pushes in so many directions equally, and all at once, with so many degrees of competing energies and volition, that the entire painting, elbowing this way and that, seemingly warping off the flat wall behind it, as if ready to leap, has the qualities and movements of a dancing one-man band.

What's equally powerful in Mondrian's painting is its sense—despite all of its movement and muscle—that it is in a constant state of movement *toward* something: its sense of becoming. The small blue triangle appears to be hatching, expanding, breaking through, and launching itself. Yet, what I find among the painting's most compelling attributes is the sense that the composition is forever trying to *right* itself—to find stasis, to get off pointe, to come back to square. (A ballerina can't pirouette forever.) The composition is like a four-step dance in which one partner is always one step behind the other. There's a sense that, if only one of its many dynamic energies could take the lead, getting every other element in step, the whole composition would find its rhythm—and arrive, and rest.

As you stand before Mondrian's *Composition with Blue*, its forces become exponential. I feel its imminent frontal impact—as if I were experiencing the forward momentum of the grille of an oncoming Mack truck. This advancing pressure, along with the composition's infinite inability to right itself, makes the painting appear to pull you, as if along its horizon, forever outward to the diamond's left and right; to propel you upward through its apex; and to spike you downward, as if with

a hammer blow. It's a combination that leaves you everywhere and nowhere—yet feeling its impact in your chest.

A CENTURY BEFORE Mondrian painted *Composition with Blue*, the Ethiopian magic scroll image *Satan Imprisoned* (fig. 8) was created as a prescription for a troubled or sick individual. This charged, abstract depiction of a red-faced devil being held between vertical and horizontal interwoven bands is a powerful, graphic image. Though similar in structure and dynamics to Mondrian's *Composition with Blue*, it has a very different story to tell, a story to a different culture of another era.

Though influenced by Persian and Islamic sources, *Satan Imprisoned* is mainly a Christian talisman, a protective prayer scroll used as a sacred treatment, perhaps after an exorcism of demons or spirits. This treatment may have included the sacrifice of a sheep, the washing of the sick person in the sheep's blood, a meal of the animal's roasted flesh, and the preparation of its skin as a substrate on which to make the scroll. Only then would it be decorated with the prescribed prayers and talismans.

The sacrificed sheep's blood may have been mixed with pigments that were produced explicitly for that particular scroll, which, after it was finished, was probably worn or kept near its owner at all times. Texts for most Ethiopian magic scrolls include passages from the New Testament. Each scroll, with its own painted form, or talisman, and choice of written text, holds significant symbolic and metaphoric meanings. These images and texts, combined and amplified, become incantations and invocations. Made primarily for illiterate laborers,

the scrolls speak mostly through their metaphoric imagery. To the afflicted, as well as for the shamans, or "priests," who prescribed them, and the artisans who created them, the scrolls were not "works of art," according to Jacques Mercier, in his book *Ethiopian Magic Scrolls*, so much as "strong medicine."

Satan Imprisoned depicts a version of an eight-pointed star, with each of its eight loops on its interlacing bands representing a point on that star. Together, the star's interweaving bands become bars visually locking Satan in his prison. The ancient symbol of the eight-pointed star has many meanings. In Islamic art of the Middle Ages, it represents the seal of the prophets, whereas in Christian art, it may connote baptism and regeneration—new life. Here the star is believed to represent an engraving of Solomon's ring and the talisman protecting the subject from all the cardinal and intercardinal directions (north, northeast, east, southeast, and so on). The "X" shapes above and below the main figure, according to Mercier, "are seals that both bind Satan and undo spells."

In *Satan Imprisoned*, the interlacing bars, knots, and braided scrollwork tie, bind, and hold Satan in place—the X's stomp Satan down, and the wavelike motion of the interlacing keeps Satan distracted and bound. The interlacing, knots, and scrollwork are of varying thicknesses and sizes; they are not rote patterns, but seem organic and interactive—like Satan, *alive*. As they interweave, and where one bar overlaps or interrelates with another, we can see the effects of the pressures that have been exerted; there are varying degrees of tightening, expansion, and compression. We get a sense of an organic prison—of forces of containment and restraint against Satan's

opposing forces, those representing his will to be free and to do harm.

At the center, Satan's head feels like a heated red balloon about ready to pop; the pressure of his bulging eyes, and of his head held back against the vertical and horizontal bars, is such that his face becomes the only real place in the composition where we sense a full, pumped-up volume. He is suspended within and expanding against the surrounding flat blackness. But the image is not completely flat, like the parts of Mondrian's *Composition with Blue*. Here, there are overlaps of the interlacing bars, the overlaps tending to cancel one another out: at each overlap, we feel that we are on top of the bar beneath, but we also feel that each bottom bar quickly, and repeatedly, regains its position on top elsewhere within the scroll, creating a space, overall, in which depth is acknowledged as much as it is denied. It's as if the bars exist, and operate their magical hold, within, not on top of, the scroll's flat plane. We sense that space is not real, actual, but a metaphoric construct.

Indeed, we sense that the bars holding Satan in place are not many, but one, which loops over and under itself, like a Mobius strip, creating a space *without* top or bottom. This denial of spatial depth within the flat plane suggests that although Satan is volumetric, he is imprisoned so tightly in the magic world of the scroll that he (a three-dimensional form) is held within a two-dimensional (or *other*-dimensional) magic realm. His restraint is further enhanced by the fact that the vertical and horizontal bars, like heaven, have no beginning or end. The bars act like a force snaking around Satan, holding him in a prison without space or time.

Satan's sense of imprisonment is furthered by the movement of the bars. Their machine-like energies move diagonally and circularly through the braids and the loops of the prison, creating a dynamic equilibrium similar to that which we experienced in the diagonal and circular forces and movements in Mondrian's *Composition with Blue*. In *Satan Imprisoned*, we experience a tension not only between flatness and volumetric form, but also between the endless circular movement around and containing Satan, which functions like a wall, and a sense of immobility—of Satan's movement and life, his powers, arrested in the plane.

Like Mondrian's *Composition with Blue*, the Ethiopian scroll is infinitely active yet also static, fixed. This paradoxical dynamic creates a further tension among the forms in each artwork: tension between action and rest, between containment and release, between life and death—a sense of energy compressed inward, and yet unable to be confined. This sense of energy imbues both images with a kind of magic, a charge like that of a live wire.

ARTISTS CONSIDER ALL art from every period as living, relevant, and contemporary. They don't think of art as progressing or as existing on a timeline. They think of art as a living museum. Museums are often criticized for putting objects behind glass and on pedestals, and for removing ritualistic objects and other artworks from their religious or everyday contexts, as used by people outside the museum: a family portrait, relocated, becomes anonymous; a magic totem, taken from its village, becomes a sculpture; and an altarpiece, removed from

its church, becomes a painting. Ellsworth Kelly's monumental masterpiece *Sculpture for a Large Wall* (1957), created for the lobby of Philadelphia's Transportation Building, spends most of its life—dismantled, entombed—in New York's Museum of Modern Art storage vault; and a tiny basket holding a handful of personal trinkets—amulets, toys, cheap jewelry—from about 1800 BC, meant to accompany a little Egyptian girl in a tomb on her eternal journey in the afterlife, arrives like lost luggage in New York's Metropolitan Museum of Art. But museums also convert these objects into cultural emissaries, leveling the playing field and allowing us to experience artworks from distant places and times in the context of other works of art. They allow thousands of voices from various cultures and times to speak to one another and to us, enabling us to make visual connections among works that clamor for our attention and speak to us, and to the idea that all art is contemporary and relevant.

Think of the primitive art, in Paris's Musée de l'Homme—where Worringer had his epiphany—that also influenced Picasso, inspiring him to reconsider the art of other cultures, and to create Cubism; and then, of Cubism's influence on countless other artists, which led to abstraction. Think of the influence of Rembrandt's expressive paint-handling on the Expressionism of Chaim Soutine; and of both Picasso's and Soutine's pictures on de Kooning's expressionistic *Women* in the 1950s; and of de Kooning and African tribal art on the expressionistic and graffiti-laden paintings of Jean-Michel Basquiat in the 1980s; and of Basquiat on contemporary graffiti art. All of it bringing us full circle.

Or consider the influence of Byzantine Madonnas and Japanese prints on van Gogh, or of Islamic art and Byzantine Madonnas on Matisse, in those two artists' uses of pattern, flatness, volume, decoration, and color. And then, of Matisse's and Mondrian's influence on the large, flat color planes in the paintings of Ellsworth Kelly, some of whose pumped-up yet flat forms seem ready to torque and to jump off the walls—ready to pop, like Satan's head in that Ethiopian manuscript's prison.

Artists often discover that, in their personal engagement with the language of art, they arrive at similar places. Consider Picasso's linear images of bulls, created in the early twentieth century, and those Paleolithic bulls drawn and painted forty thousand years ago on the walls of the Lascaux and Altamira and Chauvet caves.

Both Picasso and those Paleolithic artists convey the same writhing line, the same gait of the animal, the same paradoxical swelling between flatness and illusionistic volume. Both prioritize not necessarily the *look* of the bull, but the animal's energy, movement, and life. Picasso and those anonymous cave artists wanted us to know that we are looking at a bull, but, more importantly—using the expressive power of line—they sought to convey to viewers the animal's motion, volume, weight, strength, and grace; the rhythm and speed of its running legs; the shifting of its massive body, like ballast, within its skin. They wanted to capture something of its power and quickness, something closer to the bull's life-force and spirit.

It may very well be apocryphal, but Picasso is often said to have told his guide, upon exiting the Lascaux caves, in France,

or the Altamira caves, in Spain: "We have invented nothing new." Of course, Picasso, who was among the most inventive of Modern artists, knew he had invented something new. But he also realized that, through his own journey of discovery and invention, he had arrived exactly where other artists had arrived before him. These discoveries, I imagine, both reassured and humbled him.

If you compare, for example, ancient Roman Fayum mummy portraits, on the one hand, to painted portraits, in the early twentieth century, by Matisse and André Derain, among others, on the other hand, you'll experience how fresh and contemporary—how Modern—the Fayum mummy portraits really are. And if you compare some of Matisse's paintings of women, such as his *Woman in Blue* (1937), in the Philadelphia Museum of Art, to Byzantine Madonnas, or to Giotto's *The Ognissanti Madonna* (c. 1310), you'll see that the tension between flatness and volume is similar—that both Giotto and Matisse, from different times, were expressing themselves through the same language.

ONE OF THE most overwhelming experiences I've had with art was while standing at the base of Egypt's Great Pyramid on the Giza Plateau. More than 450 feet high and 750 feet wide, the Great Pyramid demands that you bend yourself to its will; that you right yourself in relationship to it; that you honor its square; that you meet it at the midpoint of its base; that you stand there to pay the mammoth sculpture its due respect.

And, like Mondrian's *Composition with Blue*, the Great Pyramid wants to square off with you, head-on, centrally, face to

face. While standing before it, you have the feeling, because of the numerous dynamic pushes and pulls exerted on you (up, down, left, right), of being lifted and suspended, of being held and stretched like taffy, of rising and falling.

While standing in front of the Great Pyramid, the largest sculpture on earth, you feel its incomprehensible enormity, which threatens to squash and obliterate you, but you seemingly cannot stay grounded: you are pulled to the far ends of the colossal base. You feel, because of the great, rising, sloping pyramid face in front of and above you, that it is infinitely falling away from you, and that you, pulled in its wake, are infinitely falling forward. It's like simultaneously standing at a precipice of a cliff and being inverted and flying, as if you had already leapt off and were in a freefall. Because of the pyramid face's great height and speedy ascent to the distant peak, it's as if you are being catapulted and are rocketing skyward. The Great Pyramid made a physical impact on me and confronted me, taking me out of myself. It made me feel the weight and pull of gravity while simultaneously experiencing weightlessness and release.

Originally, the Great Pyramid's faces were sheathed in reflective white limestone. I can only imagine what staring into one of those bright, blinding white fields would have been like—and what kind of visceral meaning that experience would have given to the notion of walking into the light. It was while standing in front of the Great Pyramid that I realized I had had this pure, abstract experience before—I'd also felt physically dislodged yet grounded while standing in front of paintings by Mondrian.

While standing face to face with Mondrian's *Composition with Blue*, mesmerized, attempting to find a center in his active and amorphous bright white field, I felt that perhaps I was one step closer to comprehending what that experience of standing before the Great Pyramid, blinded by the ancient white limestone, might have been like. And this is how I become more familiar with the language of art. Whenever I return to certain paintings by Mondrian, and I feel their power both to ground me and to displace me, they transport me back to Egypt. I imagine that when I return to Egypt, to the base of the Great Pyramid, I'll also be experiencing a piece of Mondrian. This is the story of art.

ART IS A LIE

ART IS AN EVOLVING STORY. I ONCE HEARD ABOUT A well-heeled woman living in an apartment on New York's Upper East Side who had forked out five figures in a charity auction and won an artwork by a famous Conceptual artist. Being a work of Conceptual art, her prize, when she cast her winning bid, might not yet have been conceived by the artist, let alone made, so the buyer had no idea what she was purchasing. When the artist arrived at the woman's home to deliver the piece, he asked her if she had a vacuum cleaner. Perturbed, yet intrigued, she had her maid produce it for the artist, whereupon he opened the vacuum cleaner's bag and dumped the contents in a neat pile on an Oriental carpet on her living room floor. And then he left.

The patron felt not only cheated by the artist, but also that she had been made a fool. She complained to the organizers of the auction, demanding another artwork or a refund. The artist initially refused, but after much heated back and forth,

he eventually agreed to revisit the installation, which he documented with a camera before the pile of dirt was sucked back into the vacuum cleaner's bag. The photograph of his installation was printed, given to the collector, and, as I recall, hung near the scene of the crime on her living room wall—to her satisfaction.

This story may be apocryphal, but it illustrates a number of issues about the landscape of contemporary art: that a Conceptual artwork could be merely an idea, never physically realized, even on paper, existing only in the artist's mind; that one of the functions of a Conceptual artist's oeuvre might be to niggle the viewer, to throw her off-guard, to create something that would make her sit up, take notice, be uncomfortable, and experience art in a completely new way; that perhaps a viewer's outrage or confusion would be encouraged and could actually be an integral part of the artist's conception, an interactive performance that could also include her maid, her family, the charity auction organizers, the artist, and his dealer.

I could easily imagine the pleasure the American Conceptual artist Lawrence Weiner (b. 1942) might have taken in the scene that unfolded one morning at his 2007 Whitney Museum of American Art retrospective, *As Far as the Eye Can See*. There, while walking through the show, I saw a viewer being reprimanded by a guard. The unsuspecting visitor had just stepped onto Weiner's proto-conceptual painting *One Pint Gloss White Lacquer Poured Directly upon the Floor and Allowed to Dry*. Conceived in 1968, and freshly executed for the exhibition at the Whitney, the artwork was exactly what its title implied: a dried puddle of glossy white paint (which may or may not have

been poured on the Whitney's floor by the artist). The guard shouted: "No step! No step! No step!" Startled, looking first at the guard and then at the painting beneath his foot, the viewer quickly apologized: "I didn't understand. I didn't see it. There was no rope around it!" With a sigh and a shake of her head, the guard said—as if she'd said it before—"I understand," her words trailing off as she leaned back against the gallery wall.

And I could also envision the Mexican artist Gabriel Orozco (b. 1962) accepting that it was par for the course in the life of his artwork when, in 2009, during his retrospective at the Museum of Modern Art, one of his sculptures experienced a case of mistaken identity. There, I watched a two-year-old girl excitedly pounce on one of Orozco's sculptures and bounce it across the gallery floor. That artwork, *Recaptured Nature* (1990), comprises two used truck tire inner tubes that have been patched together and reinflated into a sphere resembling a big, black rubber ball. After being scolded by museum guards, the traumatized toddler, kicking and screaming, was removed from the gallery by her father, while her frazzled mother pleaded for leniency. The guards lectured the mom about the sanctity of art as they rolled *Recaptured Nature*, seemingly no worse for wear, back into position.

There are claims that Orozco's *Recaptured Nature*—because it is refurbished rubber inflated into a sphere—is an object of "morphological transformation." Is there something appealing about Orozco's misshapen black rubber ball? Maybe, since inflated objects are handsome. But, overall, I'd say that *Recaptured Nature*, as art, is pretty inert—which might be why that little girl was inspired to put it in play, in motion. And I understood

her impulse, having myself resisted the playful urge to kick *Recaptured Nature*—as if it were a ball, not a sculpture—across the gallery's floor.

PROVOCATION CONTINUES TO be a popular springboard and stance for many contemporary artists. Some believe this tongue-in-cheek attitude started with the French Impressionist painter Manet (1832–1883), with his shocking paintings *Olympia* and *Le Déjeuner sur l'herbe* (fig. 1) (both completed in 1863). In both paintings, Manet, mixing highbrow and lowbrow, treated painting with looseness and slapdashedness—a sense of unseriousness—as well as with the harsh light of photography, a medium that was becoming increasingly popular, though it was still thought to be a lower art form than painting.

In *Olympia*, an ironical exploration of the sacred and the profane, Manet nearly irreversibly transformed a traditional, revered subject, the goddess Venus, into a whore. Calling attention to the notion of the "male gaze," he perhaps shed light on the true motivations of those who wanted lascivious paintings of naked ladies decorating their drawing room walls: the tasteless industrialists who sought nudes in the respectable guise of Venus. With Manet's *Olympia*, as well as with *Le Déjeuner sur l'herbe*, the already strained relationship between the artist and the public, between the avant-garde and the official French Academy, was laid bare.

Impressionism, though nearly universally loved today, was the most hated art movement in the history of art in its own time. By the mid-nineteenth century, the public already realized that artists were making art about whatever they pleased,

and doing it however they pleased. For many, however, the Impressionists' tessellating fields of light took painting one step too far: it made the space depicted in the picture so shallow that the world seemed to be advancing on the viewer, making it more challenging for the viewer to enter, navigate, roam. The public rebelled—not because the colors that James Abbott McNeill Whistler and Monet used were not pleasing, but because viewers felt duped—as if pots of paint had been flung on the canvas: the Impressionists had taken away not just the traditional subjects of art, gods and myths, replacing nymphs with cows, and not just whole, tactile objects, but navigable space itself. They had transformed pictures into an assault, leaving viewers with nowhere to wander within them.

With *Olympia*, Manet, who understood how the public felt, self-consciously provoked the public further, meanwhile also provoking artists and art collectors, and poking fun at art itself, especially art traditions. In the process, he opened a Pandora's box. In calling attention to the public's folly, he contributed to the public's distrust of the artist. Manet fired a volley of shots that landed nearly everywhere and targeted nearly everyone: his paintings called out and attacked both the plebeians, or unsophisticated public, and the powerful philistines of the art world in the official academy, who in turn ignored the value of Modern art. Manet's paintings acknowledged that neither group really appreciated or understood the art of the avant-garde, exposing the fact that there was a major rift between these groups and Modern artists. Yet, in using the art of painting not just as art but also for gamesmanship, as a niggling, self-conscious vehicle or a weapon, Manet shattered one of the

walls between art and viewers, introducing into art the role of provocateur, and emphasizing that role as something valuable in and of itself. Intentionally or not, Manet lobbed an attack that affected not just the public and the French Academy, but also artists and the art they began to make. He introduced a division between artists and the public that continued to develop, a division that has been exploited by some, and that has never been fully bridged, in the years since.

Fifty years later came the uber-provocative, uber-self-conscious "Readymades" of Duchamp (1887–1968), the disillusioned French painter and master chess player who, in 1915, bought a snow shovel, hung it from his studio ceiling, and called it art. This was not just art as gamesmanship. It was gamesmanship as art.

Titled *In Advance of the Broken Arm*, the snow shovel was one of many Readymades that paved the way for Postmodernism and contemporary art. Many believe, with good reason, that it was Duchamp's Readymades—those ordinary, mass-produced objects that Duchamp brought into hallowed artistic settings to challenge traditional notions about art—that were the first artworks to signal the seismic shift that we call the birth of Postmodernism. Art, according to Duchamp, should no longer concern itself with aesthetics—things pleasing to the eye, in service of the retinal—but should instead concern itself with the intellectual—concepts and ideas in service of the mind. Duchamp's ploy was an attempt to subvert traditional notions of aesthetic beauty, skill, and the individual artistic genius as defining characteristics of art. He attacked the notion that the artist was anything special, that the artist was talented,

or mythical—a shaman, a seer, a visionary. He challenged the idea that a work of art was different from or more powerful than any other object found anywhere.

Duchamp's *Fountain* (1917), a hand-signed ("R. Mutt") porcelain urinal the artist purchased from the J. L. Mott Iron Works, and placed on its back on a gallery pedestal, is the most famous and influential of his works and is frequently copied. Cattelan's solid-gold toilet, which he called *America* (2016), and Manzoni's *Artist's Shit* (1961), in different, though obvious, ways, both riff off of Duchamp. *Fountain* was rejected by an exhibition committee that didn't deem it to be "art," despite the fact that every artwork accompanied by a paid entry fee was supposed to be accepted and exhibited. Duchamp's Readymades were not fully embraced until after the mid-twentieth century, but they changed the nature of what an artwork could be. Since then, art has no longer needed to be a unique, handmade object created by a gifted individual dedicated to his or her craft. It can now be something found, bought, or mass produced; or can be merely an idea existing in a person's mind, as in Conceptual art. As soon as Duchamp's premises were accepted as art and entered into the canon, anything—anything whatsoever, as long as it came from an artist—could be designated as art.

Duchamp had poked fun at the belief that art was an act of transformation—or transfiguration—of the ordinary into the extraordinary. The Readymade object argued that art with a capital "A" was, in fact, something of a con; it also focused on art as commodity. The Readymade took the found or store-bought object and "transformed" that ordinary object into "art"

by the mere wave of the artist's hand. Any cheap, store-bought item would do, a utilitarian object available basically to everyone, which everyone thought they understood, became an "artwork," something that only a very rarefied few could begin to appreciate and comprehend, let alone afford. A Readymade was something that you understood—whose irony you "got"—rather than something you appreciated for its aesthetic or universal appeal.

Duchamp made distinctions between the mind and the eye in the experience of art. With his anti-aesthetic Readymades, he attempted to separate an idea in a work of art from the form that it took. He sought to bring a urinal into a gallery setting, assuming that through its vulgarity, its seeming incongruity with the traditional paintings and sculptures on view, it would prod viewers and other artists, challenge the notion of what is and isn't art, demystify art's lofty position, and sever, once and for all, the distinction between art and everything else. Duchamp imagined that the urinal would exist only as an *idea* of the Readymade, as an archetype of the found object—because really, any given found, mass-produced object could stand in as a Readymade just as well as any other: it broke through the distinction between art and life. This is seemingly an impossible task, since we take in visual art through our eyes and through the workings of our minds; nevertheless, it was what Duchamp set out to do.

We see and appreciate objects and make aesthetic and intellectual judgments about them as artworks without being able to separate what we see from what we think. It's impossible for our minds to separate form from content: forms are expressive;

both form and content are fused. A porcelain urinal, though made in a factory from a mold, whether it's considered a work of art—a Readymade—or merely a toilet, has form, purpose, and some sort of aesthetic appeal. While looking at a porcelain urinal, we might be reminded of mass-produced or hand-made Modern sculptures that are also sleek, smooth, minimal, and curved. The urinal, whether it has a title, like *Fountain* did, or is just another utilitarian toilet, feeds both our minds *and* our eyes. But the Readymade has now become ubiquitous. And unlike the numerous still lifes, portraits, landscapes, and sculptures that artists have created throughout millennia, most of which are meant to be experienced as unique and individual, the Readymade is not meant to call attention to itself per se, but to call attention to the *idea* of the Readymade as a concept, a construct—a construct that trumps the Readymade object itself.

Duchamp's idea of the Readymade—and especially *Fountain*—was original and unconventional and extremely thought provoking a century ago, or even half a century ago: that is, the first, second, third, and fourth, and maybe even hundredth time around. But it is no longer original, and with so many contemporary Readymades in galleries and museums, there are lingering questions: How much does the Readymade continue to feed us—to nurture us, or even really provoke or challenge us? How much does it still provoke the art world? And in what way, exactly, does it still provoke? How many Readymades does it take before the Readymade becomes merely a ready-made, hand-me-down stance? How many does it take before the Readymade is no longer representative of the avant-garde

or of provocation at all, but merely becomes indicative of to-day's art academy? The fact that Readymades have become a routine fixture in our contemporary art world is doubly ironic, because the original idea a century ago was to provoke, to challenge, and to overthrow the academy.

DURING THE EARLY twentieth century, numerous revolutionary art movements were in ascendance on both sides of the Atlantic. In 1915, the same year that Duchamp suspended that snow shovel from his studio ceiling, and that Malevich painted his *Black Square*, the Impressionist Pierre-Auguste Renoir was painting his glimmering and rotund late Rubenesque nudes. There were then, as now, many different approaches to making art.

But by 1915 a lot had changed since the early years of the nineteenth century, when Western artists had worked representationally, in traditional materials of paint, clay, wood, marble, and bronze. The change was rooted in the fact that artists were no longer receiving the formal commissions that had sustained them for hundreds of years, which had encouraged them to paint the dictated religious and mythical subjects. Paint had been put into portable tubes, and Modern artists began to venture into the landscape to paint what they saw and felt, rather than painting landscapes from studies in their studios. It wasn't that artists before the Realists and Impressionists hadn't painted what they felt, but out in nature, artists' feelings about the world took precedence as a concentrated subject. Without traditional patrons, artists had felt increasingly abandoned and misunderstood. Their livelihoods were threatened. But they also now felt

liberated to make art about whatever they wanted and to use whatever methods they wanted.

Out in the landscape, the Impressionists brought art one step closer to abstraction, creating the first real rift between what artists were doing and what viewers were accustomed to seeing, what they expected from art. In Paris, the French Academy rejected the artistic innovations of the avant-garde, including the Impressionists Manet and Renoir, the Realists (Courbet, for example), and the Postimpressionists (such as Cézanne), whose methods, styles, and subjects were increasingly seen as vulgar and ridiculous. Like so many flashing sensations, Cézanne's brushstrokes conveyed not so much things seen, but the existential experience of *seeing*. It combined numerous viewpoints simultaneously—the sensation of responding to a dynamic world in flux. Cézanne, nearly flattening painted space, brought distant forms, such as a mountain peak, right up to the picture plane—because that is how it affected him. By the time Manet painted *Olympia*, in 1863, the stage was set for scandal.

And there would be more shocking innovations to come, including van Gogh's jostling, flat patterns, vigorous brushwork, and emotionally driven, invented color, and Gauguin's paintings and sculptures, which were inspired by non-Western, primitive peoples and their artworks, customs, and myths. After Impressionism and Cézanne, movement, emotion, and anxiety—a relativistic world—became vital preoccupations and inspirational subjects for art.

The Cubists, especially Picasso and Braque, pushed Cézanne's innovations further. Working from the still life, the portrait,

and the landscape, Picasso and Braque did away with the notion of a single fixed viewpoint altogether. The Cubists fractured the universe. They conceived of form, space, location, and time as shattered and intermixed. Objects could be experienced from the front, the back, the top, and the bottom; from inside looking out and from outside looking in. They could be experienced yesterday, today, and tomorrow, through dreams and imagination, all at the same time.

Matisse and the other Fauvists heightened color to the point that Matisse wondered if he wasn't dabbling in witchcraft; he thought the colors might make him go blind. Cubist structure, combined with intensified Fauvist color, paved the way for the invention, around 1913, of abstraction, in which the perceived world outside of art was let go of completely, and the artwork became its own subject. Meanwhile, other artists, such as the Dadaist Jean Arp, were creating poetry and artworks using the laws of chance, and the Expressionists were emoting through their artworks. When Duchamp purchased that snow shovel, he was taking what he saw as art's natural trajectory and story to its pinnacle, its logical conclusion and final resting place. And if he hadn't done it, somebody else, sooner or later, probably would have. Already in 1915, while Modernism was still in its adolescence, Postmodernism was born.

YET MODERN ARTISTS, not dissuaded, continued to make art of all stripes. And Duchamp's Readymades failed for decades to take hold. After World War II, the art capital shifted from war-ravaged Paris, where it had existed for well over a century, to New York, where American Abstract Expressionism became

king. Combining elements of pure abstraction, Surrealism, and representation, Abstract Expressionism, led by Arshile Gorky, de Kooning, Pollock, and Philip Guston, was both an extension of and a break with European Modernism.

Abstract Expressionism couldn't have happened without European painting and sculpture, and especially Picasso, but with its large-scale, bravado brushwork and sense of liberation, at its core the movement was authentically American. Among the Abstract Expressionists' chief aims was the desire to sever the cord with the Europeans, and especially with its reigning master, Picasso.

The Ab Ex painters, high on existentialism, celebrated the artist's personal, calligraphic handwriting on the canvas. These Romantic American artists also elevated sensibility, action, and personal confession above all else. "The picture," wrote the art critic Thomas B. Hess, "was no longer supposed to be Beautiful but True—an accurate representation or equivalence of the artist's interior sensation and experience. If this meant that a painting had to look vulgar, battered, and clumsy—so much the better." And this idea dovetailed nicely with Duchamp's stance that art should be anti-aesthetic, that it should serve not the eye but the mind.

IN 1953, DE Kooning, on his way to becoming an art superstar on par with Picasso, was visited by the fledgling artist Robert Rauschenberg (1925–2008), who would soon become the darling of the American Pop art movement. While visiting de Kooning's studio, Rauschenberg asked de Kooning for a drawing. Artists often gift or trade works, but Rauschenberg

confessed that, as Mark Stevens and Annalyn Swan wrote in their biography of de Kooning, he "wanted the drawing not to hang in his studio, but to *erase*." De Kooning reluctantly complied, giving Rauschenberg the most worked-up, mixed-media drawing he could find. After spending two months attempting to obliterate de Kooning's artwork, Rauschenberg appropriated and exhibited the ghostly, stained piece of paper as his own work of art: *Erased de Kooning Drawing* (1953). De Kooning said it made him feel "symbolically raped."

Rauschenberg's *Erased de Kooning Drawing* became symbolic of more than just the appropriation and destruction of a work of art; it was a ceremonial, neo-Dadaist dismissal of the sanctity of art. It was a way to squash not only a connection to European art, but also the notions of authenticity, high seriousness, originality, and aesthetic rigor—tenets of both Modernism and Abstract Expressionism. Rauschenberg's *Drawing* signaled that now, the revolt against the seriousness of art was coming from within, from fellow artists. Though *Drawing* was related to the self-destruction introduced by Manet's *Olympia*, it took Manet's gamesmanship much further. Rauschenberg's erasure of de Kooning's artwork was not so much a provocation to the public as, like Duchamp's Readymades, a provocation to art.

Drawing set the artistic act of transformation in reverse. It not only brought the anti-aesthetic Duchampian Readymade to center stage, but transformed the act of destruction into an artistic act. It established the idea that serious art and personal expression were now ironic jokes: aesthetic probity and high-mindedness in art and culture had been dethroned.

Collectively, the public, and many artists, breathed a sigh of relief with the rise of Rauschenberg, Warhol, and Pop art. If standards were now officially erased, if highbrow and lowbrow could be indistinguishable and interchangeable, and there was no barrier between art and entertainment, then maybe, finally, we could all just relax a little. The pop-culture mindset, along with appropriation and destruction, became reigning tenets of contemporary art. This mindset could be experienced in the celebration of the polychrome stainless-steel balloon animal replicas of Koons, or in Fischer's *You* (2007)—that jackhammered dirt hole in Gavin Brown's enterprise gallery.

ENTER THE CHINESE dissident and Postmodern artist Ai Weiwei, who was lauded for his controversial artwork *Dropping a Han Dynasty Urn* (1995). The piece consists of three black-and-white photographs, taken in succession, showing the artist actually dropping and smashing into bits on the floor a rare and expensive two-thousand-year-old ceramic ceremonial urn. When faced with criticism, which was to be expected, Ai responded: "General Mao used to tell us that we can only build a new world if we destroy the old one." Ai's ironic response was as much a comment on the state of Communist China as it was a comment on the value of art, both culturally and in the inflated marketplace.

Dropping a Han Dynasty Urn has been accepted into the canon as a mainstay of the traditional avant-garde. Ai's documented performance—the obliteration of another artist's work, which, because Ai bought it, was legally and technically his to do with as he pleased—is now understood, like Rauschenberg's

Drawing, to be another in a long history of artistic appropriations and destructions in which the avant-garde overthrows the past in order to forge the future.

Such art calls attention to the very nature of art as commodity; it calls into question the true value of art and of culture, the nature of what value actually is and how it can be measured. The Impressionists, the first artists to be dismissed by critics and the public, were also the first artists to be undervalued. When, in the early twentieth century, the shock of Impressionism wore off, and the economic value of the works of so many Modern artists was rising, the public began to feel that Modern artists had been misunderstood and undervalued. So many people had missed out on Modern art, and missed out on the opportunity to profit from it financially. As E. H. Gombrich pointed out, this gave everyone pause: critics, collectors, and members of the general public became more accepting of whatever artists produced—no matter how seemingly ridiculous. They wondered whether artists were always right: perhaps we should embrace and champion and value whatever artists make, in order to avoid missing out again, culturally and financially, in the future. This receptivity toward new art helped further to liberate art and artists, giving artists a certain level of carte blanche—whether they chose to do nothing at all, as in some Conceptual art, or, like Ai, chose to destroy priceless and irreplaceable cultural treasures.

Ai's champions see *Dropping a Han Dynasty Urn* as a great work of artistic appropriation, arguing that Ai achieved cultural and political critique as well as transformation. He provoked and challenged us to question both our present and our

past, as well as the value of art. We can question the morality of Ai's destructive artwork, which attacks the idea that we should be cultural caretakers. However, the fact that Ai's photographic documentation of the destruction of the artifact has sold for many more times the price Ai paid for the vase itself, and the fact that no one really remembers what that erased de Kooning drawing looked like, but that Rauschenberg's erasure of it has become iconic, may be enough, in both Ai's and Rauschenberg's artworks, to prove the point of "transformation." But "transformation" into what, exactly, and at what cultural cost?

MODERN AND CONTEMPORARY artists have long been free to choose their subjects, as well as their materials and their approaches, to making art. And ever since Duchamp introduced the Readymade, art is whatever an artist says it is. But it's good to remember that when artists create, they're making decisions about why and how they make art, and for whom they make it. We should also remember that art is about degrees of depth and experience. We have the freedom to accept or reject—to believe in, or not—whatever an artist does or makes.

Art, at least to me, is about vertical levels: How deeply, convincingly, and surprisingly does the artist persuade me of the exploration of his or her subject? Ultimately, there is no right or wrong answer. It's all about degrees. As Picasso said: "Art is not truth. Art is a lie that makes us realize truth, at least the truth that is given us to understand. The artist must know how to convince others of the truthfulness of his lies." An artist dumping a pile of dirt on your living room carpet may get your juices flowing—get you to sit up and pay attention. It's all about what

you expect, require, and desire. It's about how well an artwork delivers—how well it convinces you of whatever it is saying.

It's also, I think, about meaningful conversation. Any artwork that merely makes a statement, rather than encouraging dialogue, fails to inspire me to stay with it for very long. And I'm not just talking about Conceptual artworks or Readymades. There are as many tepid still-life paintings made while worshiping at the altar of Cézanne as there are tepid remakes of Duchamp's *Fountain*. My advice is to see everything you can—and to look closely. But I suggest you seek out artworks off the beaten path, not just in blue-chip galleries and museums. Great art happens in surprising places. And in art, it takes time and effort to separate which lies are merely masquerading as truths from those in which truths are revealed.

SECTION II
Close Encounters

AWAKENING
Balthus—*The Cat with a Mirror I*

T HE ARTIST KNOWN AS BALTHUS—IT WAS A CHILDHOOD nickname—repeatedly explored the subject of the nude in his paintings. He brought the history of the nude to bear, contemplating not just the subject, but also its evolution in the greater tradition of art and its metaphoric meanings.

Balthus was born in Paris in 1908 and came of age as an artist during the transition between the waning of the nineteenth century—the old world—and the waxing of the twentieth—the Modern, the new. His father, Erich Klossowski, was an art historian. His mother, Baladine, and the poet Rainer Maria Rilke (Balthus's mentor and champion) were lovers. Along with the writers André Gide and Jean Cocteau and the painter Bonnard, Rilke was a frequent visitor to the family's household. In 1917, Balthus's parents separated, and he moved with his mother and brother to Geneva and then, in 1921, to Berlin.

Balthus became friends with Picasso, Matisse, and Giacometti, but he never fully accepted the tenets of Cubism, Fauvism, and Surrealism—of Modernism. As the world changed and sped up, Balthus, with one foot determinedly in the past, slowed down. Embracing the subject of transition, he created paintings that seem both ancient and Modern—timeless.

Although Balthus painted portraits, landscapes, still lifes, interiors, and adult nudes, he returned again and again to the subject of the adolescent. Most cultures have recognized a rite of passage from childhood to adulthood and explored the nude as an artistic subject. Whether adolescence is seen as a luxury of the modern era, or an imposed period of arrested development, or a genuine passage of sexual awakening, identity crisis, and psychological disequilibrium, during which one's child-self and adult-self come head to head, adolescence is universally understood as a period of gestation and change. It is a phase of transition during which one's childhood past—shrinking away, just beyond one's grasp—one's present self, and one's imagined adult future self must all be reconciled into a personality.

Many artists have tackled the subject of adolescence, but no artist has been as vilified for that choice as Balthus. Most recently, his masterful painting *Thérèse Dreaming* (1938) has been under fire. More than eleven thousand well-intentioned yet misguided people have signed a petition demanding that it be removed from display at New York's Metropolitan Museum of Art, or at least for its presentation to be reimagined with new wall text.

Thérèse Dreaming depicts an adolescent girl in a skirt sitting with one leg up, exposing her white slip and underwear, as a cat,

at her feet, suggestively laps milk from a saucer. The painting makes the awakening of adulthood, with its beckoning range of fantasy and possibility, synonymous with the awakening of sexuality. As Thérèse dreams, her head swells, her face flushes, she becomes restless, and her universe whirls. Darkness falls as distortions and adolescent haughtiness rise. A white cloth stands up, practically leaping off the table. The cat's phallic tail seems erotic and charged. But as Thérèse's interior world spills over into her surroundings, and she appears to descend into the floor, she takes on the monumentality of a goddess. Balthus honors the slipping away of her childish self, the emerging of her adulthood, and especially the dreamy adolescent bubble she navigates. In other paintings of young girls, Balthus—like no other artist I've ever encountered—sees adolescence as a period primarily of gestation and death (of childhood's winter, not adulthood's spring). In *Reclining Nude* (1983), he conjures a shipwrecked survivor clinging to a rock or debris; he quotes the fallen figure in the ancient Greek pediment sculpture *The Dying Warrior*, from the Temple of Aphaia at Aegina; and he evokes, in areas of her young flesh, overripe fruit, moss-covered, pockmarked monuments, and autumnal leaves. Yet Balthus magically holds onto and honors the innocence of her youth. Ruminating about the subject of young girls in his work, Balthus wrote: "Painting is something both embodied and spiritualized. It's a way of attaining the soul through the body....Believing that my young girls are perversely erotic is to remain on the level of material things. It means understanding nothing about the innocence of adolescent languor, and the truth of childhood."

Thérèse Dreaming is much richer and plumbs more depths than the adolescent portraits by the popular contemporary Dutch photographer Rineke Dijkstra (b. 1959), whose sullen preteens and teenagers—standing alone, as if exposed and unsure of what to do with their gangly limbs—mask their awkwardness with adult expressions. Dijkstra, like Balthus, is empathetic with her teenage subjects, and she encourages them to be themselves, to be vulnerable and brooding, uncomfortable in their developing bodies. But Balthus's adolescents, though painted from models, transcend individuals and archetypes. In Dijkstra, we are aware of individuals, and we feel for them, especially when they remind us of our adolescent selves. In transcending individuals, Balthus's subjects transcend us. Although Balthus has painted "Thérèse," his subject is not Thérèse, per se, but adolescence itself, and the dream. Balthus embraced the dream of the adolescent female nude not as a single subject, but as an exploration of the themes of childhood and adulthood, development and transition, dream and fantasy, in all their myriad forms.

Balthus's adolescent female subjects (whom he often referred to as angels and apparitions) do not seem to have been painted or portrayed; it's as if they've been summoned to the canvas. Enchanting and enigmatic, seemingly entranced, they glide between premonition and solid form. Though Balthus's girls are not religious in any traditional narrative sense, reminiscent of both angels and humans, they assume and hover between the dual roles of the heavenly and earthly figures in paintings depicting visitations and annunciations. Even when

depicted alone, it's as if they embody the union of soul meeting flesh. Formally rigorous and concrete, they suggest reveries and reminiscences made solid—as if our own adolescent psyches had reawakened and taken form. Transition is a rich metaphor for an artist, and Balthus does extraordinary things with it. He interprets and then distills the awkwardness and awakenings of adolescents—their lingering childhood fantasies, their bashfulness, innocence, and budding eroticism; and their sense of daring and dread—in profound, dreamlike dioramas that explore not just adolescence but the nature of growth, transformation, and transcendence.

What makes Balthus's adolescent nudes so mysterious? First of all, he sets them in the wonderland of painting, where many contradictory things, such as purity and malevolence, youthful hopefulness and melancholic nostalgia, are present, true, and at odds simultaneously. He paints not to represent the appearance of the world, but to reach into the interior, to penetrate to the heart of life's secrets—"to surround them," as he said in relationship to his depictions of young girls, "with a halo of silence and depth, as if creating vertigo around them." He added: "That's why I think of them as angels, beings from elsewhere, whether heaven, or another ideal place that suddenly opened and passed through time, leaving traces of wonderment, enchantment, or just as icons." Balthus's paintings of girls are made up of layers of specificities, yet those details add up not to a single personality, but to something larger and more universal—beings that represent the nature of adolescence and of change itself—not just physical but spiritual transformation.

Concerning his work with these themes, Balthus, who claimed he was always painting his own childhood and the imaginary elements that childhood inspired, wrote:

> There is nothing riskier or more difficult than to render a bright gaze, the barely tactile fuzz of a cheek, and the presence of a barely perceptible emotion like a heaviness mixed with lightness on a pair of lips. I aimed at reaching the miraculously musical balance of my young models' faces. But the body and facial features were not my only focus. That which lay beneath their bodies and features, in their silence and darkness, was of equal importance.

The mysteriousness of the girls, however, is not fleeting, but concrete. Balthus composes his paintings, which are overwhelmingly ephemeral, with formal assuredness, mass, and the gear-like precision of a clock. Everything in his puzzling compositions fits seamlessly, but as if through the fluid logic of dream. Uniting civilizations and centuries, Balthus also mathematically fuses ancient Chinese art with Nicolas Poussin's Neoclassicism. Like his loves Masaccio, Piero della Francesca, Titian, and Courbet, as well as Poussin and Cézanne, Balthus does not capture on canvas a scene already lived. He cultivates life within the breathing skin of the canvas, allowing his forms to play out their lives, independently and unpredictably, in relationship to and through the viewer's experience.

INITIALLY, WHEN LOOKING at a work of art, it is useful to acknowledge what about it affects you first and most; and to

think about it in terms of its big forms and big moves and its small forms and small moves.

In Balthus's *The Cat with a Mirror I* (1977–1980) (fig. 9), in which a nude adolescent girl—life-sized, if not larger—holds a mirror up to a cat, the nude girl is big, primary. She appears with the suddenness of a bright full moon emerging from the clouds, or a blossoming flower in a garden—large forms and moves that are among this picture's chief elements. She inspires questions. Who is this girl? Where has she come from? What is she doing? Where is she going? What does she resemble? Is she real or a premonition? Is she made of marble, or air, or flesh, or stone? Is she a girl, a ghost, or a figment of a dream? Is she toying with us, and with the cat? And is she looking into the mirror, or showing the cat its own reflection, or turning the mirror toward us—or, perhaps, all of those things? The girl appears to be pleased with, if not surprised by, her own beauty, innocence, presence, and light. And although she is not look-ing directly at us, she appears to be opening herself to us, as if making herself into some kind of offering.

Looking at this painting, however, after I have acknowl-edged its big moves and big elements, I am immediately struck and captivated not by the life-sized girl, or the Sphinx-like cat, or the gleaming, golden mirror, but—as when I look at a full moon—by the painting's roughened, veiled light. *The Cat with a Mirror I* conveys a looking-glass quality, an atmosphere that is paradoxically luminous and opaque, velvety and stucco-like. It's a vibrating field, like breeze-churned water, over which my eyes move slowly to take in each nuance, and which they attempt to penetrate to discover what lies beneath. But to go

beneath, one must begin on the surface—with the mesmerizing girl, cat, and mirror.

Every form in *The Cat with a Mirror I*, whether flat, folded like patterned origami, or built up like low-relief sculpture, is interlocked, pieced together to create an odd puzzle. The bedcovers, reminiscent of carved stone, petals, and lips, remind me of the mountains and trees in Giotto's frescos. Giotto (1266–1337), the first Western painter to put weight, volume, and human emotion into his figures, bridged the abstract world of medieval art to the representational art of the Renaissance. But Giotto retained a number of earlier forms and practices in his innovative frescos, such as gold-leaf halos and simplified, almost symbolic renditions or essences of nature—forms that alert us to nature and to the elements of a story (that it happened outside, for example)—but do not distract us from the main event.

Likewise, Balthus's blankets and folds read not as specific blankets, but as the idea of blankets and folds, of petals and lips. Pared down like Giotto's hills, Balthus's bedcovers transcend particularities to become symbolic equivalents that seemingly stand in for all bedcovers, as they also remind us of stone sculpture and natural forms. Like Balthus's nude girl, they exist in the in between. And, also like her, his blankets leave the safe haven of individuality and brave the seas of universal significance. Balthus, who has quoted Giotto in other paintings, seems here to be extending the metaphor of the passage to touch upon painting's own transition (its early adolescence) from medieval abstraction and symbolic generalization to the visual specificities—believable textures, light,

weighted volume, three-dimensional space, and atmospheric perspective—of Renaissance representation.

The Cat with a Mirror I shifts not only between elements such as cloth and stone, but also spatially, between near and far, between volume and flatness. Like the girl with the cat, Balthus seems to be toying with us—shifting our experience between near-abstraction and full-on representation. In places, such as around the girl's head, hand, and mirror, the maroon plane, or background, advances extremely close to us, seemingly enveloping her body, which feels lodged inescapably in the back wall. At her bent elbow, near the center of the painting, the maroon ground loosens its grip and recedes. Elsewhere, the reddish violet background appears to advance even more toward us, as in the area just above the bed's headboard, where forms feel flat and stacked vertically, like bricks in a chimney. Although this background field maintains its sense as a continual flat plane—a back wall—it is malleable, shifting in appearance among fresco, rock, liquid, and purple haze.

What we experience here is a paradoxical sense of Hofmann's push and pull, an elastic space that confounds and defies our understanding of an actual three-dimensional room. To take in what Balthus's forms are doing, we must read what he is telling us in his painting, as opposed to trying to get his painting to align with what we think we know about a bedroom, a cat, and a girl. We must look closely and try to comprehend exactly what Balthus is doing and why; to see how he is pushing a form—the girl, for instance—toward us in one area, and elsewhere pulling her body back into space. He is offering her and then taking her away.

I believe, in part, that Balthus is exploring the metaphor of the girl's straddling of two worlds, childhood and adulthood, waking and sleeping, reality and dream. As the girl opens up to us, she appears to rise off the bed and to float toward us. But look, for example, at how her incised blue robe, her thumb, and the letter she holds seem to pin her, like an entomologist's specimen, to the bed. The bed compresses against her, tips her upward, and pushes her toward us. But she still clings to her fantastical painted world—literally holds onto it—by her thumb.

We feel the tension between the girl being held in place, cocooned, and pulling herself free; between her desire to stay wherever she happens to be and her desire to change and advance. We get the sense that, indecisive—torn between childhood and whatever is next—she is struggling to flower; that, like a butterfly, she is spreading her wings. She pivots on the footstool, turning parts of her body (her head, her right knee, her right shoulder, and elements of her torso) toward the cat—inward and away from us. And she turns other parts (her trapped left leg and left shoulder) in the opposite direction— away from the cat and the confines of the painting—outward, toward us. Conflicted, she both closes off and opens herself.

GRACEFUL YET TIMID, natural yet monumental, Balthus's nude adolescent girl rises like a colossus, as if she were outgrowing her bedroom, a giant or monument straddling a river. She appears both to be getting out of and getting into bed. She is a messenger pressing a letter under her thumb, perhaps; she could be mounting or dismounting a flying carpet, coming ashore or

pushing off to sea. As she increasingly materializes, like a mirage, from out of the shimmering maroon field, you can almost feel the cat shrinking away into the distance of memory. And to scale the girl's body—a sheer, coarsened cliff face—you must first climb her long, outstretched right leg like a tall, limbless tree. That leg, the painting's entrance and fulcrum, is a dynamic movement in the composition. Touching down, finally, her right foot alights unsteadily upon a footstool that has the bearing of a skateboard ready to zip her away.

Though clearly a Modern figure, Balthus's nude girl is an amalgamation, an evocation of numerous artworks and mythologies. As you move around and across her body, she takes you to other works of art: she suggests Greco-Roman statuary and Byzantine Madonnas, weathered dolls and ancient relics. Other artistic sources include many paintings of Venus— by Giorgione, Titian, Peter Paul Rubens, Diego Velázquez, and Jean-Auguste-Dominique Ingres—including that humble beauty by Sandro Botticelli, surfing ever closer to us on her half-shell; and specifically, Caravaggio's erotic tour de force *Amor Victorious* (1601–1602), in which a nude, winged Cupid stands impishly on his right leg, with both legs seductively splayed, while his bent left leg, resting on a table, disappears beneath his buttocks. Yet Balthus's girl, besides Venus, also conjures Botticelli's surf, sand, and shell. She evokes Eve, extracting herself from Adam; Adam, extracting himself from the Garden of Eden; an animal with its leg caught in a trap; a spinning, music-box figurine, a ballerina; and a wishbone ready to snap. Her robin's-egg-blue robe—a clear nod to the Virgin's sky-blue mantle—in places as if scratched or worn—reveals

fleshy raw patches of pink and red beneath. The robe—never merely a robe—opens like a canopy of heaven, flows out of her like a waterfall, and drops from her shoulder like a shed skin.

IMMERSING MYSELF IN Balthus's painting of a nude girl, a cat, and a mirror, I'm reminded of nighttime and moonlight, and of the seductress Venus, the goddess of sex, beauty, and victory, who represents sacred and profane love, and who is often depicted with a mirror. And I think of Diana, the goddess of nature, the moon, the hunt, and wild animals, which she held under her spell. I'm reminded that our ancient ancestors used to perform the hunt at night, by the light of the moon, when animals were sleeping and more vulnerable, and that their guide, the female goddess of the moon, was often deemed higher than her male counterpart, the god of the sun. I'm aware that the shining yellow mirror in the painting's nocturnal, maroon field is sun to the girl's bluish moonlight; that she is beautiful yet eerie, suggesting ancient monument and child. I wonder if she is lit, bathed bluish by moonlight, or if she is the glowing moon or moonlight personified. As the painting gets my mind going, I'm reminded that it was often at night, in the stillness and darkness of my own childhood bedroom, just before sleep, that my imagination often flitted among memory and fantasy, dreamy and nightmarish places.

Balthus's painting inspires this kind of free association, imagination, and nostalgia, but the painting's various qualities take you much further than down memory lane, and they never allow you to stay in one place for very long. The flesh in

Balthus's nude girl, though believable as human and youthful, is about as mysterious as any skin I have ever seen in a painting. Built up out of multiple layers of opaque and translucent color, the girl's flesh is difficult to navigate. Glowing from within, it actually is mostly pale bluish (though sometimes pearlescent white or pale ivy or golden or rose), and flits from silken to chalky to translucent to opalescent. Her warm lips, cheekbones, and sex are burnished pink, and her skin and hair shine in places, as if gilded. She evokes artifacts, chrysalis, and peeling fresco. Nothing here, however, is overt or fixed. Balthus keeps everything in stages of possibility and transition. The painting's associations, registering in flashes, build poetically and remain always in motion and at play, as if the canvas and its forms were undergoing alchemical transformation, as if she were as fleeting and malleable as fantasy.

YET, AS FLEETING and dreamy and indecipherable as *The Cat with a Mirror I* is, Balthus seems to want to tell us a story, and he knows how to draw us in and to keep us interested—mesmerized. The girl and cat appear to be transfixed by the gleaming hand mirror, as by a watch being swung by a hypnotist. And I am right there with them. Balthus sets up a Ping-Pong dialogue among the cat, the girl, the mirror, and the viewer, bouncing our eyes back and forth among them as we follow the paths of their Sphinx-like gazes. Besides resembling a sliver of sunlight, the mirror suggests a fiery hoop, a burning torch, or a golden keyhole in the maroon field. To again mention Giotto, it's as if the mirror were a halo, as if the girl,

an angel, had just removed it, like a tiara, from her head—so that she, the cat, and now the viewer can better contemplate its beauty and light. The girl's mirror or halo, or amalgamation of the two, like the painted or gilded halos in medieval paintings—which often remain flat, paradoxically fixed both to the full round head of its owner and to the back wall of the painting—also reads simultaneously as flat and volumetric, as frontal and in profile. And, also like painted or gilded halos, the mirror seems to turn in space and to open into the wall, like a window, or a golden portal of light, like a bridge between one realm and another.

And what about the story of the cat, which is like a mystic or voyeur in Balthus's painting? Cats are enigmatic in and of themselves. In the painting's title, Balthus gives pride of place to the cat and the mirror, instead of the girl, whom he fails to mention. This is true in the titles of many of Balthus's paintings depicting cats, girls, and mirrors—a theme he explored in earnest during the last twenty-five years of his life.

Balthus, who once had as many as thirty housecats, knew cats well—or at least as well as one can know cats. His first artwork, the small, autobiographical picture book *Mitsou*, a wordless novella published in 1921 when Balthus was only thirteen years old, comprises forty graphite and ink drawings that tell the story of the eleven-year-old Balthus, who finds, falls in love with, and then loses an adopted cat he calls Mitsou. Rilke wrote the preface for *Mitsou* and arranged to have the book published. In it, Rilke asks: "Does anyone know cats? Do you, for example, think that you do?...Cats are just that: cats. And their world is utterly, through and through, a cat's world...a

world inhabited exclusively by cats and in which they live in ways that no one of us can ever fathom."

Balthus's painted cats are never merely household pets. They retain their sense as *other* and unfathomable. They connect us to a time when animals were unknowns—envoys from beyond. In *The Cat with a Mirror I*, Balthus's cat, poised on the chair like a gargoyle or an incubus, seems to have risen from out of the bed like a periscope. Or perhaps it has emerged from the wall, like an angel bearing news from another realm. As Balthus wrote in his memoir, "I believe that mirrors and cats help in personal crossings." And further:

One of my art's main motifs is the mirror, invested with the mark of vanity as well as the highest ascendancy. To me, it often gives an echo of the spirit's profoundest varieties, in the style of writings by Plato, whom I often read.... That's why my young girls often hold them, not only to look at themselves, which would be a mere sign of frivolity—and my young girls are not shameless Lolitas—but to plumb the furthest depths of their underlying beings.... Painting is part of a distant, secret domain, where one cannot insert a significant object like a cat or mirror without entering into the particular, or explicit, aspect of a canvas. Thus, a mirror might be the symbol of an attic window, open to dreams and imagination. That's not what I intended. The mirror imposed itself as one inherent element of a painting. Some of my young girls have mirrors; they gaze at them, and the painting takes off unpredictably. It's up to viewers to rediscover the diverse strands that are unconsciously and obscurely gathered therein.

In *The Cat with a Mirror I*, Balthus touches, through free association, upon many metaphors, sources, and ideas, all of which he has absorbed from a lifetime of looking and reading and thinking, and which he keeps alive and in play. These influences, passed from artist to artist, surface in Balthus's work like mannerisms, facial expressions, and traits naturally passed down, through nature and nurture, from parent to child. Balthus is never painting just a cat and a girl and a mirror. Nor is he merely referring to or borrowing from established symbols from art history. By his own admission, these things such as cats and mirrors, and even the nudes in his paintings, have virtually no historical or symbolic meaning to him per se. Although Balthus's paintings carry with them vestiges of earlier art and earlier art's narratives and meanings, his pictures—like dreams—are journeys unto themselves.

PAINTING, FOR BALTHUS, was an "Orphic labor," a way of getting closer to what he called the crack, the mystery, the opening into the unknown—a realm, as in Rilke's poetry, where reality and dreams are juxtaposed, merged. Balthus, who said a prayer before he began every new painting, believed that the artist is merely a channel bridging the physical and spiritual realms, and that the extremely difficult task of creating light in a canvas was a way literally to get closer to God.

In *The Cat with a Mirror I* and other Balthus paintings, our experience of each element is like another key, another turn of the tumbler on a safe's dial. But with every opening, a new door is revealed. It is not unusual in a Balthus painting to discover contradictions, and numerous seemingly discordant

associations, metaphors, and sources. It's natural to flit from one symbol to another, from one period of art to another. But in Balthus, a symbol is never that, just as a cat and a nude and a mirror are never just those things. Balthus's pictures exist beyond the things they seem to depict.

The more art you've seen, it seems, the more deeply a Balthus painting opens up, and the more it reveals not only about itself but about the tradition of painting. A viewer needn't know any allusions, sources, or antecedents from mythology and art history, necessarily, to appreciate a Balthus painting. One could gaze as lovingly and absent-mindedly at *The Cat with a Mirror I* as one would at a full blood moon. Nor is it necessary to notice that Balthus's nude girl glows very much like the moon, or that she resembles marble or an ancient fresco or a chrysalis, or that she quotes from Caravaggio or Botticelli or Titian, or that she seems to float like a cloud or to open like a butterfly. Her transfixing beauty is beyond these things. *The Cat with a Mirror I* will get you there eventually—or to wherever you need to go. It's enough to bathe in and to contemplate Balthus's imagery, his light, his forms, and the mysterious forces at work in this miraculous canvas, and to let these things puzzle and surprise you and seduce you with their strangeness and poetry—a dream as if made solid.

SENSING
Joan Mitchell—*Two Sunflowers*

THE CHICAGO-BORN PAINTER JOAN MITCHELL (1925–1992) transformed her personal sensations and memories into beautifully lyric, muscular abstractions that immerse us in particular feelings and qualities, in seasons and times of the day, and especially in her sense of place. Her subjects included wind, mountains, flowers, trees, and rain; a view of Lake Michigan seen from her childhood balcony; poems by T. S. Eliot, James Schuyler, and Frank O'Hara; a Billie Holiday tune; her Freudian analyst; a Parisian sky; and her beloved pet dogs. But what I often find most enthralling in Mitchell's large abstract diptychs and triptychs—mural-scale paintings that are as much environments as pictures—is their sense of immediacy, frontality, and of whooshing upward. Their licking colors, which erupt and rise like heat and flame, create a rushing quality that can singe and steal the breath from your

lungs—a combination of power, weightlessness, vertical thrust, and escape—the liftoff I feel in the greatest paintings of the Assumption of Mary into Heaven.

Mitchell's signature abstractions most notably recall the active, calligraphic brushwork of de Kooning, Guston, and Pollock. She is often associated with the New York School and classified as a second-generation Abstract Expressionist. But Mitchell, prominent among the few women artists who rose to stature in New York's male-dominated, mid-twentieth-century art world, owed as much to the School of Paris—the French and émigré artists active before World War II, when Paris was the center of the Western art world—as she did to her Ab Ex contemporaries. Mitchell was a metaphoric artist who wanted something much more precise and personal in her abstract pictures. She wanted paintings that rose to the level of the best poems, in which intimacy and secrecy, though private and immersive, are felt at mural-scale. She wanted her pictures to excel beyond what had come to be known in American painting as gestural abstraction, and that had come to be celebrated as heroic—pictures in which the evidence and truth of the artist's hand, no matter how ugly, was thought to be paramount. Mitchell wanted her art to be beautiful yet bold. And she looked back to her cherished European painters for guidance and inspiration. A metaphoric abstract landscape painter, Mitchell transplanted her American roots in French soil.

Mitchell swooned not over the bravado of Franz Klein's large, bold, black-and-white abstract emblems, or over the extroverted action paintings of her close friend de Kooning, but over the searing specificity and intensity of Cézanne, the

nuanced light in Matisse, the evocative, powerful linearity in the early abstractions of Kandinsky, and the fluid, thick, lapping staccato brushstrokes of van Gogh. Although Mitchell was an abstractionist, at heart she was a landscape painter who was not afraid to give us the look of a tree as long as she conveyed her feelings about that tree. She strove not to emulate her American cohorts, but to emulate the European painters, the very artists with whom so many of the Abstract Expressionists wanted to break ties.

In 1968, after living since 1959 in Paris, Mitchell settled permanently in Vétheuil, a tiny village about thirty-five miles northwest of the City of Light. Her two-acre property included gardens, a view of the Seine, and a small house once owned by the Impressionist Monet. Many of Mitchell's large abstract paintings made here recall not only the frontal, lyric, allover intensity of Pollock, but also Monet's big, lush, densely entangled paintings of water lilies.

Not surprisingly, however, if there is any primary influence in Mitchell's unique paintings, that most notably pulses within and propels Mitchell's compositions, it is the fluid, writhing brushwork of van Gogh—an artist whose marks and invented colors are felt as both humbly descriptive of nature and personally, emotionally charged. We also, of course, feel the inspiration of Pollock. However, whereas Pollock, working in the analytic, early Cubist, monochromatic palette of silvers, grays, blacks, browns, creams, and whites, made connections in his paintings to landscape—as in his cool, brittle-leaf-earth-and-sand-colored painting *Autumn Rhythm (Number 30)* (1950)— Mitchell favored nature's vibrant palette and visceral textures:

hothouse flowers; verdant greens, bloody reds, and oily, muddy browns; and the bruised and tarnished silvers and bluish-violets of stormy skies.

There is abundant beauty in Mitchell's nature-informed abstractions. She achieves vibrant balance between the structural and the organic, between the abstract and the literal. These are abstract paintings—but abstract paintings that hint at the ferocity and outbursts and occasionally the fleeting appearances of nature. Dreaminess and nightmares, ecstasy and violence, go hand in hand. She gives us the rising climax and subsequent sadness, the roses and their thorns. In some of Mitchell's late abstractions, diptychs in which pairs of enormous bunches of tangled colors join together like bountiful bouquets just cut from the garden, those sprays can also conjure two tempests shooting lightning, the wings of a bird of prey, two animals butting horns; with their dangling lines and long-running drips, they also recall paintings of Herod lifting the freshly severed head of St. John the Baptist by the hair from a silver platter.

IN THE LARGE, lush diptych *Two Sunflowers* (1980) an oil painting nearly twelve feet wide, Mitchell presents us with an inferno of slapping colors—oranges, yellows, pinks, blues, blacks, reds, and greens. A white and cobalt-violet ground feels subsumed by the picture's frontal onslaught of yellow-orange and turquoise-green, which stands up confrontationally, completely vertically to the plane, its heat advancing on us as if we were faced with a walk-in furnace—or as if we were at the

precipice of the mouth of hell. The painting is as gorgeous and lush as it is infernal; it both reels you into its interwoven brushstrokes and, like an impenetrable assault or a wall of flame, holds you at bay.

Mitchell's diptych is about two sunflowers, or at least uses sunflowers as its touchstone for whatever Mitchell felt or thought about her experiences with sunflowers, or, perhaps, with a specific place or person who reminded her of sunflowers. It is something of a portrait, in that it brings the face of sunflowers right up to the two canvases' faces, right up to our faces, while simultaneously it recalls looking out over a field of sunflowers, a sea of individual blossoms that build into a monumental waving force of black and gold, where each sunflower mimics both the human face and the face of the sun, burning above the field.

She immerses us in the whole as well as in the sunflowers' bits, which Mitchell brings to us as if in the palm of her hand. It is not the flowers she paints but our experience of the flowers; or, perhaps, the sunflowers' experience of being sunflowers. She suspends us precariously over the precipice of beauty; she pitches us, en masse, into the field and inserts us into the sunflowers' leaves, stalks, petals, and seedpods. She throws us into the colorful blaze and up into the air—as if a fire were devouring us or a strong wind were taking us to seed.

Two Sunflowers reminds me not just of painters like Pollock, de Kooning, Guston, and Monet, and of sunflower fields, but also of altar diptychs, which explore and glorify myth, life, light, spirituality, sacrifice, and rebirth. Bright, grand, and

energetic, *Two Sunflowers* prompts me to think of pictures depicting Apollo, the god of the sun, racing his golden, horse-drawn chariot across the sky each morning, pulling and raising the burning sun up to its loft; dragging it all day around the earth until he tucks it away at night in the darkness; bringing light and warmth, his curly yellow locks flailing behind him, the quickened, heavy gallop of his horses' hooves trampling black across the blazing sky.

And *Two Sunflowers* makes me think of van Gogh's late double-square landscape paintings, made just before the Dutchman took his own life with a shotgun in a yellow wheat field. In fact, *Two Sunflowers*—in which black strokes sprout and skid across the bottom of the frame; and orange and gold and pink rise like heat; and turquoise green Xs and Vs fly like birds—could be an homage to van Gogh's late if not last picture *Wheatfield with Crows* (1890). *Two Sunflowers* feels like a precursor to Mitchell's later diptych *No Birds* (1987–1988), a painting of broad horizontal black strokes above broad vertical golden strokes that again recalls van Gogh's *Wheatfield with Crows*, with its inky-black birds, flying Vs and Xs, peppering an oily blue sky above a brilliant yellow field of waving wheat.

MITCHELL PAINTED THE two abutting canvases of *Two Sunflowers* individually, seemingly separately, but with the same palette. They press against each other like two flowers in a vase or two kissing faces. Mitchell, in forcing them together, pairing them like conjoined twins, gets us into the up-close

act of contrast and comparison; of going back and forth between left and right; of discerning similarities and differences across the thin black line of empty space that separates the two canvases.

We sense that the painting is starting, and then starting over again; that it—like two sunflowers, where no two are alike—is repeating itself, yet not. The diptych is beckoning us to move from left canvas to right canvas and back again, to consider bulges and depressions, expansions and contractions, clottings and liberations; to notice and appreciate subtle interactions of call-and-response between left and right, yellow and orange, violet and green; between colors mixing and clashing, exploding and contracting. *Two Sunflowers* helps us to become aware that one side is of the same species and family as the other, even near the same point in its life cycle, and that, though each is markedly the same yet markedly unique, together the two sunflowers create the whole.

I get the sense that Mitchell's *Two Sunflowers* is a skin under which forms are rustling, gestating, and that that membrane is being built up, atomized, scabbed over, and peeled away. Despite the enormous activity of collisions, the violent brushwork, and the thickened, congested color, despite *Two Sunflowers'* sense of drama and inflammation, Mitchell's diptych overall achieves a quality of lovely, aerated colored mist, a gritty, hard-boiled haze of ebullient light. It's an immersive, heady atmosphere that leaves me almost breathless, as if the painting, like a conflagration, were consuming all of the oxygen in the room. Yet all feels right. *Two Sunflowers* gives as much as it takes. Its

energies charge the air like electricity during a thunderstorm. And Mitchell's diptych, though contained within its rectangles, is effusive, bubbling over—as if it cannot be held, bridled—so that we sense not just the rightness and beauty within the chaos of *Two Sunflowers*, but also rightness and beauty within the chaos of nature, and within the world.

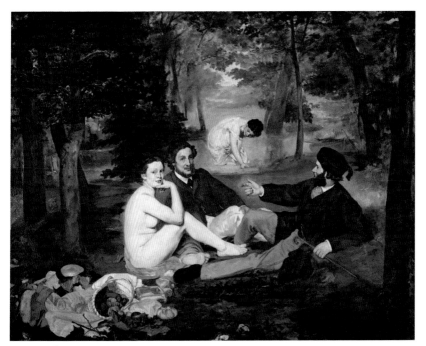

Figure 1—Édouard Manet, *Le Dejeuner sur l'herbe* (*The Luncheon on the Grass*) (1863)

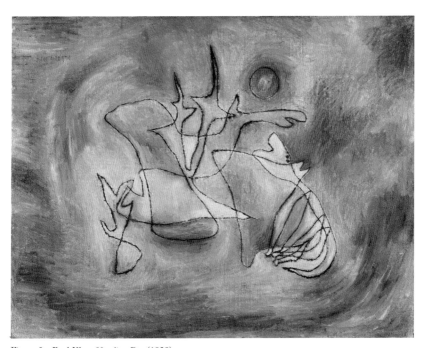

Figure 2—Paul Klee, *Howling Dog* (1928)

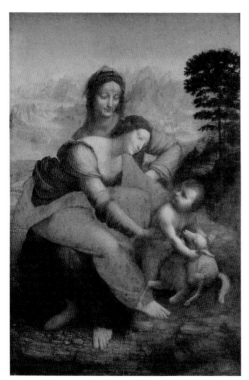

Figure 3—Leonardo da Vinci,
The Virgin and Child with St. Anne
(c. 1503–1519)

Figure 4—Henri Matisse, *Icarus*,
from *Jazz* series (1947)

Figure 5—Hans Hofmann, *The Gate* (1959–1960)

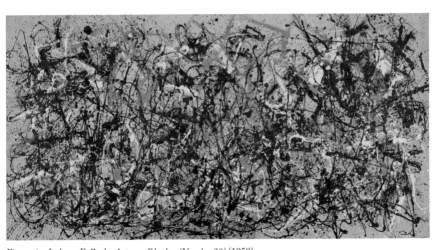

Figure 6—Jackson Pollock, *Autumn Rhythm (Number 30)* (1950)

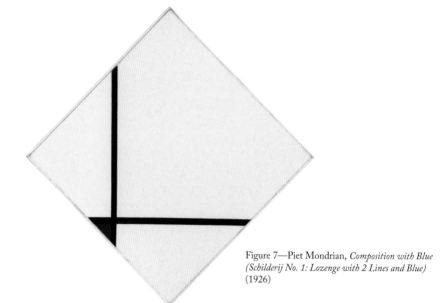

Figure 7—Piet Mondrian, *Composition with Blue (Schilderij No. 1: Lozenge with 2 Lines and Blue)* (1926)

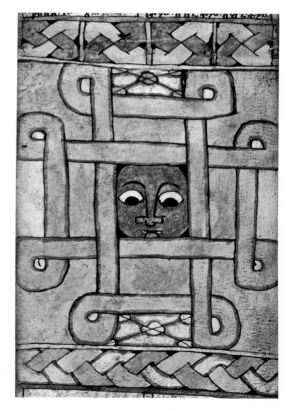

Figure 8—Ethiopian, Anonymous, *Satan Imprisoned* (early nineteenth century)

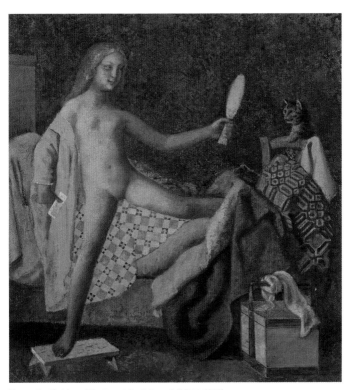

Figure 9—Balthus, *The Cat with a Mirror I* (1977–1980)

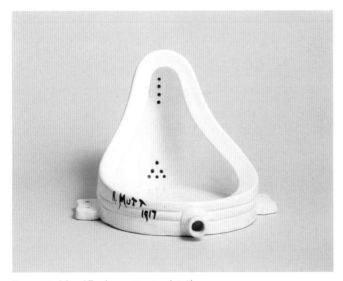

Figure 10—Marcel Duchamp, *Fountain* (1917)

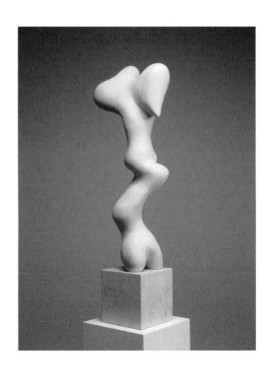

Figure 11—Jean Arp,
Growth (1938)

Figure 12—Paul Klee, *Signs in
Yellow* (1937)

Figure 13—Richard Serra, Installation view at Dia:Beacon (1996–2000)

Figure 14—Robert Gober,
Untitled Leg (1989–1990)
© Robert Gober,
Courtesy Matthew Marks Gallery

Figure 15—Richard Tuttle, Installation view of *The Art of Richard Tuttle* (*White Balloon with Blue Light*), far left (1992)

Figure 16—Jeremy Blake, Still from *Winchester* (2002)

eight

GROWING
Jean Arp—*Growth*

W HILE WALKING AROUND JEAN ARP'S WHITE MARBLE
sculpture *Growth* (1938) (fig. 11), which stands just
under four feet tall, analogies of stones, bones, horns, clouds,
buds, fruit, totem poles, and classical nude figures all flash and
flit among one another, as if forms and associations were con-
flating, as if they were metamorphosing one into the next, and
then the next, and then the next. These metaphoric suggestions
come so fluidly and rapidly—so much like birds racing across
the peripheries of consciousness—that for me it's difficult to
keep up the chase, let alone net them. Yet Arp's *Growth* em-
phasizes not its various forms but its boundless development.
It's as if the surface of the piece were elastic and malleable, as
if the forms themselves were being rolled around like so many
marbles in a mouth. It's as if Arp's sculpture were in the act of
expanding, contracting, and changing, as if *Growth*, a living

151

thing, were breathing, shifting, striving, and reforming—sculpting itself beneath its skin.

Jean (or Hans) Arp (1886–1966) was born to a French mother and a German father in Strasbourg, a German city subsequently recovered by France, and his art, like his nationality, straddles borders. He thought of himself as much as a poet as a visual artist. His written poems and abstract drawings, collages, paintings, prints, reliefs, bronzes, plasters, and marbles are all born of the same poetic impulse, and each artwork and piece of writing is like a stanza in the epic poem that is his life's work.

In both France and Germany, Arp was a leading and founding figure in the movements of abstraction, Dadaism, and Surrealism—at home with the artists Klee, Kandinsky, Picasso, Amedeo Modigliani, and Robert and Sonia Delaunay, as well as with the poet and playwright Guillaume Apollinaire. As an artist, he is primarily thought of, however, as a proponent of the abstract language of *biomorphism*—a term that, though not inaccurate, tends to pigeonhole him as a creator of nondescript organic blobs that can be interpreted as anything at all yet nothing in particular.

Arp's artworks certainly are often organic, relating to basic forms of flora, fauna, amoebas, torsos, and eggs. And, in some ways, Arp—whose influence is most notably felt in the abstractions of Joan Miró and Calder—seems the simplest and most childlike of artists. In his poems and artworks, as if embracing child's play, he welcomes chance as another of the many creative paths that lead toward the creation of the finished work—which always seems to be gestating in embryonic

stages. This fresh, open-ended, bare-bones, and nascent aspect of his art is part of its soul, its enduring charm. A true poet, however, Arp was not a generalist; he was much more exacting and complex in his thinking than that. Arp's disarming, childlike, organic minimalism and his embrace of chance leave you unprepared for the crystalline clarity of his artworks and his purity of vision. Arp reminds us that, although accident may play its part, it is ultimately unimportant how an artwork comes into being; that, in the end, what matters are the artist's hand and eye—which dictate what the artist decides is and isn't art.

To begin with, while looking at one of Arp's artworks, I usually start with my first thoughts and feelings: with *Growth*, I ask myself what, exactly, I am getting from Arp's sculpted poem. Among *Growth*'s most prominent impressions, from most points of view, as I circle the marble, is its sense of being two primary stacked forms in symbiosis. The vertical sculpture is totemic, with each form, like a symbolic godhead, seemingly evolving out of the one below or above it. But, because of its major rotation, break, and shift, almost like a compound fracture midway up the sculpture, *Growth* feels divided into two bigger forms or sets of movements. Of these two, the larger, heavier form is on top and suggests an enormous burden being lifted or supported by the smaller, bottom half.

In *Growth*, the symbiotic relationship between upper and lower, not unlike that of a parasite to its host, creates a sense of balance and stasis. I feel that the top form is responsible for the stability of the bottom form, and that the slenderer, lither lower form would be incomplete without the burden of the upper, and

vice versa. *Growth*'s bottom form pliés and bends, resembling one dancer lifting another, or a weightlifter doing a clean and jerk. But it also makes me think of classical Greek columns that bulge slightly before they taper back inward at their bases, an aesthetic ruse that gives the column an organic sense of bearing the force and weight of the pediment pushing down from above and being distributed outward.

Growth winds upward gracefully and sensuously, but it also struggles like a twisted root. It elbows itself here and there, seductively cocks its multiple hips, and pushes out its multiple breasts, which then become noses, toes, knees, and chins. Backs become fronts and then profiles; seeds become buds which become ripened fruit. A female belly extends into a neck, which extends like a pear. An elbow morphs into a beak, the head of a penis, a yawning mouth. As soon as you believe you have discovered the curves of pursed lips or of buttocks or breasts, the forms realign in your imagination, becoming specters, blossoming flowers, changing clouds. Countering and yet extending the sculpture's eroticism is its sense of struggle, the impression that the upper form is being birthed by the lower one, or vice versa. Arp reminds us of the violence inherent in life, and that the interdependent relationship between mother and child, no less than that of pediment and column, involves loadbearing. As I contemplate *Growth*, I'm reminded of how a woman once described to me the experience of childbirth: "Pull your upper lip over your forehead and your lower lip over your knees. That's what it feels like." This sense of beauty and violence, and of infinite reversal of parent and prodigy, of load and support, toys with our understanding of what is top and

what, exactly, is bottom; of what came before and after. My inability to mark out the various boundaries and evolutionary stages of the life of the sculpture plays with my very sense of the progression of time and the process of development. It is unclear whether we are looking at something in the act of growth, or whether, instead, we are experiencing a distillation of the essences of growth—or all of the above.

Arp furthers the metaphor of the ambiguity of time and progression through other analogies. By creating such smooth, biomorphic forms—forms that shift from fruit to bud to hip to architectural column; from torso to tree to sculpted figure bust— he brings to bear not just a range of possible histories, or even of possible futures, but also a seemingly infinite range of possible presents. I might be looking at the bone or skeleton—the internal structure—of a once living, yet now deceased organic being; or I might be seeing not the whole of something but merely a part—a leg, for example; or I might be looking at a conflation of fragmentary pieces of Greco-Roman architecture and figurative sculptures sporting broken and missing limbs, bases, heads, and crowns; or encountering something cellular and out of control, such as a cancer; or seeing the ghost of all of these things. Combining and merging the organic with the man made, the internal with the external, and the sense of the infantile and the well-worn antique, *Growth* keeps aloft a range of cultural, symbolic, and organic processes. Working in the before and after, at the micro and macro levels, Arp's *Growth*—contracting and expanding; turning like a belly dancer and a DNA spiral—conveys the violence of growth, the eroticism of seduction, and the primitivism of ancient fertility figures whose detailed polychrome

features have been rubbed colorless and smooth by weather, age, and touch.

At one point, seen from a distance, *Growth*'s forms appear to be parted lips blowing kisses from across the room, or alluring, crooked fingers beckoning with come-hither curves. Arp seduces. And as I move closer and around *Growth*, caressing the softly billowing arcs, bulges, and hollows with my eyes, Arp's forms seemingly respond to my presence and movements, turning toward and then away from me, inspiring cat-and-mouse chase, their forms becoming increasingly fidgety, blowsy, seductive, and then reticent, as if the sculpture were interacting with me personally. While moving around the sculpture, at one moment, as if my eyes were undulating in flesh, *Growth*'s pillowy volumes are all breast, buttock, navel, lip, soft crevice, and rolling hip; then, suddenly, those forms appear to sharpen and stiffen, to transform into elbow, tooth, club, arrow, and hammerhead shark. Moving around the sculpture further, I suddenly feel small and at a distance, left behind, as *Growth* transforms into a figure strutting away, bearing an enormous crown.

ARP'S SCULPTURES, BASED on poetic themes—like the theme of growth—encourage me to free-associate and to move with them, without ever arriving at an exact destination; they require that I allow my mind to be in as much a state of flux as the sculptures themselves. When I experience an Arp, I realize that it is essential not to see the sculpture merely as what its title suggests, but to use that title as a thematic springboard; to allow the sculpture to be in a constant state of change and

becoming; to look for and to accept that his sculpture, like a poem, comprises metaphoric relationships, a buildup of metaphors that refers to many seemingly incongruent forms and ideas and processes, and that never actually exists as any one specific action or thing.

With Arp, I must go with the flow, following any lead the sculpture inspires, riding it wherever it takes me. I must accept that in the sculpture *Growth*, Arp is not starting with a nude, or a budding plant, or a mother giving birth, and then paring those forms down into faint resemblances or vestiges of their former, fuller, more complete, complex selves. He is not softening or whittling away the sharper details. He is not "abstracting" from or lessening something—rather, he is bringing forms into greater specificity and focus, into a crystalline state in which he reveals the imaginative conflation of pure form and pure processes, states and stages of action, growth, forming, and becoming.

That is why Arp, when referring to his artistic creations in the studio, preferred the term "concrete art" to "abstraction." Arp was paring away the excesses and details of specific forms to reveal the essentials of *all* forms. He was freeing his forms of their exactitudes as actual things in nature in order to focus on their relationships—on the realm of the in between, a realm where things are always not just more than one thing, in series, but actually *no* thing. Arp was getting at the nature of nature. He understood that to make an abstraction is not to remove particulars in order to stress reduction and vagueness. He understood that "less is more" only when "less" frees itself from the inward spiral of reduction, and into the realm of infinite

possibility and expansion—the realm of poetry. In *Growth*, Arp's forms suggest growth and gestation at the embryonic, cellular, mature, and relic stages all at once, to the point that we do not even experience the marked stages themselves, but instead are always floating in the buoyancy of possibility—in the before and after.

Yet, no matter how far he takes us, Arp almost always brings his sculptures in one way or another back to the human body. It's as if, with each sculpture, he begins and ends—grounds us—in the nude torso, in the experience of ourselves. When *Growth* is considered as a nude torso, it is much less specific and oblique than other Arp sculptures to which it feels related. But all of Arp's sculptures, like an extended family, speak to and help to illuminate one another—just as, at a family reunion, the aunts, uncles, and cousins all tell us something about the family lineage at the same time that they extend our understanding about each individual.

Arp's *Torso* (1931) is much more grounded than *Growth* in the form of a classical antique torso, one with its legs missing below the buttocks, its arms broken at the shoulders, and its head long gone. But right away, one budding shoulder, curved and smooth, as if it has been rubbed by countless ocean waves, seems to strive outward and swell. That shoulder then appears to extend itself into a neck and then a head, to emerge as if coming out of a womb. The sculpture's buttocks then suggest that they could be breasts, which, in turn, transform the torso's back into developing face and head. Moving around the sculpture,

the whole torso appears as weightless as a ghost, alighting like a feather on the pedestal. As if by magic, suddenly, it becomes a bird setting down, or the essence of flight, or of drift, or of weightlessness itself.

Arp's titles immediately put us in the poetic, and often humorous, realm. *Dream Flower with Lips* (1954), a tabletop marble sculpture, darts among associations of plants, a carved wood figure on a ship's prow, and an upside-down human leg with a boot. The lip-like forms at the top appear to pivot, as if looking over the sculpture's shoulder, becoming both head and hands waving goodbye. And in *Torso Fruit* (1960), a bulbous, marble figurative form also suggests a vase, a pear, and a bowling pin morphing into a Cycladic idol or a classical Greco-Roman nude.

In Arp, we are drawn to the same exacting forms and qualities that attract us to a classical marble sculpture or a piece of actual fruit: a purity of means that is clear, concise, accepted, natural, and unquestionable. Arp's forms are both contained within themselves and freely expanding within their environments. There is oneness and a sense of clarity to their contours, their weight, and their inner sense of purpose, which feels energetically pushed outward against their skins and into the world. We accept and embrace Arp's sculptures as we do organic forms: because of their exactitude, their rightness, their sense of life. As artworks, however, they feed our consciousness and imagination. As Arp once said, "Art is a fruit that grows in man, like a fruit on a plant, or a child in its mother's womb. But whereas the fruit of the plant, the fruit of the animal, the

fruit in the mother's womb, assume autonomous and natural forms, art, the spiritual fruit of man, usually shows an absurd resemblance to the aspect of something else. . . . Art is of natural origin and is sublimated and spiritualized through the sublimation of man."

IGNITING

James Turrell—*Perfectly Clear*

IN 1980, A WOMAN VISITING AN EXHIBITION OF THE ARTIST James Turrell at New York's Whitney Museum of American Art mistook one of his light sculptures for a gallery wall. After stepping back to lean against it and encountering nothing but illuminated, colored space, she fell and sprained her wrist. She ended up suing the Whitney. At the same show, another woman claimed she became so "disoriented and confused" by Turrell's illusions, which magically transformed light and air into seemingly solid form, that she was "violently precipitated to the floor." She also filed a lawsuit.

Illusionism in art is nothing new. Pliny the Elder, in his *Naturalis Historia* (AD 77–79), recounts that during a painting contest between Zeuxis and Parrhasius, Zeuxis's still life was so realistic that birds pecked at his painted grapes. When

Parrhasius, whose own still life was hidden behind a curtain, asked Zeuxis to unveil it, the curtain itself turned out to be a painted illusion. "I have deceived the birds," Zeuxis said, "but Parrhasius has deceived Zeuxis."

Turrell is not attempting to deceive or confuse people with his artworks—and certainly not to precipitate them violently to the floor—even though many of his light installations consist of apertures cut directly into walls and illuminated by low, indirect, artificial light in otherwise dark rooms. Turrell's light sculptures create a number of illusions, including some that transform void into volume. And adjusting your eyes to Turrell's sculpted light is a slow, though rewarding, process. Viewers are instructed that it can take as long as fifteen minutes for their pupils to open sufficiently to perceive the nuances in Turrell's work. But increased visual perception does not make his artworks any less perplexing.

Born in Los Angeles in 1943 to Quaker parents, Turrell received a bachelor's degree in perceptual psychology in 1965 and a master's in art in 1973. He also trained as a pilot and practices pacifism. He has fused this array of interests—psychology, flight, and peace—into his art. He is best known as a proponent of the Minimalist Light and Space movement in California in the 1960s and 1970s, which brought together a group of artists, including Larry Bell, Robert Irwin, Craig Kauffman, John McCracken, Bruce Nauman, and Doug Wheeler, who created atmospheric installations by controlling, to varying degrees, the interactions among architectural features, viewers, and natural and artificial light.

As your eyes adjust, in Turrell's installations, to the artist's vibrant fields of light, the colored, airy space before you appears to breathe, to open inward, and also to advance toward you; to harden, liquefy, and dissolve, playing havoc with your senses and your perceptions about what is form and what is not, about what is pure lighted space and what is light reflected across a wall—literally about what you are and aren't perceiving. In these disorienting artworks, I have often timidly pushed my hand forward into their velvety light, as if reaching into another dimension, not knowing if I will encounter space or solid. "Generally, we don't see light this way," Turrell once said, "because we see light illuminating things. But my interest is in the thingness, the physicality, of light itself."

TURRELL WAS REFERRING to the experience of his immersive light installation *Perfectly Clear* (1991), on view in his long-term retrospective *Into the Light* at the Massachusetts Museum of Contemporary Art. Being inside of this work at times makes you feel like you are freefalling, or floating in a sea of colored light, and at other times like you are being bombarded by the special effects of a discotheque. Comprising numerous smooth and slow single color changes punctuated at several points by fifteen-second-long stroboscopic effects, this environmental artwork, in a white room about the size of a studio apartment, lasts for nine minutes. Viewers must remove their shoes and put on blue booties before climbing a wide set of ziggurat-like carpeted stairs to enter the main room of the installation. The protective booties help to keep the installation as clean as an

operating theater for surgeons. People are advised not to participate if they are photosensitive.

Perfectly Clear actually takes place in two spaces, a large white waiting room, where you put on the booties, and the main room, where the action—or art—happens, at the top of the nine steps. The opening to the main room at the top of the staircase, through a wide, cave-like entryway, feels both ancient and futuristic. The opening glows brightly, throwing carnivalesque light into the waiting room that casts it into twilight, then sunset, then nightclub. At other times, the doorway appears to spit sparks and fire, beckoning like an amusement park funhouse.

In the waiting room, participants get a preview of what they're about to experience. As viewed through the open doorway, the stark, silhouetted bodies of the participants in the main room look like they're being bombarded by lightning flashes; drenched in colored light—rose, honey, lime, purple, blue— they stand as if fully haloed. Their variously colored clothing feels heightened and saturated, as if their bodies were electrically charged, and their contours sometimes vibrate, as if they were rematerializing or dematerializing—beaming up into or down from the Starship *Enterprise*. This effect adds irony and humor to a scene that also triggers thoughts of crematoriums and electrocutions.

Once the previous group's experience concludes, your group of up to six participants is invited to enter. But the experience as actor in the main room is markedly different from the previous one of audience. Taking a step into *Perfectly Clear* is like taking a step into another universe. Without any sense of

transition, I left behind my role as onlooker and walked into a situation where my experience swung wildly between sensory deprivation and sensory overload. It's akin to watching versus being strapped into a whirling, zigzagging carnival ride. I experienced a blitzkrieg of light, as if we had been ignited, immersed suddenly in violent, though perfectly silent, volleys of yellow: pure lemon yellow walls, floor, ceiling, and air, all of which bled into a seemingly boundaryless space, before the colors began to shift.

Perfectly Clear's white ceiling is high, and the white floor vertiginously slopes slightly down toward the back of the space as if toward an empty unknown. The listing floor, adding precariousness and drama, gives you the vague impression that you could lose your footing and slide down the artwork's throat. I could vaguely make out that the room is without right angles: that the ceiling curves into the walls, which curve into the floor. But it seemed to be toying with my depth perception and my ability to distinguish concepts like top, bottom, front, rear, and sides. Near the far wall of the room, that inclined floor, becoming precipice, abruptly ends, and the wall just beyond it, brightly lit like a lightbox, shines like a portal within a portal.

Inside *Perfectly Clear*, light is indirect and mostly even, enlivening the atmosphere as much as the surfaces of the reflective white interior. The light has a forceful presence. It creates the illusion of the floor beneath you, as well as the far horizon, having been erased. The strong bright light also begins to dissolve the people around you and even the physicality of your own hand when you hold it in front of your face. As the light in *Perfectly Clear* intensifies, you lose any sense of a room at all. Even

your perception of up and down comes into question, and your fellow travelers appear, like you, to be suspended and fried, liquefying in light. Sometimes, especially during the intervals of stroboscopic effects, light attacks you with pointillist spasms, as if you were hurtling at warp speed through space, through volleys of shooting stars in a 3-D movie, or as if you were lost in a blizzard. At other times, as one color slowly melts into the next, the space surrounding you settles into a thickened slowness and buoyant stillness, as if the increasingly liquid colors, which at first merely tinted the air, are beginning to engulf you.

PERFECTLY CLEAR IS fueled by Turrell's interest in illusionism and by his deft manipulation of the various effects of light on our senses, both physical and emotional. But the artwork appeals to us in the same way that all visual art appeals. And its abstractness—its ability to lessen our sense of its three-dimensional world, replacing that world with a buoyancy and suspension that almost feels weightless—is a feat unto itself.

The experience of *Perfectly Clear* is very different from that of the large scrim and fluorescent light installations of the California Light and Space artist Robert Irwin (b. 1928), whose subtle transitions create a meditative atmosphere in environments through which you move and in which you can contemplate the mysterious passages and the ghostly presence of other viewers, who are veiled behind translucent walls. And *Perfectly Clear* is also quite different from the sculptures and environments of the artist Dan Flavin (1933–1996), whose fluorescent-lightbulb sculptures are experienced as both light and object. A disorienting environment, *Perfectly Clear* blurs

the boundaries between artwork and participants, who never really remain mere viewers in the traditional sense, but become active elements and forces within the artwork. Inside *Perfectly Clear*, you are not able, really, to see the artwork from an objective distance—to separate yourself and your experience from the environment—any more than you could as a swimmer underwater separate yourself from the pool.

The appeal of *Perfectly Clear*, as with many of Turrell's installations, is its ability to give light physical presence and weight, to liken light to our own bodies, and our bodies to light. What's unique and uncanny about the experience is how much it dissolves distinctions and plays with our senses, how it embeds us within the work itself. *Perfectly Clear* achieves equilibrium among light, spaces, and physical solids. Standing inside of it, I felt at times that it was dissolving my sense of where my own body ended and my environment began. As the work began to remove my sense of external limits among things and light in the environment—as, like the Impressionists, it atomized the world into an assault of color—it not only immersed me in an impressionistic environment but awakened in me a sense of limitlessness.

TURRELL IS NOT only a Light and Space installation artist but also an environmental and earthworks artist. Since the late 1970s, he has been converting an extinct cinder volcano near northern Arizona's Painted Desert outside of Flagstaff into *Roden Crater*, an enormous work of art incorporating tunnels and apertures and featuring naked-eye observatories—what the artist refers to as Skyspaces—with open views of celestial

phenomena in pristine desert skies. Although *Roden Crater* remains unfinished, and is largely inaccessible to the general public, it represents a pilgrimage, a mysterious, minimalist mecca for Turrell fans on par with sculptor Robert Smithson's monumental earthwork *Spiral Jetty*, a 1,500-foot-long sculpture constructed out of basalt rock, salt crystals, earth, and water in 1970 on the northeastern shore of Utah's Great Salt Lake.

Turrell plays with our perception of where an artwork ends and the outside world begins. In 2014, with the enormous site-specific installation *Aten Reign*, Turrell transformed the rotunda of Frank Lloyd Wright's Solomon R. Guggenheim Museum, in New York City, into an hour-long, six-story-high installation combining natural and artificial light progressing exquisitely and seamlessly through the chromatic spectrum. For days after I saw *Aten Reign* and *Perfectly Clear*, I saw my surroundings as if through new eyes. The uninterrupted blue sky above, the flowing gray-green river behind my house, the deep orange sunset, and the lights falling and liquefying on New York City's buildings all reminded me of Turrell's saturations and movements of light. It was as if, for a few days at least, he had cornered the market on my experience of the world, as if he were inside my head.

He's not alone. Each artist's particular voice with light— the temperament, color, and tone of it—affects how I see light outside of art. Whenever I see dawn or twilight I think of Jan Vermeer. When I'm in Paris, I see the multitudinous grays of the City of Light through the eyes of Jean-Baptiste-Camille Corot and Braque. At times, Turrell's colored lights transport

me into other places and works of art: Mark Rothko's vibrating abstract lozenges; the ecstatic, colored shafts streaming through the stained-glass windows of Paris's Sainte-Chapelle; J. M. W. Turner's seething, watery tumults; a Poussin sky; a fireworks show; the light sculptures of Irwin and Flavin.

Art excites and influences us and has the power to alter the very ways in which we see the world. I grew up in the Midwest farming belt, but I don't think I ever really saw or appreciated the beauty and drama of that place until after I moved away and spent considerable time in the verticality of New York City; until I had traveled widely and seen a lot of places and landscapes and landscape art, and then returned to the horizontal expanse of the Midwest. In the Netherlands I experienced the Dutch landscapes of Jacob van Ruisdael—who stirred in me a re-appreciation for the drama inherent in immense and wide gray, blue, and white-cloud-stacked skies; and who helped me to savor the slow coming and buildup of an advancing summer storm, first seen from tens of miles away. And after seeing many van Goghs, I was able to appreciate, finally, the restless beauty and energy in seas of tilled fields and wind-whipped wheat. Ruisdael, Vermeer, and van Gogh, among others, opened my eyes to all landscapes. They opened up to me the beauty of the American landscape of my youth.

TURRELL IS PERHAPS best known and most revered for his inimitable Skyspaces. Compared to the controlled assault of *Perfectly Clear*, the Skyspaces—Turrell's most unadulterated and understated artworks—feel almost artless, handless. They are

fueled by humility and restraint. With the Skyspaces, it's as if Turrell has done nothing much more than to point to a piece of sky and say "Look."

Turrell's Skyspaces are actual apertures—round, ovular, or square holes—cut into the ceiling and open to the sky. The Skyspaces, like windows, act as frames. They are moving paintings in which sky is both subject and action. Turrell's Skyspaces are housed in either autonomous structures built specifically for them or integrated into existing works of architecture. Some are large and can accommodate dozens of visitors. Others are as intimate as a restaurant booth.

Turrell points and you look. You climb inside one of his Skyspaces, sit back, often against banquettes, relax, gaze up into the framed shape of sky that Turrell has cut out for you, and watch—as the light changes, and as birds, clouds, and aircraft sometimes move through your field of vision. But mostly you savor the slowly shifting light, color, and weight of the sky, which can feel like liquid moving through various densities, and even at times to be as solid as a piece of cake.

SOME OF TURRELL'S Skyspaces are round, and as you look up at their blue circles, which begin to swell seemingly into solid spheres, they can't help but remind you of what it would be like to see the earth from the moon, which can displace you somewhat. As dusk settles on one of Turrell's Skyspaces, and its blue opening darkens and the stars begin to brighten against deepening blackness, it's as if Turrell has gifted you with something special, in part because it is so simple and unadulterated. I've

felt like I had never before seen and really taken in the vault of the sky in such a concentrated way.

Each Skyspace is unique and focuses on a different piece of sky. On every occasion I've spent time with one of these Minimalist marvels, I've experienced purity and elegance, sometimes feeling as though the sky were throbbing or pressing comfortably down upon me, and I've always been surprised at how calm, alive, appreciative, and cleansed it makes me feel. Apparently others feel the same way. The experience is akin to floating on your back in the ocean; you become relaxed and weightless, suspended between here and above.

Turrell's Skyspaces are almost mute in their purity and simplicity. But I have never encountered a viewer anywhere in one of these spaces who did not take the experience seriously. People respond to the Skyspaces with reverence, as if they were at a scenic view of the Grand Canyon or in a shrine. Whether young or old, they seem to get what Turrell is trying to do, and they're thankful for his unique vision—his handless gift. They're more than willing to see the world through Turrell's focused lens, to try on his eyes temporarily as their own. To experience a sunset through one of these apertures is to feel as if Turrell had discovered fire. He offers these concentrated pieces of sky to us in a way that helps us to focus on and to contemplate areas we normally take for granted, allowing us to recapture not only a piece of nature, but to rediscover, to see, what's always been right there in front of us.

EVOLVING

Paul Klee—*Signs in Yellow*

L EGEND HAS IT THAT WHEN PICASSO VISITED PAUL KLEE in 1937, the Spaniard said to the Swiss painter: "I am the master of the large. You are the master of the small." It is true that Picasso, a representational artist, sometimes worked very large, and that Klee, an abstract painter, never worked larger than easel scale. Yet, Picasso, in calling attention to the diminutive size of Klee's art, is not giving him a backhanded compliment; he is calling attention to the power of Klee's intimate world.

Klee mines a contemplative inner realm—the personal, one-to-one scale of portraits, mirrors, books, and dreams. Representational painters attempt to create the illusion of a three-dimensional world on a flat canvas—an illusion of space that mimics our own known world. An abstractionist such as Klee does not ground us in our known, three-dimensional world.

Instead, by denying us the comfort of navigating a pictorial space that mirrors our own, Klee opens up a world to us that is other, limitless, unknown—*abstract*.

Extremely eclectic—a true Renaissance man of Modernism—Klee (1879–1940) was a painter and a teacher, a philosopher, a natural scientist, a concert violinist, and a poet. He was an objective Romantic and an expressive Classicist who looked at the world at both the macro and micro levels with a crystalline detachment. Klee believed that the creative energy of the artist is fed by and feeds into greater universal energies. His monumental, two-volume Bauhaus teaching notebooks, posthumously published as *The Nature of Nature* and *The Thinking Eye*, have been compared in their thoroughness, depth, intelligence, and scope to Leonardo da Vinci's notebooks.

In his broad-ranging oeuvre, Klee was influenced as much by illuminated manuscripts, textiles, tribal art, commercial advertising, board games, and hieroglyphs as he was by plants, shells, fossils, crystals, stars, and cells. Two of his major themes were birds and fish, inhabitants, unlike human beings, of the lower and upper—*other*—realms of sea and sky. Klee seems to have preferred as subjects the lowest forms of life—things and beings in which the processes that formed them are most visible to the naked eye—as well as the subjects of children and childhood—the early realm of human development. In his pictures, Klee explored the embryonic and cellular growth of organic forms as well as the development of solar systems. He personified plants, animals, mountains, woods, music, and even moods, seeing everything in terms of its inner nature and as a subject for art.

Klee's omnivorousness and his almost scientific and often childlike economy are sometimes misunderstood as dispassion and simplicity. His pictures are sometimes mistaken as offshoots of Surrealism and fantasy, as well as primitive art, but Klee's art comes from studying nature intimately and rationally, from the inside out. He believed that nature speaks, and that it is the artist's job to listen. His fusion of his broad interests and knowledge imbues his pictures with qualities that feel foreign yet familiar, summoned yet scientific, as if they were stories and specimens brought back by an explorer from ancient cultures and distant lands.

Klee's encyclopedic intelligence never gets in the way of the experience of his pictures. You never feel that Klee is *teaching* you something. He allows for the pleasure of discovery, presenting everything clearly and poetically, and allowing us to tease out his metaphors. Klee convinces me that it is I, not he, who is the explorer. His artworks penetrate into the heart of nature, but his straightforward, archetypal forms are often actually transparent, layered, revealing his subjects' existence at multiple levels—visual, emotional, structural, spiritual—making you feel as if you were looking at them through successive realms of time and place.

KLEE'S *SIGNS IN YELLOW* (1937) (fig. 12) is a vertical picture of concise black markings interacting within a gridded field made up of a wide range of yellows. A mixed-media work done in pastel on cotton in colored paste, mounted on an earth-colored jute, it is roughly thirty-three inches tall by twenty inches wide, and announces itself as much as an object as a picture.

Klee often made or repurposed old, used frames for his work, paying particular attention to their colors and sizes and incorporating their unique characteristics. As with *Signs in Yellow*, he would finish a work to its outermost edges—its integral wooden frame—transforming it into a thing akin to an altarpiece or icon.

In *Signs in Yellow*, he evokes a wide range of analogies and actualities. For one thing, the raw jute—which borders the colored pastel field, and which occasionally peaks through the colored rectangles—relates the picture to a weaving or carpet, a textile made up of warp and weft: of energies moving horizontally and vertically and interweaving together to form a piece of cloth. But, besides the analogy of a weaving, Klee suggests the metaphor of a desert landscape—the place, perhaps, where the weaving was produced. In making the jute substrate, or ground, apparent, and sometimes equally present, he suggests a field in motion, or resurfacing and tilling itself. Although it is a pastel picture on cloth, conveying the illusion of a weaving, its colors recall hot-desert yellows and oranges, sunrises and sunsets; the jute is the color of earth, and of cool desert sand. The jute border and its frame further the analogy of a bordered landscape; it's as if the viewer were looking at a map of an actual landscape marked with signs.

Indeed, the title of Klee's picture informs us that we are looking at signs *in*, not *on*, or *under*, yellow—that the signs are embedded within a primary color; that we are looking at a puzzle, of sorts; that we have been presented with some elementary things. *In* implies that these signs are forces, that they

are planted and integral to the dynamics of the picture, especially in relation to Klee's analogy of the landscape. *Signs in Yellow* suggests flickering light, shimmering mosaics, golden facets, and fields of sunflowers. It evokes aerial views of a landscape, patchworks of cultivated fields or desert sands. And Klee's strata of rectangles also suggests a section or segment of stacked layers of earth, a cross section of geological sediment built up over time. Klee puts me above, next to, and inside his landscape simultaneously.

Klee furthers the planting metaphor all the way to the picture's peripheries, where black lines read as stalks growing out of the earth-like jute border. There, along all four sides, the tan jute becomes ground (literally, as the substrate for the artwork, and also metaphorically, as the earth beneath the picture's yellow flowering of life). As I visually move around the picture, Klee rotates my view so that, as I traverse each side or edge of the rectangle, the picture rotates with me: I seem never to leave the baseline of the landscape. Klee's picture, reorienting itself, interacting with me, goes where I go.

Through the movement of rotation, Klee denies me any clear reading of top or bottom or side within the picture. The landscape's four baselines, seen along each edge of jute, repeatedly interchange like four horizons; inside the picture, each horizontal and vertical movement from edge to edge of the rectangle becomes yet another baseline and also another horizon. As every baseline becomes horizon and then baseline again, his picture frees me up to see and to allow for every element of it to be in the process of starting, of becoming, of never

arriving—of genesis. No matter how far or for how long I travel through Klee's picture, and no matter how much I unravel the meaning of its signs, every one of its elements is destined to remain, at least in part, a sign for something yet to come.

KLEE'S INVERSION AND interchange and interweaving of above and below, of top, bottom, and side, can begin to suggest the realm of the beyond. In *Signs in Yellow*, I am never actually located somewhere specific—as I might be while looking, say, from a fixed vantage point at a traditional representational landscape. Instead, I'm in a place of becoming—in multiple places simultaneously. In a sense, Klee puts me everywhere at once. He puts me on an omnipresent perch.

When I begin to accept the variousness of my orientation and of the analogies in *Signs in Yellow*, I can begin to allow the picture to open up to me fully. I become aware that Klee has inverted the traditional horizontal orientation of landscape into the vertical orientation of portraiture. He has created an abstract portrait of a landscape that, besides farmland and desert and cross sections of earth, evokes stained-glass windows, or children's alphabet primers, Advent calendars, or papyrus scrolls. I realize, oddly, that I am looking at plants, seeds, stalks, bits of letterforms, pictographs—but never, actually, any of those things. I realize that in the title, the word *Signs* can be both noun and verb. As noun, it describes objects, qualities, or events—signals, symptoms, or evidence. As verb, as in to *sign* one's name, it can be an actual inscription—the act of marking. *Signs in Yellow* evokes not only early letterforms or ancient hieroglyphs—but the *evolution* of writing—the transformation

of pictures into characters. Klee has conflated all of these analogies and extended them. He evokes not only the growth of a seed, or a dot, but the birth of writing, of art, of agriculture, and of architecture. The elements of his picture begin to add up like building blocks.

KLEE BELIEVED THAT a work of art is a universe unto itself, with its own set of rules, stories, and structures. He often employed the geometry of the grid (the internal, divisional structure of the rectangle) as the compositional basis for his pictures, including *Signs in Yellow*.

Every time I traverse the horizontal or vertical passage of a rectangle in one of his grids with my eyes, no matter how large or small it is, I also, in a sense, traverse (or at least revisit, through memory) every other horizontal or vertical passage of rectangle in the grid, including the outer edges of the entire picture. Each time I consider a single internal rectangle, I consider, or relate it to, each of the individual rectangles in the whole group, as well as the entire rectangle of the picture. When my eyes rest at the lower left corner of an internal rectangle within the composition, I feel as if, in a sense, I'm making contact with that point, that corresponding corner, on every rectangle within the grid, including the larger rectangle of the picture. It's a structure that allows me to be at an exact point and at many other points simultaneously.

For the abstractionist, the grid's building blocks are literally and metaphorically the building blocks of the composition, whose spatial and organizing structure, like an exoskeleton, is brought to the surface and laid bare. Stressing vertical and

horizontal over diagonal, flatness over depth, the grid brings everything up front to the literal face of the picture plane. As in *Signs in Yellow*, the grid in other works makes every element equally present, immediate. Denying spatial depth, relative location, and succession, the grid—as if it were revealing everything all at once within a crystal ball—also denies the sense of time.

In narrative art, time and location, cause and effect, are paramount: this happened here and then that happened there. Abstraction does away with the linearity of progression. This does not mean, however, that an abstract picture employing a grid can be taken in all at once, or that it is without a sense of depth. Colors and forms and lines and shapes read spatially. The flat though malleable membrane of the abstract grid has its own spatial laws that are dictated by the artist. An orange rectangle, though held flat within the grid, might read as more frontal, or forward, than its abutted yellow rectangles, which are also held flat to the grid. This gives the flat plane of the picture the quality of a pliable skin: an elastic surface (like that of a piece of rubber) that can be pushed inward and pulled outward, strained to the limits, and even twisted, without ever losing its sense of being a flat and continuous surface.

This elastic membrane can stretch and fold and turn inside out. It can be an opaque wall and a transparent window simultaneously—giving us multiple, simultaneous views of its outer surface and its insides; its front, behind, before, and after. Because the abstract grid does not *represent* a world such as an interior with a woman seated at a table (a picture *of* something

seen in nature), it can simultaneously offer a view like a window *on* nature and a window *into* nature—as well as a window view from nature, looking back at us.

One other useful aspect of the grid for an abstractionist such as Klee is the structure's ability to reorder and reimagine everything as rectangular building blocks, or as forms transforming themselves and adhering to a new structure, one that has metaphorically and literally combined and conflated them. The grid becomes a new, metaphoric playing field, where forms of various species and materials—rocks, flowers, skyscrapers, the sails of a ship, the songs of a bird—can be grafted, reimagined, and reborn.

As I MENTIONED in Chapter 2, Klee famously remarked that a line is a point that "goes out for a walk." A point, of course, can stand for one of many points (or locations) on a line. But points, especially in *Signs in Yellow*, can also suggest periods, beginning and ending points, or atoms, buds, berries, planets, eyes, mouths, or navels, or portals. In *Signs in Yellow*, points suggest any number of things all at once, such as the first mark of writing, or of picture-making, or a demarcation on a map: *You are here.* "Art," Klee wrote, "is a simile of the Creation. Each work of art is an example, just as the terrestrial is an example of the cosmic." Furthermore, "the point," Klee said, "as a primordial element is cosmic. Every seed is cosmic. The point as an intersection of ways is cosmic."

In the language of art, of course, a line begins with a point, a dot: a beginning. And those points move and/or accumulate,

growing into a line. Klee suggests that the line can mean many things, from the measure of distance, to a stream, to a line of thought, a pathway, the sharpness of a knife, or an arrow. In art, a line, the most basic and primitive element of communication, can move and change direction and meet itself back at its beginning, closing itself into a shape, a plane. After establishing itself as a plane, a line can restart itself and move diagonally in space, creating another plane—a top, or bottom, or side—transforming from two into three dimensions.

Point and line are the most basic elements of signs, suggesting the energy, movement, and growth of written communication. Klee knew that points and lines were used by children for spirals (motion and emotion) as well as for stick figures. He was aware that the vertical line was undoubtedly the first and is still the simplest sign for human beings (for life), just as the horizontal is the simplest symbol for the horizon (and for death).

Klee knew that pictures had developed into pictographs— simple picture-symbols that represent the thing itself (such as a circle or star that stood for "sun")—which then developed into ideographs (the sun picture representing "day," "light," "heaven," "god"), which became the basis for the evolution of writing: and that after going from pictographs to ideographs to cuneiforms and hieroglyphs, they developed into calligraphic characters, and eventually into modern letterforms.

In *Signs in Yellow*, Klee gives all of these thematic elements play. His black lines, or signs, suggest seeds, flora, animals, tools, figures, boats, fishing hooks, canes, horizon lines, shapes, and letterforms. They act here as pictures as well as signs, and

they represent the stages along life's way in their evolution from thing to picture, picture to pictograph, pictograph to sign, sign to letterform, and then back, seemingly, to a child's first attempts at drawing and writing.

Klee's signs exist in motion. Their marks, like stalks and seeds, stand in for the evolution of a picture—of artmaking itself. We see two dots, which could be points hoping to become lines, eyes in search of a face, periods looking to end a sentence, sperm in search of an egg. Economical yet exhaustive, they run the gamut of possibility. And although they are aligned with the grid, they are free agents. In places, Klee's black marks appear to be reordering and reshaping the grid, suggesting a question: Which came first—landscape or seed?

Maybe what came first was light. In *Signs in Yellow*, Klee explores the full range of yellow—evoking sunrise and sunset. Black and yellow are fully present, pure. But yellow is also often in transition. Through hues of gold, orange, red-orange, tan, and cream, we have signs that red and white, either dawning or setting, are on the horizon.

These other colors, such as oranges, in concert with black lines, are wildcards within the grid. They introduce diagonals, curves, and near-circles. In the lower right, orange—as if mounted on a pole—feels dislodged and independent, like a flag raised on conquered soil. In other places, black lines become crosses or change directions, becoming planes. These lines, with intent, signal growth, not just in two but toward three dimensions: flat lines rotating through the diagonal into the circular, expanding space from front to back, and into volume.

In *Signs in Yellow*, Klee has planted seeds—the signs of life, potential, intent, and free will. Everything necessary is here, germinating, in motion, evolving. Klee has created, I think, not just an abstract portrait of a landscape, or a picture of the evolution of signs, but an abstract portrait of the seeds, roots, and flowering, the genesis and evolution of civilization.

eleven

INTERACTING
Marina Abramović—*The Generator*

BORN IN BELGRADE, YUGOSLAVIA, IN 1946, THE SERBIAN performance artist and filmmaker Marina Abramović is best known for her interactive audience participation piece *The Artist Is Present* (2010). Executed at New York's Museum of Modern Art, it was a 700-hour-long artwork attended by more than 1,400 visitors—including the Icelandic musician Björk, the influential rock star Lou Reed, and the actress and filmmaker Isabella Rossellini—who all queued up for hours to sit silently at a table, one on one and face to face across from Abramović, for as long as they liked. Nearly 800,000 more people watched via MoMA's live feed. The performance, during which the artist and her partner from the audience sometimes held hands, often looked like a staring contest and brought some participants to tears.

During her other works of performance art, Abramović has danced until she collapsed, or brushed her hair until her scalp bled; she has been injured in some of them by antipsychotic drugs, knives, hard slaps, ice, and fire. In the twelve-day-long ritualistic piece *The House with the Ocean View* (2002), at New York's Sean Kelly Gallery, Abramović, like a nun vowing silence, lived openly, publicly, and continually—drinking water, sleeping, urinating, meditating, bathing, and fasting—in three spot-lit, dollhouse-like cubes, elevated five feet above the floor in front of a changing live audience.

The Artist Is Present was not the first time Abramović, who is as much an endurance as a performance artist, has invited people to her table. In *Rhythm 0* (1974), she placed seventy-two objects—including a scalpel, a rose, a whip, olive oil, a feather, and a loaded gun—next to her on a table, at which she sat for six hours straight. During that period, audience members were allowed to use the table's objects and to manipulate her body in whatever ways they chose—which included cutting off her clothes and cutting her skin.

It's impossible, really, to separate Abramović the vulnerable artist from Abramović's artworks, which have been known to make viewers feel vulnerable. A *New Yorker* profile of Abramović stated that she believes her "role as an artist...is to lead her spectators through an anxious passage to a place of release from whatever has confined them." In many respects, her position about her role as an artist and her art's purpose—which is shamanistic, and also shares some of Sigmund Freud's beliefs about the therapeutic power of art—sounds more like

experimental therapy, for both artist and viewers, than art. But in therapy—as well as while going on a shamanic journey—at least you have a trained professional to counsel and guide you through the anxious passages, rather than a performance artist just dropping in and creating havoc.

In 2014, I was a guest critic on a panel at which we agreed to discuss Abramović's *The Generator*, a work of interactive performance art that at the time was on view at the Sean Kelly Gallery. I knew that some people had had cathartic experiences participating in Abramović's performances; even though I had staged some performance art pieces in my youth, however—and had seen many such performances over the years—I'd resisted participating in contemporary performance artworks. Those days were behind me. I seriously doubted that I would get much from an artwork that turned viewers not only into performance artists themselves, but into guinea pigs, and, literally, the main event.

Unlike with Abramović's other performances, in which the artist had always actually been present, when I heard about *The Generator* it felt too random, uncontrolled, and viewer dependent. Granted, Abramović herself, along with more than sixty other people, might occasionally be participating in *The Generator* at any given time along with me. But I objected to *The Generator*'s free-form premise, the proposed setup, and the sense of manipulation it seemed to exude. It struck me more as a sociological and psychological experiment than art. I considered not participating in *The Generator*, and then making my

case for nonparticipation on the panel. In the end, though, I realized that I had agreed to do a job: I decided to put aside my misgivings and to be open to the piece.

To participate in *The Generator*, I had to enter a locker room, remove my shoes, stow my valuables, sign a waiver (it was being filmed and live-streamed), and then don a blindfold and sound-suppressing headphones. These didn't actually work. I closed my eyes to make it darker and tried to ignore what little muffled noise I could hear. Still, the experience was akin to that of getting into a sensory deprivation tank, except that, instead of floating in salt water, we would be walking or crawling on the floor, and bumping into walls, support columns, and other people. What actually happens when you make contact with other people is up to you and them—keeping in mind that your interactions—because you are basically deaf and blind—exclude visual and verbal communication. When you've had enough of *The Generator*, you simply raise your hand, and a gallery attendant comes over and escorts you back to the locker room.

To get me started, a young, chic gallery assistant dressed in black, who had been assisting me in the locker room, took me by the hand. She guided me into *The Generator* and left me standing somewhere in Sean Kelly's brightly lit exhibition space. Just before she set me adrift, she lifted one cup of my headset momentarily and instructed me to "move slowly" and to "go meet your neighbors." Meet my neighbors? I was almost completely blind and deaf, and I had no intention of meeting anyone. It had never occurred to me to approach my participation with that objective in mind. My only goals were to avoid

touching anyone inappropriately and to avoid getting stepped on or injured: basically, not to hurt anyone and not to get hurt.

Feeling a little aimless out in the open gallery space, I wanted to regain my bearings, so I moved forward hesitantly, slowly, extending my arms and gently pawing and exploring the emptiness in front of me and to my sides with my hands while pushing my feet slowly along the floor. Soon, encountering bits of architecture, I discovered that the gallery seemed to be empty except for its outer walls; its padded, inner support columns; and, I assumed, my fellow *Generator* participants, none of whom I had yet met. Eventually, relieved, I touched a wall. There I stood, leaning with my back against it. I felt more secure knowing that I was grounded, that I was exposed on fewer sides. Rather than walking normally, I then instinctively extended my hands carefully through the space and slid my feet—never lifting them—across the floor. But as I swish-swished through the space, an experience surfaced in my mind that had happened thirty years earlier. It was something I had almost forgotten about. Things were being released. Art, of course, like a madeleine in Proust, can take you many places.

Soon after I had moved to New York City, I had ventured to a party in Brooklyn—perhaps my first subway trip alone out of Manhattan. As we pulled into the Brooklyn subway station, I had noticed something weird. I hadn't quite been able to identify it, but I had sensed that the others standing up to exit with me also felt that something was off. Still, even as the train came to a stop and the doors opened, and we all left the security of the well-lighted cars, I wasn't yet sure what was wrong. It wasn't until the doors closed and the train began to pull out

of the station, taking its illuminated cars with it, that I realized the underground Brooklyn platform was getting darker and darker.

Making my way—swishing—along that bare wall at the Sean Kelly Gallery put me right back there on that subway platform, where I, in the darkness, had felt vulnerable and disoriented thirty years earlier. In *The Generator*, I didn't experience the sudden fear I'd felt when we had suddenly been stranded in that dark, underground Brooklyn station, but what did surface was a sense of unease about not knowing what, if anything, would happen next. In both instances, my senses were heightened and I was filled with anticipation. As I pushed my feet across the gallery's cement floor, I remembered that I had moved my feet in exactly the same way on that subway platform, producing a strange and threatening sound that had startled some of my fellow travelers.

Both of those experiences connected within me, and each awakened something deep and primeval—alertness, perhaps, that was normally buried, ancestral. In *Generator*, that alertness completely pulled me out of any preoccupations I'd had upon entering the space, just as, in that subway station years before, I had been awakened to the fear and fantasies of a mugger's attack, and to the fear of racking my shins against a hard, wooden bench, or plunging headfirst onto the tracks and being electrocuted by the third rail.

Nothing at Sean Kelly equaled that level of distress, but the sensory deprivation of *The Generator* and the darkness on that subway platform both placed me very squarely in the here-and-now. In *The Generator*, I held to the wall for a sense of support,

safety, and location. In the Brooklyn station, I had also tried to get my bearings, but I knew I had to keep moving. As soon as the train noise had subsided and the platform was completely black, people seemed to stop momentarily; we were mostly silent, as if we were all gathering our senses and coming to terms with our predicament. There were some murmurs and exclamations, some shouts out to companions, and some joyful reunions, but mostly there was increasing silence and stillness as the train disappeared deeper into the tunnel.

In the silent, darkened space of *The Generator*, my senses intensified, especially when, as I inched my way along the gallery wall, I made physical contact with a woman who was frozen in place. Like a mountain climber impeding my movement and unable to progress, she indicated that I should continue along the wall around her.

As I passed over her, the warmth of her body seemed to form a bubble between us. I was aware of smells and textures, of heat, wool, sweat, and perfume. *The Generator* forced me to rely on underused senses, to hear, as if amplified, the foreign sounds of my own breathing. I recalled that in anechoic chambers, those soundproof rooms that completely deaden all echoes and reflections, some visitors are driven out because the sounds of their own heartbeats and breathing become deafening.

In my interactions in *The Generator*, which were all physical, I had no subtle facial expressions to read, misread, and project; no visual observations or judgments to entertain and distract me. Every communication was bodily, immediate, fully focused, and expressed only through physical contact. I thought of the difficulties and even the comforts and freedoms

of being blind and deaf; and of how much we depend on what we already know, what we have learned, presume, or think we know about places and one another, and how we take it all for granted. I was aware of how many assumptions we make while navigating the world. And I was reminded of a woman I had read about in Annie Dillard's *Pilgrim at Tinker Creek*. Blind from birth, she had regained her sight. Astonished, she had been "eager to tell her blind friend that 'men do not really look like trees at all,' and astounded to discover that her every visitor had an utterly different face."

ONE OF THE other members on my panel, describing his own experience of *The Generator*, said he had felt it was "slightly oppressive," and "mildly coercive"; that, try as he might, he had been unable to repeat his movements, to keep his bearings, or to walk a straight line between two pillars. Nearly deprived of two of my senses, I had overcompensated. But I wasn't alone. When I bumped into people, there was an inordinate amount of politeness expressed between us: an unexpected collision or touch would be followed by a soft and apologetic, "I'm so sorry for invading your space and startling you" touch, followed by an "It's perfectly all right, very nice to meet you, and isn't this an odd situation?" kind of touch. How quickly, I realized, speech had become unnecessary, like a burden I was happy to shed.

Eventually in *The Generator*, I had bumped into a participant who was just as in need of contact and companionship as I was, or perhaps as anyone else stranded in the quiet darkness might

quickly become. Against the wall, a friendly and enthusiastic woman grabbed my hand and started touching me. It escalated quickly. We left the safety of the wall. She and I pressed our fingertips together, then our hands. We took turns repeating and mirroring each other's movements.

We placed our palms together and alternated taking the lead. We started to dance out in the wide-open space of the gallery floor. I realized that to dance you need music. No matter: I played out a rhythm in my head. She knew how to waltz and allowed me to lead and to spin her around the room. And then she led me. Surprisingly, we ran into no one. Then we stopped. Wobbly, tense, and sweaty under the gallery's bright spotlights, which felt especially warm, we touched each other's faces and hair and gave each other hugs and brief shoulder rubs. Though intimate, our interaction never became very erotic, even though at one point she placed my hands on her breasts. Was it a challenge? A provocation? A dare? Or was it just an offer of thanks, of intimacy? I wondered if she expected a gesture in kind. I stood still, my hands in place, shaky yet immobile, feeling her chest rising and falling.

Eventually—after, for variety's sake, we rolled around a little on the floor—she broke our contact. Had I offended, or, worse yet, bored her in some way? I wondered. I stood alone on the gallery floor, waiting, letting her absence and abandonment sink in; feeling my body, deprived of her interaction and touch, begin to cool, and my racing thoughts to slow. I waited. I listened to my heartbeat and breath. I extended my hands into the emptiness. She was gone. Would someone new take her

place? I waited some more. Then I raised my hand, and another young, chic gallery assistant dressed in black led me out of the performance and back to the locker room.

THE EXPERIENCE OF *The Generator*, unlike, say, a painting by Matisse, depends almost exclusively on one's subjective encounters. One of my fellow art critic panelists likened it to "gambling against the house." Another said it had made her feel uncomfortable, that she had waited to be affected by it more than that, but never was—that *The Generator* was not generous enough to be truly generative. She also suggested that Abramović might be too much of a celebrity, that her bigger-than-life, charismatic persona as the world's most famous performance artist had led us, like the Pied Piper, blindly and willingly along. There is certainly a therapeutic, messianic quality to Abramović and her work and school. And once I became engaged in my own personal interactions with a total stranger, I gave in to *The Generator*'s unique qualities and put my trust in the experiment. I let it carry me blindly, silently, and willingly along, accepting its unique gifts—one of which was its element of pure chance, which was both its engine and its Achilles' heel.

What was unique about *The Generator*, for me, at least, was that it created an intimate pocket of space, a bubble that felt freeing and secretive and that altered my perception of my reality. Meeting that other person and interacting with her was like finding a life raft in a sea of uncertainty, a companion among strangers.

The Generator triggered visceral memories from thirty years ago, but it was also a visceral experience in its own right. In

The Generator, the reality was that I was deprived of most of my sight and most of my hearing, that bright lights were shining on me, that cameras were rolling, and that some of Abramović's acolytes were watching our every move. But the reality I chose to perceive—the one inside my head—was that my participant-partner and I were all alone, in a private space, where we could see no one and we couldn't be seen.

My reality was inverted. My perception, though false and childish, took me back to childhood, reminding me of games of Make-Believe, Hide-and-Seek, and Seven Minutes in Heaven. The reality I perceived was one in which I was like a child who chooses to believe—whether from shame, or because he feels overexposed, or simply because he wants to be left alone, to disappear—that if he closes his own eyes and covers his own ears, no one will be able to see or hear him. My external and true reality was that I was being watched and filmed, perhaps even judged. But *The Generator* generated an alternative, internal, and false reality in which my partner and I disappeared in plain sight. Unable to see or hear how we were being perceived, I felt unburdened—as if there were no perceptions but my own. Abramović, tapping into the child within me, had covered my eyes and ears for me, leaving me, and my partner, able to be alone, and free to play, to create and to explore whatever reality we imagined ours to be. Abramović had exposed us by taking away our fear and even our awareness of our exposure.

A writing professor once told me that writing, as well as making art, is like walking across a stage nude: the writer or artist—not literally nude, but still naked, unprotected—has to expose and bare the self completely. But, he said, the trick is,

through the act of exposing and revealing the self, to get the audience not to notice the writer's nudity, but instead to make them become increasingly naked and unprotected themselves, to become increasingly aware of their own nudity, their own exposure. The artist, then, through his or her personal disclosure and confessions, becomes a universal conduit for everything each of us keeps hidden, sometimes even from ourselves.

Abramović has often performed nude, but even when she is fully clothed she walks naked and unprotected across the stage. While merely watching her performances, I have almost always been much more aware of her own nudity than my own. In *The Generator*, even if, as I suspect, I might have been interacting and dancing with Abramović herself, I was deeply affected. I felt fully present. My preconceptions about what the artwork would be were not at all like my actual experience of it, exposed, in the flesh. The lesson I learned was one I already knew: art, which requires a blind leap of faith, takes you to the realm of the unexpected.

JOURNEYING

Richard Serra—Torqued Spirals and Ellipses at Dia:Beacon

THE AMERICAN SCULPTOR RICHARD SERRA (B. 1938) gives us an inimitable experience, one that merges art, architecture, and nature. Moving through one of Serra's monumental Torqued Spirals or Torqued Ellipses—those hulking, labyrinthine, rusted-steel sculptures that at once suggest beached shipwrecks, sandstone canyons, and enormous seashells—is primal, visceral, and mysteriously disorienting. Their tall, sloping double walls, though stationary, seem responsive to your presence—as if they were expanding and contracting, alternately leaning toward or away from you, as you journey through their narrow passages. Exploring their innards, I've felt as if I were being propelled through their curving channels, as if through a digestive tract; as if I were being

squeezed in a vise or had been trapped in a maze; as if I had been entombed or were being sheltered in some uterine cave. And to emerge, alone, from the narrow, sloping tunnels into their central, oval, open clearings, where you and space and light are suddenly liberated, yet harbored, can inspire a sense of seclusion that verges on joy.

Four of these enormous sculptures, *Torqued Ellipse I* (1996), *Torqued Ellipse II* (1996), *Double Torqued Ellipse* (1997), and *2000* (2000) (fig. 13), are installed inside the Riggio Galleries of Dia:Beacon, the Dia Art Foundation's collection of art, mostly Minimalist, from the 1960s to the present. Serra's four hulking sculptures are lined up in a cavernous hallway in what was originally the train depot of a Nabisco box-printing factory, overlooking the Hudson River in Beacon, New York. When I last visited the installation, light pouring in through the gallery's clerestory windows was just beginning to wane, and it washed like firelight across their rusted and streaked steel facades. The shadows were deepening and lengthening, and the bowed high walls of Serra's sculptures were darkening. Their velvety reds and burnt-oranges were browning; their steely grays blackening, gleaming; their gingers, auburns, and ochers glinting like russet tears and veins of gold.

You might not immediately think of Serra—the Post-Minimalist, blue-collar Classicist, and provocateur of imposing, monumental steel sculptures—as a colorist or a Romantic. Serra sometimes works with large lead slabs that carve, shape, and delineate space, and that are suspended threateningly from the ceiling. He creates big, confrontational steel ribbons that cut and ripple through the landscape like unfurled, wind-whipped

cloth. Serra's double-walled Torqued Ellipses and Torqued Spirals are made of two-inch-thick rolled-steel plates twisted into shape by shipyard steelworkers. Each of the large, coiling sculptures at Dia towers at least thirteen feet high, is about thirty feet in diameter, and weighs twenty-five tons or more. Serra is an artist who seems at first to favor brute scale over subtlety, and who appears to take his humble, industrial materials as they come from the foundry. Scale and drama, not gradations of color and light, seem to be his primary concerns. But as you move among and through Serra's snaking behemoths, you realize that rust, dished up in multiple velvety square-yards, is beautiful—that it responds to light and evokes nearly every color of earth and fire—and that intimacy and mystery are as much a part of Serra's sculptures as spectacle, provocation, and epic scale.

Born in San Francisco, Richard Serra grew up in a house on the sand dunes and, while in college, spent his summers working on building construction sites for Bethlehem Steel as a sticker, a steelworker catching red-hot rivets and cramming them, still warm, into small holes in steel girders. (His father had worked in shipyards during World War II.) Although Serra received a bachelor's degree in English from the University of California, Santa Barbara, he claimed he also majored in surfing. Serra's sculptures evoke undulating sand dunes, rogue waves, and the scale and rise and fall of the ocean. After earning a bachelor of fine arts degree in painting from Yale University, he traveled to Europe, Egypt, and Japan.

Serra was wowed by the spare biomorphic distillations, to essences, of Constantin Brâncuși's Modernist figurative

sculptures; the torsion and sinuous muscularity of Donatello's fifteenth-century sculpted figures; and the "Borromini ellipse," which he experienced in Borromini's seventeenth-century church of San Carlo alle Quattro Fontane in Rome—in which Borromini mirrors an oval on the floor with one on the ceiling. These would prove to be major influences on Serra's signature Torqued Ellipses and Torqued Spirals, some of which are half-moon shapes. So, too, were his experiences among monumental ancient Egyptian temples and tombs, which impress us not so much for occupying space as for redefining, sculpting, activating, and interacting with the Sahara, the Nile River, and the sky. Serra was also inspired by Japanese gardens, through which you must walk in arcs and circles; and which reveal themselves through movement, space, and time; and where memory, nature, art, and anticipation all play their parts.

It was after seeing Velázquez's *Las Meninas* (1656) at the Prado in Madrid that Serra was convinced to give up painting and become a sculptor. Since *Las Meninas* is a pinnacle of European painting, this might seem like an odd reaction, but Serra was responding to the space in Velázquez's life-sized picture—how space seemingly projects from out of the painting's illusionistic interior and into the viewer's own physical space. In *Las Meninas*, the painter paints himself at the easel painting a family portrait, and Serra realized that he himself, not the Spanish royal family, was the subject of the painting— that Velázquez was looking at the viewers. This imposing use of space fascinated him, and Serra became interested in sculpture that had been taken off the pedestal—interested not in

making things and placing them, but in creating palpable space and orchestrating interactive environments.

It takes time to warm up to Serra's orchestrations. In the installation at Dia:Beacon, I thought at first that his four sculptures looked like giant tilted tree stumps, and that they were all basically the same. Soon, I realized that, although each could exist as a freestanding work of art, together they were like arrangements on a theme. Like mature trees planted indoors, they seem to be on the verge of overgrowing their allotted space. Listing this way and that, the large oval sculptures feel alive, as if they were muscling, bullying, and overpowering their environments. But what becomes apparent is that Serra is not bullying space, but composing it—that he is creating journeys in which every element, whether it is steel, light, or air, is interactive with viewers and has physical presence and palpable tension. In time, I felt not that I was in a gallery housing big steel objects, but as if the sculptures were awakening and stretching, as if I were moving through a cage among four ginormous beasts.

Given time, Serra's sculptures seem more calming, less threatening. Like Japanese gardens, the Torqued Ellipses play with your memory and anticipation in seductive, puzzling, and surprising ways. You expect the sculptures to repeat themselves, which makes their infinite variety that much more impressive. If you stand at a distance from the sculptures, they can look rather cumbersome and inert. But they pull you in like whirlpools, drawing you in to walk around and among their seemingly endless facades in figure-eight spirals. After

realizing that each sculpture's outer shell is unique, and that an opening—not unlike the kind that opens up in double-Dutch jump roping—has suddenly and unexpectedly presented itself, you decide to enter.

The outer shell of each Torqued Ellipse at Dia:Beacon is split in only one place, which opens like a narrow full-height slit in a towering curtain, and forces you to enter and exit at the same place. Each opening/exit faces a unique direction: west, southeast, southwest, or east. At these entrances, the walls of the ellipses lean in opposite directions, as if they were splaying outward at their bases, or perhaps falling in on you. Even at their thresholds, you want to brace yourself and make sure that everything in this house of cards is steady, as the sculpture, inducing vertigo, already begins to throw off your sense of balance, even getting you to question that the floor is level.

You also expect the sculptures, from the outside, to be open inside. But, as soon as you enter, you realize that Serra's sculptures, made up of tall, curving hallways of varying widths, spiral toward their centers. Inside their high, slender, spiraling corridors, their walls seemingly threaten to pinch and compress you, and you are pulled forward, then outward, swaying slightly. You feel as if you were navigating a ship rolling in heavy seas. Serra gives a charged atmosphere to his interior spaces, which, on occasion, seem to transform void into volume. It's like walking inside a Cubist or Constructivist sculpture. Serra's two-inch-thick steel walls occasionally lift slightly off the floor, as if heaved or pliéing; sunlight creeps in from beneath and outside the sculpture's walls, flowing in like surf, blackening into silhouette the sculptures' tall reddish facades,

and cutting away the gray-green cement floors with sharp, bright white.

As I moved farther within their curved walls, among the sculptures' listing, expanding, and contracting corridors and open clearings, I felt like I was burrowing, mole-like, deeper within the sculptural cavities. The experience is similar to that of exploring caves or ancient tombs. The last time I felt a comparable rush of the mystery of exploration while inside an artwork was when I navigated the claustrophobic channel linking the burial chambers in the Great Pyramid at Giza.

As I stood alone at Dia within the innermost clearing of one of Serra's sculptures, staring at a pair of haloed stains beneath what resembled long, diagonal claw marks, or pictographs of rain, I felt as if I were seeing ancient signs. I felt that I was neither in a contemporary artwork, nor in an ancient tomb, nor in nature, but in some odd fusion of the three. I experienced what I have felt before during late afternoons hiking in the woods, when my senses have been heightened and when the hushed spaces, now darker, cooler, richer, have seemed to awaken, and to begin to disclose their secrets. There is that moment when the sun is still high, but the forest below has pushed into dusk, that darkening time when shadows lengthen and nature puts into relief things you hadn't seen before, and the forest—as in a cave or an ancient tomb or a Serra sculpture—makes you choose between the familiarity of withdrawal and the revelation of discovery.

GOADING
Robert Gober—*Untitled Leg*

IN Alfred Hitchcock's 1956 black-and-white film *The Wrong Man*, a true-crime story about an innocent man mistakenly accused of robbery, there is a short, claustrophobic scene in a jail cell. There, Henry Fonda—the all-American everyman—is locked up and alone as the facts of his wrongful confinement begin to take hold. Never letting go, Hitchcock's camera zooms in on Fonda with unnerving attachment.

We see close-ups of Fonda's heavily shadowed jail cell and head, framed by bars, as he scans the room. Hitchcock gives us the cell in pieces, like a puzzle that just won't add up: the cell's wire caging; its cracked, dingy cement walls and dark corners; the iron bars and their raking grids of shadows; Fonda's clenched fists; his feet pacing the floor. The scene ends with Hitchcock's clinging lens—rising and falling around Fonda's

head like heavy seas pulling him under—speeding up and eventually spinning, like Fonda's psyche, out of control.

Yet the scene's most poignant and disturbing frame, only a couple of seconds long, lingers on a wall-mounted white porcelain sink. Unlike the jail cell's bench, or the bed, which is merely a cushionless board attached to the wall, the sink is a familiar, domestic object. It should be comforting. But it is blank, stark, odder still—if not surreal—because, though it suggests normalcy and the comforts of home, its smooth forms and bright white surfaces betray their opposites. Missing, seemingly, its faucet, knobs, and bar of soap, the sink looks naked, robbed, faceless, useless.

Hitchcock's jail-cell sink, affecting because it is discomfiting and increasingly mute, feels like the impetus behind the best work of the American sculptor Robert Gober. And not just because Gober sometimes works with the subject of fixtureless, wall-mounted white sinks.

Gober (b. 1954) turns the Duchampian Readymade—the found or store-bought object exhibited as art—on its Dadaist head. Working entirely from scratch, he and his studio assistants meticulously handcraft familiar domestic objects, such as disposable diapers, newspapers, a pair of girl's white leather ice-skates, and white porcelain sinks and urinals, into artworks that, though nonfunctional, are sometimes nearly indistinguishable from the mass-produced goods that inspired them.

Sometimes, Gober blows these Neo-Realist objects, such as an unwrapped stick of butter, up to gargantuan scale; or he cuts a small window high up in a gallery wall, lights it as if it were a view of blue sky, and then barricades it with bars—transforming

the museum into a prison for both patrons and art. At other times he merges two or more quotidian forms—such as a porcelain sink and a picket fence; female breasts and a bag of kitty litter; a sink and a gravestone; a sink and a male torso; a male torso and a candle; a stuffed chair and a sewer pipe; a wedge of Swiss cheese and a girl's shoe, both sprouting human hair. These sculptures, in quick succession, transform the mundane into the surreal and back again. The effect is akin to lighting a match and then extinguishing it, and then, as in a magic trick, restriking and relighting it again.

Besides Duchamp's *Fountain* (1917)—the white-porcelain-urinal-cum-sculpture—Gober's influences include classic Surrealist artworks such as Méret Oppenheim's *Object (Le Déjeuner en Fourrure)* (*Object [The Luncheon in Fur]*) (1936)—a fur-covered teacup, saucer, and spoon—as well as the lifelike, and life-sized (though lifeless), human figurative sculptures of the quintessential 1970s Realist sculptor Duane Hanson. Hanson's hyperrealistic figurative imitations, in the tradition of Madame Tussaud's, are cast from actual people (such as obese tourists and museum guards); with their additions of real hair, freckles, props, and clothing, they can inspire anxious double takes. But, whereas Hanson's sculptures close down so tightly and mindlessly in the mimicry of their subjects so as to constrict and suffocate them—forcing the relationship between artwork and viewer to a standstill—Gober's realistic figurative conundrums prod, befuddle, and rankle, if not trip us up.

Gober has produced various versions of his *Untitled Leg* (1989–1990) (fig. 14). But the first incarnation—precisely because, like Duchamp's *Fountain*, it was best and freshest the

first time around—is the best of what has become his signature handmade life-sized beeswax sculptures of truncated human body parts. These figurative human oddities conjure visions of the morgue, the operating room, a carnival funhouse, and the mad scientist's laboratory. They also recall the nineteenth-century French painter Théodore Géricault's preparatory studies of severed limbs; the surreal, pubescent female dolls of the German artist Hans Bellmer; van Gogh's studies of his own well-worn leather shoes; and even human prosthetics.

Equally gifted at orchestrating drollery and space, Gober, both a prankster and a provocateur, knows how to get the most out of his spare, witty eccentricities. *Untitled Leg* first suggests a corpse's severed leg, and then, perhaps, a fake leg left there as a practical joke, and then an actual man's leg protruding through a hole cut in the gallery's wall. It also reminds me of the fate of the Wicked Witch of the East, all but her lower legs flattened by Dorothy's house.

The sculpture, which was exhibited in Gober's Museum of Modern Art retrospective, *The Heart Is Not a Metaphor*, in 2014–2015, is a beeswax replica of a man's right leg, cut off just below the knee and sticking out of a white gallery wall at floor level. It is sprouting real human hair, and is dressed in dark gray trousers with a light gray sock and old brown leather shoe, which points, toes up, at the ceiling. The foot is turned out slightly, as if the leg is relaxed or had fallen, or as if the owner of the leg had been falling asleep when the wall sliced it in two. The gray trouser is cuffed and too short; it ends to expose a wide band of hairy, pale white flesh, implying that the poor chump's high-water pants are ill-fitting hand-me-downs.

In context, it verges on obscene—to appropriate Cole Porter, "a glimpse of stocking" has become "something shocking."

Untitled Leg's lingering sense of tongue-in-cheek indecency was compounded by other artworks in Gober's MoMA show, such as *Untitled (Man Coming out of a Woman)* (1993–1994). In this Frankensteinian sculpture, made of beeswax, human hair, a sock, and a leather shoe, Gober conflates his own *Untitled Leg* with two well-known paintings—Courbet's charged erotic masterpiece *Origin of the World* (the up-close and personal painting of a nude woman's crotch), and René Magritte's Surrealist painting *Time Transfixed* (a steaming locomotive exiting a fireplace). In *Untitled (Man Coming out of a Woman)*, a pantless, hairy male leg, wearing a sock and shoe, charges not from a fireplace but from the vagina of a nude female beeswax torso. In the MoMA exhibit, it was attached at the floor to a gallery's corner.

Taken by itself, *Untitled Leg* seemed more forlorn than vulgar or indecent. Nearby, the only other artwork present was a shallow, doorless, empty closet cut into the museum gallery's wall. Like *Untitled Leg*, the closet was also truncated, useless, hopeless, and abandoned—though it verged on the perverse.

Untitled Leg also seemed rather lifeless. But then, inertia is part of the sculpture's momentum, its ironic joke, which, as with any inanimate reproduction of an animate object, plays itself out as you watch in vain for the leg to move, thinking that if you stand patiently, waiting and watching—as you would over the practical joke of a silver dollar glued to a floorboard—you will see other viewers' similarly perplexed reactions. The sculpture's diverse associations—including vintage prosthetics,

Surrealist and Dadaist sculptures, and glory holes—allow for *Untitled Leg*'s drab, goofball simplicity and comical uselessness to embrace, and expand beyond, the Readymade even as it pokes fun at it. These qualities build exponentially, adding increasing weight to the sculpture's sense of irony and understatement, which—taken in the larger context of *The Heart Is Not a Metaphor*—imbued Gober's *Untitled Leg* with a lingering melancholy presence and the niggling of an itch that can't be scratched, making it, perhaps, the contemporary art world's phantom limb.

fourteen

ALCHEMIZING
Richard Tuttle—*White Balloon with Blue Light*

IN HIS *WHITE BALLOON WITH BLUE LIGHT* (1992) (FIG. 15), installed by the artist during his 2005–2006 retrospective at New York's Whitney Museum of American Art, Richard Tuttle attached an inflated white balloon at the juncture of the gallery's white wall and bluestone floor. A mundane paradox, it was as if—too heavy to move, even from the breeze of passersby—the balloon had just fallen, had settled on the floor, was clinging to the wall, and was dying. A wobbly, drawn pencil line, like a stationary though feckless string, crawled up the wall, tethering the balloon to the high ceiling. The line made you look up, as if to a rooftop from which a person had jumped or fallen. Tuttle bathed the scene in low blue light, the color of dusk blanketing snow, as if the light, too, were perpetually

dying. Nearby, a number of other small-scaled artworks by Tuttle—pictures and low-relief sculptures, each also moored to the ceiling by a single pencil line—were attached in a row to the same wall just a few inches above the floor. They hung there like still kites on a windless day. To see these forlorn works you had to kneel, as if genuflecting, or crouching down to check on an accident victim.

White Balloon with Blue Light had the fixity of a photograph, but one through which you could move. It was as if the gallery were an actionless stage set, as if the air were completely still, as if gravity and lethargy had overtaken the room, and as if the balloon, now leaden, were unable to budge. Tuttle's drawn "string" suggested that the balloon had floated as high as it could go (which, paradoxically, was also rock-bottom). Taken together with the other artworks, the elements of Tuttle's spare installation of balloon, line, and blue spotlight created an inversion that gave the museum's gallery a topsy-turvy quality and uneasy stillness. It reminded me of the episodes of *The Twilight Zone* in which people are marooned among stopped clocks in a motionless world.

RICHARD TUTTLE WAS born in Rahway, New Jersey, in 1941. He studied art, literature, and philosophy, and divides his time between New Mexico and New York. Considered a Post-Minimalist, he works at the extreme analog end of multimedia—using bits of string, wire, detritus, or textiles in sculptures, assemblages, collages, or installations, or drawing and painting, or handmade books—and often, in whatever media, employing light and shadow. And his work—which

often causes you to stop and consider if it even is art, whether it does enough to qualify—is infamously Minimalist.

In 1975, regarding Tuttle's first survey at the Whitney, Hilton Kramer, then the chief art critic at the *New York Times*, wrote: "To Mies van der Rohe's famous dictum that less is more, the art of Richard Tuttle offers definitive refutation. For in Mr. Tuttle's work, less is unmistakably less. It is, indeed, remorselessly and irredeemably less. It establishes new standards of lessness, and fairly basks in the void of lessness. One is tempted to say that, so far as art is concerned, less has never been as less this."

Kramer's scathing review put the show's curator, the late Marcia Tucker—the founder of New York's New Museum of Contemporary Art—out of a job, but it put Tuttle on Minimalism's map. It is true that Tuttle has a history of making the most out of very little, out of found objects and the throwaway; and that, occasionally, he makes too little out of less. But Tuttle is working within a rigorous aesthetic tradition that goes at least as far back as the early Cubists Braque and Picasso; the German collagist Kurt Schwitters; the American artist Calder, who made sculptures that resembled and worked like toys, and who created inventive, forceful portraits out of wire; and the American Joseph Cornell, the creator of magical collaged and assembled fairy-tale boxes—all of whom transfigured detritus into powerful works of art.

Tuttle, too, is a charmer of the mundane, the hodgepodge, the humdrum, and the happy accident. He works sometimes brilliantly with wire, trash, and found scraps and little pieces of this and that. And he is an early pioneer of the common,

accepted contemporary practice of making assemblages—in which piles and piles of whatnots are dragged into the studio or gallery and reassembled into large, sprawling, Frankenstein-ian installations of what before might have been mostly junk. At their best—in the hands of, say, American installation and collage artists such as Cornell and Jessica Stockholder—such assemblages achieve a gestalt in which the found object takes on a surprising, totemistic power, transforming garbage into gold.

Tuttle, however, usually moves more toward subtraction than addition. He tends toward understating, almost at times to an imperceptible whisper, rather than overstating his cause. And he is best when he pares down his artworks to a few choice elements. Tuttle alerts us to the purity and beauty of the pedestrian, the dismissed, the minuscule, and the over-looked. Sometimes, like one of Duchamp's Readymades, a Tuttle artwork will do little more than alert you to the charms of a small piece of tattered, patterned wallpaper or cloth. But his artworks tend to bolster one another, working best in number, where we can begin to get larger glimpses of Tuttle's philosophy. At his best, Tuttle is a playful alchemist, a casual poet of collagist haiku, an artist whose less-is-more approach to art-making pushes the "less" threshold to its absolute lim-its, but who also gets you to zero in on the magnificence and monumentality of minutiae. In Tuttle, whose insouciance is his aesthetic stronghold, less is not always *more*; but Tuttle's particular less—calling just the right amount of attention to itself—crosses firmly over into a realm where less is something entirely *other* than less.

It is here, in the world of less, that Tuttle is the reigning master, the spokesperson for the small incident and the sweet nothing, their liberator. Tuttle's artworks, given the chance, force us to shrink our attention to microscopic scale, to slow down to a crawl, to take in the minutest bits and interactions, and to consider their petite nuances of rhythms, movements, patterns, surfaces, and textures, their Lilliputian qualities of being. The only other artist who has so focused my attention on his sculptures' shadow play is Calder.

When you walk into a Tuttle exhibition, at first glance around the gallery, it may strike you as a show of preschool artworks, or as having not yet been fully installed. But as you move closer to what is on display, Tuttle gets you to ruminate about the perforations of torn paper; the various weights and color changes among overlapping shadows under pieces of cardboard; the interplay among an artwork's forms and its reflections in the glass vitrine that is encasing it; the nubby, pliant tooth of a gallery wall, swollen from too many successive layers of spackle and tacky white paint. Tuttle gets you to ponder the flow and tone of wood grain, the frayed hairs standing up on a piece of twine, the facets and prisms of crinkled cellophane, and the range of whites, grays, and creams in a crumpled white paper ball.

In *3rd Rope Piece* (1974), Tuttle imbues a mere three-inch-long piece of white cotton rope, nailed in three places horizontally to the white wall, with a latent power that, if installed just right—and that is key—evokes the violence of a crucifixion, and the iconic presence of a crucifix. In *White Balloon with Blue Light*, the oval shadow cast on the floor at the foot of the

balloon is a major element in the installation. The shadow is a flat black shape that mirrors and contrasts with the voluminous form of the white balloon; it is in tension, like an anchor, against the climbing pencil line, mooring the balloon, wedging it to the wall.

AFTER LEAVING A Tuttle exhibition, I find that I am suddenly fascinated by—and have a newfound patience for—watching a fly rub one leg against another, the patterns of color and texture in cement and corkboard, the contortionist, happenstance twists in a discarded strand of dental floss. Just because an artwork is made out of ordinary materials, Tuttle reminds us, does not mean that there cannot be transformations, or that the humdrum cannot heighten awareness.

A simple balloon, in the right setting and context, can transmute a whole room and transcend itself. In *White Balloon with Blue Light*, Tuttle conjured and imbued, within those few everyday items, a melancholic wave, an end-of-the-party power, that washed over me—something emotionally heavy out of things mundane and physically light.

Standing there in Tuttle's show at the Whitney, at first giving short shrift to his little white balloon flooded in blue, initially thinking it was little more than a tongue-in-cheek pun, it hit me: How many times has each of us missed last call, realized too late that the music has stopped, that the lights are coming up, that the one person we had hoped to dance with has already left, and then felt the sudden, sobering glare, and the air—that uncontrollable sigh—exiting our lungs, and felt left behind, emptied, and alone, unable, like Tuttle's white balloon,

to rise, to budge? Am I projecting? Yes, and probably too much. But *White Balloon with Blue Light* was among the most powerful installations I've experienced by Tuttle, precisely because it was unanticipated, and because it transported me and revealed profundity and humor in unexpected places. It hit me with the blues, but with kid gloves.

Tuttle's installations strain the limits between artwork and environment, constantly pushing against and redefining those boundaries about how far, exactly, the artwork can extend its reach. Part of the power of Tuttle's white balloon and its soft blue light was that seeing it in the relatively bare, cold space of the old Whitney's cavernous, white galleries on Madison Avenue increased the feeling in the sculpture of insignificance, loneliness, and deflation, of good times gone—if not leaving completely, or turning to bad, then just staying in a perpetual, playful state of going, going, going.

fifteen

SUBMERGING
Jeremy Blake—*The Winchester Trilogy*

W HEN THE EXPERIMENTAL FILM ARTIST JEREMY
Blake took his own life in July 2007 (ten days earlier,
he had discovered that his girlfriend, the video-game designer
and critic Theresa Duncan, had committed suicide in their East
Village apartment), the art world lost a visionary—an abstract,
narrative painter who used the screen as his moving canvas.

Blake, who was born in 1971 in Fort Sill, Oklahoma, studied
at the School of the Art Institute of Chicago and the California
Institute of the Arts. Before his death, he had been included in
three biennials at the Whitney Museum of American Art and
been honored with solo exhibitions at the San Francisco Mu-
seum of Modern Art and the Museo Reina Sofía in Madrid.
He is best known for some two dozen collaborative films, but
he also produced paintings, collages, and digital chromogenic
prints as well as video and imagery for Beck's 2002 album

Sea Change, and the hallucination sequences in Paul Thomas Anderson's 2002 film *Punch-Drunk Love*. Just before he died, Blake had been collaborating with Malcolm McLaren (the former manager of the British punk band the Sex Pistols) on the unfinished film *Glitterbest*, a giddy, nursery-rhyme romp that appears to have been riffing off of and sending up pop culture and the rise and fall of the British Empire.

To say that Blake, whose kaleidoscopic film collages immerse us in the dreamy, swinging psychedelia of the 1960s and 1970s, had his finger on the pop-culture pulse—though true to a certain extent—would be to overinflate his relationship to Pop art and to kitsch, and therefore, to undermine the unique and personal poetry of his art. For anyone who was living during the 1960s and 1970s, or for anyone who has since gotten caught up in the nostalgia for that period's intoxicating blend of hedonism, flower-power social radicalism, and midcentury retro-chic style, along with its hallucinogenic palette—and who has been at least a little seduced by *Austin Powers: The Spy Who Shagged Me*, the period films of Quentin Tarantino, and *Mad Men*—watching Blake's films is a heady, wistful immersion in our technicolor past.

The artificial palette of Blake's impressionistic films is high keyed, swirling, and digitized. The aftereffects of his electric, Color Field–inspired drips, brushstrokes, washes, and starbursts feel hyped up—as if on steroids. Those ramped-up hues, though as cool and sharp as brain freezes, tend to brand their images, as if sizzling, onto your retina.

Blake's neon colors run, merge, envelop, and compete with the fuzzy, sepia-toned images—flashes of racist, midcentury

cartoons, the Marlboro Man, children's drawings, sexy pinups, Victorian architecture, commercials, signage, pop icons, and film stars. *Mad* magazine's Alfred E. Neuman, George Burns's *God*, Twiggy, Dracula, cowboys, Playboy bunnies, and angels all make their appearances—to the ominous sounds of science-fiction film noir soundtracks and the music of Bob Dylan and the Rolling Stones. Blake's characters enter, exit, flit, and dissolve in fluid collages, as if turned like genies into smoke, or absorbed in the shimmering fields of a melting Sonia Delaunay or Rothko painting.

Surreal blends of past and present, reminiscence and fantasy, Blake's films are high on the promise of nostalgia and fueled, seemingly, by free association. We often hear in his films, like background noise, the clickity-clack and whir of a movie projector, or the phonograph record's pop-and-click static—rhythmic distortions that allude to the warmth and comfort of earlier analog times and that propel Blake's dramas both forward on the screen and backward in time.

Blake excelled at combining childhood and adult fantasies. *Alice in Wonderland*, Life Savers candy, Froot Loop cereal, guns, sports cars, leading men, bikini-clad models, gargoyles, flocked wallpaper, twinkling bits of light suggesting the cosmos, and the sounds of country music and its wailing slide guitars, or of the televised moon landing, all intermix, submerging us as if in a kaleidoscopic dream. Blake appears to think in color. In his film *Sodium Fox* (2005), a collaboration with the poet and singer David Berman, we hear the lines "a rhinestone octopus" and "a sweater covering the spectrum of hospital Jell-O." In *Reading Ossie Clark* (2003), snippets of the British fashion

designer's diaries are read aloud, but in colorful voiceover. The line "She comes in colors" is heard as a liquefied rainbow pours, as if from a waterfall flowing in reverse, back into a woman's mouth.

I WAS EIGHT years old in 1970, and if you frequented movie theaters in the 1970s, you probably remember very well the eighteen-second-long interlude film, a mod technicolor-rainbow whirlpool—accompanied by an upbeat, jazzy-rock melody of horns and percussion suggesting music for strippers—that introduced coming attractions and feature presentations. Staring into that colorful, hypnotic eddy, just before the previews or before a film began, was to give in willingly to whatever story or fantasy the screen promised; to tumble as if into a hallucinogenic vortex. That short theater interlude reel—which felt like it had been dreamed up by a druggy corporate think tank, and to which my friends and I tapped our feet under elephant bellbottoms—would have worked best, and perhaps only, right before a showing of *Easy Rider* or *Barbarella*, but it made old movies suddenly feel hip, akin to dressing up middle-aged men in tie-dye, and it made new releases feel much more modish than they actually were.

When viewing Blake's films, I've often thought that that psychedelic 1970s film interlude must have been lodged somewhere in Blake's encyclopedic memory, or at least in his subconscious. Blake clearly drew on many different sources— from Oscar Wilde to *Space Invaders*. Perhaps that coming attractions and feature presentation film reel resided in Blake's repertoire right next to those cool, sexed-up James Bond film

title sequences, which always ended with the gunshots from 007's Walther PPK, and the subsequent screen-sized drench of blood. Or the reel and its swirl of psychedelic color acted for Blake—not unlike the black-and-white centrifuge used in the actual 1960s television show *The Time Tunnel*—as a leaping-off point or a leitmotif for his films.

Blake returns again and again in his films to mirrored, bi-laterally symmetrical abstract images. They are butterfly shapes that suggest Rorschach tests: bleeding, fusing rainbows of color in which images of people and things appear and then disap-pear. Whenever I see those colorful butterfly images in Blake's films, I'm reminded of—if not taken back to—watching the coming attractions from those maroon-velvet theater seats in the Victorian vaudeville-theater-cum-movie-house of my youth.

THE LONGEST AND most ambitious of Blake's films is *The Win-chester Trilogy* (2005), a nearly hour-long work comprising the three standalone films *Winchester* (2002) (fig. 16); *1906* (2003), referring to the 1906 San Francisco earthquake, which dam-aged the Winchester house (the film's subject); and *Century 21* (2004), referring to a futuristic-looking Cineplex that was built near the Winchester house. It was produced from 8mm film footage, static 16mm shots of old photographs, hundreds of Blake's ink drawings, and an intricate process of frame-by-frame digital editing and retouching. Whitmanesque in subject and scope, *The Winchester Trilogy* takes as its theme the Winchester Mystery House in San Jose, California—a subject whose in-finite scope and eccentricity seems a perfect match for Blake.

Built over a period of decades by Sarah Winchester, the widow of the rifle magnate William Wirt Winchester, the enormous, rambling, mazelike Victorian house has some 160 rooms, miles of corridors, thousands of windows, and numerous trapdoors, as well as many doors and staircases that open over dangerous drops or lead nowhere.

Originally, Sarah purchased what was then an eight-room house in San Jose to escape the violent thunderstorms in New Haven, Connecticut, which had frightened her on the anniversaries of the days when she had buried her newborn daughter and her husband. The ghost of her dead husband had supposedly visited her and told her she would always be haunted by the ghosts of every one of the thousands of victims of Winchester rifles unless she followed his instructions. To placate the dead, she was to provide shelter for the victims' spirits in her mansion. And she was never to stop building.

Dressed in mourning clothes, Sarah cloistered herself with her servants in what became known as the Winchester Mystery House, a place that was active day and night with reported hauntings and endless construction. Because of the need to keep building, the mansion grew and grew. Outside walls became inside walls, windows were put into floors and ceilings, and rooftops became floors. To top it off, beginning in the early 1960s, three movie houses, Century 21, Century 22, and Century 23—all resembling giant flying saucers—were built right next to the Winchester Mystery House. As in Blake's films, it was as if the past had collided with the future. Today the house is a tourist spot that charges admission.

The Winchester Trilogy seemingly ruminates not only on the impenetrability of the Winchester Mystery House and its juxtaposition with the adjacent futuristic spaceship movie theaters, but also on the mystery of America itself. *Winchester* begins with and returns to postcard photographs of the exterior of the house, which is flanked by palm trees, whereas *1906* explores more of the interior of the mansion, and *Century 21* holds to images of the spaceship theaters. We feel as if we are given three overlapping views of the same world.

Drenched in sepia and blue-gray, the pictures of the exterior of the Mystery House flit between the heights of Victorian wealth and earthquake-ravaged ruins. Blake tilts these postcard images somewhat, as if the house were slipping off its foundation, or, like a foundering ship, beginning to sink. The films' sounds are eerie, going from film projector noises to science-fiction thriller and film noir tracks to synthetic, ambient electronic music from the 1970s, or long blasts of John Philip Sousa's magnum opus, *The Stars and Stripes Forever.*

Images of the American flag appear and dissolve into liquid, and in *1906*, the film's frames shake and twitter, suggesting the earthquake, which nearly toppled the Mystery House and almost killed Mrs. Winchester, trapping her for hours in her bedroom. Blake's film intersperses shadowy silhouettes of cowboys carrying rifles and six-shooters. These ghostly figures, mixed with psychedelic colors, blend into the Rorschach-test butterflies I mentioned earlier. The figures do not stand in as ghosts, however, but read as visions, premonitions, or as flashes from the past.

We are aware here not of places, people, and times gone by, however, but of transformations—of evolution and of the intermixing of present and past. The butterfly forms feel like heraldic emblems and insignia, indecipherable symbols that blaze like specters, their liquefied forms—suggesting flower petals, human pelvic bones, mirages, birds, insect heads, and strange, iridescent sea creatures—all pouring into and out of one another and folding and unfolding like origami. During one section of the film, a slow-burning bullet hole begins to suggest a bloody wound and then a colorful flower, but, eventually transforming into pure abstract color movements, resists ever fixing on one of these identities.

In *The Winchester Trilogy*, Blake keeps numerous balls in the air as styles, forms, and time periods all lyrically express the artist's vivid imagination. Blake's fever dream is a journey that honors Raquel Welch, rock 'n' roll, gunslingers, and spiritualism, all as important elements of Americana. It launches us as voyagers penetrating deeper into the Mystery House and into America's past. Through its immersive, fluid colors and metaphoric layers, it submerges us, as if it's exploring not merely a house, or the chambers of Sarah Winchester's psyche, but a deep-sea wreck, a lost city, the depths of our collective unconscious.

CONCLUSION
Looking Further

THROUGHOUT *THE ART OF LOOKING*, I'VE STRESSED THAT artworks have power—that artworks speak for themselves—and that it's our job to listen. Sometimes, though, we don't encourage that communication, the essential dialogue art requires of us. We make hasty judgments and assessments. We let our biases get in the way. We close down too quickly. We interfere with the process, employing artworks to perform for us in ways that were never intended: to act as simplistic illustrations; to reassert what we already believe; to perform more as narratives than as poetry. In these ways, we delimit art. We diminish an artwork to its subject, its style, the biography of its artist, or its historical context. Perhaps we read a bit of wall text or listen to an audioguide, identify those things noted, and move on. We forget that in art, as in life, it is not the

destination that matters and engages us, but the journey. And journeys require patience, curiosity, and stamina.

Even as an art critic, and a former artist and professor, I've been guilty of tripping over self-imposed barriers and closing down too soon with works of art. While teaching art history, I avoided discussing the very artwork reproduced on our textbook cover with my students, because I thought the painting—which I had only seen in reproduction—was overblown and hyperbolic. That painting, by the Italian Renaissance artist Antonio Allegri da Correggio, was *Jupiter and Io* (1532). Housed in Vienna's Kunsthistorisches Museum, *Jupiter and Io* is a life-sized depiction of the nude Io, whom Jupiter, in the guise of dark gray smoke or cloud, seduces on the banks of a river. I understood the myth and even recognized some of the metaphors in Correggio's work, but it was not until I experienced the painting face to face that I left behind my place of mere understanding and entered into Correggio's roiling erotic universe.

Before I encountered Correggio's painting, I hadn't known that Io's flesh—pearlescent here, red-hot there, like flickering firelight—appears to quiver at its edges. I hadn't realized that Jupiter—spinning like a tornado, then seeping like miasma—transforms from vapor into liquid into solid; or that Io in places dissolves from solid into atmosphere, as if her physical or mortal self were slipping away, losing purchase; and that she pulls Jupiter toward, around, and into her, suggesting embrace, penetration, and fusion with a god.

In reproduction, I had felt that Jupiter's mist was evenly handled; that Io's wantonness was overstated; that the climax

of Correggio's picture, unearned, arrived too quickly. Photographic reproduction had muddled and degraded Correggio's nuances. But I was at fault for believing that just because the reproduction of *Jupiter and Io* didn't reveal those nuances, those nuances weren't there. I had missed the mysteriousness of Jupiter's dark mist—evocative of earth, stone, figure, and mirage. I missed that Io, in her hypnotic arousal, becomes increasingly airborne—that she rises from seductress into assumptive goddess. What I had misread as exaggeration was in fact a slow gathering of seductive forces, the buildup of the storm of sensuality—the collision and conflagration of mortal with god.

I almost closed myself down yet again to Frank Lloyd Wright's extraordinary *Fallingwater*, a Modernist house built in rural Pennsylvania. In my classes, I had discussed *Fallingwater* (1935–1938), a flat-roofed, cantilevered structure built over a waterfall, for years, but I had never seen it. I had seen many photographs of the house: surrounded by the colorful blaze of fall foliage, blanketed in snow, and enlivened by rhododendron blossoms. I expected to see what I had already seen in reproductions. Before I visited *Fallingwater*, I had envisioned myself walking among the familiar rooms of the place, and taking in its vistas. The trip would serve to confirm what I already thought I knew.

On the summer morning of my visit, booked weeks in advance, my heart sank. It was raining. I imagined that my trip was nearly ruined, that my fantasies—of looking out at nature through Wright's large picture windows; of standing out on Wright's balconies and taking in those views; of experiencing how Wright had organically fused nature and architecture,

how he had orchestrated the outside to move inside and the inside to move outside—would all be washed away. But I didn't realize that Wright, whom I should have trusted wholeheartedly, had anticipated my visit.

Wright had built *Fallingwater* for the family of Liliane and Edgar J. Kaufmann Sr. The Kaufmanns loved looking at the waterfall on their property, and therefore wanted a house with a view of it. Wright decided that, if they loved the waterfall, why not put the house directly over it. Through his unorthodox design, he made the falling water a vital force—like the engine or soul—of the house.

How, I wondered, in a downpour, would I be able to experience the organic fusion of landscape, waterfall, and architecture on a day when the rains were drowning everything out? But Wright's lipped roofs, his balconies, and his walkways and low cement walls allowed for the rains to flow in transparent, veiled sheaths off of the house, enveloping it in stepped, cascading walls of falling water, instead of being funneled away in downspouts. Wright transformed *Fallingwater*, during a downpour, into a waterfall *over* a waterfall—as if the waterfall nature provided was opening up exponentially, pouring under, through, over, and out of the house itself.

Sometimes, our expectations overpower and blind us to what's actually there. At *Fallingwater*, inclement weather had turned my pilgrimage into an unexpected and profound experience beyond anything I could have imagined. While there, I was reminded of a parable about a Zen master who was led by his disciples up to a mountain peak that was legendary for its panoramic views. As they reached the summit, a dense fog

rolled in, reducing visibility to nil. The disciples were crest-fallen. "Absolutely breathtaking," said the Zen master.

ALTHOUGH I'VE WRITTEN a great deal in this book about how formal and metaphoric elements add up in artworks, I would stress that it is more important to recognize that art has the ability to move us, to have an inexplicable effect on us, than it is to try to clarify how and why. Too often, we convince our-selves that we *know* an artwork. I am still getting to know art-works I have been living with for decades, that I have visited and revisited; artworks often seem to grow as I grow—as in any relationship. This is a process that must be nurtured. And for that to happen requires time, fortitude, and a hospitable environment. Paul Klee wrote that a pictorial work takes time to make, that "it is constructed bit by bit, just like a house," but that far too often the beholder is "through with the work in one glance." Klee also said that "in order to understand a picture one must have a chair....Why the chair? So that your tired legs won't distract your mind" while doing the difficult job of looking. He understood that the experience of art requires fo-cus and time.

Studies conducted by museums have shown that the average viewer spends only about fifteen to thirty seconds with an art-work. If you frequent museums, you'll notice that people often spend that much time reading the label, only glancing at the artwork, or they photograph the artwork and its label, or take a selfie next to it. Many artworks are as complex as movies and novels and took as long to create. Yet too often we spend very little time looking at a piece and absorbing and contemplating

its complexities. This might be because we believe that an artwork—like a snapshot—captures a moment frozen in time, and therefore takes only a moment of time to comprehend. We forget that rumination is one of the keys to the experience. When museums provide wall text or audioguides that suggest what we should notice and get from an artwork, we may accept these synopses as substitutes for experience. Granted, these aids may be a good starting place—but they can't replace our own exploration of what an artist is trying to convey. When we leave a museum, we want to feel as if we've had a meaningful encounter with art, not that we're taking away with us some nugget of information—like a souvenir. Art is capable of inspiring shifts in perspective, self-revelations. This is what art does. Revelation is its job. Art wants us to leave with something bigger and messier, something idiosyncratic—certainly not something so small that it fits in our pocket.

THERE HAS BEEN a push to make art more "accessible" and "relevant." In museums, this shift has manifested itself through the removal of imposing entrance staircases, or through the increase in art that doubles as entertainment or spectacle—the implication being that engaging with and appreciating art is not so much work after all, that there are shortcuts. Art is being repositioned not as something you experience, and with which you engage and form relationships, but as something you get and receive, rather than work for—something whose gifts you deserve simply for showing up. And there is a growing self-consciousness among museums about how they are perceived—in particular, a fear that they demonstrate an elitist, musty air

and a lack of diversity—even in world-class museums housing encyclopedic collections. This fear implies a lack of faith in the innate power and universality of art. I am not a Luddite. I am not arguing here for any kind of prejudice toward one group, genre, subject, or medium, but for the idea that great art, if given the chance, and if viewers do the work, speaks to everyone.

During the past thirty years, this push to become more accessible and relevant, and to woo more diverse and younger audiences, has fostered an environment in which some museums reimagine their cultural missions and rebrand themselves. It also leads them at times to embark on curatorial fishing trips, hoping to catch *this* or *that* demographic, or to bait audiences with what the audiences already crave—apps, French Impressionism, entertainment, *Star Wars*, motorcycles, hip hop, or an exhibition *about* their particular group, or artworks made by artists who represent their particular group. It has led museums to sponsor after-hours mixers and dance parties. Despite these efforts, attendance at most museums continues to decline; although the exhibitions and activities lure in crowds, they don't tend to inspire repeat visits during regular hours or to increase membership.

When museums relegate art to mere backdrop for other activities, both the art and the museum are disempowered. And when art is fronted and employed to acknowledge and reinforce our existing interests and predispositions—to appeal to what we already like or know, or who we are—it brings our differences into high relief. Used in this way, art can begin to push people further apart. When art is used to pacify and reflect

233

specific segments of the public and fulfill their wishes, it becomes narrow and partisan. Art starts to be employed to speak for—and to—a specific group, rather than being allowed to speak for itself and provide illumination. Some of these well-meaning exhibitions, chasing specific demographics—and hoping to celebrate diversity—may undermine a museum's best intentions; rather than bringing a new audience to art, these shows can emphasize our differences, and advocate for an idea of art that is much smaller, narrower, and less universal than art actually is. Art has the power to get us out of ourselves and into the larger world; to get us excited even though we don't have any predisposition toward its subject or even the artist. By its very nature, art brings people together. Great art elevates our experience and gives us the promise, anticipation, and expectation of further greatness. Great art bridges us into the realm of our shared humanity.

I'm not suggesting that great art can't speak to our specific interests and differences. But when one element of an artwork—its subject, or the artist's race or sex, or nationality or politics—is emphasized curatorially over other elements, art is reduced, made subservient. And this stance, in turn, may motivate artists to reduce their thinking about the scope of what art is and what it can do: to make art that is narrowly focused, that serves an agenda, that is easily digestible.

Museums, I think, need to resist the urge to identify, reinforce, and indulge public interests. Otherwise, they risk turning museums from cultural institutions into purveyors of social activism, into crowdsourcing institutions that serve up

specific kinds of art to specific people—institutions that pander. Museums should be educational. They should further culture. But shouldn't art be left alone a bit, in order for it to do the educating? Art wants viewers to be excited, stimulated, opened, expanded—not indulged, catered to. The late Thomas Hoving, a former director of New York's Metropolitan Museum of Art, said in a 1993 interview with the *Chicago Tribune* that "if you don't work yourself up into a fever of greed and covetousness in an art museum, you're just not doing the job." Hoving was referring to the job of museum director, and the importance he placed on working as hard as he could to get more people into the Met, to encourage more members and donors, and to make art more fresh, stimulating, and accessible—but he let the art do the heavy lifting. With the mounting of the exhibition *Treasures of Tutankhamun* in 1976, Hoving created the first museum blockbuster. In reality, the "fever" is no less necessary for the job of the viewers. We must expect and allow art to get our hearts racing. Sadly, museums, at times, in their push to make art more accessible, fun, and interactive, are making art increasingly passive instead of advocating for it and fostering an immersion in it, instead of allowing art to be worked for and discovered.

Museums, I believe from my own experience, are closer in kind to houses of worship—where you are actively, deeply, perhaps even spiritually stirred—than they are to entertainment centers, where you are passively amused. I'm not implying that both experiences aren't worthwhile—only that they are different in kind, and that we should recognize and celebrate those

differences. The fusion of museum-introduced technology with art is in danger of becoming a runaway train on which we are destined to ride, and afraid to get off. We are in a perpetual cycle of chasing the titillating and the new, rather than embracing what's challenging and everlasting.

My advice is to turn off or at least ignore all supplementary technology when you're in a museum or art gallery. Resist apps, audioguides, docents, discursive wall text, and the urge to consult your mobile phone. Only in art museums, it seems, do we invite people to murmur into our ears about context and history and how we should be looking, thinking, and feeling. It's not that the information provided isn't useful or insightful. I obviously believe in writing, teaching, and speaking about art in order to advocate, excite, and instruct. And I lecture in front of art myself. But my primary concern is to provide an entryway, to incite passion, to empower viewers and art. The experience of art is intense. It is better to do your research either before or after attending an exhibit, not during your experience with the art.

Why do we allow outside voices to distract and direct us with art? Contemplation and passion require concentration and immersion. You have to give yourself over. There are so many other places, other activities, and other intense, passionate experiences where we trust in *ourselves*—experiences where we would positively balk at others' intrusions and interruptions, and their implication that they know better than we do. Why not trust ourselves with art? Why not trust the artist? It's essential, while trying to engage with art, and to work yourself up into Hoving's "fever," to drown out as many distractions and

intrusions and other voices as you can. Passion does not thrive in fits and starts. A fever can't be corralled. These excitements need the space and freedom to mount, and to rove.

MY AIM WITH *The Art of Looking* has been to make a case for pausing, for patience, for lingering, for slowing down, for trusting yourself and art—for immersing yourself in art in order to give art a fighting chance, and to instill in you that the experience of art requires humility and daring. My aim has also been to encourage you to give in to your passions. It has been to make art more accessible by stressing that, in part, what makes artworks worthwhile is their complexities, and that those complexities are within reach to all who are willing to make the effort—willing to get the fever.

All great art is accessible. Accessibility in art is not about abundance, expediency, and convenience, however. By "accessible," I mean that great art is easily approachable, entered— even if one's entryway is perplexity. Just about everyone has the necessary tools at his or her disposal. All of us who have felt and thought deeply in other areas of our lives have access to the depths of art. The doorways into art are nearly as infinite as there are sets of eyes. But some of these doorways are more difficult to enter than others. Artworks, after all, can be very deceptive, and it can take a long time to access their inner chambers. Artworks, if they are worth your time and attention, require your time and attention. This is part of the natural process of entering into the dialogue.

Today, you can encounter and access art just about anywhere—not just in galleries, art fairs, and museums, but in

alternative and pop-up spaces, skyscraper lobbies, office build-
ings, restaurants, specialty hotels, stores, parks, alleyways, and
streets, and on the exterior walls of buildings. Art happens on
the Internet and in virtual reality. It's available on your mobile
phone. If you buy a new Rolls-Royce Phantom, you can com-
mission a one-of-a-kind contemporary artwork for the dash-
board of your car. Increasingly, however, art is being treated
as a commodity, status symbol, and trophy. And museum and
private art collections are becoming more homogenized.

Just because you have more access to more art doesn't mean,
though, that you need to embrace everything with open arms. I
recommend that you go out and look at as much art as you can.
But be discriminating. Pace yourself. Follow your heart. Some
people believe we are obliged to pay close attention to the art
that is being championed today, that we need to take all of the
contemporary artists headlining museum marquees seriously,
if for no other reason than that they are an expression of con-
temporary culture and offer us windows into ourselves. There
is some truth to this, but it is also important to remember that
we don't have all the time in the world, and that some windows
offer more profound views than others.

When you next go to a gallery or museum, or to a perfor-
mance or alternative exhibition space, remember that you don't
have to see everything or like everything. You don't have to
follow the crowds. You can walk into a room and focus only
on the one thing that excites you. If nothing excites you, you're
free to move on. It is much more rewarding, I think, to spend
fifteen minutes with one great artwork than to spend fifteen

seconds each with sixty mediocre works of art. Keep in mind that the contemporary art world is as driven by fashion, competition, money, power, deception, and politics as any other major market, and that there are all kinds of reasons—not all of them in the greater culture's best interests—why art arrives and is celebrated at your local gallery or museum. It is perfectly okay to ignore the hyped-up retrospective headlining the marquee and instead revisit some art object over in a corner of that museum, some object that, like an old friend, has spoken kindly to you in the past, or, perhaps, has stung you, because sometimes it's healthier to rekindle an old friendship or to reengage in a difficult conversation than to make a dozen new forgettable acquaintances. Perhaps you need to take art slowly, and immerse yourself in artworks with which you already have an affinity, before attempting to engage with art that demands more from you and challenges you. But remember, too, that you must give art and artists the chance to work their magic.

As you look at art, keep in mind that you are not alone. The artist is your guide and travels with you. An artwork began as a journey for the artist who made that artwork, and who therefore made your journey with it possible. Traditionally, artists have been understood to be explorers, visionaries, shamans, and seers. I believe that the best of them still are.

For the true artist, the journey of creation—one of self-discovery and immense challenge—is both humble and heroic. Artists must mine their own depths, hone their talents, ascertain their strengths and weaknesses, and expose themselves through the harmony and faltering of their own voices. Artists

must confront their own limitations—not just as individuals, but as artists in the greater lineage of art. As artists guide us, they expose us not just to the depths of their art, and to their own personal depths, but to the depths within us, the viewers. Navigating art is not always easy or pleasurable. But it can lead us to discoveries. Discoveries unearth truths, and truths are often difficult. This is why, for both the artist and the viewer, honesty is so essential to the process.

When you're out there looking at art, pay attention to what you like and don't like, and ask yourself: Why? Try to ascertain your own beliefs. Strive to sort through your prejudices and knee-jerk reactions. Check in with yourself to see if an artwork you don't like is at fault, or if, instead, you are uncomfortable because that artwork has revealed some hard truth. Strive to understand what the artist is trying to say. Accept when a celebrated artwork or artist bores you, or when you change your mind about something. Develop, symbiotically, your critical self, alongside your childlike curiosity.

Grant yourself permission to trust your own eyes, gut, and common sense, but look to art to inform those parts of you. Be as demanding of yourself as you are of the art you encounter. Great art is mysterious, timeless. And if you haven't had it yet, be on the lookout for that first powerful experience with art: when you find that you are not merely amused by it, attracted to it, or perplexed by it—but truly moved, worked up into a fever. That first deep experience, like lovesickness, is unmistakable and will inspire your search for new and deeper relationships. But don't force it. Let the journey happen naturally, honestly. When it comes to our personal relationships with art, to what

we value and engage with, we have no obligation other than to honor the truths we unearth—in and through our own experiences with art. Then, like artists, we might discover that we have moved beyond the art of looking, to the art of finding— the art of *seeing*.

ACKNOWLEDGMENTS

I AM GREATLY INDEBTED TO MY TEACHERS (AND ALSO MY students), who answered and asked increasingly tougher questions—especially my professors, the painters Deborah Rosenthal and the late Gabriel Laderman, as well as the late painter Leland Bell, who were key to my development.

I'd like to thank Quynh Do, who, while at Basic Books, first approached me to write this book; my agent, Jennifer Lyons, who has stood patiently and steadfastly by me all these years; and the author and critic Jed Perl, who placed my first essay in *Modern Painters*, in 1996, and who read the fledgling manuscript in its very early stages and provided sage advice, encouragement, and the occasional shove. Thank you to Eric Gibson, my longtime editor at the *Wall Street Journal*; and former editors Robert Messenger, Manuela Hoelterhoff, and Karen Wright, among many others, who gave me the platforms to develop my writing and my ideas.

Thank you also to Nancy Krakaur, who first suggested I write a book about how to look at art, and to Chris Stern, who talked me down off the ledge while writing it. I am also grateful to Esther Abbey, Brice Brown, Cindy Claassen, Don Joint, and Georgia Sclafani, as well as my mother and my late father, for their help and support.

Lara Heimert, my spectacular publisher and editor at Basic Books, was indispensable in helping me to shape my manuscript. Her patience, wisdom, and wit kept me on track. Production editor Michelle Welsh-Horst, line editor Roger Labrie, and copyeditor Katherine H. Streckfus were exceptional allies, providing close readings and sharp eyes. Ann Kirchner and Katie Lambright were instrumental in the design and production of *The Art of Looking*.

My deepest gratitude goes to my wife, the artist Evelyn Twitchell, to whom this book is dedicated. Without her love and encouragement, astute advice, and editorial prowess, this book would not have been written.

ILLUSTRATION CREDITS

1. Édouard Manet, French (1832–1883)
 Le Dejeuner sur l'herbe (*The Luncheon on the Grass*) (1863)
 Oil on canvas
 81-1/8 x 106-1/4 in. (206.1 x 269.875 cm)
 Inv. RF 1668
 Musée d'Orsay
 Photo credit: Erich Lessing / Art Resource, New York

2. Paul Klee, Swiss (1879–1940)
 Howling Dog (1928)
 Oil on canvas
 17-1/2 x 22-3/8 in. (44.45 x 56.83 cm) (canvas)
 25-1/4 x 30-1/4 x 2-3/4 in. (64.14 x 76.84 x 6.99 cm) (outer frame)
 Minneapolis Institute of Art, Gift of F. C. Schang, 56.42
 Photo credit: Minneapolis Institute of Art
 © Artists Rights Society (ARS), New York

3. Leonardo da Vinci, Italian (1452–1519)
The Virgin and Child with St. Anne (c. 1503–1519)
Oil on wood
66-1/8 x 51-3/16 in. (168 x 130 cm), pre-restoration
Musée du Louvre
Photo credit: Erich Lessing / Art Resource, New York

4. Henri Matisse, French (1869–1954)
Icarus, from *Jazz* series (1947)
Stencil from paper cutouts, published by Tériade, 1947, in an edition of 270 copies.
Twenty pochoir plates, each double sheet 16-39/64 x 25-5/8 in. (42.2 x 65.1 cm)
© 2018 Succession H. Matisse / Artists Rights Society (ARS), New York
Photo credit: Erich Lessing / Source: Art Resource, New York

5. Hans Hofmann, German American (1880–1966)
The Gate (1959–1960)
Oil on canvas
75 x 48-1/2 in. (190.5 x 132.2 cm)
Courtesy Solomon R. Guggenheim Museum, New York, 62.1620
© Artists Rights Society (ARS), New York

6. Jackson Pollock, American (1912–1956)
Autumn Rhythm (Number 30) (1950)
Enamel on canvas
105 x 207 in. (266.7 x 525.8 cm)
George A. Hearn Fund, 1957, 57.92
The Metropolitan Museum of Art
Image copyright © The Metropolitan Museum of Art
Image source: Art Resource, New York

© 2018 The Pollock-Krasner Foundation / Artists Rights Society (ARS), New York

7. Piet Mondrian, Dutch (1872–1944)
Composition with Blue (Schilderij No. 1: Lozenge with 2 Lines and Blue) (1926)
Oil on canvas
24-1/16 x 24-1/16 in. (61.1 x 61.1 cm)
Framed: 30 x 30 x 3-7/16 in. (76.2 x 76.2 x 8.7 cm)
Courtesy Philadelphia Museum of Art, A. E. Gallatin Collection, 1952-61-87

8. Ethiopian, Anonymous
Satan Imprisoned (early nineteenth century)
Mixed media
Client: Ehtä Maryam Täyma
From *Ethiopian Magic Scrolls* by Jacques Mercier
Copyright © 1979 by George Braziller, Inc.
Photo credit: Jacques Mercier
Reprinted with the permission of George Braziller, Inc., New York, www.georgebraziller.com
All rights reserved

9. Balthus, French Polish (1908–2001)
The Cat with a Mirror I (1977–1980)
Casein and tempera on canvas
71 x 67 in. (180 x 170 cm)
Private collection
(Plate #338, in "Balthus: Catalogue Raisonne," by Jean Clair and Virginie Monnier, p. 196)

10. Marcel Duchamp, American French (1887–1968)
 Fountain (1917)
 24 x 14 x 19 in. (60.96 x 35.56 x 48.26 cm)
 © Artists Rights Society (ARS), New York
 Photo credit: Jerry L. Thompson / Art Resource, New York

11. Jean Arp, French German (1886–1966)
 Growth (1938)
 Marble
 31-5/8 in. (80.3 cm) high
 Courtesy Solomon R. Guggenheim Museum, New York, 53.1359
 © Artists Rights Society (ARS), New York

12. Paul Klee, Swiss (1879–1940)
 Signs in Yellow (1937)
 Pastel on cotton on colored paste on jute mounted on stretcher
 Original frame strips 32-7/8 x 19-7/8 in. (83.5 x 50.3 cm)
 Fondation Beyeler, Riehen / Basel, Beyeler Collection
 Photo credit: Robert Bayer
 © Artists Rights Society (ARS), New York

13. Richard Serra, American (b. 1938)
 Installation view at Dia:Beacon, New York
 © Artists Rights Society (ARS), New York
 Photo credit: Bill Jacobson Studio, New York
 Courtesy Dia Art Foundation, New York

14. Robert Gober, American (b. 1954)
 Untitled Leg (1989–1990)
 Beeswax, cotton, wood, leather, and human hair
 11-3/8 x 7-3/4 x 20 in. (28.9 x 19.7 x 50.8 cm)

The Museum of Modern Art, New York. Gift of the Dann-
heisser Foundation. Digital Image © The Museum of Modern
Art / Licensed by SCALA / Art Resource, New York
© Robert Gober, Courtesy Matthew Marks Gallery

15. Richard Tuttle, American (b. 1941)
Installation view of *The Art of Richard Tuttle* (*White Balloon with
Blue Light*) (1992)
Mixed media
Whitney Museum of American Art, New York, November 10,
2005–February 5, 2006
Courtesy Whitney Museum of American Art
Photo credit: Sheldan C. Collins

16. Jeremy Blake, American (1971–2007)
Still from *Winchester* (2002)
Digital animation with sound; 55 minutes and 40 seconds long
Copyright and courtesy Estate of Jeremy Arron Blake

NOTES

INTRODUCTION

6 "...this has been my aim": Gustave Courbet, artist's statement in the preface to the catalog of Courbet's exhibition at the Pavilion of Realism, World's Fair, Paris, 1855, reprinted in *Artists on Art: From the XIV to the XX Century*, 3rd ed., ed. Robert Goldwater and Marco Treves (New York: Pantheon, 1972 [1945]), 295.

CHAPTER 1: ENCOUNTERING ART

34 "...more alive today than it ever was": Pablo Picasso, quoted in Marius de Zayas, "Picasso Speaks: A Statement by the Artist," *The Arts* 7, no. 5 (May 1923): 315–326; Herschel B. Chipp, Peter Selz, and Joshua C. Taylor, *Theories of Modern Art: A Source Book by Artists and Critics* (Berkeley: University of California Press, 1968), 264.

36 "...rather, it makes visible": Paul Klee, "Creative Credo," originally published in *Schöpferische Konfession*, ed. Kasimir

Edschmid (Berlin: Erich Reiss, 1920) (*Tribune der Kunst und Zeit*, no. 13), trans. Norbert Guterman from *The Inward Vision: Watercolors, Drawings, and Writings by Paul Klee* (New York: Abrams, 1959), 5–10, reprinted in Chipp et al., *Theories of Modern Art*, 182.

36　**"...neither serves nor rules—he transmits"**: Paul Klee, *On Modern Art*, trans. Paul Findlay, with an introduction by Herbert Read (London: Faber and Faber, 1984 [1948]), 15.

CHAPTER 2: THE LIVING ORGANISM

42　**"...shifting its position forward"**: Paul Klee, *Pedagogical Sketchbook*, ed. Walter Gropius and L. Moholy-Nagy, trans. Sibyl Moholy-Nagy, with an introduction by Sibyl Moholy-Nagy (London: Faber and Faber, 1986 [1953]), 16.

58　**"movement and countermovement"; "force and counter-force"; "plasticity"; "push and pull"**: Tina Dickey, *Color Creates Light: Studies with Hans Hofmann* (Salt Spring Island, BC: Trillistar Books, 2011), 30.

62　**"...things in motion, motion in things"**: Ernest Fenollosa, *The Chinese Written Character as a Medium for Poetry*, ed. Ezra Pound (San Francisco: City Lights Books, 1983 [1936]), 10.

63　**working out their own fates**: Ibid., 9.

66　**"...changed in the slightest degree"**: Meyer Schapiro, "On Perfection, Coherence, and Unity of Form and Content," in *Theory and Philosophy of Art: Style, Artist, and Society. Selected Papers* (New York: George Braziller, 1994), 41–42.

CHAPTER 3: HEARTS AND MINDS

72　**"...reasons for disliking a work of art"**: E. H. Gombrich, *The Story of Art*, 16th ed. (London: Phaidon Press, 1999 [1950]), 15.

74 **"distance yourself"**: Clement Greenberg, "Esthetic Judgment," in *Homemade Esthetics: Observations on Art and Taste* (New York: Oxford University Press, 2000), 17.

·74 **"...when reasoning"**: Ibid.

75 **"...your taste or your reasoning becomes"**: Ibid.

75 **"...more adequately represent the species"**: Ibid.

81 **Sigmund Freud**: See Sigmund Freud, "Lecture XXIII: The Paths to the Formation of Symptoms," in *Introductory Lectures on Psychoanalysis*, trans. and ed. James Strachey (New York: W. W. Norton, 1977), 358–377.

CHAPTER 4: ARTISTS AS STORYTELLERS

90 **"...spiritual dread of space"**: Wilhelm Worringer, *Abstraction and Empathy: A Contribution to the Psychology of Style* (Chicago: Ivan R. Dee, 1997 [1908]), 15.

91 **"...their graves their houses"**: Erwin Panofsky, *Tomb Sculpture: Its Changing Aspects from Ancient Egypt to Bernini*, ed. H. W. Janson (London: Phaidon Press, 1992), 13.

96 **"strong medicine"**: Jacques Mercier, *Ethiopian Magic Scrolls*, trans. Richard Pevear (New York: George Braziller, 1979), 33.

96 **"...bind Satan and undo spells"**: Ibid., 108.

CHAPTER 5: ART IS A LIE

107 **"morphological transformation"**: Laura J. Hoptman, quoted by Ann Temkin in *Gabriel Orozco* exhibition catalog (New York: Museum of Modern Art, 2009), 61.

117 **"...vulgar, battered, and clumsy—so much the better"**: Mark Stevens and Annalyn Swan, *de Kooning: An American Master* (New York: Alfred A. Knopf, 2004), 267.

118 **"...not to hang in his studio, but to *erase*"**: Ibid., 359.

118 **"symbolically raped"**: Willem de Kooning, according to Susan Brockman, in ibid., 455.

119 **"…destroy the old one"**: Ai Weiwei, quoted by Janet Marstine, *Critical Practice: Artists, Museums, Ethics* (New York: Routledge, 2017), 81.

121 **"…truthfulness of his lies"**: Pablo Picasso, quoted in Marius de Zayas, "Picasso Speaks: A Statement by the Artist," *The Arts* 7, no. 5 (May 1923): 315–326; Herschel B. Chipp, Peter Selz, and Joshua C. Taylor, *Theories of Modern Art: A Source Book by Artists and Critics* (Berkeley: University of California Press, 1968), 264.

CHAPTER 6: AWAKENING
Balthus—*The Cat with a Mirror I*

127 **"…truth of childhood"**: Balthus, *Vanished Splendors: A Memoir. As Told to Alain Vircondelet* (New York: HarperCollins, 2002), 130.

129 **"…wonderment, enchantment, or just as icons"**: Ibid., 37.

130 **"…was of equal importance"**: Ibid., 65–66.

139 **"…can ever fathom"**: Rainer Maria Rilke, "Preface," in Balthus, *Mitsou: Forty Images by Balthus* (New York: Metropolitan Museum of Art and Harry N. Abrams, 1984), 9–10.

139 **"…help in personal crossings"**: Balthus, *Vanished Splendors*, 176.

139 **"…obscurely gathered therein"**: Ibid., 175–176.

140 **"Orphic labor"**: Ibid., 117.

CHAPTER 8: GROWING
Jean Arp—*Growth*

160 **"…the sublimation of man"**: Jean Arp (1948), in *Arp on Arp: Poems, Essays, Memories*, ed. Marcel Jean, trans. Joachim Neugroschel (New York: Viking Press, 1972), 241.

CHAPTER 9: IGNITING
James Turrell—*Perfectly Clear*

161 **"disoriented and confused"**: Quoted in Grace Glueck, "Whitney Museum Sued over 1980 'Light Show,'" *New York Times*, May 4, 1982.

161 **"violently precipitated to the floor"**: Ibid.

163 **"...the physicality, of light itself"**: James Turrell, quoted in Elizabeth Kolbert, "Art's Sake Dept.: Incidents," The Talk of the Town, *New Yorker*, June 19, 2017, 23.

CHAPTER 10: EVOLVING
Paul Klee—*Signs in Yellow*

181 **"goes out for a walk"**: Paul Klee, *Notebooks*, vol. 1, *The Thinking Eye*, ed. Jürg Spiller, trans. Ralph Manheim (London: Lund Humphries, 1992 [1956]), 105.

181 **"...terrestrial is an example of the cosmic"**: Paul Klee, "Creative Credo," originally published in *Schöpferische Konfession*, ed. Kasimir Edschmid (Berlin: Erich Reiss, 1920) (*Tribune der Kunst und Zeit*, no. 13), trans. Norbert Guterman from *The Inward Vision: Watercolors, Drawings, and Writings by Paul Klee* (New York: Abrams, 1959), 5–10, reprinted in Herschel B. Chipp, Peter Selz, and Joshua C. Taylor, *Theories of Modern Art: A Source Book by Artists and Critics* (Berkeley: University of California Press, 1968), 186.

181 **"...intersection of ways is cosmic"**: Paul Klee, *Notebooks*, 1:19.

CHAPTER 11: INTERACTING
Marina Abramović—*The Generator*

186 **"...release from whatever has confined them"**: Judith Thurman, "Walking Through Walls: Marina Abramović's Performance Art," *New Yorker*, March 8, 2010.

192 **"...an utterly different face"**: Annie Dillard, *Pilgrim at Tin-ker Creek*, in *Three by Annie Dillard* (New York: Harper Peren-nial, 1990), 35.

CHAPTER 14: ALCHEMIZING
Richard Tuttle—*White Balloon with Blue Light*

213 **"...less has never been as less this"**: Hilton Kramer, "Tuttle's Art on Display at Whitney," *New York Times*, September 12, 1975, 21.

CONCLUSION: LOOKING FURTHER

231 **"...bit by bit, just like a house"**: Paul Klee, "Creative Credo," originally published in *Schöpferische Konfession*, ed. Kasimir Edschmid (Berlin: Erich Reiss, 1920) (*Tribune der Kunst und Zeit*, no. 13), trans. Norbert Guterman from *The Inward Vision: Watercolors, Drawings, and Writings by Paul Klee* (New York: Abrams, 1959), 5–10, reprinted in Herschel B. Chipp, Peter Selz, and Joshua C. Taylor, *Theories of Modern Art: A Source Book by Artists and Critics* (Berkeley: University of Cal-ifornia Press, 1968), 184.

231 **"...through with the work in one glance"**: Ibid.

231 **"...won't distract your mind"**: Ibid., 184–185.

231 **fifteen to thirty seconds with an artwork**: Stephanie Rosen-bloom, "The Art of Slowing Down in a Museum," *New York Times*, October 9, 2014, https://www.nytimes.com /2014/10/12/travel/the-art-of-slowing-down-in-a-museum .html.

235 **"...just not doing the job"**: Thomas Hoving, quoted in Ken-neth R. Clark, "The Fine Art of Greed: Tales of Intrigue at the Met," *Chicago Tribune*, January 21, 1993.

ADDITIONAL RESOURCES

The best art resources are art galleries and museums, or any place where you can see art in the flesh. *The Art of Looking* includes only a handful of reproductions—and images in a book can never be adequate substitutes for actual works of art. If possible, try to go see some of the artworks I discuss, or artworks by the same artists. The second-best option is to consult lavishly illustrated art books, many of which will be available at your local library—the newer the better, as color reproductions have improved in quality over the years. (However, be aware that although the images in newer books are almost always better than those in older books, some of the earlier texts are better written.) The third option is the Internet, which will give you a visual reference point for artworks. Larger screens are preferable. But also keep in mind that monitors backlight artworks artificially, and that paintings with amazing light will look different, and *other*, from the original artworks; mediocre paintings, or those without light, will be altered and even perhaps helped and unified by the light of the screen.

I also recommend building an art library of monographs on artists you like. This collection will allow you to return to art without

having to look at a screen, to see mini-retrospectives of artists, and to take in an artist's range. To read and learn more about art, read books and essays written by the artists themselves—artists generally make the best spokespeople for artists, especially for their own work.

In addition, allow artists you like to introduce you to other artists. Some of the best advice I was ever given as an art student was something a professor told me: "If you like that artist [fill in the blank], don't just look at his or her work, look at what *that* particular artist you already like looked at." Not only does this practice give you better insight into artists you already know and love, but it opens you up to an extended family and lineage of new artists, expanding your understanding of what shaped that artist you already love into the artist he or she became.

Below I have listed some general art history and reference books that are good primers for the beginner as well as treatises by artists, books of essays and criticism, and books and memoirs on art, film, philosophy, and aesthetics. This list is not exhaustive, but it's a good start and represents part of the small library I assembled around my desk while working on *The Art of Looking*.

Albers, Patricia. *Joan Mitchell: Lady Painter, A Life*.

Arnason, H. H., and Marla F. Prather. *History of Modern Art: Painting, Sculpture, Architecture, Photography*.

Arp, Jean. *Arp on Arp: Poems, Essays, Memories*. Translated by Joachim Neugroschel. Edited by Marcel Jean.

———. *Jean (Hans) Arp: Collected French Writings: Poems, Essays Memories*. Translated by Joachim Neugroschel. Edited by Marcel Jean.

Ashton, Dore. *Picasso on Art: A Selection of Views*.

Balthus. *Mitsou: Forty Images by Balthus*. With a preface by Rainer Maria Rilke.

———. *Vanished Splendors: A Memoir. As Told to Alain Vircondelet*.

Barrett, William. *Irrational Man: A Study in Existential Philosophy.*
Baudelaire, Charles. *The Painter of Modern Life and Other Essays.*
Berger, John. *About Looking.*
———. *John Berger on Art.*
———. *Portraits: John Berger on Artists.*
———. *Ways of Seeing.*
Chipp, Herschel B., Peter Selz, and Joshua C. Taylor. *Theories of Modern Art: A Source Book by Artists and Critics.*
Clark, Kenneth. *Landscape into Art.*
———. *The Nude: A Study in Ideal Form.*
Colley, Ann C. *The Search for Synthesis in Literature and Art: The Paradox of Space.*
Delacroix, Eugene. *Journal of Eugene Delacroix.*
Dewey, John. *Art as Experience.*
De Zengotita, Thomas. *Mediated: How the Media Shapes Your World and the Way You Live in It.*
Dickey, Tina. *Color Creates Light: Studies with Hans Hofmann.*
Dickie, George, and Richard J. Sclafani. *Aesthetics: A Critical Anthology.*
Fenollosa, Ernest. *The Chinese Written Character as a Medium for Poetry.* Edited by Ezra Pound.
Freud, Sigmund. *Introductory Lectures on Psychoanalysis.* Translated and edited by James Strachey.
Gilot, François. *Life with Picasso.*
Goldwater, Robert, and Marco Treves, eds. *Artists on Art: From the XIV to the XX Century.*
Gombrich, E. H. *The Story of Art.*
Graves, Robert. *The White Goddess: A Historical Grammar of Poetic Myth.*
Greenberg, Clement. *Art and Culture: Critical Essays.*
———. *Homemade Esthetics: Observations on Art and Taste.*
Groenewegen-Frankfort, H. A. *Arrest and Movement: An Essay on Space and Time in the Representational Art of the Ancient Near East.*

Hall, James. *Dictionary of Subjects and Symbols in Art.*

Hamilton, George Heard. *19th and 20th Century Art: Painting, Sculpture, Architecture.*

Harrison, Charles, and Paul Wood, eds. *Art in Theory: 1900–1990.*

Hauser, Arnold. *The Social History of Art.*

Haverkamp-Begemann, Egbert. *Creative Copies: Interpretative Drawings from Michelangelo to Picasso.*

Herbert, Robert L., ed. *Modern Artists on Art.*

Hicks, Stephen. *Explaining Postmodernism: Skepticism and Socialism from Rousseau to Foucault.*

Honour, Hugh. *Romanticism.*

Hughes, Robert. *Nothing If Not Critical: Essays on Art and Artists.*

Kale, Pauline. *For Keeps: 30 Years at the Movies.*

Kandinsky, Wassily. *Concerning the Spiritual in Art.* Translated with an introduction by M. T. H. Sadler.

———. *Point and Line to Plane.*

———. *Sounds.* Translated and with an introduction by Elizabeth R. Napier.

Kellogg, Rhonda. *Analyzing Children's Art.*

Klee, Paul. *Diaries: 1898–1918.*

———. *Notebooks.* Vol. 1, *The Thinking Eye.* Translated by Ralph Manheim. Edited by Jürg Spiller.

———. *Notebooks.* Vol. 2, *The Nature of Nature.* Translated by Heinz Norden. Edited by Jürg Spiller.

———. *On Modern Art.* Translated by Paul Findlay, with an introduction by Herbert Read.

———. *Pedagogical Sketchbook.* Translated by Sibyl Moholy-Nagy. Edited by Walter Gropius and L. Moholy-Nagy. With an introduction by Sibyl Moholy-Nagy.

Kramer, Hilton. *The Revenge of the Philistines.*

———. *The Triumph of Modernism: The Art World, 1985–2005.*

Kurosawa, Akira. *Something Like an Autobiography.*

Léger, Fernand. *The Functions of Painting.*

Marstine, Janet. *Critical Practice: Artists, Museums, Ethics.*

Matisse, Henri. *Matisse on Art.*

McBride, Henry. *The Flow of Art: Essays and Criticism.*

Meggs, Philip B. *Meggs' History of Graphic Design.*

Mercier, Jacques. *Ethiopian Magic Scrolls.* Translated by Richard Pevear.

Mondrian, Piet. *The New Art—The New Life: The Collected Writings of Piet Mondrian.* Edited and translated by Harry Holtzman and Martin S. James.

Panofsky, Erwin. *Tomb Sculpture: Its Changing Aspects from Ancient Egypt to Bernini.*

Perl, Jed. *Alexander Calder: The Conquest of Time: The Early Years, 1898–1940.*

———, ed. *Art in America, 1945–1970: Writings from the Age of Abstract Expressionism, Pop Art, and Minimalism.*

———. *New Art City: Manhattan at Mid-Century.*

———. *Paris Without End: On French Art Since World War I.*

Picasso, Pablo. *Picasso on Art: A Selection of Views.*

Porter, Fairfield. *Art in Its Own Terms: Selected Criticism, 1935–1975.* Edited and with an introduction by Rackstraw Downes.

Renoir, Jean. *My Life and My Films.*

———. *Renoir, My Father.*

Rewald, John. *Cézanne: A Biography.*

Richardson, John. *A Life of Picasso.* Vol. 1, *The Prodigy, 1881–1906.*

———. *A Life of Picasso.* Vol. 2, *The Painter of Modern Life, 1907–1917.*

———. *A Life of Picasso.* Vol. 3, *The Triumphant Years, 1917–1932.*

Rilke, Rainer Maria. *Letters on Cézanne.*

Schapiro, Meyer. *Modern Art: 19th and 20th Centuries. Selected Papers.*

———. *Theory and Philosophy of Art: Style, Artist, and Society. Selected Papers.*

Schneider, Pierre. *Matisse.*

Spurling, Hilary. *The Unknown Matisse: A Life of Henri Matisse. The Early Years, 1869–1908.*

———. *The Unknown Matisse: A Life of Henri Matisse. The Conquest of Color, 1909–1954.*

Stevens, Mark, and Annalyn Swan. *de Kooning: An American Master.*

Tarkovsky, Andrey. *Sculpting in Time.*

Worringer, Wilhelm. *Abstraction and Empathy: A Contribution to the Psychology of Style.* Chicago: Ivan R. Dee, 1997 [1908].

INDEX

art museums
attempts to make art more accessible, 232–233
concern for perception of, 232
criticism of, 98–99
curatorial activism, 8
curatorial fishing trips, 233
fusion of technology with art, 236
pitfalls for, 234–235
purpose of, 235
similarity to houses of worship, 235–236
value of, 99
art museums, names of
Barnes Foundation, Philadelphia, 73
Dia Art Foundation, New York, 198
Dia:Beacon, Beacon, 198, 201–202
Guggenheim Museum, New York, 2
Kunsthistorisches Museum, Vienna, 228
Massachusetts Museum of Contemporary Art, North Adams, 163
Metropolitan Museum of Art, New York, 99, 126, 235
Musée de l'Homme, Paris, 89, 99
Museo Reina Sofía, Madrid, 219
Museum of Modern Art, New York, 99, 107, 185, 208
New Museum of Contemporary Art, New York, 213
Philadelphia Museum of Art, 91
Prado Museum, Madrid, 200
San Francisco Museum of Modern Art, 219
Whitney Museum of American Art, New York, 106, 161, 211, 213, 219
The Artist Is Present (Abramović), 185
artists
expectations for viewer, 86
interaction of forms within artwork, 84–85
loss of traditional patrons, 114–115
planting seeds for viewer, 85
as poets, 28

as rebellious, 11–12
as revolutionaries, 2, 12, 22, 51, 114
sharing of deeply personal feelings, 81
as storytellers, 87–88
viewer's response, 82–86
Artist's Shit (Manzoni), 1, 111
As Far as the Eye Can See retrospective, 106
assemblages, 214
Assyrian art, 88
Aten Reign (Turrell), 168
atmospheric perspective, 22
audioguides, 232, 236
Austin Powers: The Spy Who Shagged Me (film), 220
Autumn Rhythm (Number 30) (Pollock), 64–65, 145, insert fig. 6
avant-garde, 119

Balthus
appreciation of, 141
awkwardness and awakenings of adolescents, 129
belief that artists bridge physical and spiritual realms, 140
composition of paintings, 130
The Dying Warrior, 127
exploration of the nude, 125
fascination with adolescence, 126
friendships with Picasso, Matisse, and Giacometti, 126
girls seen as angels, 129
mirrors, as main motif, 139
pictures as journeys unto themselves, 140
Reclining Nude, 127
timelessness of paintings, 126
on young girls in his work, 127
See also Cat with a Mirror I; Thérèse Dreaming
Barbarella (film), 222
Barnes Foundation, 73
Basquiat, Jean-Michel, 99
Bauhaus school, 50–51, 174
Bayer, Herbert, 50

Index

Photo credit: Sonya German

Lance Esplund is an art critic for the *Wall Street Journal*. Previously, he was chief art critic for the *New York Sun* and US art critic for *Bloomberg News*. Trained as a painter, he has taught Studio and art history at the Parsons School of Design and Rider University and served as visiting critic in the master of fine arts painting program of the New York Studio School. His essays have appeared in *Art in America*, *Harper's Magazine*, *Modern Painters*, and *The New Republic*, among others. Esplund lives in Brooklyn, New York.

OUTRUN THE DARK

OUTRUN THE DARK

OUTRUN THE DARK

Cecilia Bartholomew

G.P. PUTNAM'S SONS • NEW YORK

1.

I had been in this place thirteen years. They said that I hit Bubber, my little brother, on the head with the big wrench from Daddy's workbench in the garage. Mama came home for lunch from the neighborhood variety store where she worked on Saturdays and found me with the wrench in my hands. Daddy said she only wanted to work to insult him. Mama said she'd stop working when he brought home more money. The wrench was slippery and red. I was grinding my teeth, like Daddy did. Mama couldn't lie. She had to tell what she heard me say. "I hate him, I'll kill him," I said.

Daddy had gone to dump a load of trash in the woods at the edge of town, which was against the law, and I wasn't ever supposed to talk about it, but it was a shitty law. Mama made me stand in the dark bedroom closet when I talked like that, but Daddy roared with laughter. I adored going to the woods with Daddy, but I had to stay home because Bubber was hiding. When Mama was at work, my job was to look after Bubber, and he was always doing things like that to make me mad. When Daddy came home, I climbed him like he was a tree. "A father is a tree of life," Shap said. Mrs. Rose who was in charge of our minimum-security cottage called him Shap from Dr. Reuben Shapiro. I called him Shap because that was the sound of his shoes in the corridor—shap-shap.

"It won't be for long, Billyjean," Daddy whispered to me, at the same time untangling my fingers from his shirt. They took Bubber away in an ambulance with a siren. They had to carry Mama into her bedroom and the doctor came. There was another car to take me away. "They won't keep a little girl for a long time," Daddy said. They had to carry me, too. I was eight years old. Now I was twenty-one and Muriel was coming to take me home. That was what I called Mama now, Muriel. Shap said it would be easier. I could call Daddy, Stuart. "Isn't it easier?" Shap asked. I loved Shap. I said it was easier.

Muriel started coming to see me when I was in the cottage. Before that I was in the dormitory, and before that there was a dark place like the bedroom closet at home. Stuart never came to see me. I was alone in that dark place. No one wanted me. I was so bad that no one even wanted to see me. Something was very wrong with me, so I had to be abandoned. I wanted to be dead. That was the way it went: the first thing was that I was bad, then I wanted to be dead. After that I was just a loony, and I could move into the minimum-security cottage. "Loony" is what the girls in the cottage called themselves. We were all loonies.

"Stuart is ashamed of me," I said to Shap.

"Have you ever thought that he is ashamed of himself?"

"Why?"

"When a young child is seriously disturbed, the parents must ask themselves what they have done."

I knew better than that. Daddy was strict and he was hard. When his big hands reached to unbuckle his belt, I didn't wait to see if he would take it off and use it, I jumped to do what he said all right. Bubber jumped, too. He ran to Mama to protect him. Just by clenching his jaws tight so that the bones turned white and throbbed in his red face, Daddy could make Bubber run to Mama. I would do anything for Daddy. If he had to let them take me away, it was because I had been bad, so bad that it couldn't be talked about. It was better to let them say that I hit Bubber on the head.

I didn't know if I had hurt Bubber bad. I didn't know if he was still mad at me. Sometimes in the night I woke up and Bubber was lying on the floor, his face too white, his hair getting red, like Daddy's hair. Bubber's hair was supposed to be light brown, not red. It was my job to see that he was washed and dressed and

combed. His hair was silky, and I could feel his head hard through it, and yet I had this feeling that it could crack like an egg. He would hold still like an angel, which was what Mama called him, her little angel, and then when I wasn't expecting it, he would hit me in the stomach or with his doubled-up fists down there.

If I asked about Bubber, I would have to see him again, and I didn't want to see him like that, so I never asked. And no one ever asked me if I wanted to see him. They asked me lots of questions. They asked questions all the time. But they never asked that. I thought about it a lot. I had time. Nothing much ever happened, not counting the baths or the tubes or the things on my head, or the dark place where I died. Those things didn't stop me from thinking. Even dead I kept on thinking. Bubber hit me lots of times. I didn't hit him back near so much.

"He's smaller than you, Billyjean," Mama said, "he's only a baby. If you hit him again, you'll have to go and stand in the dark closet."

Had I ever hit him on the head? Maybe. With Daddy's wrench? We weren't allowed to touch Daddy's tools in his workshop. Daddy would reach for his belt, and his jaw would be clicking lickety-split if he even thought we had been near his workbench. Bubber loved Daddy's tools. When Bubber was caught in a fib, he always screamed that I made him do it, he screamed that he hated me, he screamed that he was going to kill me. Sometimes he screamed at Mama like that, too, when she wouldn't give him money for the ice cream man on the street or let him stay up for a TV program, and then she would. Sometimes he screamed it at Daddy, and Daddy reached for his belt, and Bubber ran to Mama. Sometimes I screamed it at Bubber. I hated Bubber sometimes. I loved him, too. How hard did you have to hit to kill? Bubber was four. Daddy said he was getting too big for his britches.

"You always take Billyjean's side," Bubber shouted, "I hate you, I'll kill you."

Mama scooped Bubber up into her arms. "You do always take her side," she said. I loved Daddy so much it hurt my chest.

Besides me and Bubber, there was Glenn. He was only a half brother. Someone had done it to Mama besides Daddy, the kids said. No one else I knew had a half brother, and I was kind of ashamed. I was ashamed because I didn't know what "it" was, but at the same time in a way, I didn't know what way, I did know. Glenn was almost as big as Daddy. He had a big thing, not as big

as Daddy's but not little like Bubber's. Glenn didn't go to school, and he didn't go to work. If he didn't get off his ass and pay his way, Daddy was going to kick him out. Glenn said, "You and who else?" Mama ran between them, pushing one and then the other, and then she jumped and hung herself on Daddy, with her hands clasped behind his head. I was already almost as big as Mama was. Daddy had to push her in front of him to go after Glenn. Pretty soon that made Daddy laugh. He loved to laugh. And then he was hugging Mama and kissing her, and I rushed to be part of them, and Bubber bumped into me, fighting me. Glenn slammed out of the house. "Let me handle him," Mama pleaded. "I can handle him, Stu."

"And who is going to handle me, eh?" Daddy said. Mama acted mad, and I screamed, "I will. Let me handle you, Daddy." That made Mama madder, but Daddy had a wonderful roaring swearing laughing time over what I had said. I adored Daddy. That time Glenn came back.

Besides Saturdays, Mama worked at the variety store when a regular salesgirl was sick. Those times I had to stay home from school to take care of Bubber. Glenn said he wasn't a fucking baby-sitter. Mama said Glenn shouldn't talk like that, but she never made him do anything. She was sorry for him because he was only a half brother. She was sorry for him because he had no father, she told Daddy. Mama said she'd box my ears if I didn't stop listening to what wasn't any of my business, but I couldn't stop. Even if I had to have boxes on my ears, I'd listen. Mama was littler than Daddy but she was older. She had been married to someone else before Daddy. I couldn't see how she could have done that. She said she didn't even know Daddy then, but even so.

In vacation, I had to take Bubber with me wherever I played. The summer when I was eight years old, the kids played in the abandoned slaughterhouse on the edge of the town. The part where we lived was called Paradise Valley. The name was written on a big arch in the sky made out of metal and attached to two posts. Daddy said cattle used to be kept in pens in this valley waiting to get fat and butchered. The slaughterhouse was supposed to be torn down. We kids were glad that it wasn't. It scared us, but it was lovely. Even the word was lovely, red and bloody. Actually, the slaughterhouse was gray, like old bones. We found some old gray bones, too. The boys said they were human bones. The boys played

war, sometimes against the Indians, sometimes against the Japs. They killed each other and the blood ran down the troughs where there were still stains of red. The girls played house. Sometimes we played waiting for our husbands to come home from war. Michael was the only boy who came home much. He said he didn't believe in war. And, anyway, someone had to stay home and take care of the women and children. Bubber was the baby, and the trough was the bathroom. Giggling and pushing each other with loud screeched warnings that someone was coming, someone was peeking, we sometimes really used it, instead of going all the way home. We only did it when everyone was gone off to work or to war. Bubber was only four. We didn't know that he was snoopie. "Why don't you ever come home?" Mama asked. "What do you do when you have to go to the bathroom?" I could hold it, I said.

The slaughterhouse was at the edge of the woods. We weren't supposed to go into the woods; there were wild animals in there, Mama said. We went on a picnic once and I didn't see any wild animals. "Tell her where they are," Daddy said. Mama said we had chased them away. But we all caught poison oak. Bubber even got it on his little thing. "You are lucky I didn't get it there," Daddy said to Mama. I said why was she lucky, and Mama got mad and wouldn't let Daddy say. I knew then that it was about mommies and daddies. I could always tell because I would feel the way I felt when I stroked Mama's velvet pillow cover, the one she bought at the variety store less her discount. "You'll wear it out," Mama said. "The next time I catch you at it, you'll stand in the closet."

"Bubber strokes it, too," I cried. "How come Bubber never has to stand in the closet?"

Bubber was only a little boy, too little to be bad, too little to have to stand in the bedroom closet. He was too little, but I knew bad things he did that Mama didn't know about. Mama thought he was a little angel.

I thought Mama was pretty silly about Bubber. She was silly the way she was always pushing Daddy away when he wanted to love her. I'd have let Daddy do anything he wanted to do and say anything. Daddy had a fine roaring stamping angry wild time about everything. I wanted to be just like him. He was a lion or a tiger. When Bubber overshot his potty, clear to the corner of the kitchen, Mama said it wasn't a bit funny, but Daddy raised the roof with his

laughing. Bubber thought he was smart, too, and put on airs. "I can shoot farther," I boasted.

"You watch your tongue, young lady, or you'll go stand in the closet," Mama said.

"It's healthy, goddammit," Daddy roared. Then likely he'd snap his finger at Mama's right nipple. Then she'd say, "Stuart you hurt me," and he'd try to make it well, and she'd cross her arms to stop him, but Daddy was as big and strong as the whole world.

Sometimes, to show off, the boys went into the woods with a big girl. They came back swaggering and pushing each other with secrets. One day Glenn came to the slaughterhouse with a friend, another big boy. Mostly Glenn didn't pay me any attention. "Phil would like to take you for a walk in the woods, Billyjean," Glenn said. He was so polite, I could tell that he wanted to please Phil. "What about Bubber?" I asked.

"I'll watch him for you," Glenn offered.

It was so unexpected that I filled up with love for him.

Phil didn't talk on the way. I had to hurry to keep up with him. When we got where it was shady and quiet, he asked me what we kids did. "Glenn says you play house." When I told him about the boys going to war, Phil said that was kid stuff. I even told him about using the trough for a bathroom, and he just laughed. He said he would show me the real way to play house. I didn't want to lie down because of the poison oak.

"There is no poison oak here," he said, and he pushed me a little, but not rough. He wasn't at all rough. I didn't know what to expect, and I was a little worried that I wouldn't do good.

"Why, Billyjean, you fooled me. You're not eight years old, you're a woman."

"I love you," I said, the way we did when we played house.

That upset him. I thought he was going to roar and swear like Daddy. He began to shake. Even his teeth chattered. A drop of wet fell from his forehead to my face. I was afraid to wipe it away. If he got mad at me, Glenn would be mad at me, and I had just found out that Glenn loved me and I loved Glenn. I tried to meet Phil's eyes to see what I should do, but he turned away his face. I could never have guessed what he would do, and yet I wasn't really surprised. I wondered why I wasn't surprised. Afterwards he turned his back. I thought he was disappointed in me. I didn't know if I did all right, if I did what mamas did. I was ashamed, too, because

I had to pee. He was very polite about that and didn't look. Then he walked back with me to where I could see the edge of the woods and I went the rest of the way alone.

That night Glenn and Daddy had a big fight. "You tell me where you got that money or get out of this house," Daddy roared. It was hard to decide whose side to take, now that I loved both Glenn and Daddy.

"He didn't steal the money," I cried.

"You stay out of this," Glenn ordered.

"Yes," Mama said, "you stay out of this, this has nothing to do with you."

That time Glenn left and didn't come back. Mama looked at me as if it was my fault. Because of me she was never going to see Glenn again. I was bad. "What's the matter with you, always sulking," Mama said, and Daddy took her side that time.

One day when I went to the slaughterhouse to play, no one was there but Michael. He was hunting bones. He was planning to be an anthropologist when he grew up, or a paleontologist. That meant the study of fossils, of old bones, he said. He said we could be a husband and wife team out in the field hunting fossils. I had Bubber with me, of course, and he said that was all right, we'd take Bubber with us on the expedition. Michael knew a lot of interesting things and when I found a funny little round bone, he was real pleased. A wife could be a big help to a husband in that kind of work, he said. In some ways Michael was very smart, and in other ways he was young. Mama said I was born old. I didn't know if she meant that was good or bad. Phil never came again.

The summer evenings were warm and long. The grown-ups sat in the garden or more often on the front porches, and talked as they tinkled the ice in their glasses. It sounded like a game they played with poker chips. I liked to sit and listen to them, but the kids were playing hide-and-seek and they kept calling me. We all had homemade Popsicles that Mr. Bernhard handed out. Mr. and Mrs. Bernhard lived next door to us for as long as I could remember. On the other side was a vacant lot. Mama would talk to Mrs. Bernhard through the breakfast-nook window without even having to shout. Mrs. Bernhard had bad legs and wasn't supposed to walk much or even stand. Mr. Bernhard gave me a pair of skates for my eighth birthday. I loved Mr. Bernhard. I was afraid to skate on both skates

at once, but I loved to coast on one with my arms out wide, pretending to be an angel on account we lived in Paradise. "She'll learn," Mr. Bernhard said. But Mama said I'd make one hip bigger than the other and if I didn't skate on both skates, I couldn't skate at all. Bubber played truck with the skates.

Mrs. Bernhard wanted me to call her Auntie Bessie. "What's the matter with your tongue?" Mama cried, but Mrs. Bernhard took my side. "Leave her alone, she's shy, the little madonna. God should forgive me, I love her like my own, a gentle little Gentile madonna."

"Raising a girl is a worry," Mama said, tightening her mouth.

"You are going to make wrinkles at your mouth if you keep doing that, Muriel," Mrs. Bernhard said and sighed. "To have such a worry as raising a girl, I should be so lucky." She had a nephew, Max, her only brother's son, who was just like her own boy because she never had children. He'd been a wild boy, she said, losing his parents young, but the Navy had straightened him out. It was bad luck that he came home with only one leg. He had a long pale pushed-in face and eyes that were close together, crowding his nose. "He looks like a prizefighter," Mama said.

"Jews aren't fighters," Daddy said.

"Max lost his leg in the Navy," I said.

"He lost his leg in a car accident."

I didn't like to look where his pants leg was turned up with a big safety pin. "Just until he can get his artificial leg," Mr. Bernhard said. "But Max can do anything with that crutch."

"There's one thing he can't do with it," Daddy said, "eh, Bessie?"

Mrs. Bernhard laughed comfortably, like stroking the velvet cushion. She never got mad, like Mama, when Daddy said those things. I pretended I was looking for four-leaf clovers in the lawn, though it was getting pretty dark, so they wouldn't notice me and tell me to run and play. Mr. Bernhard puffed his cigar. His hand patted Mrs. Bernhard's fat arm. He owned cigar stores so he had to smoke all the time. Daddy said he spent his days going around from one cigar stand to the next picking up money. "Hard work," Daddy said, meaning it wasn't. Sometimes I saw Mr. Bernhard come home carrying canvas sacks, one in each hand, when the banks were closed. I could see that the sacks were heavy. "He rigs those machines," Daddy said. Cigar machines?

"He wouldn't do anything illegal, Stu."

"Did you ever see a Jew who didn't know how to do it legally? Look at the way he put me in the wrong on those houses."

"Now don't get started on that again," Mama said.

"I can do more with my crutch than you can do with whatever it is you've got," Max said. He was awfully mad when he got out of the Navy with a disability discharge and found that Daddy had lost the money that belonged to him and Mr. Bernhard for the houses.

Holding the crutch in both hands like a witch's broom, Max leaped off the porch. "Come on, Billyjean, I know a good place to hide." He grabbed me up from the lawn. Bubber had been trying to catch fireflies in a jar, and then there was a crash as he broke another jar, and he cried, so the kids let him be "it." He could count good when he tried, but he was likely to get tired and jump to the end. "Where are we going?" I asked Max.

He went awfully fast on the crutch, like it was a pogo stick. "Where do you think?"

"To the woods?"

"What woods?"

"By the slaughterhouse."

He was already pulling me into the Bernhards' backyard. At the porch, he threw his crutch under, and then hitched himself under. "Come on, quick."

"There's no room."

"Sure there is, on my lap. Hurry, or Bubber will find us."

He fixed my dress nice and neat, "so your Mama won't be mad at you."

"Sometimes I go to the woods with Phil."

"Is he one of your little boyfriends?"

I boasted, "Phil is as big as you."

"What do you do there in the woods with Phil?"

"We play house. We play house at the slaughterhouse, too." I was wondering how I could lie down; it was going to be crowded there under the porch steps.

Max set me off his lap carefully. "Billyjean, you listen to old Uncle Max, and don't you play house until you are a big girl, you hear? You are just a little girl. Don't try to grow up too fast. Do you understand what I'm talking about, do you?"

I felt ashamed. I hadn't done it right with Phil, not as good as a big girl would. I had only done it because Glenn asked me to do it. It was the first time that Glenn had ever asked me to do anything. I

loved Glenn because he offered to take care of Bubber for me. I was ashamed, too, that I wasn't big enough for Max.

"You're not my uncle. You're just plain Max."

"Hey, hey! You can't be mad at me. I knew you before you were born."

I looked up surprised. "How could you?"

"I knew you were going to be born. That must make me some kind of a relative. Is 'just plain Max' a relative?"

I giggled.

"I guess your mother tells you not to be in a hurry to grow up, too, doesn't she?"

"I don't tell her anything. She's pretty silly."

"You shouldn't talk about your mama like that."

"She wouldn't even understand what you mean about not growing up too fast."

"Do you?"

"Sure."

He kind of whistled in a funny way and he said, "Jeez, I think you do," which I thought was strange. But I liked his talking to me straight like that, it made me feel sweet and proud. And grown-up. But I wouldn't tell him that if he didn't want me to.

"I love you, just plain Max," I said

He laughed. "I love you, too, just plain Billyjean. Honest to God, I don't know how old you really are. But no more playing house, do you hear, no matter who asks you, or if they offer you presents, and especially if they give you money, don't you take it."

How did he know about the money that Phil gave Glenn? Some way I had always known where Glenn's money came from. Was he supposed to give that money to me?

"Mama says I was born old, just plain Max." I kept saying his name like that because it made him laugh and that made me feel good.

"No, you're still just a little girl. Don't forget."

"I don't forget anything. I'll let her think I'm old if she wants, but with you I'll be a little girl. I told you Mama was silly."

"You can talk to your Aunt Bessie about things like this, you know. She knows you're just a little girl. Uncle Bernie does too."

The game was over when we came out of hiding. "Why didn't you come when Bubber called?" Mama asked coldly.

"We didn't hear him, did we, Billyjean?"

"Why do you want to play with the little kids?"

"Maybe Max can't get any girls his own size," Daddy said.

"Maxie can get any girl he wants," Mrs. Bernhard said. "You should see the gorgeous girls Maxie gets."

Bubber was mad at me and he made waves in the bathtub when I gave him his bath, and I had to mop the floor. I was in the tub when Mama came in. "Why is your belly button red?" she asked angrily. "Have you been picking at it? You pick at it and you'll have trouble when you grow up and have a child of your own. I suppose you've been picking down there, too."

Before that I wouldn't even have thought about doing that.

Every Saturday morning Bubber and I had a race to see who would wake up first and get into the warm place in Daddy's bed left by Mama who had to go to work early at the variety store. Dressed and smelling of toast and toothpaste, Mama would come in to say good-bye. Daddy would grab her and pull her down on top of him while she kept telling him to stop. "Come in with me," he coaxed, "and we'll send Billyjean to work at the store."

"Send me, too," Bubber shouted.

"You're too little," I said.

"I hate you! I'll kill you!" he shouted.

On that Saturday morning when they took me away to this place, I woke up first. Bubber was still sound asleep in the bed next to mine, spread out on his back. I got out of the room without waking him. Mama was gone. Daddy was asleep, and I lay there in Mama's warm spot half asleep and half awake, playing house in my head. Daddy didn't move, didn't open his eyes, but something was waking up in him. He was making a dream, like I was.

"What you doing with your hand down there, Billyjean?"

"I've got an itch, Daddy." My voice was far away. I couldn't bring it closer. "I have to scratch," I said from far away.

The bed shifted. Daddy's leg was hard. His hand removed mine. I was ashamed because it was smelly.

"I'll scratch for you," Daddy said. He sounded like he had a cold. He pulled me over to sit on top of him. His thing was standing straight up. I giggled. "Be still," he said sharply. He lifted me in his two hands like I was no bigger than GrandmaLoreen Doll, and he bounced me up and down, up and down. "I won't hurt you," he said, "we are just playing horsie like Bubber and I do. Understand?"

I said that I understood. But the way you played horsie was to sit on Daddy's back.

Then Bubber was in the doorway, his eyes sharp and black as his teddy bear's and jumping about like fleas. Daddy pushed me off and jumped out of bed pulling up his pajama bottoms. "How long you been there, snoopie?" Daddy asked, and went pounding to the bathroom, not waiting for Bubber to answer.

I had to be picked up and carried to this place. It was worse than when Mama made me stand in the dark bedroom closet to punish me. "You have your father's temper, but don't forget he is a grown man. You aren't grown up yet. You'd better remember that," Mama would shout angrily. I screamed and screamed to get out. I promised, I confessed, I took the blame even when Bubber was really to blame. Could Bubber be to blame this time? Could he have hurt his head just to get me into bad trouble?

It was a very long time later that I understood something for myself that no one ever came out and told me. That blow from Daddy's wrench had killed Bubber dead.

"No one ever told me. I didn't know," I said.

"You were only eight years old," Shap said.

2.

"Mama," Shap said.

"She's got the baby," I said.

"Very good, Billyjean." He put on his glasses and wrote in tiny cramped letters in the folder.

It was a game we played. Games were not bad, Shap said. Everybody played some games. Having no game to play could be worse. I loved Shap.

"What else do you see?"

The baby was dead, but I was not going to say that. "Mothermothermother," I said.

"What does that mean, Billyjean?"

"I don't know the language."

"You have a mother, you know that, don't you?"

"She didn't come."

"Do you know why she didn't come?"

"Because I was bad."

"What did you do that was bad?"

"I did it."

"Did you hit Bubber?"

"No, that part doesn't come now."

"Tell me what comes now."

"You know. I already told you."

"Won't you tell me again?"

"You say it."

"All right, I'll say it. You bounced on Bubber like the clowns did."

"Yes."

"Do you want to tell me about the clowns again?"

The clowns came to school for the Christmas show. There were other acts, but nothing as good as the clowns. Mrs. Stacey, the principal, got up first and said that we were going to have the privilege of seeing two famous acrobats perform feats of skill and strength never before attempted. Her face was red from trying not to laugh. Then out came the clowns in big shoes that they tripped over, and pants that kept falling down. Everything went wrong for them. They kept losing the things they needed for their stunts. They even lost each other. The big clown would climb on the wire to jump, and the little one wouldn't be there to catch him. Then the big clown would get in position to lift the little one, and he wouldn't be there. They went around looking for each other, but they never looked in the right places. They always missed each other. They backed up and bumped into each other and that scared them and they'd run away. "Turn around!" all the kids yelled, but they turned too late. We died laughing. Finally the little clown crawled right between the legs of the big clown and the big clown bounced on him, and he didn't even know what he was bouncing on. "Look down, look down," we shouted, "he's between your legs." But he couldn't understand. I taught Bubber his part. He was the little clown, and I was the big clown.

"Go back," Mama yelled at Bubber, "go back the way you went in." But Bubber didn't want to go back. He wanted to come out the front way. He was scared to go backward. Mama yelled at me, "Where did you learn to do such dirty things?"

"Do you know why she called it dirty?"

"Because I was a big girl and Bubber was a little boy. I wanted to get out of the way so Bubber could stand up, but Mama wouldn't let me move. She held my arms so tight she hurt me, and she made Bubber back up, she made him crawl out the way he went in."

"What happened then?"

"That's all."

"Wasn't that when she made you go and stand in the bedroom closet?"

"Let me out, let me out. I did it. I'll say it."

"What did you do, Billyjean?"

"I'll say what you want me to say."

"The door is open, Billyjean," Shap said. "You can come out any time you decide to."

"Daddy," Shap said.

"Nut," I said.

"Is Daddy nutty?"

"I can't crack that nut."

"Do you want to hurt Daddy?"

"No, I wouldn't hurt Daddy. I love Daddy best of all the world."

"Billyjean, here are some crayons and a piece of paper on the table. Will you draw me a picture of Daddy?"

I drew a big square face, and I filled it in with the color red. I made a lot of red hair, like a brush. With the yellow crayon I drew long curly eyebrows. Then I made a bigger square below the head. I studied for a long time, and then I chose the blackest crayon and, pressing hard, I filled the big square with black, until I broke the crayon.

"Why did you cross out your picture, Billyjean?"

"I didn't cross it out. I filled it in, like Daddy."

"What is Daddy filled with?"

"Can't you see?"

"Can't you?"

"No one can see it because it lives inside Daddy."

"What is it? Is it an animal?"

"Yes."

"A black animal?"

"I don't know, I had to make it black because I can't see it."

"Can you give me another hint?"

"It roars."

"Is it a lion?"

"Yes, it is a lion."

"Why does he roar?"

"He wants to get out."

"What will he do when he gets out?"

"He wants to make something."

"Can you pretend to be Daddy with a lion in him, and show me how he roars?"

"Is it a game?"

"Maybe you can't do it because you're just a little girl."

"I can, I can. I used to do it all the time."

"Did you want to be Daddy?"

"I have a terrible temper just like Daddy. Mama said so, god-dammit, goddammittohell!"

"Why are you swearing, Billyjean?"

"Don't you know anything?" I roared. "Doesn't anyone around here know anything, for crissake?"

"Why are you so angry?"

"That's how Daddy makes things. Where's that fucking screw that I put right here? Who took the fucking screw?" I frowned horribly and made fierce faces, and I threw myself around on the floor swearing. I had a fine roaring time. When I was tired, I stopped.

"What things did Daddy make, Billyjean?"

"He made Bubber's sandbox."

"Were you mad because he made a sandbox for Bubber and not for you?"

"He made more things for me than for Bubber. He sewed clothes for GrandmaLoreen Doll, goddam that GrandmaLoreen Doll!"

"Why did you call your doll, Grandma Loreen?"

"Are you deaf or something? Can't you even hear? I called her GrandmaLoreen Doll, not GrandmaLoreen."

"Do you love your Grandma Loreen?"

"She's dead," I said, testing it on him.

"You can love someone who is dead, you know that, don't you?"

I wasn't going to answer that.

"It was Mama who sewed for your doll, wasn't it, not Daddy?"

"Mama never made anything for GrandmaLoreen Doll. Daddy made everything, until she was bad, and then he wouldn't make anything for her."

"What did she do?"

"Her eyes dropped down."

"Dropped out?"

"If they dropped out, I'd say they dropped out."

"Excuse me, they dropped down. Where?"

"Inside her head, of course. They rattled in there. She made Daddy stick himself on the needle."

"Did you poke out her eyes because she hurt Daddy?"

"I put yellow pencils in the holes so her eyes wouldn't be empty. Yellow pencils with brown erasers."

"I'm sure you didn't mean to poke out her eyes. It was an accident, wasn't it?"

"I didn't do it."

"Did Bubber do it? Is that why you were mad at Bubber?"

"No one poked out her eyes."

"Someone had to."

"Why?"

"You told me that they were gone, dropped down. You put pencils in the holes. You won't be punished for saying you did it. Billyjean, you know that you won't be punished, don't you?"

"Why did you poke out her eyes? Look what you did to GrandmaLoreen Doll!"

"Who is that talking?"

"It was Mama. She was crying with her mouth full of spit, like Bubber."

"Did you tell her that you didn't do it?"

"She slapped my head."

"Why?"

"For being smarty."

"Were you being smarty?"

"Why did you do that, Mama? You could have made my eyes drop down inside my head. That was Billyjean talking."

"Was that why Mama was crying?"

"No. A letter came."

"What did it say?"

I didn't want to say it.

"Billyjean, the letter said that your Grandma Loreen was dead."

"I didn't do it!"

"Of course you didn't. No one did it. She was an old lady. She died naturally, of old age."

"Mama said I was too old anyway to play with dolls. I had to look after Bubber. I had to do everything for him. It made me very tired. I had to take him wherever I went."

"Is that why you were mad at him?"

"I wasn't mad at him."

"All right," Shap said, "that's all for today. Mrs. Rose, Billyjean is ready to go back to the dormitory."

* * *

"Brother," Shap said.

"I don't want to see. I won't look. You can put me in the dark closet, but you can't make me look," I screamed.

"I won't put you in the dark closet, Billyjean. There is no dark closet any more. I won't punish you. Don't you know that?"

"I'm in here," I said, peeking at him.

"What kind of a place do you think this is?"

"It's jail."

"No, Billyjean, it is a hospital. You are here because you've been sick. We want to help you get well."

"I'm here because I'm bad."

"Why do you think you are bad?"

I wouldn't answer.

"You had a great shock, Billyjean. Something happened that was too big for you to handle—"

"It wasn't, it wasn't, don't say that!"

"Hush, Billyjean. It made you very discouraged, very tired. But you are getting well. We are helping you. But to help you more now, you must accept our help. I don't think that you are bad."

"I don't think you are bad, either."

"Thank you."

"You're welcome."

"Will you let me help you?"

When I don't answer, he says, "All right, Mrs. Rose."

"Shap," Shap said.

"That's you."

"Yes, that's me."

"You didn't fool me."

"I wasn't trying to fool you. I wasn't sure that you would remember me. It's been a long time."

"Did you go away because I wouldn't remember?"

"You know better than that, don't you?"

"Mrs. Rose said you went away to learn more."

"That's right. I went to study and work under a great professor in Europe who is the wisest man I know."

"Now do you know as much as he does?"

"Are you teasing me, Billyjean?"

"Yes."

Shap laughed.

"Soap bubbles," I said.

"What does that mean?"

"Your laugh makes soap bubbles."

"That's very pretty. You can make soap bubbles, too, you know that, don't you?"

"I could, if I had any soapsuds."

"Mrs. Rose tells me that now you live in one of the cottages with the girls."

"Yes."

"And you've completed the courses for high school."

"Yes."

"There is no reason why you shouldn't leave here now, Billyjean."

"Is there any reason why I should?"

"Life is out there, it is outside."

"You came back."

"It's my work."

"Won't you work with me again?"

"Twenty minutes a week. That's not much time. That's all the time we will have."

"Is there more time in life?"

"It will be up to you what you make. Nobody can promise what life will be. But you have a chance to make it what you want."

"I've brought you a present, Billyjean." He took a small box out of his sagging coat pocket and held it out to me. "Well, open it."

"I don't have anything to give to you."

"You have the best present of all. You can decide to go outside."

"I'd rather stay in here with you."

"Billyjean, life is a bigger present than anything that comes in a box."

"Why is my life a present for you?"

"It will make me very happy to see you living outside."

"Will I see you?"

"At first you will see me at intervals almost like in here, but soon you won't need me. You will have other people. But I hope you won't ever forget me."

"All right, let's go, right now."

"You know better than that, Billyjean. You know we have to close out your file first. Will you try?"

"Did you bring me a present so I'd give you a present?"

"The present is yours, whatever you decide to do."

"I can't decide right now." I handed him back the box.

"Will you try?"

"Yes."

"Then keep the present, to show me that you'll try."

"I can't keep it now. I do have to give it back."

Mrs. Rose's shoes went squish in the corridor as if she had to pull each foot out of the mud. My felt slippers didn't make any noise at all.

"Today let's talk about that Saturday morning, Billyjean."

"I don't think I can."

"Why not?"

"I don't think I remember."

"Perhaps I can help you to remember."

"If you know, why do I have to tell you?"

"So that you will know, too. You have to face what happened. You have to accept it. Without shame or blame. I can't do that for you. I can go with you, Billyjean, but that's all I can do."

"I'd rather play a game."

"All right, we'll make a game. We will call them Muriel and Stuart. We will call you Billyjean."

"I am Billyjean."

"They are Muriel and Stuart."

"Stuart is ashamed of Billyjean," I said.

"Why do you think so?"

"Billyjean thinks so. He doesn't come to see her."

"Maybe he is ashamed of himself, not her."

"Should he be?"

"Most parents find it difficult to recognize that they may have failed their child in some important area, but they can't ignore it, and they feel shame."

"Muriel didn't come for a long time, but then she came. Billyjean thinks she is still ashamed. She is nervous."

"That is very observant of Billyjean."

"I observed that. But Billyjean is observant, too. Muriel isn't observant. She doesn't have to be nervous. What is she afraid of?

What will we do to her? Does she think there are wild animals in the woods?"

"Perhaps you can help her not to be afraid."

"Billyjean is ashamed of her, too. She wears too much lipstick. Her dresses are too short. Who does she think she is? The girls laugh at her. Is that why she is nervous? Aren't you going to tell Billyjean that she shouldn't be ashamed of Muriel?"

"No."

"Isn't it bad to be ashamed of—someone?"

"Of your mother? No. It is not bad to be ashamed of your child either."

"How do you know she is ashamed of me?"

"She told me so."

"When?"

"She comes to see me, too."

"Why? Is she a loony, too?"

Shap's laugh rang out. It sounded like outside.

"I don't think she is a loony," I said. "That was a joke."

"I know. I like to hear you make a joke. It's fine that you have separated yourself from Muriel."

"I didn't separate myself. They picked up Billyjean and carried her away to this place."

Shap cleared his throat. "But now Billyjean can go back."

"Stuart doesn't want to see me."

"He doesn't want to see you here. He wants you to come home."

"I did something bad, and I had to be punished. That's why he doesn't want to see me here, isn't it?"

"You are not here to be punished, Billyjean. You are here because of a state of mind. No one gets punished because of a state of mind."

"Chronic depressive psychosis." I said.

"That means that you were frightened and despairing, that's all it means."

"Maybe no one hit Bubber on the head. Maybe the wrench fell off the workbench and Bubber happened to be there and it hit him on the head."

"You know better than that. Someone had to hit Bubber on the head."

"Why?"

"The doctors who examined him could tell that he had received a

blow. They could see the nature of the injury. You will not be punished for saying it, Billyjean."

"May I go back to the cottage now?"

"Of course. You may go whenever you wish to go."

"What do you want to talk about today, Billyjean?"

"I don't want to talk."

"Do you want to go back to the cottage?"

"I want to think."

"That's a good beginning for talking."

"Maybe it is bad."

"Even if it is bad, it is better to say it than to keep it locked inside of you."

"Are you sure?"

"Well, almost sure."

"Suppose this is one of the times when you're not sure."

"What could I do to you even if I don't like what you have been thinking?"

"You could be mad. You could go away."

"I promise I won't be mad."

"Do you promise you won't go away again?"

"I'm not sure I can promise that. You see, now I've made you mad, but I had to take that risk. It's best that you know that you can't depend on me."

"That's what I've been thinking. I've been thinking that in the end you can't do anything for me. I have to decide for myself."

"Precisely."

"Is that what all this has been for? All the games? All the questions? All the listening? For me to understand that I have to decide for myself?"

"I have never heard it put better, Billyjean."

"In that case, I don't want to talk to you."

The silence buzzed like a fly.

"We can sit here for the rest of your time without talking, Billyjean, if that's what you want, or you can talk."

"Billyjean wants to talk to Shap."

"I'm listening."

"Billyjean got into Stuart's bed that morning after Muriel went to work."

There was a second fly in the silence now.

"We can sit here for the rest of my time without talking, Shap," I said.

"Why don't you trust me, Billyjean?"

"Why don't you listen to me?"

"Was this Saturday different from other Saturdays?"

"Goddammit, are you deaf? Billyjean said she got into bed with Stuart."

"I'm sorry. I'll listen better from now on."

"That's OK. I'm not really mad at you."

"Where was Bubber?"

"He was asleep. Billyjean made herself wake up early so she could be alone in bed with Stuart."

"Go on."

"Stuart said whatareyoudoingdownthere. Billyjean said that she itched. He took Billyjean's hand away."

"Did he say that was bad?"

"He said he would scratch my itch for me. Then we played horsie."

"Tell me how you play horsie?"

"Don't you know how to play horsie? Don't you even know that?"

"There is more than one way to play horsie."

"I know that, too. Sometimes Stuart played horsie with Bubber, but he played different with Billyjean. Billyjean didn't sit on his back, she sat on his front. Stuart is awfully strong. "I won't hurt you," he said. He did, but there was nothing that Billyjean couldn't stand for Daddy."

Shap blew his nose noisily. I could tell he wasn't getting anything. He made a lot of noise when he didn't know what to say.

"Is that all for today?" I asked.

"Are you tired? Don't you want to go on?"

"I'm not tired. I thought probably Billyjean's twenty minutes were up."

"We can take more time today if Billyjean wants to talk."

"Bubber was standing in the doorway. He was too young to know what he knew."

"How could you tell what he knew?"

"Not me. Billyjean. She saw it in his eyes. She was eight. He was only four."

"Eight isn't very old."

"Billyjean was born old. Muriel said so. She said that Billyjean had never been a child."

"Why did she say that?"

"Bubber is too young to be blamed for anything, too young to be punished. Bubber is too young to stand in the dark closet." In my own voice I said, "That was Muriel speaking."

"What did Billyjean answer?"

"She said she wasn't old enough either to stand in the dark closet. Muriel said, 'Billyjean, you have never been young.'"

"On that Saturday morning, did Bubber get in bed with Billyjean and Daddy?"

"He couldn't. Daddy jumped out of bed and went to the bathroom."

"What did Billyjean do?"

"She got dressed."

"What did Bubber do?"

"He ran away."

"And Billyjean followed him."

"No."

"But she did go to the garage."

"She had to look for Bubber. That was her job on Saturday, to watch him. Stuart was taking a load of trash to dump in the woods. Billyjean wanted to go with Stuart, but he said that she'd better stay and find Bubber or Muriel would be mad."

"That's when she went to the garage."

"First she looked other places. She didn't think of the garage right away. Bubber wasn't supposed to go there."

"But when she thought of it, she went, and there she found Bubber."

"Not right away. He was hiding from her behind the workbench."

"She picked up the wrench from the bench."

"No, it was on the floor."

"How did it get there?"

"Maybe Bubber was making something with it."

"When she picked it up, what was she going to do with it?"

"She doesn't know."

"Was she going to hit him with it?"

"She doesn't know."

"Billyjean was ashamed because Bubber saw her in bed with Daddy? Why wasn't she proud that she had beat him there?"

"Because she was smelly."

"But afterwards she was mad because he hid and she couldn't go to dump the trash with Daddy."

"Yes."

"She didn't want to hurt him bad. She didn't mean to hurt him bad. But you did hit him, didn't you, Billyjean?"

"Maybe Billyjean hit him."

"We are talking about you, aren't we?"

"We're talking about Billyjean."

"But you are Billyjean, aren't you?"

"Yes, I am Billyjean."

"Why don't you want to say it, Billyjean?"

"I do want to say it."

"Then say it!"

"I can't!"

"You've blocked it out for so long that it is hard to say it now, but push the block away, Billyjean. Push away the block and go out. Say it. Shout it. Let the lion roar. Say what you feel like saying. Feel how you felt then. Let yourself feel it again. Then you will say it. You must say it, to be free, to free yourself. You were too young to know the consequences of what you did. But you don't want to stay in here any longer. I can't do it for you. Make the decision, Billyjean!"

There were drops of sweat on his forehead. A drop fell on me from Phil's forehead as I lay in the woods, looking up at him, worrying if I was doing all right, as good as a big girl.

"I hit him and I hit him and I hit him until I was too tired to hit him any more!" I screamed. I could hear my scream going on and on. Then it ran out. Shap said, "Are you sure that you picked up that wrench, Billyjean?"

"You wanted me to say it."

"But are you sure?"

"I could feel it slippery and wet."

Shap blew another blast into his handkerchief. Then he wiped his forehead. "That's fine, Billyjean, that's just fine. You did fine. Go ahead and cry now. You did just fine."

I could see he was crying and wiping his eyes, but I couldn't cry. I knew that I still hadn't let it all come out. I knew that I hadn't

told Shap the whole truth. I still couldn't. It wasn't that I didn't trust him. Sometimes Bubber and I woke at the same time and raced each other to Daddy's bed. Bubber would get in on one side, and I'd get in on the other. Daddy would groan and roll over on to his back, pretending that he couldn't wake up. We'd all three of us lie there on our backs, and then when we waked up, we'd play the game of finding pictures in the ceiling plaster. Bubber wasn't good at finding anything. So he talked. He rattled on sometimes so fast that even I couldn't understand. Sometimes I had to translate for Daddy. Sometimes Daddy would get mad and disgusted and he'd yell, "For chrissake, don't you ever shut up? You're as bad as your mother, yak yak yak." Then he'd roll over with his back to Bubber, and he'd cuddle up real close to Billyjean, and his sweetness would run into Billyjean, and Billyjean was proud because she knew that Daddy loved her best. He never turned his back to her and rolled over close to Bubber. It was like when sometimes they went for a walk, Billyjean and Daddy, and Muriel said, "Can't you take Bubber just once?" Billyjean would walk on one side of Daddy and Bubber on the other, and in Daddy's coat pocket on Billyjean's side there would be treats for her, shelled walnuts or even chocolate. She knew there were no treats in the pocket on Bubber's side, and she never shared with Bubber, because it was a secret between her and Daddy. Just like the other secret.

Later that night I had a terrible ache in my stomach. Under the covers, I put my hand between my legs and it came away all wet and slippery with blood. "I did it, I did it," I screamed at the top of my voice and the bottom of my stomach.

"Stop scaring yourself, Billyjean," Mrs. Rose said. "You've begun your periods at last. Thank goodness for that."

3.

"It is a state institution for the mentally disturbed, a small facility as those places go, a good facility that is proud that it maintains a personal touch." A reporter from a newspaper came to write a story about us girls in the minimum-security cottage. That was what he wrote.

We scrubbed the cottage from top to bottom before he came. We always kept it clean, but we made it more clean. I liked seeing it pretty and clean. Mrs. Rose brought us a copy of the newspaper story. We read it aloud to each other. We liked to quote it, and then we would laugh like crazy, excusing the expression. We thumbtacked the clipping on the wall in the bathroom where we could see it when we sat on the john.

I tried, but not successfully, to remember how it had seemed to me in the beginning when I first came there. I had not always been in the minimum-security cottage. Before that, there was the dormitory. And before that, the dark closet. There was the dark closet at home in my bedroom, and sometimes I got them mixed up. How had it been on the first day? On the tenth day? If not then, how had it been on the one hundredth day? the one thousandth day?

I had been there thirteen years. Today I was going home. I flew to that word like a bird that sees it reflection in the windowpane, and slap! falls down dead. Home was where when you went there they had to take you in. That was a poem, Shap said. We girls in

the minimum-security cottage laughed about that poem, too. We laughed a lot, like crazy. I wondered who had written that poem. Shap said it was an old man. I wished I could know that old man. I could love him.

Shap said that Muriel and Stuart wanted me back. "Who are Muriel and Stuart?" I asked. Of course I knew, but then again, I didn't know. Did they know who Billyjean was? I had been eight. I was twenty-one.

Waiting in Shap's office for him to come and get me, I occupied myself with the mental arithmetic. Three hundred sixty-five days in a year, multiply by ten, it came out 3,650 days. Half of that was 1,825. Add 1,825 to 3,650. I could do it in my head. "You've got a better than average IQ, Billyjean," Shap told me. I did it with pictures in my eyes. I didn't tell him because Shap knew everything. But I hadn't been there for fifteen years! That was a mistake! I had only been there for thirteen years. If they knew I made a mistake, would they let me out? I would have to watch myself.

I had been in this nut house for thirteen years. The girls I lived with in the minimum-security cottage talked like that. Nut house, they said. Nutty, we called each other. Nutty as a fruitcake. The girls had made me some terrycloth potholders for a going-away present. There were cherries in appliqué on one, and a yellow banana on the other. We laughed like crazy over those potholders. "Now girls," Mrs. Rose said, "there's nothing funny about potholders." That made us laugh harder. She was either very dumb, or she played innocent.

I was dressed in a new brown skirt and sweater, with a Dacron shirtwaist, easy iron, the label said. I liked to iron. I liked to smooth out all the wrinkles. I liked to see the wrinkles go under the iron and come out, ironed out. I wore new shoes, and everything was new underneath, down to my skin. I has having my menstrual flow, and I hoped I wouldn't dirty my new panties. Shap said now that my body was functioning as it was meant to, everything was going to be fine. Everything was linked, he said. The body couldn't be separated from the mind or the emotions. A blow to the body could affect the mind. A shock to the mind was a shock to the body. The glands with their hormones were the key to the personality, to the person.

I was twenty-one years old. Thirteen years had gone somewhere. Could I jump right over thirteen years to be twenty-one? Or would

I have to start at eight, where I left off? Would I be able to catch up? Where would I start? If I could start back on that morning when I got into Daddy's bed without waking Bubber, maybe it wouldn't have to happen the way they said it happened. I had said it, too, in the end. But if I hadn't waked up before Bubber . . . That was the way my mind worked.

Shap said it was a good sign if my mind jumped around. The time to be worried, Shap said, was when it got stuck in a groove. If I hadn't sneaked out of our bedroom without waking Bubber . . . Shap said I had a free-wheeling mind. He said that some of the things I said were almost poems. He said I could write poetry if I wanted to try. He didn't mean that crap that some of the teachers fed us about "Even if you can't learn to change a typewriter ribbon, people like you can be artistic because you are not hampered by reason or logic that stops normal people [who can change typewriter ribbons]." Who would want to write poetry after that? Anyone, even a loony, could see that trap. I had learned to change the typewriter ribbon. I was going outside. I would be on probation for a year, and after that, I'd be free to do anything silly or stupid or careless that other people always did, the ones hampered by reason and logic, without being watched and suspected. If I hadn't gone by myself to get into Mama's warm place beside Daddy . . . If I had not dreamed . . . If I had gone on dreaming . . . Was this a groove?

In a moment of stunning panic, I believed that my thoughts could be used against me. "They" had ways to find out what we were thinking. "They" always could. They could keep me there if they wanted to, snapped into the bathtub under the heavy rubber cover, or tied by the sleeves of the straitjacket. The talk in the cottage was that "they" were glad to get rid of us when they could. It helped the budget. It helped their record of rehabilitation. The panic subsided. All that had kept me there these last months was my own stubbornness, Shap said. I had to admit the reality of that morning. Normal people admitted reality. I had admitted it. I was normal.

I had a cramp in my stomach. It was really in my uterus. My uterus was cramping in an effort to expel the lining of blood vessels that had been built up in anticipation that there might be a need for them, if the egg from the ovary had been fertilized by a sperm from a male. We learned about that in biology class. No one ever

said they had a cramp in the uterus; everyone said stomach. It was a lie, wasn't it? Or was it reality?

I was proud of having my menstrual flow. I had been the only girl in our cottage who hadn't started. This was my third month. I even liked the cramps, at least I didn't mind. I liked the clean napkins in the pretty box. This month Mrs. Rose had given me a new kind of napkin. When she told me how to use it, I thought it was a trap, but the girls told me that everybody did it. Then they laughed like crazy. Mrs. Rose said that most girls nowadays started at twelve years of age. Was that my age now, twelve? What age would Stuart expect me to be? Did he know I was so tall? I was the tallest girl in the cottage. I also had the flattest chest. "You'll begin to fill out now," Mrs. Rose said. Right now my boobs were sore. I was proud of that, too. It meant that they were getting bigger.

Shap-shap went the footsteps in the corridor. The door of the office opened and he was there. His mouth turned down in what it did for a smile. It made me want to do what he asked. But, also, I knew that his mouth turned down to hide his teeth which were crooked and decayed. He had been very poor, he told me, and he had never been taken to a dentist until, as a grown man, he had taken himself. "They" saw to it that I went for a dental checkup twice a year. My teeth were white and straight.

Shap often sat with his eyes closed while we talked, opening them in a thin slit from time to time, and then I would get a glimpse of a light inside, something alive, loving. I used to think it was God. He said there was, he hoped, a little bit of God in everyone.

"In me, too?"

"Of course in you, too."

He had more in him than other people had, more than Mrs. Rose, our cottage matron, lots more than the assistant superintendent. There must have been a superintendent somewhere, but I had never seen him. Shap kept his eyes closed, only opening narrow slits, because you had to take God in small doses, too much of the glory of God could blind you. Shap said he closed his eyes because they were tired. He had trouble sleeping. It was an occupational hazard. I knew what that meant. He didn't sleep at night because he worried about his patients. When he put on reading glasses to consult Mrs. Rose's chart on me, or to write in my folder, his eyes were magnified into fishbowls. He was pretty thin and short to be a

doctor, I thought. He didn't look strong enough for all the work he had to do. He said that my problems didn't bother him at night any more. I felt left out.

He had a round face and his neck was short and fat. It didn't go with the rest of him, that was slight. His shirt collar was always rumpled. I would have liked to iron it for him. He wore a plain gold ring on his little finger, his mother's he told me when I asked if he was married. The sleeves of his jacket were spattered with ashes that he brushed at without seeing that he wasn't doing any good, or even sometimes spilling more ashes from the cigarette in his fingers. He picked at bits of tobacco delicately and patiently, like Bubber when he was a baby and offered Zwieback crumbs from his highchair tray to your mouth. I could talk about Bubber now. Shap had said I could, and he was right.

I liked to watch Shap's fingers. I liked the way they held his cigarette. I liked the way they picked at the bits of tobacco. I knew I shouldn't stare at his fingers. I shouldn't stare at the crotch of his pants where ashes fell in the folds, as he leaned back in his swivel chair. Once when I stared, I had seen his hand creep like a spider to his zipper to check that it was closed, so that what was in there couldn't come out. After that session, I was sick in the bathroom. Shap never said if he knew I had been sick, or why, but Mrs. Rose wrote everything in my folder. Shap's pants hung down flat in back as if he didn't have anything more to sit on than Bubber's teddy bear did. The legs of his pants were too long and lay in folds on the laces of his shoes. He didn't mind that I called him Shap, not from Dr. Shapiro. "Ready?" he said.

I stood up, too tall because of the new shoes. "They're the latest style," Mrs. Rose said. "You aren't going to be ungrateful, are you, when your mother went to all the trouble and expense to buy something nice for you."

It was a good thing it wasn't a question because I didn't know if I was going to be ungrateful.

"She has given you so many nice things," Mrs. Rose said.

"I gave her wrinkles," I said.

The girls, assembled to say good-bye to me, screamed with laughter.

"Now, girls, Billyjean didn't mean to be funny."

Shap surveyed me. He pursed up his lips and blew, but he couldn't whistle any better than Bubber. I remembered things like

that about Bubber now. It was like he was getting out with me today, but he would not be at home, of course I knew that.

"How do you like yourself?" Shap asked.

"I don't know."

He opened the door that hid his washbasin. There was a towel, not fresh, on the rack, and a yellowed toothbrush, and a bottle of mouthwash on a shelf, and over them a square mirror. He studied our two faces in the mirror. "I'd rather look at you than at me," he said.

"I'd rather look at you," I said.

"We should be able to look at our own face and like it."

"Stuart called me Moonface," I said.

"It is a kind of moonscape," Shap said. "You've got the right number of features, nothing's missing, it's all there, but everything's close together and there is space all around. The astronauts have room to walk."

"You're trying to make me laugh."

"Yes. And no. Your skin is like pale moonlight. There! You've looked. Now, don't you like yourself?"

"I guess I won't break your mirror."

"Take my word, you are a very good-looking young woman."

"I think you are good-looking, too."

His mouth turned down. His eyes were almost closed.

"How did you sleep last night?" I asked.

"Lousy, thank you, and you?"

I had slept all right, but I said, "Lousy, too."

His clean fingers picked at a piece of tobacco on his lapel that he squinted at. He said, "You wouldn't be normal if you didn't have trouble sleeping last night."

Panic came back.

"Muriel is waiting in Reception. Stuart is waiting for you at home."

"You told me."

"So I did. I must be nervous."

"I'm nervous, too."

He nodded. He didn't ask if I was glad or sorry that Stuart hadn't come. "I'm glad and I'm sorry," I said.

"That's the way things are most times, mixed up. When they get all separated out and unconnected—"

"That's the time to watch out," I finished.

"No soapsuds?" he asked.

I shook my head. "Did Stuart stay home from work for me?"

"It's Saturday."

"I forgot."

"It's all right to forget."

"I know. I wouldn't be normal if I didn't forget."

"It seemed a good idea to start your new life on the weekend, new-old life."

"Why?"

"You'll have time to get acquainted again."

"Did Stuart say that?"

"I said it. Muriel goes to work on Saturdays, and if it was a work day for Stuart, you'd be alone. I thought you'd prefer not to be alone on your first day home."

"I wouldn't mind."

"Do you mind Stuart being home?"

"No."

"What do you expect to happen when you see him?"

"I don't know."

"Just be yourself. That's all. Don't worry."

"If I was eight years old I'd run and jump on him, I'd climb him like he was a tree."

"A father is a tree of life."

"You're a poet," I said.

"Thank you, Billyjean. So you will climb him like a tree."

"Not now."

"Why not?"

"I'm too big now."

"Is that all that would stop you?"

"I know I have to stand alone."

"Not alone, Billyjean. On your own feet, but not alone. We all need someone. Someone to be there."

"Where?"

"Where we can touch them."

Touch it, Billyjean.

I don't want to.

Go ahead. It won't hurt you.

It's ugly. It will make my hand dirty.

"This is going to be a kind of trial run, Billyjean."

"I know. You told me."

"For a year you'll have to follow the rules, like it has been in the cottage. It will be a time of getting reacquainted with your family, with the neighbors, with family friends. You can go anywhere with your family. But you can't take a job. And you can't have dates with a boy."

"Do they think I'd let the boy put his hand up my pants if I was alone with him?"

"It would be normal, if you did," Shap said. "I will come to visit you every month." He took out his handkerchief and blew a loud blast into it without getting anything. "You were a victim, Billyjean, just as much a victim as Bubber. Children know more than we give them credit for. There is no telling how much they know. Before a baby can talk, we can't know what he knows. One theory says that we are born knowing a fixed amount and that is never added to. The other theory says we are a clean slate at birth, and life writes upon us."

"Can you erase what life writes?"

"You can write over it. You can cover it up, when you decide it isn't you any more, isn't important, and then pretty soon when you don't keep on looking at it, you forget it. The days are covers, like the pages of a calendar, one on top of the next, to write over. You can only live one page at a time."

"You made me take off the covers."

"That's right. In here we take off the covers. Out there, you will put them back on."

"Why?"

"Most people are more comfortable with the covers on. It's called diplomacy or social manners."

"It sounds crazy to me."

This time he made good soap bubbles, then he said earnestly, "You will have to watch it at first, Billyjean. You are probably more honest than most people will accept."

"Because I've been studying with you?"

"Some people are born older than others, Billyjean. Some people are old souls when they are born. Memory can go back a long way in some people, back to infancy, back to another life, maybe back several lives, back even to the beginning of the race. The individual recapitulates the history of the race. Most people aren't aware of the knowledge they have in them. Some people have access

to that primitive memory. It's a gift, but it's also a responsibility. It's best sometimes not to use the gift."

"Like you don't open your eyes wide unless you have your glasses on."

His eyes grew round like swimming fishbowls, then almost closed as he laughed. He put his hand in his pocket. "I almost forgot to give you your present. You'll take it now, won't you?"

"You're funning about forgetting."

"Yes, I didn't forget. . . . It's a friendship ring."

No one had ever given me a present like this. A potholder, even talcum powder couldn't compare with a ring.

"Don't you like it?"

I knew he was funning again. I didn't want him to see that I was close to crying, and I bent my head as I put the little box into my purse. I wanted to be alone when I tried it on. I would wear it on my little finger, like he wore his ring.

"We have closed your folder now, Billyjean."

"What will happen to it?"

"It goes into a file drawer, and the drawer is shut and locked, except when I put in my monthly reports. When the probation year is up, the folder goes down into the basement. No one will ever look for it there."

We walked down the corridor together. People seeing us might think we were on a date together. I could feel the ring like it was on my little finger. When I looked at my hand, I could even see it there.

Since I'd lived in the minimum-security cottage, I had been allowed to go and come for my appointments with him alone. Before that, Mrs. Rose or some other Mrs. Rose had walked with me to and from the dormitory, unlocking doors all along the way. There was another time before that when I didn't go anywhere. "Can you hear me, Billyjean? Answer your doctor, Billyjean, if you can hear." It was too far away in my head to answer it, it was too far away to look at it.

My new shoes went drip-drip down the corridor. Two drips to one shap. My old felt slippers didn't make any sound at all in the corridor. I was real now. I was going outside.

Just before we reached the door of Reception where Muriel was waiting to take me home, I looked at Shap. His eyes opened a thin slit, and inside I saw my own fear.

4.

"Say hello to your mother, Billyjean," Mrs. Rose said. She had my suitcase.

Mr. Grayson, the assistant superintendent, talked from behind his hand as if he was afraid that he had bad breath. "This is the big day, eh?" Today his hair was very black. He combed it sideways over his bald head and patted it to make sure it was there.

I ducked my head down to Muriel and she reached up and pecked my cheek, her lips like hard rubber. I was not sure how we began that greeting, if I had ducked down first, or she had reached up first, but when she came to see me in the cottage, that was how it went. Her blouse was tight across breasts like volley balls. That was what the girls said. Or grapefruits. They said that, too. I looked away. Are you jealous of Muriel, Billyjean?

Muriel had brought my new clothes in the suitcase on her last visit, and now it was packed with everything I owned. My felt slippers were in there, and my two denim uniforms, my comb and brush and toothbrush, and the potholders from the girls in the cottage, my underwear and nightgown. Mrs. Rose's present was a can of violet talcum powder, her kind that smelled up the cottage.

Mr. Grayson led the way to the parking area, then came Muriel and I, and behind were Mrs. Rose and Shap. He had the suitcase now. It was like a parade. I was the clown on stilts.

Look down, look down, there's something between your legs.

"Why are you walking so funny?" Muriel hissed. She was more nervous than usual. Her mouth was tight in deep brackets at the corners. Her shoes had pointy heels. Her short skirt showed little-girl legs with rolls of fat above her knees like her thighs had slipped down.

"I don't want to scratch my new shoes on the gravel," I said. I felt how their eyes met around me, congratulating each other. Mrs. Rose felt good because "one of her girls" was leaving for the outside. Mr. Grayson felt good about his budget, I guessed. Shap felt good because he was my friend and he wanted me to have a chance at real life. Muriel didn't look as if she felt good.

"Is this our car?" I asked before I could stop myself, and then I knew it was a mistake to be surprised. "Ours was blue."

"We live in the age of obsolescence," Shap said, letting a little light out of his eyes for me.

Mr. Grayson coughed up some phlegm which he swallowed. The breeze raised a long strand of hair across his dome. His hand with the white patches of skin patted it.

Muriel was giggly. I guess that she didn't know what obsolescence meant. "I know the old one would be worn out by now," I said. "The car is different, that's all."

"You're different, too." She sounded huffy. Shap's mouth was turned down. What had they talked about when Muriel went to see him? "This will interest you," he'd say to me, giving me something to read, and afterwards we discussed it. Muriel never read anything. I was smart, but I had been stupid about the car. After thirteen years, absolutely everything was going to be different. I had to remember that and not keep making mistakes.

Shap put the suitcase in the back of the car. Mr. Grayson helped Muriel in on her side. I kept my eyes on the top of his head. Mrs. Rose hugged me. The violet talcum powder made me need to sneeze. I held it in and that brought tears to my eyes. She saw the tears, and her own eyes filled. Shap opened the door for me. "I will see you in a month," he said, leaning down.

A month! A whole month!

He straightened up and shut the door.

Inside, I saw him every week, even if it was only for twenty minutes. You tricked me, I shouted at him soundlessly through the car window.

The car started and began to move. It was dark in the bedroom closet. I screamed and screamed.

"I thought we'd drive right through without stopping," Muriel said. "There's deli stuff at home all ready for lunch. I planned it that way. All we have to do is take it out of the frig."

The door is open. You can come out any time, Billyjean.

"You'll have to make yourself useful, you know. I work full time now. Saturday is a big day. I have Monday off. But sometimes I have to work Sunday. Another person in the house makes a difference in the work. It costs, too, another mouth does."

The door is open. You can come out.

"*Haven't you got anything to say?*"

"I can file and I can type. I can change a typewriter ribbon."

"Not now you can't. You know the rules. They told you, didn't they, how it was to be this first year, probation? You can't get a job during this year. It would make more sense—if you could find someone to hire you. It won't be easy. Not without lying. Nothing's going to be easy. You know that, don't you?"

"I don't mind. It isn't easier on the outside, but it's life. Inside isn't life."

"Don't use those words. Nobody uses those words."

I had no idea how long the trip would be. I had not even thought of being alone with Muriel on the trip. I should have prepared something to talk about. I stared at my hands in my new brown lap. "Thanks for the new clothes," I said.

"See that you take care of them. Money don't grow on trees."

"The shoes are the latest style," I said.

"I'm glad you like them. Remember to thank your father. Not every man would accept a twenty-one-year-old who can't pay her way. It's not like taking a child. Doing for a child is one thing. They can't do for themselves. They're small. You're not even a minor. But you'll have to mind, you hear?"

"I'll tell him as soon as he comes home."

"It's Saturday. He don't work on Saturday." Her eyes flashed at me briefly and went back to the road. She kept her eyes on the road and gripped the wheel in both hands.

"I know it's Saturday. For a minute I forgot. I've got a good memory. I've got a better than average IQ." I felt dizzy.

"You don't have to make a production."

The road went round and round on itself. I felt sick.

"This freeway's new," Muriel said. "Some of the girls won't drive the freeway."

I didn't know which girls she meant.

"They're scared of the traffic. But driving don't bother me. I drive like a man. Your father even says so. I guess you remember he don't throw compliments around. Men like to think they're strong, but when there's trouble, where are they? They can't face facts. He's waiting for you at home."

I was a fact. "Is it the same house?"

"We didn't strike it rich while you were gone, if that's what you mean. Maybe you thought we were living it up, with a pool maybe, and our own jet."

"I'm sorry I said that about the car," I apologized.

"Some people turn over their car every couple of years. The Campolinis do. They're neighbors. He's a lawyer. We been marking time, same as you. Seems like everything stopped all at once. I can't get your father to do a thing to the house or yard any more. All he wants is to sit and watch TV and drink beer when he's home. Not now, some other time," she mimicked. "I don't know what he's waiting for. He don't go near his workshop."

Her voice spun off like a thread of cooked sugar. "On Saturday nights Mrs. Rose lets us make candy," I said.

"Too much candy ain't good for your teeth. It's a good thing I have a full-time job. What gets done, I hire. All he does is mow the lawn. We don't have to have the shabbiest house on the street. It's a nice street. We have nice neighbors. I told you about the Campolinis. He's the lawyer."

The car ate up a long unraveling ribbon of road. Her lips continued to move as if she was talking to herself. Then she began to talk to me again. "We had an accident. That's what it was, an accident. The same as if we was hit by a truck. I couldn't even get your father to empty the sandbox. I did it myself, with Bubber's little bucket and shovel, crying all the time. The tears I've cried would fill the ocean."

In the bright sunlight, she looked old and ugly. Her cheeks sagged. The tip of her nose sagged. She felt bad about Bubber. She cried an ocean of tears for Bubber. She wished she was bringing Bubber home. Not Billyjean, who was twenty-one and couldn't get

a job—who would hire her?—escaped from the nut house, nutty, a fruitcake.

"What'd you see?" she asked, putting up one hand to touch her hair. "Do you like it this way? It's teased. That's what they call it. I get a touchup, too, just a rinse. I don't need anything more. I hardly have any gray. I'm unusual that way. Most girls my age have lots of gray. . . ."

"Does Stuart have gray hair?"

"What? No, I guess he'll never get gray. Doesn't worry enough. His eyebrows are gray. Funny thing about hair, it's different different places. I guess you'll have a lot to catch up on."

"In the cottage we have house beautiful magazines and fashion magazines. They don't let us have movie magazines, but sometimes one gets sneaked in by a visitor. Or a confession-story magazine. They have to be hid from Mrs. Rose."

"So I guess you know everything."

"No, we aren't allowed to use makeup. We weren't allowed to have long hair."

"Now you can let it grow. You need a little more hair around your face. I suppose short it's easier for them to keep you clean."

"Some girls learn to cut hair."

"It looks like it."

"One girl hanged herself by her hair when it was long."

"Did you see her?"

"No, it was a long time ago."

"Well, you don't have to talk about things like that. All that is over and done. No one wants to hear about it. Take my advice and forget it. Your hair will grow fast, if it's like mine. Then I'll show you how to tease it. Maybe you can have a home perm. Make you look more normal. I suppose you weren't allowed to have perms."

"The girls taking hairdressing could. I took the typing course."

"You don't know it, but you had it good. It wasn't that easy for your father and I. You've got to remember that and do your part. We don't want to be reminded where you been or that you're different. Just try to be like us, do you hear?"

"I'm not deaf."

"That kind of talk will get you a slap when I don't have to keep my hands on the wheel."

"I didn't mean anything. The girls talk that way."

"Well, just remember where you are now and who you're talking to."

"Is it far yet?"

"Far enough. I had to make this long trip every time I went out there."

"It wasn't easy," I said.

"Do you mind not talking? I don't like someone talking in heavy traffic. Don't thing looks different to you? All the cars? The new styles? The big buildings? The cloverleafs?"

People on the outside could forget and no one considered them loonies. "Everything goes by too fast," I said.

"If you think I drive fast, wait until you drive with your father."

He was taking the trash to the woods in the trunk and he wouldn't let me go with him because I couldn't find Bubber.

"I guess you're a little nervous seeing him again after all this time. You got to let bygones be bygones, you know that, don't you?"

"Which bygones?"

"Men don't like scenes. Just be natural. Your doctor said that. Just be natural. Look at that crazy fool!" She hit the horn, hitched her bottom forward on the seat, stretched her leg to press her toe down hard on the accelerator. When she was ahead again she continued. "It's those kind that cause the accidents and make our insurance sky high. Young punks. Hippies. You know the rules, don't you, no boys, no sneaking out on dates, no getting into trouble."

"Shap told me."

"I hope you don't call him that to his face."

"He lets me."

"I'm sure I tried to teach you right. If you learned otherwise, you didn't learn it in my house. I suppose there are all kinds of girls in there. Your father knows how to get respect. He'll take his belt to you, even now, you're not too big."

"Does he take it to you?"

"You'd best watch yourself, Billyjean."

"I didn't mean anything."

"They say the early years are the important ones. I don't know, maybe I should have sent you to Sunday school. But Stuart wouldn't get up and take you, wouldn't let me get up. Why did it happen to me? Today kids run wild. I'm glad I don't have to raise kids today, with dope and sex and all those dirty books and nudie magazines. I warn you. I won't take anything like that from you."

Her voice dropped. "What do the girls in there do about, you know, about boys?"

"There aren't any boys."

"Did they sneak out to meet boys?"

"No, ma'am."

"Don't call me that. It makes me feel like your keeper. You can call me Muriel, I guess. That doesn't seem right either, but thirteen years is a long time. You're not a little girl now. You're not a woman either. You're a whole different person. People tell me that I haven't changed at all. They know me right off, even when I haven't seen them for years. I ran into a high school friend the other day and she knew me right off. 'Muriel Stanhope,' she said. Of course she didn't know my married name. 'Muriel Reasoner,' I told her. I had to pretend that she hadn't changed either, but I hardly knew her. I mean, you know, what do the girls do about—well, some of them look pretty developed to me, big breasts, swinging their hips, especially those black girls, they look like they're getting it somewhere. . . ." Her voice drifted off as if we had dropped it behind on the road.

Some of the girls said that certain ones kept a wooden clothespin under their mattress. I didn't know if it was true or not. They liked to boast. Muriel was waiting. "My boobs will get bigger now," I said.

"That's fine language you learned in there!"

"Everything in the body is connected. I've started my menstrual flow."

"For hevvins' sake, don't call it that. We called it the Curse. I suppose that's old-fashioned. If you have to talk about it, call it your monthlies. I hope you know how to take care of yourself."

"Yes, ma'am—Muriel. I've got a box of Tampax."

"They give you that, do they? In my time that would mean you weren't a virgin."

"The hymen is a membrane that can get broken in many ways besides sexual intercourse. It can happen when participating in athletics, for instance, or it can be broken by a physician in cases where the girl has painful menstrual cramps. But it doesn't have to be broken to insert a Tampax."

"Well, you don't have to go on about it. Just take care of yourself and see that you don't leave anything around, and for hevvins' sake don't clog up the plumbing. In all the years I've been married to

your father he has never once found anything that I left around. They told me you finally started. Did you have a bad time?"

"I had a glad time."

"No cramps?"

"I don't mind the cramps."

"I don't know why you should have been so slow. Your Dr. Shapiro says it could have had something to do with all that happened. . . ."

"It could have caused pressures," I said.

"No one in my family was slow. It don't run in my side of the family to be slow, no more than in your father's. I wasn't even twelve when I started."

Why, Billyjean, you fooled me, you're not eight years old, you're a woman.

"I've heard stories about girls' schools and boys' schools, the things that go on. I hope you didn't learn any bad habits."

"We had a class in family living," I said. "They showed us pictures and films."

"If anyone asks, you've been in a girls' school. That's all you need to say. Nothing else. It's none of their business. It ain't a lie, either. That's where you were, in a girls' school."

It was a state institution for the mentally disturbed, a good facility, proud of its personal touch. . . .

"Well, here we are," Muriel said, as she pulled into the driveway beside a small white house. Two small imitation Greek columns flanked the yellow front door. All the blinds on the front of the house were closed tight.

5.

I had had no warning. There was no familiar landmark to warn me that we were getting close. There were stores that I didn't remember. There were big houses I didn't remember. There were some large apartment units. There was nothing in the neighborhood that I recognized. There were no empty lots, no tall weeds, no woods in the distance. Where was the gateway to Paradise? Why hadn't we passed the slaughterhouse?

"Aren't you getting out?" Muriel was waiting.

I stumbled to the driveway and stood blinking in the sunshine as the house expanded and contracted.

"How does it look to you? It's not a bad-looking house, is it?"

"The columns are Doric," I said. "I studied about Greek columns."

"Well, for hevvins' sake, they're the same old columns. There's nothing new. I can't get your father to do anything."

"You told me."

"And I'll tell you again as many times as I feel like telling you. You can't stand to hear your father criticized, can you? He's perfect, isn't he? Well, let's go in, for hevvins' sake."

At the front door she used her key. Inside it was cool and dusky. The television was on, the sound very low. Someone—Stuart—Daddy—I loved Daddy best in the whole world—was sitting in

front of the set, close, watching. I was going to be sick. My legs wouldn't hold me.

"We're home, Stu," Muriel said nervously.

He turned his head stiff-necked, his eyes at the level of the TV screen. I could scarcely make out his features, just the large square of his head. Color it red. He rubbed his hands over his face making a sandpaper sound that set memory on edge in my teeth. Was he looking down there for eight-year-old Billyjean? Had he expected me to come back the same as I had left? Was I too tall? He was wearing a sport shirt with short sleeves, printed with pineapples, that hung outside his pants. His big hands twitched on his knees. Did they want to reach for his belt buckle? Slowly his head tilted back, his eyes raised blindly. At last they met mine and went on through me to the other side. Color them bright blue.

"Say something to your father, Billyjean," Muriel said.

Stuart lunged to his feet. The chair tilted forward with a jerk, like it was striking out with him.

"No!" I cried, flinging up my hands. He grabbed my wrists.

"What's the matter?" Muriel cried.

He let me go.

"I'm sorry," I said, ashamed.

"Is that all you can say?" Muriel began to sob noisily. "You come home after all this time and all you can say is that you're sorry?"

"The chair scared me. I didn't expect it to move."

"They've sent you back in a fine state, if a chair can scare you."

"Shut up, Muriel."

His voice set off a booming in my head. For thirteen years I had heard it saying only certain words.

What are you doing down there, Billyjean? It won't be for long, Billyjean.

When the booming stopped, he was saying, "You've changed. Hasn't she, Muriel? It's not little Moonface any more." He didn't smile. "You're not a little girl any more."

"So why does a chair scare her?"

"For crissake, Muriel, stop sniveling." His jawbone was clicking. His Adam's apple rose and fell above the paler V within his shirt collar.

"Of course she's not a little girl any more," Muriel said.

You were never a little girl, Billyjean.

"How could she be?" Muriel said. She had stopped crying at his

command, but her sensitive skin was already blotchy and swollen. The inside of her mouth was purple. But in this dim light she looked young and pretty.

"How could she be?" he echoed.

"You're not the same either," Muriel said.

"Have I changed, Billyjean?" he asked.

His hair stood up like the bristles of a red brush. His eyebrows were paler, more tangled. Inside him the lion was alive waiting. Color it black. He was thicker.

I said, "You haven't changed much."

"Well, I can't stand here all day. I have to eat and go to work," Muriel said. "You can help me in the kitchen, Billyjean. You're not company, you know." She went in a bent-knee trot.

"Billyjean knows that she isn't company." Stuart's eyes peered into me.

We can call him Stuart and we can call you Billyjean. Billyjean is my name. Stuart is his name.

I didn't know what to say. Should I say I was glad to be home? What do you see when you say glad? Glad ran away. You could hold on to sorry all right. Sorry was there even when you chased him away. "The chair doesn't look like a rocking chair," I said.

"Better do what your mother says, Billyjean, like a good girl." The old words made shock jump into his face. He sat down facing the television set. Like magic the screen came alive.

"You've got color," I said.

"Remote control, too." His voice was too loud. He switched from channel to channel showing it off. "Magic, isn't it? Want to try? Just don't switch too fast, or you'll jam it." That shock jumped into his face again.

"Not right now, thank you."

"Suit yourself. It's a handy gadget. You don't have to get out of your chair. Hell, we've come to a pretty pass if we can't get out of the chair to switch channels. Costs plenty, too. They squeeze you. What the hell, money doesn't mean anything these days. Unless you don't have it. You can only do what you can do, eh, Billyjean?"

"Billyjean!" Muriel called.

"I guess you know the way to the kitchen," Stuart said.

In the dining-room end of the front room was the old pedestal table Bubber and I used to play under. Three of the lyre-backed chairs were placed at its side, the three others were against the side

walls. The lyre was a musical instrument used in ancient times. We never ate at the dining table. The silver-plated tea set stood on the buffet covered by a plastic cover. "I can keep the tea set polished," I said.

Stuart, arms on knees, peered at the tube. It was a baseball game. "Your mother likes plastic covers."

"In the cottage we have a plastic cover for the electric mixer."

Stuart's head twisted around. "Christ!"

The kitchen was painted bright yellow now. In the bay window was a new table with chrome legs and a shiny Formica top. Outside was the garden. The garage was on the other side of the house where I couldn't see it.

"I hated that old tan." Muriel was measuring coffee from the can into the pot. "Yellow's cheerful."

The table was set with three yellow straw mats braided into circles. One of those mats was for Stuart, one for Muriel, and one for me. I decided that I would give her the violet talcum powder from Mrs. Rose.

"Well, don't stand there. Get the deli stuff from the frig. It's that in the store paper. Put it on these two platters. See that you do it neat. I like things arranged pretty."

"I do, too," I said.

The kettle was whistling and she began to pour the boiling water little by little over the coffee. "There's milk for you." Her hand stopped pouring, then began. "I suppose you drink coffee now."

"Yes, please." I fixed the thin slices of cheese and cold cuts in a perfect overlapping circle on the platters, making centers of pickles and olives. They looked like two large flowers when I was finished. Muriel called Stuart and he took a can of beer from the refrigerator. He ripped off the top, swallowed a huge mouthful, swirled it around in his mouth, and wiped his mouth with the back of his hand. The chair cushion let out a gust of air as he dropped down on it.

"Billyjean fixed the platters," Muriel said as Stuart reached.

"Damn stuff is cut so thin you can't taste it. I've told you not to buy it already cut. You pay for them to cut it and it has no taste cut."

"And I've told you to take as many slices as you want. I like it cut. It's neater and easier. You go in behind the table, Billyjean. That's your place."

There was a bouquet of yellow marigolds in the center of the table. Seated in my place I said, "In the cottage, I arranged the flowers. I did it best of any of the girls."

"Do you have to keep talking about that place?"

"You remember the garden, don't you?" Stuart said.

"The garden that you don't take care of no more unless I nag and nag."

"You nag and nag all right." He winked at me.

The garden was small but laid out like a miniature of a great park, with formal geometric flower beds, and low-trimmed hedges and shrubs cut into shapes, and gravel paths. There was a fountain in the center, and flanking it, stone benches. In the damp earth under the plants were small cement elves and frogs. It was a child's play garden. Stuart had made it all. Bubber's sandbox and the jungle gym were behind the garage. In the garage behind the workbench, Bubber lay on the floor, his hair staining red.

"You ain't eating," Muriel said. "Billyjean did a nice job on the platters, didn't she, Stuart?"

"For crissake, why shouldn't she be able to put out a plate of cold cuts?"

The air in the plastic cushion under me moved.

"In the cottage we did everything we cooked the meals and planned the menus—"

"You had to plan them before you cooked them, I hope."

"Now, Stu!"

"This isn't a funeral, is it?"

"Different girls did different jobs and we rotated each week."

"That must have been something to see, all those girls rotating every week."

"Don't mind him, Billyjean, he thinks he's a comic."

Look down, look down, there's something between your legs.

"In France, a comedian is any actor, not just one who is funny."

"Billyjean took French," Muriel said. "She got her high school diploma."

"Who you boasting to, Muriel?" He got up and got another beer. When he sat down, I thought I was prepared, but I jerked. He laughed. "Sounds like a fart, don't it?"

"STUART!"

"She's so refined, of course the pillows don't do it when she sits down."

"I complained to the store, didn't I, like you told me. They said you sit down too hard."

"That's not all I do hard."

"I don't care, throw them out if you don't like them."

"We did everything for ourselves. Mrs. Rose only inspected." I was talking too fast. They were watching me.

"Bessie said to tell you they'll be over to see you." Muriel looked out the window as if talking about the neighbor had put her there in the window next door. "Her legs have been bad lately. You remember Bessie and Bernie."

"She wanted me to call her Auntie Bessie."

"You were so stubborn you wouldn't do it. Bubber did it."

"Bubber did it to get more presents," I said.

Stuart laughed with his old roar. It made circles inside me.

"Don't you go talking about Bubber that way," Muriel said.

"It's the truth," Stuart said.

"I'll call her Auntie Bessie now," I told Muriel.

Muriel's mouth set in those brackets.

"Do you remember Max?" Stuart asked.

"He played hide-and-seek with us."

"You remember that, do you?"

"Once he gave me a silver dollar." He told me never to take money from a boy but he gave me a dollar.

"And I made you give it right back," Muriel said.

"It was for good luck, from Las Vegas." Maybe it was all right to take money from a relative, even a not really relative.

"We could have used some luck," Stuart said.

"He said it would be worth more some day."

"He was wrong. They flooded the market. Then they devalued the dollar. I bet they didn't teach you that in French."

"In Econ," I said.

His jaw was white again and beginning to throb.

"I made you give it back," Muriel repeated. She took a pink bakery box from the refrigerator and, standing, ate a cream puff in her fingers, breaking off the little round hat on top to use like a spoon. "Max never married. Who'd have him, a one-legged man."

"A woman who can't get a two-legged man," Stuart said.

"Well, I'll say this for him, he knows how to make more money than some two-legged men."

"Maybe he's been waiting for Billyjean to grow up." He winked at me.

"Don't talk like that, Stu."

"She's a big girl now."

"She's on probation."

"It sure as hell don't mean that I'm on probation, too."

"Anyway," Muriel continued conversationally, "Max walks with hardly any limp at all on that artificial leg he got. It's wonderful the things they can make nowadays. There isn't anything they can't make, new lungs, new heart—"

"There's still one thing I ain't yet heard of them making."

"You'd find a way to put that in, wouldn't you?"

"That's the idea, to put it in."

"Shut up, Stu."

"Who's telling who to shut up?"

Muriel tossed her head. "Bessie said they'd likely drop over tomorrow, Sunday. Max has a business in Vegas, a string of second-hand car lots. But he's here with them almost every week. They're a close family."

"That's Jews, always sticking together."

"Maybe I should tell the Campolinis to come over too, and get it over with. They live on the other side in the two-story house. I told you about them, Billyjean."

"He's the lawyer who gets a new car every two years," I said.

"Christ, she didn't lose any time throwing him up to me, did she?"

"I was just talking about the neighborhood, Stu, bringing Billyjean up-to-date. They didn't build the house, the Furbushes did. Then it stood vacant a long time. The Campolinis had it all repainted."

"Even though this is just a stepping-stone, we like to make our home attractive." Stuart was mimicking someone.

"Lawyers make good money," Muriel said. "Mr. Campolini is going places. They have two kids. Dione is twelve, his sister's name is Diane. Dione and Diane. It's kind of cute, isn't it? She's eight. I'll tell them to bring the kids, too. The more the merrier."

"Christ!"

"You're the one said it wasn't a funeral. We don't want them to think there's anything queer about Billyjean. We don't want to act like we've got something to hide. Your Dr. Shapiro said you were to

meet our neighbors and friends, Billyjean. He said it was important for your rehabilita-tion."

Stuart belched. Muriel glared at him. "Your mother is so refined, she doesn't need to belch either, Billyjean."

"Well, I have to change or I'll be late to work. There's all these dishes." She looked around the kitchen dully.

"I can do the dishes," I said.

"I don't want none broke. They're good."

"Billyjean's old enough to wash dishes without breaking them."

When Muriel was gone to change I said, "When I was first in the cottage, I did break dishes. They jumped right out of my hands like fish."

"Like fish, eh?"

"Mrs. Rose said it wasn't my fault."

"Whose fault was it?"

"The dishes weren't rinsed good. They were soapy."

Stuart went to the window and looked into the garden. The fountain he had made was in the shape of a fish standing on its tail. Fish couldn't stand on their tails, not really. "Then we got some pretty plastic ones."

He stared at me.

"Plates."

"You used to like to see the water come out of the fish's mouth."

"Yes."

"Do you want me to turn it on now?"

"If you want to."

"Dammit, I asked you!"

"Yes, please."

He went through the laundry room. I heard the back screen door squeak. In a little while water came out of the fish's mouth. Through the window I could see Stuart standing and watching thoughtfully. The girls in the cottage said there was a statue in Belgium somewhere of a little boy and the water came out of his you-know-what. I didn't believe it. After a while, Stuart turned the water off and came in again.

"I told Shap—Dr. Shapiro—how you could make everything," I said.

"Head shrinkers—blabbers—"

"I didn't blab. He made games. He would say, what do you see when I say, and then he'd name someone."

"For games he gets paid."

"I didn't pay him anything."

"Well, let me tell you something, I did! I paid him every time I paid my taxes. I paid all of them. I paid for those dishes that you broke, too. Don't you ever forget that. What else did you tell him?"

What are you doing down there, Billyjean?

"What else, Billyjean?"

I had bad cramps, worse than first-day cramps. "I said I hit Bubber on the head with the wrench, and they let me come home."

Stuart's eyes blinked, and then they were gone. They had dropped down inside his head, like GrandmaLoreen Doll.

Muriel came to the doorway wearing a pink uniform with a white lacy handkerchief falling out of the pocket over her left bosom, and a little pink box pinned high on her hair. Stuart snapped his finger at the handkerchief, but not like he used to, not like he meant it.

"Well, I'm going now," Muriel said. "Your father can show you where the dishpan is, Billyjean, and the soap, and all."

I didn't want to look where his eyes had dropped down, but when I did, it was all right, they were there where they belonged.

6.

With his back to me Stuart said, "I guess you're mad at me." He turned in profile and I could see the white corner of his jaw clicking like a machine. Strangling the words, he said, "I can't blame you—"

What will you do when you see Stuart? Shap asked.

I will climb him like a tree.

A father is a tree of life, Shap said.

"I never came to see you, did I, Billyjean? All that time you were there and I never came to see you. What did you think when I never came to see you?"

A tree sends its roots down into the ground to find water and food.

A tree grows up to the sky.

"How was I to know they'd keep you there so long? You were just a little kid, eight years old. The time went slow, one day after another. Then the years were gone. You've got to understand me. I never believed, I never believed—"

I will climb into your branches, tree of life.

I will lie in the shade of your leaves, Father.

"Do you think I would have stayed away if I had believed that they'd keep you there for thirteen years? Jesus, what a thing to do to a kid!" He turned around. The light from the window shone on

his cheek which was grainy like orange peel. I inhaled the fragrance. "You weren't old enough to know what was happening, but I knew. Thirteen years. Each day I'd think, what are they doing to her today? Each day I'd say, this is the day she'll come home. It was as long for me as it was for you, Billyjean. Longer. No, it's true. A kid doesn't know about time. I served every minute of those thirteen years. I kept telling myself that I would go to see you, and then thirteen years were gone, disappeared, and I had never gone. I couldn't do it. You've got to try and understand. I couldn't! I had my job to do. I had responsibilities . . . obligations . . . your mother . . . the house mortgage . . . payments on the car. I had to go to work every day, meet people, talk to customers, take orders from the boss, take shit from everybody. If I'd seen you in there, I could never have faced anyone again, it's the God's truth. I could never have looked anyone in the face again. I couldn't have raised my head. Say something. Aren't you going to say anything? You've got the right to say something."

When I see Stuart I will tell him to shut up.

Shut up before I hate. Shut up before I kill you.

"I was here," he said. "I had to live with the neighbors. I had to walk the street. I had to live. You didn't have to deal with that. You were shut in, but you were hid. You don't know what that was like. Like being naked. Do you hear?"

He will plead, but I won't hear.

"You're mad at me, aren't you? Answer me, goddammit."

I will cross him out.

"Are you mad at me, Billyjean?"

"No." It was hard to move my lips.

"No . . . that's all . . . just no."

"No, I'm not mad at you." It was hard to use my voice.

"I'm eating out my guts and you say no calmly, like it don't mean anything. Like you don't feel anything. Like you are dead."

I don't feel anything.

I am dead.

"What did they do to you in there, Billyjean? God, all the stuff I thought of—the snake pit, brainwashing, electric shock, chemicals, hypnotism, surgery to turn people into vegetables. What did they do to you? Did they change you?"

"Yes."

"How?"

"I'm tall."

"You see, you can joke about it. Well, let me tell you, I can't joke about it. You were always afraid of being shut up. Your mother made you stand in the bedroom closet to punish you, do you remember that? I remember it. It was the worst thing she could do to punish you. You went crazy. You came out shaking like you were having a fit, jabbering nonsense. I could see your heart knocking like it was outside your body. Was it like the dark closet, Billyjean? Did you get used to it? How did you stand it?" He hiccoughed.

"I couldn't trust myself to go with Muriel to bring you home. I was afraid to be there and see when you came leaping out, running for your life, the way you used to jump out of the bedroom closet. I couldn't watch that. I waited for you here, sweating blood, here alone in front of the TV, not seeing, not hearing. And you walk in cool as a cucumber. Did they do something to you to make you so quiet? What did they do to you, Billyjean?"

They fed me with a tube down my nose.

They tied me to the bed.

They shut me up in the covered bathtub.

"I can still hear your screams when they took you away that day." The hiccoughs continued, a kind of sob, a kind of dry weeping. "It was a Saturday. I bet you don't remember that it was a Saturday, do you? But I remember. I hear your screams wherever I go. I'm at work. I'm drinking a beer. There's only one time when I don't hear your screams and that's when I'm screwing—" He broke off, shaking with those hiccoughs again. "You don't know anything about life. They took away an eight-year-old kid, and they send you back, twenty-one years old." He studied me. "What are you, Billyjean? Did they send a child back to your mother and I? Did they send a woman? Every night for thirteen years I've heard your screams in my sleep. Could you sleep, Billyjean?"

Drops of sweat hung on his face. My nostrils flinched from a strong sharp odor and opened to it. Like ammonia now, not orange peel.

"I suppose they gave you something to make you sleep so you wouldn't bother them at night, so they could sleep. That's what they do. They keep you doped so you don't bother them."

"Insomnia is an occupational disease," I said.

He looked at me with shock, surprised that I was there, that I was real.

"I don't have any goddam disease. I fall asleep, and I dream, and I can't wake up from the dream."

"What is the dream?"

"What in hell do you think it is? The dream is that my kid is in the crazy house."

"Maybe you won't dream tonight."

He came slowly toward the table where I still sat. I looked down, but I could feel the way he walked, with his legs apart. He squatted down across the table from me, pulling a chair under him.

"What do you remember, Billyjean?"

"About what?"

"About that day when they took you away."

"I can't remember. The lid is on."

"What lid? Did they tell you not to talk about it?"

"Yes."

"Who?"

"Shap."

"Why?"

"He said that was the difference between outside and inside. He said inside we take off the lid, outside we keep it on. That's what the days are for, he said."

"Well, we're going to take off the lid one more time, Billyjean. You and me are going to take it off, OK?"

"There are too many covers. Each page of the calendar is a cover. There are three hundred and sixty-five days in the year, multiply that by—I can do it in my head, can you?"

"I swear I don't know what's in your head."

"Shap said I've got a higher than average IQ."

"Are you still nutty? Or are you pretending? You play games with me and I don't have to keep you here, Billyjean. You know that, don't you? I didn't have to take you back. You want to be home, don't you?"

"Shap says it is life. Inside is not life."

"No games, Billyjean. Maybe that kind of talk works with your Dr. Shap, but it don't with me. I want to know what you remember."

"I don't remember anything."

"You remember hanging on to me, don't you?"

"No."

"You remember begging me not to let them take you."

"No."

"You remember climbing me—"

There was a great gush of something between my legs.

Look down, look down!

A father is a tree of life.

"You told me that it wouldn't be for long," I said.

"Aaah! You remember that. You remember that I told you it wouldn't be for long. And you think I lied to you. Listen to me, Billyjean, I didn't think it would be for long. How could I know that they would keep you there? Did you wait for me to come and get you? Did you keep count of the days?"

"Not then."

"When?"

"Today while I was waiting in Shap's office, I counted the days in my head."

"Do you know why they kept you there so long?" He was breathing through his nose.

"I didn't know what they wanted me to say."

He pushed back his chair violently and stood up, leaning on the table. "Listen good, Billyjean. I'm going to give it to you straight. They kept you there all that time not for what you did, but because you were sick in your head. It wasn't a game where you had to guess the right answer. You wouldn't talk at all, not to your doctors, not to your mother, not to anyone. You wouldn't eat. You wouldn't get out of bed. You even messed your bed. They have a name for it—"

"Chronic depressive psychosis," I said. "Psychosis means a serious mental derangement."

"They had to put you into a straitjacket. Do you remember that?"

"No."

"They told your mother. They had to keep you from doing harm to yourself. They told her she wouldn't like to see you like that so she came home without seeing you. They told her it was better not to come again until you got better. They said you fought them, a little girl fought grown men. They had to tie you for your own safety. That was what I dreamed about. They had to feed you with a tube down your throat because you wouldn't eat, do you remember that?"

I swallowed. "No."

"They said you cut yourself. How could you do that? Christ, you

must have been crazy to cut yourself. Was it because you were alone? Did you think you were always going to be alone, that you would never come home? Did you think I had forgotten you? Did you really want to die?"

I hid my hands under the table. He grabbed my arms, pulling me up around the table to his side. He stared at the inside of my wrists. "How did you do it?"

"I don't remember."

"You broke your toothbrush glass—Jeezus! an eight-year-old kid dragged away from her family, from her home, from everything she knows, put into a strange place with strangers, with men in white coats, kids are afraid of doctors—you thought you were lost, abandoned. You thought I had forgotten you. You thought you were never going to see me again. Is that it?"

"Why are you asking me all these questions?"

"Because I have to know. I have to know how you felt, how you suffered."

"I don't remember."

"You must have thought you were in hell."

"There is no such place as hell."

"By God, I think—do you want to know what I think? I think you are still nutty. I think you aren't real." He found the chair under his hands and picked it up in a tight grip. "What's the matter? What are you staring at?" Then he saw the chair in his hands. "I could smash it, is that what you're thinking? That'd be one way to get rid of these damned farty chairs. It would serve Muriel right." He put it down softly. "You don't believe I would hit you with the chair, do you Billyjean? I didn't mean those things I said, not the way it sounded. It's the way I am, loud, crazy, I'm full of anger. It's a shitty life. Man is born to pain, that's what the minister said. Did you know that Muriel went to church because of you? She went to your Dr. Shap, too. Did you know that? Everybody says things they don't mean, it doesn't mean anything. Look what you made me do, you made me yell at you on your first day home."

"Did you want me to come back?" I asked.

"Christ, you'll make me mad again, Billyjean. If I didn't want you, you wouldn't be here. They said you could be discharged if someone took responsibility for a year while you were on probation. It didn't have to be me and Muriel. It could have been someone else, a foster home. Your mother and me, we talked it over.

We said this was your home. Your mother had to agree to see your doctor like she was nutty, too. I said she'd better be careful or they'd keep her there."

"You're feeling better now," I said.

His jaw tightened. "I gave your mother money to buy you new clothes. I didn't want you coming here wearing clothes you wore in there."

"Thank you for the new clothes."

"I don't want thanks. But I was beginning to wonder if you knew where the new clothes came from. I just don't want to be treated like I did something wrong. I'll level with you—"

"You don't have to."

"I know I don't have to. I don't have to do anything I don't want to." He was so mad he didn't go on for a minute. Then he said, "I thought I was going to have my little Moonface back again. You were my favorite. Bubber was jealous, even Muriel didn't like it, but I can't hide my feelings, what I feel shows. But now, I hardly know you, by God. It's like you're only half here. Maybe I shouldn't say it, but it's the truth, by God." He shook his head like he had an earache. "I don't know how it's going to work out. A kid is one thing. You have to take care of kids. But you're someone I know but don't know, twenty-one-years old, taller than your mother. I don't know what to feel about you. Your mother and me, we got used to being alone. At first, we battled. Then we settled down. Things are better, sex is better." He looked at me with a gleam like silk. "Muriel'd say I shouldn't talk to you this way. Do you know what I'm talking about?"

"Yes."

He studied me, then he shrugged. "Kids in the house make some women nervous. When I first married your mother, before—she was sure hot for me. You wouldn't get her to admit it now, but one time she went with me when I was buying a new suit and she came into the dressing room with me, and right there in the store she wanted it. I turned her on. She'd been married before, she had a kid—"

"Glenn," I said.

"You remember him, do you? He was with his father, and then his father died and he came to live with us. I agreed. I'm not a monster. Anyway, we already had you. She couldn't be natural with kids in the house. Even with the doors closed, she couldn't forget you kids were there. Now she's more relaxed. She damn well knows

there's nothing to keep me home except I want to stay. Sure I want to stay. Muriel's all right. She's a scrapper. I like a scrapper. She's a little older, a little fatter, but she's a nice big handful of woman, she's still a good lay—"

"She thinks she hasn't changed at all," I said.

"She's had a lot to change her, but she was a good mother, she fought me over you kids." He frowned, tangling his eyebrows. "Now whammo, we've got to get used to something else again. It ain't going to be easy." He flexed his arms and his shirt went tight across his chest, pulling the buttonholes.

"Billyjean thinks you're the strongest man in the world," I said.

"Now what in hell does that mean?"

"Nothing."

"Don't give me that. It meant something or you wouldn't have said it. What were you hinting at? Did I ever let you feel my hand? Did I ever give you my belt? I threatened you with it, but I never used it on you. If you ask me, you're crazy like a fox. But I never laid a hand on you. You aren't going to say that I did! Why do you call yourself Billyjean?"

"It's my name. Stuart is your name."

He put one hand on the top of my head. Not as if he knew what he was touching, but as if his hand had suddenly got too heavy for him to hold and he had to lay it down somewhere. I braced my neck and shoulders, not to tremble.

"It was all a long time ago," he said. "There is no use remembering. We'll put the lid on, like you say. Your shrink can't be all wrong."

"I'm strong, too," I said. I was strong enough to hold the weight of his hand for as long as he wanted to leave it there, but he removed it and left the room. I started scraping the dishes. He came back in a minute and said he was going out. I wiped my hands on the tea towel. "Am I going, too?"

"I can't take you where I'm going. You're old enough to stay alone. You're not a little girl. I'm going on business. I have to see a man. I do estimating now, did she tell you? The boss gets a cut, but I'm on my own on the job. I like it that way. My time's more my own. Sometimes I have to work at night. But I don't mind. We're doing all right now between us. Muriel's got her job at Henry's. He calls it the Fashion Restaurant. He doesn't say what kind of fashion. I guess that's not much of a joke. You know enough not to

leave the house. You know you're not allowed to go out. Where would you go? It's a lot of crap. Why shouldn't you go out? You've got a lot of living to make up. Be the best thing in the world for you to get balled. But while I'm responsible for you in the law, you'll stick by the rules. You hear? You'll not go out alone or you'll get my belt, I don't care how old you are."

"I'll get your dinner ready."

"Don't bother, I'll pick up something somewhere."

"Maybe you'll eat with the man," I said.

"What man?" He shot a look at me under his eyebrows. "No, not him, he justs wants to see me about a remodeling. It's just that I don't know how long it'll be. There's enough of the deli stuff left for you, isn't there? Look in the freezer. Fix what you like. You can cook, you said, you planned menus, you did everything, you said. You rotated. Let's see you rotate, Billyjean. Come on, show me. You could be a good-looking dame. You've got to learn not to stare. You've got to smile once in a while. You've got to stop watching and listening. What you listening for all the time?"

"Footsteps," I said.

"You've got to stop talking like that. You don't want people to know where you been. No need to advertise it. You don't want to scare off the fellas. You've got my height, my frame. When you fill out, you'll be fine. You've got your mother's hair, and you've got my eyes. I don't know where you got that moonface from. Heh! I like the moonface. You're going to be all right, you'll see. You just got to learn to loosen up. Come on, Billyjean, we'll rotate together."

He grabbed me by the waist and twirled me around the kitchen. "You got to forget where you been, you got to forget all that. Loosen up, Billyjean, attagirl, loosen up."

7.

I leaned against the sink counter feeling like I was still rotating, but following Stuart's movements by the sounds he made. He pulled out drawers. He changed his shoes. He ran his electric razor for a couple of minutes. I must stop listening. The front door slammed. The house shook.

While I was doing the kitchen chores, clearing the table, putting away the food, washing and drying the dishes, it was almost like I was back in the cottage. I wiped off the outside of the refrigerator and the stove, just like Mrs. Rose said we should. I polished the chrome faucets until they shone. The girls always laughed when they polished the sink faucets. They laughed even when they put a cork into a bottle. I found the floor mop and wiped up the floor. Then there was nothing to do.

I went into the front room. I didn't know if I was allowed to turn on the television. I didn't know where Muriel had put my suitcase. The front bedroom was theirs, and then came the room Billyjean had shared with Bubber, and then came the bathroom, but I didn't go snooping. I thought about the garden out in back, but someone might see me and talk to me. I stayed away from the windows. When it got dark, I liked it better.

I didn't turn on the lights. I could see there were lights on next door on both sides. They were there, but they didn't know that I

was here. I walked about the house as safe as if I wasn't real. I thought about cute Dione and Diane. From the Bernhards' side I could hear the hi-fi. Mr. Bernhard liked to play his classical records very loud. "That's the way you hear it when you go to the opera house, sound all around you," he'd say. I remembered. He followed the music with his hands, pretending he was making it. Then Daddy would turn up our radio real loud, but it didn't make him feel better, because Mr. Bernhard didn't even know that Daddy was getting even with him. I wondered if Mrs. Bernhard would ask me to call her Auntie Bessie now. I wondered if Max played hide-and-seek with Dione and Diane. I wondered if he had given Diane a good-luck dollar. . . .

I was startled when the front door suddenly flew in. I jumped to my feet, afraid. The light went on and I almost screamed. Then I saw it was Muriel.

"My! You sure gave me a scare, to come home and find the house dark like no one was here," she said.

"You scared me, too."

"I didn't know what to expect, I didn't know what I'd find."

Was she afraid that she might find Bubber on the floor, his hair turning red? Could it happen again?

"Why didn't you put on the lights? What on earth were you doing in the dark, Billyjean? Why were you sitting on the floor?"

"I like to sit on the floor in the dark."

"It's queer. Where's your father?" She went around the room turning on all the lamps. The brackets held her mouth in a deep trap. It was too much light, blinding, like too much God.

"He went out."

"He was supposed to stay home with you. Why did he go out? What happened? Did you two fight?"

"What about?"

"How do I know, for hevvins' sake. I'm asking you."

"We didn't fight. We rotated."

"You—what?"

"It's a joke. We danced. It was nice."

"Then why did he go out?"

"He had to see a man."

Muriel's cheeks went loose. All of a sudden she looked very tired. "You worked hard, didn't you?" I said, feeling sorry.

"They don't pay me to dance, I tell you. I'm dead." She stepped

out of her shoes with the pointy heels. "Why were you sitting in the dark?" She came back to that.

"I was sleepy."

"Why didn't you go to bed?"

"I don't know which is my bed."

"The one that's made up in your room, for hevvin's sake. Where else? You haven't forgotten where your room is, have you?"

"I know where Billyjean and Bubber's room is."

"Well, now you have it to yourself. When did your father go out?"

"Before it got dark."

"You know how to tell time, don't you?"

"I didn't look at the clock."

"Did he help you do the dishes?"

"I didn't need any help."

"Is that what you said to him?"

"No."

She looked into the kitchen. "You cleaned up real good," she said grudgingly, the brackets letting go of her mouth a little. "Thank you."

"You're welcome."

"Well, go to bed now. It's been a big day for all of us." She went ahead and switched on the light in the second bedroom. "It's the same twin beds, but I put them up like bunks. It makes more space in the room. I made up the lower for you."

"I have to go to the bathroom," I said.

"Well, what's stopping you? Why don't you go, for hevvins' sake? You know where it is."

It was almost Niagara Falls. When I came back, I knew something was wrong. Muriel was waiting for me.

"What did you do all day when you had to go?" she demanded. "Where did you go? If you've done something dirty—they told me you were as good as well. I can't deal with something like that."

"I didn't have to go before. I can hold it."

"It's not normal," Muriel said. "It's not good for you to hold it that long. You don't want something else to go wrong, do you? After this, don't try to hold it, do you hear? Don't look so worried. I guess it didn't hurt you this time. Well, your first day is over—" She yawned and scratched under her left breast. "How does it seem being back? I guess it's different."

"Yes, it's different."

"Well, good night, Billyjean."

"Good night, Muriel." I don't know if I ducked my head first or if she reached up first. I felt her rubbery lips on my cheek.

"I'm going to close your door."

"In the cottage we had to leave the doors open."

"Here we keep them closed, if that's all right with you."

"It's all right with me."

Muriel had put my suitcase on the upper bunk. I would have liked to sleep there, but it wasn't made up. I put my flannel night-gown over my head and undressed under it, as we did in the cottage. The closet door was closed. I didn't want to open it. I put my new clothes neatly on the chair. I didn't like being in the lower bunk. I felt closed in. I couldn't breathe. I had to stop scaring myself. I could breathe. I had learned to breathe in the straitjacket. I had learned to breathe with the tube down my throat. I had learned to breathe. . . .

There were angry voices in the dormitory. The whimpering grew louder, grew into fear. I pulled the covers over my head and tried not to hear. Squishing footsteps rushed around. The cries grew louder, then weaker. The thing that made the sounds was dying. I uncovered my head too soon. "You filthy ape," Muriel screamed. "You run off to your whore and leave me with all the trouble which is yours as much as mine."

"You want someone to baby-sit with her, you quit your job and stay home," Stuart shouted back. "And let's make it clear who you're calling a whore."

"You've been with her, I can smell her on you. You can't come to me with her smell on you."

"I'll come smelling anyway I want, by Christ."

Something crashed and splintered. "I'll fix you for that," Stuart roared. The running feet in the corridor started again. Splat, splat. The footsteps stopped. Someone was making mudcakes. Muriel grunted. Then she screamed. More mudcakes. Then Muriel was pleading. "Don't, Stuart, please don't hit me, Stuart don't hit me in the face. I can't go to work if you hit my face. I won't ask you to do anything for her. I won't bother you again. I'll take care of her myself. I'll do everything."

"If you hadn't always wanted more money from me, if you'd been

satisfied with what I could give you, you would have been home where you belonged, and none of this would have happened."

"It was Saturday, you were home. What were you doing, may I ask?"

"What kind of a crack is that?"

"Take it anyway you want to take it."

"No, you tell me. Go ahead, Muriel. What have you had rotting in that cesspool that passes for your head? Tell me, or I'll give you some more of the same, I'll knock it out of you."

"Stuart, you'll kill me—Stuart!—for God's sake—I didn't mean it, Stuart. Please, Stuart, I didn't mean anything."

I scrunched down under the covers unable to shut out the sounds. There was only one way to shut them out. I didn't want to take that way. I had made myself a promise I'd never do that again. I wasn't eight years old any more. I wasn't nutty any more. I would not do it. I would not. In the end, I did it.

8.

I was lying in the covered bathtub. Sun was streaming in with sweet organ music and the sweet and sad smell of flowers. Someone was weeping. I could not blink my eyes. They were filled with water and the water was running down my face. I was dead and not dead. A shadow fell on my left arm and slowly spread across my body cutting off the light. They were closing the coffin! I tried to scream. A tube in my throat cut off my voice. They were filling me in with dirt. I was bad. I had to be punished. "No, Billyjean, you are not bad, the door is open, you can come out any time you want." I leaped up, banging my head on the upper bunk.

Next door on the driveway, a car engine was warming up. Then the motor was cut off and there was silence. In the silence were voices. One was like rich mince pie, the other was like the crust, crisp. I crouched on the floor, listening. You have to stop listening, Billyjean. It was my second day at home.

"Tap the horn, Matt." This was the crust.

"It's Sunday, Claudia. Everybody doesn't get up at the crack of dawn." This was the rich mince filling.

"It isn't the crack of dawn and, anyway, it would do them all good to get up and go to church."

"If I was the defense attorney I could offer cogent argument to

oppose your reasoning, but if I was the presiding judge, I would have to say you have merit."

Both voices made soap bubbles. I moved closer to the windows.

Upstairs a window opened. "Dad? Diane doesn't have her Sunday-school money. She's trying to borrow from me."

"I lost it, Daddy."

"She didn't lose it, she put it in her bank, and now she wants to get mine."

"No, Daddy, honest I didn't. If I did, it was by accident."

"It was on purpose!"

"Honest, Daddy, it was a mistake."

"You admit then that you did it."

"Never mind, Dione."

"It was a mistake, Daddy."

"All right, puss, I think I can manage a small advance."

"Thank you, Daddy. I love you better than the whole world."

"You shouldn't let her get away with that, Matt. She must learn to be truthful. I worry about her. She makes believe too much of the time."

"Claudia, she is eight years old. At that age she lives in a world of her own."

"Dione wasn't like that."

"He'll be a lawyer like me. She's imaginative. Creative. Like her mother. Maybe she'll be an artist. Would you like that?"

"I want her to be happy . . . normal."

"She will be, Claudia. We'll see to it."

A door slammed. Feet pounded. I crouched.

"Hush, children. People are asleep next door."

"Why doesn't everyone go to church like us, Mama?"

The car drove away.

It was quiet in the house now, quiet in the whole world. Then a dog barked, and that started dogs barking all over the neighborhood. I could hear the bark being picked up first in one direction, then in another, farther and farther away, making rings in a pool. Then a man's voice shouted abuse at the dogs, the first dog was quiet, and one by one the rings were gone.

I put on my denim uniform. My new clothes were on the chair. I knew I must hang them in the closet. When I opened the closet door, someone was watching for me. On the shelf was Bubber's teddy bear with shoe-button eyes, just like Bubber's eyes.

Muriel came into the kitchen with her lip swollen and one eye discolored. "Coffee smells good," she said, adding, with her hand feeling her face like a blind man, "I ran into the door getting up in the night."

Mrs. Bernhard called to her from her breakfast-nook window which was just across from our breakfast-nook window. The houses were only a few feet apart on this side, set back from the lot line the minimum the law required. Mrs. Bernhard and Muriel had got in the habit of talking through the open windows beginning a long time ago when Muriel couldn't leave the baby, who was Billyjean, and Mrs. Bernhard even then wasn't supposed to walk on account of bad legs, or even to stand much. Sitting, she kept her feet up on a stool. Mr. Bernhard ran after her with the stool. Some days he had to carry her from bed to the sofa in the front room, and she stayed there all day, with a day woman to do for her until he came home. Mrs. Bernhard had been calling for a long time and tapping with her rings on the windowpane.

"She'll break her diamonds one of these days," Muriel said.

"Diamonds are harder than anything," I said.

"I suppose you learned that in your jewelry class."

"In chemistry. We didn't have a jewelry class."

Finally Muriel leaned over the table and opened her window.

"I thought you'd gone deaf," Mrs. Bernhard said. "I got a peek at her when she walked from the car to the door yesterday. She's got a beautiful figure, tall like her father, and a beautiful long neck. I couldn't believe it was our little Billyjean." Her voice got thick like she was trying to talk with her mouth full. I left the kitchen and went to stand in the hallway in the middle of the house where I could pretend that I wasn't real. But I had to listen.

"Stu's not feeling good today, Bessie," Muriel said.

"Nothing serious, I hope."

"Nothing to do with you-know-who—if that's what you mean. He had too much to drink last night. He always has to drink when he's out with a client. It's for a kitchen remodeling, a nice job."

Mrs. Bernhard sighed. "A woman."

"What does a man care about kitchens."

"Muriel, this is me, Bessie."

"It's the truth, Bessie."

"And how are you, Muriel?"

"Well, you know how it is when Stu's not in a good mood. I

thought I'd tell you, in case you and Bernie were thinking of coming over."

"You know we were."

"Stu'll probably stay in bed all day."

"Then I'll come without Bernie and sit in the kitchen with you and Billyjean."

"Stu needs a lot of attention when he's like this, I wouldn't be able to sit still."

"You spoil him, Muriel."

"Maybe I should have varicose ulcers so he waits on me."

"You shouldn't wish for varicose ulcers, not with your nice legs, Muriel. I'd give anything to wear sheer hose again."

"I'm sorry, Bessie."

"Don't mention it."

"Maybe next week, huh?"

"How is she?"

"Billyjean?"

"Who else? Maybe Jackie Onassis?"

"She's fine."

"But?"

"Of course it's been a long time since she was in a regular house."

"Doesn't she know how to act? God in heaven," Mrs. Bernhard said.

Muriel's voice dropped so I could hardly hear. "Last night she didn't even put on the lights when it got dark."

"I saw that. I told Bernie. Bernie said she and Stuart must have gone out. Oh, the poor little scared baby."

"Stu couldn't take her. It was a business deal, Bessie. She didn't go to the bathroom the whole time, not until I got home from work."

"What do you mean? Where'd she go if not in the bathroom?"

"She held it."

"God in heaven, what did they do to her? I feel for you, Muriel. It isn't easy."

"You're telling me."

"It isn't easy for Billyjean," a man's voice growled. I smelled cigar smoke. It made my head ache.

"Is that you, Bernie?" Muriel asked.

"It's Max," Bessie said.

Standing there in the hallway, I began to shake. I hadn't thought

about seeing Max. I couldn't remember about Max. I knew I had told him about Phil and he didn't like Phil. He said Phil was too old for me. But I wasn't sure what else had happened under the back porch that summer evening when we played hide-and-seek.

"Max phoned, Muriel. Naturally I told him the news. Naturally he came. We love Billyjean. What does she say?"

"About what?"

"About that place. About everything. About what they did to her, what it was like."

"It was nice there. She told Stuart that they even have an electric mixer in the cottage. We wouldn't have left her where it wasn't nice."

"I know that, Muriel."

"They lived like anybody lives. They kept house, did the shopping at the commissary, went to the movies once a week, went to the dentist and checkups with the doctor. She did the flower arrangements. She likes things pretty."

"She takes after you in that, Muriel."

"It was like living anywhere."

"Except," Max said, "she doesn't know that she is allowed to turn on the lights or to go to the bathroom unless she's told."

"Be still, Maxie," Mrs. Bernhard said. "She can be a big help to you now, Muriel."

"She'd better be. Another person in the house makes a difference all around. It's a good thing I have a full-time job."

"Why don't you say what you mean, that she's a burden."

"Maxie, please."

"I'd better go check now," Muriel said.

"Sure. You don't want her to miss her jailer," Max said.

"You tell her that her Aunt Bessie asked about her, Muriel. I held her when she was so small she sat in the palm of one hand. I gave her her first bath when you came home from the hospital with her. You remember, Muriel? My, how she cried! Such a strong pair of lungs she had. And an arch to her mouth like I've never seen. I thought she would be an opera singer. Bernie thought so, too. You tell her her Aunt Bessie will be over to see her."

"Next weekend, Bessie, I'm planning a little party, a homecoming for the close neighbors, to introduce her."

"Remember how she used to crawl after Bernie when she

couldn't even walk yet. She went on hands and feet like a little bear. She didn't want to get dirty, the little darling."

"I remember, Bessie."

"I never saw another child do that. She was different from the moment she was born. Oh, God in heaven—!"

Muriel pulled down the window and latched it. In the hallway I leaned my head against the wall. Muriel came to look for me. "What are you doing, hiding, Billyjean? If you are going to act queer, you are going to make it hard for me and for yourself."

Stuart bellowed for Muriel and she went to him in her bent-knee trot. I went to my room. I climbed up to the top bunk. I had to think about Max. What else had happened? I had to remember. He was all mixed up in my mind with Phil, and Phil was mixed up with the littler boys. Only Michael was clear, his game was different. I had worried about a lot of things, but I hadn't worried about this. I sure was a loony. Who was it said I wasn't big enough? It was good to be big, and bad to be little. They laughed because I was little. Not even two fingers, they said. I didn't know what that meant. The other girls were bigger so I couldn't ask them. The boys made a sign about me. I didn't know what that meant either, but I kind of did know. They laughed and I knew they were laughing about me. Max hadn't laughed, but he said I was too little, too. I felt hot with shame again. Until I remembered about Max, he mustn't see me. I heard Muriel coming and I climbed down from the top bunk. Muriel would think that was peculiar, too.

"For hevvin's sake, you haven't unpacked yet."

"Am I going to stay?"

"What kind of a question is that? Of course you're staying."

"It isn't easy for you."

"Were you snooping on me, Billyjean?"

"You and Stuart fought about me last night."

"You had no business listening."

"It woke me. He was mad because I'm here."

"That's the way men are, that's all. It doesn't mean anything. He just doesn't like his routine upset. It was my fault, too, in a way. I was mad because he went out last night. He said you don't need a baby-sitter, that's all he meant. Billyjean, that's all it was. Maybe he is right. I shouldn't have gone at him because he left you alone."

"You didn't run into the door, did you?"

"Now see here, Billyjean, you are still the child, not the mother. All right, I didn't run into the door. Your father's got a temper. You ought to remember that. You have it, too. You got it from him, not from me. But when I get mad, I can get pretty mad, too. I've got a black eye, but he's got a cut on his head from my jewel box. Married people act like that sometimes. Don't worry about it. You'll see for yourself, when you get married. No reason why you shouldn't. You don't have to broadcast where you've been. I suppose it's bound to get out." She sighed.

"Where did he go last night?"

"You know. You told me."

"You told Aunt Bessie he went to see a woman."

"So, if you heard what I said to her, you know as much as I do. Let's stop going at each other. We're all in this together. I won't have you spying on me. I won't have you checking on what I do and what I say. You're the one on probation, not me. We'd best be friends, if we can't be relatives. Heh, that was meant to be a joke. It's too late for me to start all over again being a mother. It's too late for you to have a mother at your age, checking on you."

"Are you my jailer?"

"I warned you, Billyjean. If you want the truth, yes, I am your jailer until you get off probation. Then you'll be on your own, and I'll be as glad as you. You can put a family together again but not in the same way, because we ain't the same people. That's why I said you can call me Muriel."

"And you can call me Billyjean."

"Billyjean, you are not eight years old any more. I guess you're not twenty-one either. Time in a place like that where you've been ain't like real time."

"Who said that?"

"Your Dr. Shap said it."

"Then how old am I?"

"He didn't say. Honest, I don't know, Billyjean. I don't know anything any more. Stuart thought it was crap for me to go to the doctor, but I didn't know. If the doctor wanted me to see him so you could come out, I said I'd do it. I wanted to make it up to you."

"For what?"

"For what you did, what else? The doctor said you didn't know what you did. When something happens to a child, he said, you

have to ask yourself why? I swear I don't know why. I don't know what went wrong."

Stuart was banging on the floor with his shoe.

"Don't go," I said, "don't go yet. Please." I found the can of talcum powder in my suitcase and gave it to her.

"Where did you get this? Billyjean, where did it come from? Answer me!"

"It's mine. Honest. I didn't steal it. Mrs. Rose gave it to me. You can ask her. I want to give you a present."

"I'm sorry if I sounded like I didn't want it. Thank you for the present, Billyjean."

"It's violet."

"I like violet."

"It lasts," I said.

"Look, Billyjean, you're going to be all right."

"The girls in the cottage made me these potholders. We can use them in the kitchen, if you like."

"Not much use in potholders if they aren't used. But they're pretty."

I didn't tell her about the present from Shap.

"The way I figure it, you can catch up fast now that you're out, because you are not a child. Don't blame your father—"

"For what?"

"For what you heard him say. It's hard to get used to a child turning into a woman like overnight. It's hard to know what to feel, how to act. He always favored you, Billyjean, over Bubber. Fathers always favor girls." Her mouth tightened. "I want you to have your chance at life, it's only fair. But you have to do your part. I got to go to your father now."

I went into the closet and shut the door. I found the little box with the friendship ring that Shap had given me. I didn't put the ring on. I didn't take it out of the box. I just held the box tight in my hand until it hurt. Love me, Mama, I screamed into the dark.

9.

"Your father says that you sleep with the covers over your head."

"Why did he come into my room? He shouldn't come into my room when I don't know it, when I'm asleep."

"Billyjean, it isn't healthy to sleep under the covers. Why shouldn't your father come into your room? He came in to wake you. I told him you'd get his breakfast for him. I work hard. I need my morning sleep. The least you can do is get your father's breakfast."

I didn't sleep well after that, worrying that Stuart would come into my room when I was asleep. Even after Muriel bought me my own alarm clock.

Sometimes Stuart came to the kitchen in his undershirt to take a cup of coffee into the bathroom with him. He would be half awake, scratching, smelling of sleep. It was a smell like the toast and coffee I was fixing. Muscles made his arms and shoulders shiny. There were curly red hairs on his chest. Once he asked me to scratch a spot between his shoulder blades. "Harder," he said, and then he had to yell at me to stop. "You'd scratch me raw, wouldn't you, until I bleed."

I fixed eggs, two over lightly, with bacon and fried potatoes. I put the catsup bottle on the table.

"You and me are a lot alike, Billyjean. You're more like me than like your mother. She doesn't even know where she itches."

Mostly breakfasts were silent. Stuart hated getting up. "I never get used to it," he grumbled. He left the house before eight. Muriel didn't get up until noon most times.

"He didn't let me get much sleep last night," she said. "But I've made up my mind he's not going to be able to complain about me. He's not going to be able to say that I refuse him. He's not going to have that excuse for going to his—" She stopped. "Do you know what I'm talking about?"

"About his whore."

She pulled down her mouth into the wrinkle brackets. "Well, I guess you got a right to know. I'll be glad when your probation is done with. You can find out about men for yourself then. Your father is a good man, but he's a man. You can't put out a fire by banking it, my father always said."

"What fire?"

"Either you're a good actress, Billyjean, or you don't know as much as you think you know. I never could tell what you were thinking, even when you were little. I always said you were born old."

"Yes."

"Bubber wasn't like that. Bubber was an open book to me. Glenn was an open book, too."

"Bubber knew a lot," I said.

"I didn't say he wasn't smart. He took after my side, looked like my father. Daddy worked with his head, not his hands." It was a shock to hear her call her father, Daddy. "He was an insurance adjuster. I wanted Glenn to study to be a lawyer or something. I planned to send Bubber to college, too. What the hell! It was a long time ago, water under the bridge."

"Yes, there's no use remembering."

"Is that so, Miss Smarty!"

"Stuart said it."

"Now don't you go blabbing to him that we talked about Glenn, do you hear? I don't suppose you remember Glenn."

"I remember him. I love him. He was nice to me. Sometimes he looked after Bubber for me." She looked at me as if I had surprised her.

She went to work at two in the afternoon, dressed in her pink uniform that I washed and ironed for her. I was supposed to have Stuart's dinner ready, but he'd usually phone to say he wouldn't be home. Sometimes he didn't phone. Muriel ate her dinner at the restaurant. She was served by one of the other waitresses, just like she was a customer. She could order anything. She came home a little after ten o'clock. Sometimes Stuart didn't come home until much later. Those nights Muriel took a bottle into the bedroom with her, and when Stuart did come home there was the yelling and the blows and then the sounds of making up. I knew about those sounds; I'd always known about them, even when I was eight years old. I didn't know when I learned or how. Maybe, like Muriel said, I was born old, born knowing. But Bubber knew them, too.

Bubber and I shared the bedroom. At first we shared a single bed, sleeping feet to feet. Mama came in in her wrapper held closed around her, which meant that she didn't have her nightgown on under it, and found me and Bubber side by side under the covers. "What are you up to?" she demanded, her eyes jumping all over the bed like she could see through the covers, like she could see even into my head. "What have you been teaching him? Look at his face. He's all flushed. If I ever catch you—"

"Teaching me what, Mama?" Bubber asked.

"Never mind, Bubber angel. It's too hot to sleep side by side in bed."

"You don't get too hot sleeping with Daddy."

"That's different. It's a big bed. Billyjean knows what I mean."

"Do you know, Billyjean?"

"You watch what you tell him, Billyjean."

After that we got new beds. They were bunks, but Muriel wouldn't let us sleep on top of each other, so the beds were set side by side like twins. It crowded the room. It was hard for Muriel to make the beds. She looked at me with her mouth tight even then, with the brackets not so deep, but beginning. It was my fault that she had to work so hard making the beds. I was bad.

I dressed and undressed in the closet. Bubber tried to hold the door and keep me in. Sometimes he got in with me and he'd bump his head into my stomach and pummel me down there with his fists. I wasn't supposed to fight him back. I had to remember that he was little, only half my age. He pummeled and watched me

with his bright black-button eyes, eyes like his teddy bear's. He knew I was weak and sweet. He was only four years old, how could he know? I didn't teach him.

Muriel had to take me to the doctor because my nipples were sore. She was ashamed of me.

She was ignorant, Shap said. Sometimes as early as eight, the breasts begin to develop. Puberty begins in childhood.

She was ashamed because I was bad.

While Muriel got her morning sleep, I tried not to make any noise and disturb her. There wasn't much to do. I could iron, but when that was finished, there was nothing but remembering. After Muriel went to work, I cleaned the house. This was a good time. I kept the house spotless.

Mrs. Bernhard came to the front door and to the back door afternoons when Muriel was gone. "I'm not supposed to be on my feet," she'd call through the door. Every day she came bringing something for me, cookies or fudge or gems that Mr. Bernhard baked. He was a good cook because she couldn't cook. When I caught sight of her coming across, or when the doorbell rang, I went to stand in the hallway where no one could see me. She'd leave the things outside the door. "I brought you some doughnut holes," she called through the back door. "You used to love Bernie's doughnut holes."

If she called three times, I'd say I would go to the door, but when she called three times, I changed the rules. When I was sure she was gone, I opened the door to take what she had left there. I always wanted to know what it was. One day when I opened the door, she was sitting right there on the back step. She hadn't gone home. "Hello, Billyjean sweetheart."

My lungs were squeezed. I couldn't talk.

"Why did you make me come so many times, eh? You were shy, weren't you, little sweetheart? I said to myself, the little darling is shy. So this time I sat down and waited. Are you glad I waited?"

I nodded. I was glad.

"But it isn't a smart way to act, Billyjean sweetheart. It can make trouble for you. Anybody interested in seeing you put back in that place could say that you are not acting like an ordinary person, they could say that you are acting queer, even like a crazy person, they could say, and you'd have no comeback at all. Because you are acting mighty queer. I shouldn't be on my feet so much. Bernie

gives me hell. I come because I love you, Billyjean, more than I love my own legs."

"Who is interested in seeing me back in that place?"

"Help me up, Billyjean sweetheart, and let me come in. I'll sit for a minute in the kitchen." She walked with quick little steps as if when she went fast, she would outrun the danger to her legs, of breaking open the ulcer sores. She hardly came past my shoulder. She sat down on one of the yellow chairs, and I pulled another one forward for her feet.

"Think of your remembering that!" she said, catching my arm and holding it tight. She pressed on my arm, and I had to kneel beside her. Now we were face to face. She took my face between her hands. "Billyjean," she whispered, "little Billyjean." She brought her face so close to mine that I had to close my eyes. She pushed my head into the soft pillow of her breasts. She smelled of lemon and faintly of milk. "Oh, Billyjean," she crooned, rocking and crying, "welcome home, sweetheart, welcome home." She pulled my head out of her bosom, searched my face through her tears, and pushed it back into the pillow. "You're the same Billyjean."

She had changed, though. She had become a real old lady. She hadn't been young before, but now she was maybe old enough to die. Her skin was wrinkled and spotted under the makeup, and her hands flashing with her diamond rings were stiff. She wiped under her eyes with a finger that was big knuckled and painted a purplish red, careful not to smear her mascara, but trembling so that it smeared just the same. Her nose was a thin beak between painted cheek knobs. She looked like an old molting parrot. Her hair, dyed red, stood up like feathers.

"Bernie and Max said you'd be changed. They warned me to be prepared. But they were wrong. I said nobody would change you and I was right. You are the same lovely little madonna. Praise be to God! You're like my own child, the one I couldn't have, because of these legs. They wouldn't even let me adopt a baby."

"Mrs. Bernhard, who is it?"

"Who is Mrs. Bernhard, sweetheart?"

"Aunt Bessie, who wants to put me back in that place?"

"Make me a cup of coffee, sweetheart, powdered will be fine. Just put on the kettle with a little water. I drink it black now, with just a little sugar and a drop of milk. I have to keep my weight down and be kind to these poor legs of mine. It's like you've never been

gone, Billyjean, only now you are waiting on me instead of me fixing you an ice cream cone or a popstickle. Remember the popstickles? That's how you called them, popstickles. It was very clever of you because they were on a stick."

In her throat there was a kind of soft sac that swelled up and collapsed, like someone was breathing into a balloon. She didn't seem to know it was showing outside her body.

"I didn't mean anyone was looking to send you back, little sweetheart, but it won't look good on your mama's report. 'Avoids neighbors and old friends who love her.' Tell me the truth, Billyjean, how did they treat you in there? I see the same little-girl face, sweet and unmarked, those clear eyes waiting to see what life will bring, wondering about everything, expecting miracles. It breaks my heart."

"I'm a lot bigger," I said. "I am the tallest in the cottage."

"You're beautiful and tall, and thank God you are not any longer in the cottage."

"I've got a better than average IQ."

She snorted. "Of course you have. You are exceptional. You always were. You knew more than any child should be expected to know. It was too much, too heavy, it was a burden. I was afraid for you, that you'd get hurt. You knew how people felt, you knew what was in the wind, you were part of everyone and everything you looked at, a blade of grass, a caterpillar. You made a pet of a caterpillar, and when he crawled out of your box at night, you went looking for him in the garden the next day until you found the same one. You could walk up to a butterfly and pick it up so lightly and lovingly with your little matchstick fingers that you didn't disturb the powder on its wings. You loved those butterflies like you loved your brother. You had too much love. You need to love, to live. How did you live in there? Look at me, Billyjean, did you find someone to love in there? Look at me, and tell me that you did it."

"Muriel came home and I was holding the wrench."

"You could not hit Bubber."

"I don't know."

"Of course you don't know. They've mixed you up with all their questions and their tests and the things they did to you."

"Muriel said—"

"Is that what you call your mama—Muriel?"

"I'm not eight years old any more. She can't have me calling her Mama."

"God in heaven, did she say that?"

"She said I wasn't the Billyjean who went away—"

"They tore you away. They had to carry you away. To my dying day I will hear how you screamed."

"Shap—Dr. Shapiro—said it would be easier to talk if we called them by their names. It was a game."

"And is it easier?"

"I told him it was."

"You love him."

"Yes."

"I'm glad you had him. You're the same honest Billyjean. Your eyes have no dark places. I see myself in them. They're mirrors but such magic mirrors that they make everything beautiful. I always said you found Bubber on the floor. The wrench was on the floor, too. You picked it up. What more natural? As to talking wild, that is natural, too. Children talk wild. Old people would talk wild, too, if they had the courage. It must have seemed to you that by saying those things, by thinking those things, you had really killed him. I'll never believe anything else."

"I said I did it."

"If you did it, it was an accident. There was no reason to put you in that place, a fragile moth child. What was it your daddy called you? Moonface. It was an accident. It would drive anyone crazy to be torn from the arms of her daddy. How you loved him! He should have gone with you, he should not have let you go alone. Yes, I know, your mama needed him. It's a wonder you didn't die of grief. It's a wonder that your brave little heart didn't stop beating. But yet, it didn't. That shows how strong and true you are. You fell sick, who wouldn't? But you got well. You must never forget it, Billyjean. You are made of strong true stuff. You must not hide in the house, sweetheart. Someone comes to the door, you must open the door. The phone rings, you must answer. You must be proud. You did not die of what they did to you. Be proud and no one can put you back there again. I'm surprised they had sense to let you come home at last. Bernie says it's part of the economy move. When they want to cut the government spending, they don't think of the big subsidies or the billions spent on war or on space. They cut the few dollars for the poor and the sick, for the victims."

"They let me come home because I proved I was well."

"And how did you prove that, my smart little sweetheart?"

"I said I did it to Bubber. It proved I could face reality," I explained.

She laughed, and then at my expression, laughed harder. "Sweetheart, I am not laughing at you," she said through her laughter. "I'm laughing at them, the clowns. They are clumsy clowns, Billyjean sweetheart. You should laugh, too. We won't take them seriously any longer. We will laugh at them."

"Look down, clown," I cried, "look down, there's something between your legs."

"That's right, they can't see what's right under their nose!"

"Look down, look down, there's something under your nose," I screamed. Now that I started, I couldn't stop. She hid me in her arms. "There, there, my poor darling," she said, laughing or crying, "the truth was under their nose and they couldn't see it."

"Bubber was under me, Bubber played the little clown. Mama said he had to back out the way he went in. I was the big clown. I tried to move my legs so Bubber would get up, but Mama held me in jail. I didn't know what they wanted me to say."

She rocked me. "You can laugh now, little sweetheart. Now the joke is on them."

"For a long time I knew that they wanted me to say something, but I didn't know what it was," I told her.

"But finally you figured it out."

"No, finally Shap had to tell me." I laughed and laughed until I cried.

When the voices grew loud, I crept into the bedroom closet and listened through the connecting wall.

Stuart was talking. "They were laughing like crazy when I came home, and no dinner ready. She's not good for Billyjean. I don't want Billyjean to have anything to do with her. She's senile. You, either."

"Stu, Bessie and Bernie are our oldest friends—"

"I don't call him friend after what he did to me over the houses. Anyway, this is for Billyjean. They were laughing about what she said so that she could get out of that place, boasting that she played a joke on the doctor, calling the doctors clowns. If I'm to be responsible for her, not just her father but her legal guardian, then by God I have something to say about who she talks to, and I say she can't talk to that crazy old Jew woman."

"But how am I going to explain to her?"

"Just tell her that I forbid it."

"Bessie loves her—"

"That doesn't mean that she's good for her. Love can be bad. Sometimes love kills—"

"Ohmygod, don't talk like that. Bessie wouldn't harm a hair on her head."

"Ideas like she puts into Billyjean's head could put Billyjean back in that place and that would kill her, wouldn't it?"

I hated him for saying that. I'd never get up to make his breakfast again. I didn't pull the alarm for the next morning, but I woke at the right time. I lay listening and heard the bed springs when Stuart got up. Then he padded by in bare feet on the way to the bathroom. Then I didn't hear anything. He wasn't shaving. Would he come to wake me so I should get his breakfast? Would he come to see if I was sleeping with the covers over my head? Pretty soon I smelled the aromas of coffee and toast. Stuart was making his own breakfast. I put the covers over my head. The coffee and toast smell was getting stronger. I didn't move. I didn't open my eyes. I was asleep. Without the covers raising at all, he was there in bed beside me. "Remember how you used to come into my bed, Billyjean? Turn about is only fair. Don't make any noise or you'll wake Muriel. You know what'll happen then, don't you? She'll throw you out of the house, she'll send you back to that place. Hold still now. I'm not going to hurt you. Hold still, girl, dammit, hold still!" All the time his voice was getting heavier until Billyjean couldn't stand it. She was going to have to move or make some sound. Then he wasn't in her bed any longer. She was alone. She had been sleeping. It couldn't have happened. But there was dirty stuff all over her belly and thighs. After she had washed she could almost forget it. She went back to bed. It couldn't have happened.

When Muriel got up, I dressed. Muriel was sitting at the breakfast table, drinking coffee. "You didn't get your father's breakfast this morning," she said.

"I guess I overslept."

"Didn't you set the alarm?"

"It didn't go off."

"Billyjean, if it didn't go off, you didn't set it."

"Maybe it's broken."

Muriel made me go with her to look at the clock. She set the alarm and made it ring. It went on ringing until I wanted to scream. Finally she pushed in the pin.

"You didn't set it, did you?"

"I pulled out the pin."

"If you pulled it out, you pushed it in."

"No."

"Admit it, Billyjean, and I won't punish you this time for lying."
Don't make any noise.

"Maybe Stuart did it."

"Why?" *She'll throw you out of the house.*

"I don't know why. Maybe he didn't want to wake me. Maybe he wanted—"

"Don't lie, Billyjean!" *Turn about is only fair.*

"I didn't do it."

Her hand hit my cheek.

"I don't like to hit you, but I'll hit you again if I have to, to make you stop lying. Your father is upset by the way you are acting."

My father—. I couldn't say it.

"He says it's the company you keep."

Then I understood that Muriel had to make herself good and mad, mad enough to hit me, and then she would tell me that I was forbidden to talk to Mrs. Bernhard.

"You were listening last night, weren't you? You go into your closet and you snoop through the wall. You always did that, even when you were little."

Bubber snooped, too.

"Do you want me to report to your Dr. Shap that you lie?"

"I like her."

The brackets beside her mouth were deeper than ever. "When you were little and she wanted you to call her Aunt Bessie, you wouldn't."

"I will now. Aunt Bessie never believed that I hit Bubber."

The blood left Muriel's face. She looked as white as Bubber on the garage floor. I watched for her hair to turn red.

"You hold it against me, don't you?" she whispered. "You hold it against me because I told what I saw. What else could I do? You were standing over him, holding the wrench. I had to say what I saw. You were grinding your teeth, muttering that you hated him, that you would kill him, little Bubber, your baby brother, and he was already lying there dead. How could you hit him, that little head with the silky hair? You think you've got something against me, but what about me? You were always jealous of him, my baby. Yes, I know, you were only eight years old. You wait until you're a mother and then you will know how I felt. Bessie's never been a mother. What is she doing now coming between a mother and child? Stu's right. She's doing it on purpose, to persecute us. If she doesn't believe you did it, who did do it?"

"She doesn't know."

"I suppose that wrench just fell on Bubber's head. I suppose he

just happened to be there when it fell off the bench and it hit his head hard enough to kill him."

"Maybe."

"You're crazy!"

The word bounced back and forth like a ball from wall to wall. I ducked.

"And she's crazy! Stu's right. She's senile. She's bad for you, Billyjean. You don't want to go back to that place, do you?"

I didn't know. I didn't know what to do.

"If you don't want to go back there, you must not talk like that. Dr. Shap was pleased when you said what you had to say. It showed that you were in touch with reality. Don't look at me like that, that's what he said. Nobody blames you, Billyjean. No one wanted to punish you. But you had to admit it to show that you know what is right and what is wrong and what is real. Now I don't know what he'll do."

"You don't have to tell him. On the outside you don't have to say what you don't want to say."

Her mouth fell open showing its purple interior. "Who told you that? Bessie?"

"Shap did."

"Billyjean, I'm warning you."

"He did say it. You can ask him. He said the days are covers. On the outside, you don't have to tear them off."

"All right, never mind. Now we're talking about something else. If you behave, I won't tell him this time. There are things about the Bernhards that you don't know, you were too young to know then, but it's time for you to know so you can understand how your father feels. Way back, your father had a partnership with Bernie— Bernie's money and your father's hands that could make things. By rights your father should have had a bigger share because anyone can make money, but to make things is special. Anyway, your father agreed to a partnership. They built houses, first one and then they'd put it up for sale, and then another, and so on. We thought we were going to be rich." Her eyes lit up with the dream, then faded. "The houses always cost more to build than Stuart figured, and something was always going wrong and having to be torn out. It wasn't Stuart's fault. The building inspectors picked on him. Bernie was losing money, but your father wasn't even getting a decent wage, so they dissolved the partnership. But Bernie blames Stuart to this day, as if Stuart had stolen his money; you know how Jews

are about money. When Max came home from the Navy with his leg off, it started all over again, the arguments. Max had some money in the business, too."

"Is that why Stuart doesn't want me to talk to Mrs. Bernhard now?"

"Of course not. I'm telling you to show you what kind of people they are. Your father says God knows what Max does in Vegas. Those secondhand-car lots could be a front for gambling, maybe worse—"

"What is worse?"

"Prostitution. The Mafia—"

"The Mafia is Italian."

"They look alike. Your father says Max could even be a member of Murder, Inc."

"What's that?"

"It's a business. It hires out hoodlums to kill for money. They get rich from it."

"Did they hire someone to hit Bubber?"

"Billyjean, you've got to remember that you hit Bubber." She sighed. "They could be getting back at Stuart by trying to put you back in that place." She jerked her head to show who she meant.

Everyone was saying that someone else wanted me back in that place. Maybe I ought to go back before something bad happened. Maybe I ought to go back before Stuart came into my bed again. Where else could I go besides back?

We heard Mrs. Bernhard tapping on her window with her rings, which was the way she always attracted Muriel's attention. "Ignore her," Muriel said, "pretend you don't hear. We've got other friends in the neighborhood. We don't need *them*. Actually I'm the only one ever was friendly with her. People don't trust Jews. We'll invite the Campolinis over to meet you—you know, the people on the other side. Diane and Dione's parents. They're Italian Catholic, but Jews aren't even white. Maybe we'll have them for Sunday dinner. Well, it doesn't have to be dinner. For a drink and some nibbles. We'll make it casual. Dinner would seem too important, like we're trying to prove something. Get ready now and we'll go to the store. If we happen to meet Mrs. Campolini there, I'll invite them real casual."

Usually Muriel hollered to Mrs. Bernhard when she was going to the store, to see if she needed anything, though Mrs. Bernhard ordered by phone from a store that delivered. Naturally, this time Muriel didn't holler to her. As we backed out of the driveway, Mrs.

Bernhard was on her front porch. Her mouth was open, but Muriel didn't stop the car. We couldn't hear what she was calling out because the car windows were closed. I looked back and Mrs. Bernhard was still standing there.

I liked to go to the shopping center which was called Normandy Village. "Normandy is a region of France," I said to Muriel. The roofs of the shops were thatched to imitate the roofs over there, and there were cute little shops that sold things imported from France. There was a cafe with flower boxes and umbrellas and waitresses dressed in costumes of Normandy. Across the street was the Coop. "Where the radicals go," Muriel said. "It shouldn't be allowed." The supermarket where Muriel shopped had a thatched roof and cottage doors with baskets of imitation flowers that looked exactly like real.

Muriel introduced me to the lady at the cash register who said politely that she was glad to make my acquaintance. At the same time I could see other words crawling across her eyes like those news bulletins that the networks put on TV when they don't want to interrupt the program showing. "So this is the one who hit her little brother on the head with the monkey wrench, this is the one who's been in the loony house all these years, this is the crazy one, my! it must be hard on Muriel to have her home." The words crawled from right to left across her eyeballs, like insects, while her mouth said, "You've got a wonderful mother, Billyjean, the salt of the earth. Your father is the salt of the earth, too."

We didn't meet Mrs. Campolini then, but on Sunday Muriel was watching for them to come home from church. "Why don't you all come over for a little drink later on and meet Billyjean."

Mr. Campolini said it sounded like a great idea. This was the rich mince-pie voice. Mrs. Campolini reminded him that they couldn't, much as they would like to. Isabel was expecting them. "My sister, Isabel Logan. Poor Isabel lost her husband less than a year ago." Mrs. Campolini wore a small hat and white gloves. She stood very straight and spoke very crisp.

"Tomorrow then," Muriel said. "Monday's my day off so it won't be any trouble. Bring the children. Any time after five."

We were ready at five o'clock and we waited. Stuart complained. He didn't see why he had to wait on them for his dinner. Muriel's mouth was clamped tight so she wouldn't say anything and start a fight. When the Campolinis arrived, full of excuses, Muriel said they weren't a bit late.

"We can never sit down before seven because of Matt's work," Mrs. Campolini said. She had a narrow severe face with regular features, and skin with no color. Her long straight black hair was pulled back from a center part. "The children ask to be excused. They both have schoolwork to do." Nothing at all crawled across her eyeballs as I was introduced.

Mr. Campolini was very different. He was big like a football player, and he looked as rich as he sounded. He took my hand in both of his, and his were large and warm and dry. I would have liked to stay there in his hands. He made me feel rich. His face was craggy but the flesh was soft and well fed. He rolled up his eyes in a kind of funny way, but I liked it. The whites were yellow as if they were stained by cigarette smoke. "And who is this beautiful young lady?" he boomed.

"I'm Billyjean," I said.

"Where have they been hiding you?"

Mrs. Campolini coughed.

"I've been sick."

"Well, you sure look 100 percent okay now."

"I've got to be on probation for a year. Then I can get a job." There was a pause and I said, "I took a business course." I explained how we figured the speed in typing taking off ten words for each error. "I can do arithmetic in my head."

"Young lady, if you ever want a job, you come and see me. We can put you to work at Campolini and Cioffari if you're good at typing and arithmetic."

"I'd like to come and see you but I have to wait—"

"Stuart, find out what Mr. Campolini drinks," Muriel interrupted.

"Is there a Mr. Campolini here? I see Matt and Claudia—"

"And Stuart and Muriel," I said.

"And Billyjean," Mr. Campolini said, with a bow. I bowed back. I loved Mr. Campolini. I passed the hors d'oeuvres platter to him first.

"To the ladies first," Muriel said, but Mr. Campolini winked at me and took two slices of cheese.

"This was Billyjean's idea," Muriel said, "to cut up the apple and put it back together again with slices of cheese. She saw it in a magazine. It's cute, isn't it? I like to make things look pretty."

"Appearances are important," Mrs. Campolini said. I was beginning to like her better, though I hadn't liked her right off, but I liked Mr. Campolini best.

He and Stuart talked baseball for a while and then cars. Mr. Campolini tried to prove to Stuart that it didn't pay to keep a car more than two years. Mrs. Campolini and Muriel talked television programs and fashions. Muriel sure hoped they wouldn't bring back the midi. Mrs. Campolini enjoyed long skirts for at-home functions.

"I love to look at fashion magazines," I said.

Mrs. Campolini said that she was sure that she had some recent magazines that she was through with, if I would like to have them. The Campolinis didn't stay very long after that.

"Hardly seems worthwhile getting things ready for them," Stuart said.

"Now don't go imagining things," Muriel said. "I think everything went very nice. They aren't stuck up at all."

"What have they got to be stuck up about?" Stuart challenged.

"They've got the nicest house on the street, two-story, they drive new cars, two of them, he's a lawyer, she has a weekly cleaning woman."

"What'd you say, Billyjean? Are they stuck up or not? We've been living beside them going on three years without first names and Billyjean is home a couple of weeks and pow! we've made it."

I felt proud, and then I felt ashamed.

"When school is out for summer vacation, their kids will be company for Billyjean."

"I'd say they were a little young for Billyjean," Stuart said.

Didn't he want me to talk to them either? Didn't he want me to talk to anyone? *I'm not going to hurt you, but she'll send you back to that place if you make a sound.*

Mrs. Bernhard continued to knock at the window when she saw us in the kitchen. "Hope she cracks her diamonds," Muriel muttered. But she didn't come over any more, even during the day when she knew that Muriel was at work and I was alone. Then for almost a week she wasn't even at the window. It seemed as though she was going to understand without my having to tell her. I was relieved, and yet I didn't feel good. She never believed that I did it, Mr. Bernhard never believed it either, Max never believed it either.

I spent a lot of time in the garden out back after I had done the housework. I liked it there because I couldn't be seen over the hedge. I sat in the sun and sometimes I played house in my mind, for company. The miniature garden went with a miniature castle, of course. I worked some in the flower beds, pulling weeds and dry

leaves. Muriel liked the garden kept as clean as her kitchen. I watered. Once in a while, for a short time, I turned on the fountain and listened to it as Stuart had done my first day home.

Sometimes I felt that someone was watching me beyond the hedge of the Campolinis' side. When I looked up no one was there. I never heard a sound. I just felt it. I waited, wondering how and when the children would come. One day I made myself go to the garage. The big overhead door had never worked because the garage had never been used for the car. The small door beside it had a padlock on it now. The jungle gym was a skeleton of pipes. Someone had taken away the bars and swings. Something made me turn toward the hedge. Within the leaves I thought I saw a pair of eyes, unblinking. I stared so hard my eyes watered and I had to blink, and when I looked again, the eyes were gone. I tiptoed back through the garden and went straight to the back door, and there was Mrs. Bernhard sitting on the back steps.

"My legs have been very bad," she said. "Two ulcers opened up. I had to be off my feet completely. I couldn't even put on my elastic stockings. This is the first time I've been dressed in a week. Bernie would give me hell if he knew I had walked over here, so I'll deny it, and don't you call me a liar, sweetheart, do you hear? I am not here. That's my story and I'll stick to it. Now tell me, Billyjean dear, what is wrong? Why have you been avoiding your Aunt Bessie?"

"Stuart doesn't want you to put ideas in my head."

"What kind of ideas?"

"Like that I didn't hit Bubber. He says if I begin on that again, Shap will have to send me back there."

"So I won't talk about that. What else?"

"I'm not to have anything to do with you or my probation will be broken."

"How long is your probation?"

"A year."

"After that, will you come to see your Aunt Bessie?"

"Yes."

"All right, Billyjean. I wouldn't do anything to break your probation. I suppose the prohibition extends to Bernie and Max?"

"Yes, Aunt Bessie."

"Well, don't worry, I'll do my best with them. We won't do anything to harm you, Billyjean sweetheart," she said briskly.

"Maybe it will be less than a year," I said. I was glad I wouldn't be talking to her. I had almost asked her to help me.

On Saturday Mr. Bernhard pushed around the lawn mower out front, running. He wore nothing but shorts and sandals. His breasts were almost like a woman's and he wasn't ashamed to be seen that way. His face was round and under the sun it got hot and shiny. The lines on his face were circles, but still they didn't seem happy lines. An unlit cigar was stuck in his mouth.

There was no fence or hedge between our house and theirs. The lawn went across the two lots in front of both houses. It had always been that way, to make it seem that they each had a big front lawn. Besides, friends had no need of fences. One week Stuart mowed, and the next Mr. Bernhard mowed, though they never kept strict account, particularly after Mr. Bernhard bought his power mower.

As soon as Stuart saw Mr. Bernhard running around behind his power mower, he slammed out to the garage and got out his mower.

"Out of my way," Mr. Bernhard shouted gaily, the cigar waggling in his lips.

"I'll mow my own side," Stuart said.

"No need," Mr. Bernhard told him. "I need the exercise." He pinched the flab of his stomach.

"I'll mow my own side, if you don't mind!"

"Why should I mind?"

For a few minutes there was no sound but the two mowers. Then Mr. Bernhard shut his off and waited for Stuart to come back to the space between the two houses. "Is this on my side or on yours?" He was examining the line of grass that was taller than the two mowed lawns. "Maybe we'd better get a surveyor out here to mark the boundary?"

"I'm figuring three feet from the side of my house," Stuart said.

Mr. Bernhard squinted at the two houses and the space. "Your figuring has been known to be off."

"What kind of a crack is that?"

"Merely an observation. Your magnolia tree drops petals on my side, do you see?"

"Cut off the branch if you don't want petals."

"Who do they hurt? They look pretty lying on the grass, even on my grass. I wasn't sure you wanted your magnolia petals to lie on my grass, that's all, or your magnolia tree to hang a branch over in my air. How's Billyjean? I haven't even said hello to her. Why is she hiding?"

"She is not hiding."

"You keeping her locked in?"

"I'm taking good care of her."

"I'm glad to hear it." He raised his head and his voice in its singsong rhythm. "You tell Billyjean that her good friend Mr. Bernhard wishes her the best of life." He was staring straight at the front windows, and I moved back from the blinds to the center of the room.

Later that day a big white convertible with black leather seats and a Nevada license was parked out in front of the Bernhards' house. Maybe it was Max's car.

Muriel went to work. Stuart left soon after. I stayed inside the house the rest of the day, away from the windows. There was another fight that night in the front bedroom when Stuart came home, but not a bad one. Sunday we all went to a movie together. The girl at the box office called the manager when Stuart said that I was twenty-one years old. It was an X-rated movie. "To hell with it," Stuart bellowed, "we'll go home and watch television."

On Monday, Muriel's day off, we went downtown and tried on dresses. Muriel also bought material for me to sew some new clothes. That evening I modeled the new dress that was meant to make me look older. "Stand straight," Muriel said, "put your shoulders back. Hold your chest up. It's not the clothes that make you look too young."

"It's my face," I said. "Something's missing." I explained Shap's joke.

"That's not funny," Muriel said.

"Everything's all there," I explained again. "It's just that it's all together in the center and that leaves a lot of empty space to walk around in. Moonface," I said to Stuart.

"You talk like that and someone will believe you and put you back where they put empty faces."

"When your hair grows a little longer, I'll give you a perm," Muriel said.

The one thing I could do was to set the alarm clock earlier, so early that no matter how early Stuart woke up, I'd already be awake. Pretty soon I was getting up so early that I couldn't stay awake after dinner, but I couldn't go to bed early. Then I began taking naps in the afternoon. In a little while maybe I could forget it had happened, maybe I could believe it had never happened.

11.

The first time that Shap came for the monthly visit, it was a Saturday when Muriel and Stuart were both home, but Muriel had to go to work in a little while. She was flustered because the lunch dishes were still on the table. Stuart went to the door and he brought Shap right into the kitchen. Muriel didn't like anyone to see her kitchen unless everything was put away and it was empty like at night when nobody lived there.

"Don't apologize," Shap said, "it's fine."

"Would you like some thin cold cuts?" Stuart really hated those thin cold cuts.

Shap put his hand on his stomach.

"Youre lucky," Stuart said. "Have a beer or a cup of coffee."

"Coffee please." He put sugar in spoon after spoon like he'd forgotten what he was doing. He spilled sugar like ashes.

"We weren't expecting you," Muriel said nervously.

"We weren't supposed to be expecting," Stuart said. "He has to be unexpected so he can catch us chaining Billyjean to the bedpost."

"Stuart! What are you saying? We wouldn't do such a thing."

Shap was looking at me with his mouth turned down and his eyes almost closed. It was the same Shap, with his round face and his rumpled shirt collar and his sunk-in chest, and his pants folded on

his shoe tops that needed a shine, and the ashes on his sleeves, now sugar. It had only been a month. There were twelve months in a year. There were thirty mornings in each month when there weren't thirty-one. Shap blew his nose loudly and I knew he was glad to see me.

"Aren't you going to say you're glad to see Dr. Shap?" Muriel prompted me.

"I know she is glad," Shap said.

But he shouldn't have come on Saturday when Stuart and Muriel were home. Any other day was better. Any other day maybe I could have told him.

"Maybe he'll catch Billyjean locking us in the closet."

Why was Stuart talking like that?

"Why do you want to talk like that, Stu?"

"Stick it, Muriel. Doc knows I'm joking. Billyjean knows, too. It's healthy to joke about where Billyjean has been and what was wrong with her, isn't it, Doc?"

"Jokes are healthy if they aren't cruel. How are you, Billyjean?" Shap asked.

"She's fine," Muriel jumped in. "She's been a big help in the house."

"IdothedishesandIcleanthehouseandvacuumandIwashandironand Iweedandwaterthegarden."

"She works so hard," Stuart said, "that she's ready for bed by eight o'clock."

"I get up early," I said.

"She makes her father's breakfast," Muriel said.

"To be absolutely truthful and we have to be absolutely truthful, don't we, Doc, Billyjean hasn't been getting my breakfast, have you? Never mind, I kind of like making my own breakfast. It's peaceful, and I like to think of how I pamper my womenfolk lying in bed."

"Isn't she getting up for your breakfast? Billyjean, why aren't you? Why didn't I know? I swear, Dr. Shap, I thought she was getting up for her daddy's breakfast. What's going on around here?"

"What's going on is that Billyjean and I decided that she didn't have to get up for my breakfast. Right, Billyjean?"

"How are you sleeping?" I asked Shap.

"My old friend, insomnia."

As he talked I caught a glimpse of the light inside his eyes. It

wasn't God. And it wasn't my fear. It was just Shap and his friend insomnia. "Why is insomnia your friend now?"

"If you can't beat it, join it," Shap said.

"That's what I always say," Stuart agreed.

"Dr. Shap will think we're always fighting," Muriel said.

"He might as well see us as we are."

Shap cleared his throat. "I dropped in to check on how you are settling down as a family. If there are any problems we can discuss them. It's a good thing to set a pattern of talking things out as a family, healthy. You are three adults. Things can be worked out by talking."

I didn't want to look at Stuart. I willed my eyes away, but they were flies attracted to honey, maybe to sweat.

"Billyjean's looking at me like she wants to tell on me," Stuart said.

I jumped.

"Come on, Billyjean. Your doc says it's good for the soul to talk. Tell him how I don't want you to spend all your time with the old lady next door. It's not that I've got anything against Bessie but it isn't healthy, is it Doc? The difference in age, I mean."

"Billyjean has to learn to communicate with people of all ages."

"I never would have thought of it that way, but I see what you mean. Like if Billyjean had a grandmother. Well, I stand corrected, and you were right, Billyjean. You go right ahead and spend your time with Aunt Bessie."

"I don't want to spend time with her. I don't even like her. She's senile," I said. "I like the Campolinis better."

"They live on the other side," Muriel said. "I've got a teensy problem, Dr. Shap, I guess I might as well ask you now. The Campolinis are going on their vacation next month and they want Billyjean to take care of their house and yard while they're gone. They'll pay her, of course."

"You didn't tell me," I said.

"I didn't know if you'd be allowed to, or if it is a job, you know. I didn't want to raise your hopes until I had a chance to talk to Dr. Shap."

"Would you like to, Billyjean? It's a big responsibility."

"I like responsibilities."

"You sure you don't have too much to do?" Stuart asked. "There'll be no use in going to bed if you get up any earlier."

"If I'm tired I can take a nap in the afternoon." I was sorry that I said that. I didn't want him coming home early and finding me in bed.

"OK, I'll tell Claudia. They're nice people, Doctor. He's a law-yer—"

"For crissake, Muriel, next you'll be telling how they get a new car every two years."

"Ohmygosh, look at the time. I walk so Stuart can have the car."

"You walk because you want to show Henry Fashion that I don't make enough money for us to have two cars, and so he'll take pity on you and drive you home."

"I'll be glad to give you a lift," Shap said.

"Leaving already?" Stuart asked. "No more questions?"

"I'm very satisfied, Billyjean," Shap said. He had no business being satisfied. He had always known what I was thinking. Now I was shouting to him silently and he didn't hear. What good was he?

"Until next month then."

He was no good at all.

Stuart waited until they were gone, but he was blazing. He stamped around, kicking the chairs, roaring with rage, banging his fist. "Damned little prig. Treating us like we were all loonies. Don't you forget it, Billyjean, you're the only loony here, not Muriel, and not me. Just you." Then he slammed out of the house, and I didn't have to ask if he'd be home to dinner. I knew he wouldn't.

I went into the garden. On my knees, I picked the dead leaves from the garden beds and smoothed the dirt, the way Muriel liked to see it. I liked the clean feel of the dirt. The pleasantly rotting odor of the fading lavender stock was in the air. I liked being on my knees. If I thought no one would see me, I would have liked to lie down in the garden bed. I played that I had asked Shap if there was another place where I could go to live. I didn't know where. Nowhere. I didn't want to go back, even to the cottage. Outside was hard and lonely, but I already knew it was life and I was alive. I guessed I could live with anything so long as I was outside.

"Were you really crazy?"

The voice was so soft that at first I didn't know that I had heard it outside my head. I answered without turning around. "I was a loony."

"Is that different from crazy?"

"In degree." I scooped up the last of the leaves with both hands, put them into the box and stood up, brushing my hands together.

The speaker, for there was one outside my head, was a beautiful child. Boy or girl. I wasn't sure at first, slender, dressed in jeans and a very white T-shirt, barefoot with long straight separated toes, and golden skin. Glossy dark hair curled to the thin shoulders, and large golden cat eyes in a small pointed face returned my stare unblinking.

"Don't be scared," I said.

"Well, actually, that's what we came for."

"To be frightened by the loony?"

"Do you call yourself that?"

"It's what all the girls in the cottage called themselves."

"I thought you were in an institution."

"At the end, I was in the cottage."

"My dad says it's a moot question who is sane and who is insane in this crazy world."

"Is your dad Mr. Campolini, the lawyer?"

"Yes."

"What does Mrs. Campolini say?"

"She says that the good Lord never gives us more than we can bear. We're Catholics. Is it true what she says?"

"I don't know. I'm not a Catholic."

"She practices birth control, so she's kind of a crazy Catholic."

"How do you know about the birth-control part?"

"Well, there's only two of us kids, so it stands to reason. Can we come over?"

"You seem to be over."

He made the merest jerk of his head over his shoulder toward the hedge. I looked into another pair of golden eyes staring out through the leaves. "There's a cat in the hedge," I said.

"It's Diane. You can come out, Diane, she knows you're there."

Diane emerged smiling shyly, showing big dimples in her cheeks and irregular teeth. She was much smaller than the first child, like an echo.

"Hello, Billyjean," she said.

I felt good that she knew my name. "You're Diane and Dione."

"Ugh!" Dione said.

"Ugh!" came the echo.

"I think it's kind of cute," I said.

"I think Billyjean and Bubber is cute, too," Diane said politely.

"Shut up, Diane. I told you that you couldn't come with me unless you promised not to talk like that."

Diane put her hand over her mouth.

"Bubber wasn't his real name," I said. "I couldn't say brother. His other name was Alexander. I couldn't say that either."

Diane smiled. The left of the two big front teeth was longer than the other. Remembering that, she put her hand over her mouth again.

"When she's older, she's going to have that tooth filed down. The dentist wants to wait until it has stopped growing."

Diane's delicate eyebrows, as fine as silk thread, pulled together.

"I bet it has just about stopped growing now," I said.

"I stop it by pressing on it," she said.

"That's crazy," Dione said. "Excuse me, please."

"Don't mention it. It's impossible not to say it."

His mouth, which looked normal-sized, stretched and split his face into a wide grin. "Some day," I said, "your face is going to grow big enough for your smile."

"I'm twelve."

"I'm eight," Diane said.

"Exactly my age," I said.

She consulted him.

"She's very literal," he explained.

"I'm really twenty-one."

"You don't seem like twenty-one," Diane said politely.

"Can we go in the garage with you?" Dione asked.

"It's kept locked."

"Then we'd better go in the house with you."

"Doesn't your mother know that you've come to visit me?"

"I don't think she does."

"I suppose we forgot to tell her."

"I think you should," I said.

"Mommy's nervous," Diane said.

"Shut up, dopey," her brother told her.

"I'm not dopey. Mommy said curiosity killed the cat."

"I'm sorry," Dione apologized for her. "Sometimes she's very smart."

Diane's eyes were beginning to melt and run over her face like gold light.

"Maybe she's nervous, too," I suggested.

"We've never seen a crazy person before, have we, Dione?" She spoke shyly and as if she were offering me a fine compliment.

"Is your curiosity satisfied now?"

"Not entirely," Diane said.

"What else would you like to know?"

I saw Dione aim a light kick at her ankle.

"Did you make the garden?" he asked, knowing I saw.

"Stuart made it."

"Why do you call your father Stuart?"

"Shap said it would be easier to call him by his name." What would be easier?

They didn't ask who Shap was, though they must have wondered. On the whole, they were well-mannered children. If not always polite, they were skittish, innately courteous, perceptive. They stared at me, but it didn't bother them that I returned their stare. They didn't mind that I didn't blink. They didn't blink either. They did not hurry me for my answers. The three of us stood there growing friendly in the sun.

"Did you have a fountain at the institution—cottage?"

"No, but we had a television set and an electric mixer." I could see that they wanted to ask more questions about the cottage. They were very curious, but they were going to wait for a proper opening.

"I think it's kind of crazy to make a little garden that pretends to be a big one," Dione said. We all laughed.

"I think it's crazy to have a fountain that isn't turned on," Diane said. We all laughed again.

"She always has to say everything that I say." Diane wriggled, very pleased.

"Would you like me to turn on the fountain?"

"Yes, please," they chorused.

They sat side by side on the stone bench as if they were at a show, watching the water come out of the fish's mouth. After a while, I turned it off.

"Thank you very much," they said politely. Dione nudged Diane, and they backed off grinning and slipped through the hedge. I thought that I could see Diane's golden eyes for a long time afterwards. I wasn't sure just when I began not to see them.

12.

After that first visit the children came often, and as the days passed, the questions became more direct. "Did you really kill Bubber?" Dione asked.

"I don't know," I said. I could see that he was quite a bit disappointed and I almost said that I was sure that I had.

"You didn't know that you hit him so hard," Diane said anxiously.

"How many times did you hit him?" Dione asked.

"I don't remember."

"It was an accident," Diane said, her eyes filling.

"Did you want him dead? Did you hate him?"

"I hated him and I loved him."

Diane sobbed.

"That's enough of those questions," Dione said crossly, as if she had asked the hard ones. "Talk about the cottage now."

They never tired of hearing about what it was like in that place. I told them about the girl who couldn't get out of squares. The other girls would leave her alone in a room, and then watch with great amusement as she tried to follow them.

"That's cruel," Diane said, tears welling in her eyes again.

"They didn't mean any harm," I said.

"They didn't mean any good either," Dione said.

"It was a game. There weren't many games to play in there."

The tears were falling now.

"Diane is very affected by sad stories, that's all," her brother said cheerfully.

The trouble was that all my stories seemed to be sad. I told them about the slaughterhouse and about the gray bones, and about the stain of red in the trough from the butchered animals. And that was sad, but they asked if I wouldn't go with them to play there. The idea of going there was alarming. It was not possible. Why wasn't it possible? It would break my probation, I said.

I told the stories in a soft voice like I was singing a lullaby, but even so they were often too sad for Diane. She cried when I told about being tied to my bed.

"I like the part about the baths better," she said.

"I didn't."

"I do," she said stoutly.

Dione always wanted me to tell about the tube down my throat, and then he explained to Diane, "Like drinking from a straw."

"It wasn't like that at all," I said.

"Billyjean's the best story teller in the world, isn't she?" he said.

"But why didn't you want to eat, Billyjean?" Diane's voice was no louder than a kitten's mew.

"Because I was a loony."

She snuggled close.

"Go on," Dione urged.

I told about the girl who hanged herself with her hair.

"Why didn't someone stop her?" Diane cried.

"She didn't want to be stopped." Diane wept and crept into my arms, and I rocked her.

"Go on, Billyjean!"

"I don't think Diane wants me to go on."

"Yes, I do, I really do," she assured me anxiously.

Sometimes we played the game that was Shap's favorite: What Do You See When You Say . . . ? When it was Diane's turn she asked, "What do you see when you say Bubber?"

"That's not the way to play the game, dopey," Dione cried.

"I see him lying on the floor of the garage with a white face and his hair growing red," I said.

"Now look what you've done, Diane!"

"But you told me to ask that."

They never came when I looked for them. They came when I was

kneeling in the dirt, or sitting with my eyes closed, or reading, or sewing, and concentrating so that I didn't see them coming. That time of the year you could count on good weather day after day. There would be no rain until October or maybe even Thanksgiving, unless it was unusual. I would feel the presence of the children. I never paid them any attention until they spoke. It was almost as if they weren't real—imaginary children. And I was imaginary, too.

"What are you making?" Diane asked.

"A dress for me, and there is enough material left over for a doll dress if someone had a doll that needs a dress."

"I have a doll," Diane said, choking in her hurry to tell. Dione had to hit her on the back.

"Not so hard, Dione," I cautioned.

"I hate her, I'll kill her," he said, grinning. His eyes were brilliant.

"It's lucky for me that you have a doll who needs a dress. I'd hate to see this nice piece of material go to waste."

"Did you learn to sew in the cottage?"

"I learned everything there," I said. "I got my high school equivalent certificate."

"Diane's got a genius IQ," Dione said. "That's why she is so dopey sometimes. Being a genius is like walking a tightrope, Dad says."

In face of that I didn't tell them what my IQ was.

While I sewed for Diane's doll whose name was Diane, too, I told my stories in my soft lullaby voice that made us all drowsy and lazy. I told how Daddy, swearing and roaring, had sewn clothes for GrandmaLoreen Doll, and about the yellow pencils I took from his workbench and stuck into the holes where her eyes had been. Diane cried quietly throughout the story, but it was a story she liked to hear over and over again.

"Is that the workbench where the wrench was kept?"

"The wrench was on the floor."

Dione wanted to go into the garage to see the workbench, and to see the very same actual wrench, and to see the place on the floor where Bubber's hair was turned to red.

"Maybe the floor will still be red, like the trough in the slaughterhouse," Diane said, scaring herself.

"You don't have to look, dopey."

But she didn't want him to look either. It would be just as scary if he looked. It would be worse if he looked and she didn't. If he

looked, she had to look, too. "I'd rather go to the slaughterhouse," she said.

"Nobody can go into the garage," Dione said. "It's locked. Unless Billyjean has a key."

"No, I don't have a key."

"How did you get in before?"

"It didn't use to be locked."

Dione tried to look in by the small window on the side of the garage, but he wasn't tall enough. He said Diane could sit on his shoulders and she would see in and could tell us what was in there. Maybe a skeleton, he said. She let him hoist her on to his shoulders, but she was crying quietly all the time and she couldn't see anything. Anyway, the window was very dirty.

"Dad says she needs to be toughened up."

"What does your mother say?"

"She says she's too young yet to be toughened."

Diane stopped crying in order to listen.

"I'm on your mother's side," I said. Diane pushed her head under my arm for a hug. Dione's nostrils flared, his lips curled. I held out a free arm. "There's a hug in this arm for you." He bumped into me, and then sprang up again, his mouth sweet.

When the doll dress was finished, I dressed the doll, talking baby talk to her like she was a real baby.

"She can be a real baby," Diane said, "and I'm her big sister, and Dione is her brother, and you are our mother."

"Not me," Dione said.

"Dione, why not? Why not, Dione?"

"I'm too old to play house."

"No, you're not. He isn't too old, Billyjean. He likes to play house with me."

"Once or twice maybe."

"More than that."

"When there's nothing else to do and Mom says can't you play with your little sister, it won't hurt you to play with her once in a while, but I'm not the brother."

"Who are you?" I asked.

"I'm the father, of course."

"What do you do?"

"Oh, I just go off to work."

"And I fix dinner and he comes home to dinner, and he kisses me

and I hold up baby so he can kiss her, and I tell him about my day, and I ask him how his day was."

"Then what?"

"That's all," Dione said.

"No, there's more, Dione, you know." She giggled.

"What do you do, Dione?"

"He says I love you dear, and I say I love him dear, and we go to bed."

"And then what do you do?" The lullaby was going slower and softer, like a rocking chair.

"Sometimes we pretend to fight and then we make up." Diane got the hiccoughs, and Dione was frowning.

"I played house for my big brother," I said.

"I thought Bubber was your little brother."

"I had a big brother, Glenn, too."

Diane's hiccoughs had stopped because she held her breath.

"Where is he?"

"I don't know. He went away."

"Why did he go away?"

"He was only a half brother, anyway."

Diane's eyes grew big and startled.

"That only means that Billyjean and Glenn had one parent the same, and the other parent different," Dione explained. He was calling him Glenn already as if he knew him.

"My mama was his mama," I said, "but my daddy wasn't his daddy."

"Doesn't anyone know where he is?" Diane's eyes were ready to spill over.

"Probably Billyjean's mother knows," Dione said helpfully.

Now that I knew them better I could see that they really didn't look alike. Diane's big golden eyes were luminous; his were vivid, blazing.

"Stuart told Glenn to get out and not come back."

"But who is his mommy and daddy now? He has to have a mommy and daddy."

"Shut up, Diane. Why did Stuart tell him to get out?"

"Stuart was mad because Glenn had a lot of money and he wouldn't tell where he got it."

"How much?"

"A fortune."

"Did he steal it?"

"Probably somebody gave it to him," Diane said.

"No one gives a fortune," Dione corrected.

"Phil did," I said.

"Why?"

"Because I went into the woods with Phil." I told how Mama had always said there were wild animals in the woods, so we wouldn't go there alone, and then we all went on a picnic in the woods and all there was was poison oak and everybody got it but me.

"Maybe the wild animals were there and you just didn't see them, Billyjean."

I shook my head. "There were no wild animals. There was only Phil. There wasn't even poison oak where we went."

"I don't like this story," Diane whimpered. She crept close to me, and I put my arms around her and rocked her. I went on telling stories in my singsong voice as if I was crooning a lullaby that wasn't real. I was beginning to be able to forget.

Under my fingers I felt the small smooth wristbones move beneath the thin silky skin. I saw the thin stick legs. I could imagine the secret place between the legs, the thickened blurred edges of the slit. I saw the small triangular face, all golden eyes, looking up to read in the face above it if she was doing as good as a big girl, if she was doing all right as a woman. No! I couldn't imagine it! It made me sick to think even of trying to imagine it.

13.

The children were kept very busy in the days before they left on their vacation. There was shopping for new clothes, visits to the dentist and the doctor for checkups. Mrs. Campolini went over the whole house with her cleaning woman whom she had in for three days instead of the usual once a week. They filled big boxes for the giveaway. The children were set to sorting through their possessions and discarding. Dione made up his mind very fast, but for the three days Diane went around with red eyes. She couldn't bear to part with anything.

"Claudia likes to be prepared for every eventuality," Mr. Campolini said.

"Matt's a pack rat. I wouldn't want anyone to come into my house and find all this ragbag of stuff," Mrs. Campolini said.

"No one's coming into our house," Mr. Campolini said, "because Billyjean is going to keep an eye on it for us."

"I'm going to keep both eyes on it," I answered. I was to pick up the mail that did not go into the mailbox, collect the throwaways, and turn on the sprinklers to keep the lawn green. The newspaper would be stopped. I was given a piece of paper with the phone number of Mrs. Campolini's sister, Mrs. Logan. She lived very close and could come in five minutes in her car if I needed her.

"Isabel won't have to come. Billyjean can handle anything that may arise," Mr. Campolini said. "I am entirely confident."

I loved Mr. Campolini. He had very tightly curled black hair which in the sunlight sparkled with bits of silver. His sideburns were long and thick, and grayer.

The day before they were to leave, the children slipped through the hedge long enough for Dione to tell me that they had not forgotten about Glenn. "When we get back we'll help you find him."

I thanked him, but I didn't know how they could do that. I didn't know if I wanted that.

"It's bad luck to have to go away just now."

"I wish we didn't have to go. It's bad luck."

"You will have fun," I said. "Its a vacation." I had never had a vacation. Its a llama. It's another planet.

"Even though we're not here, we will continue to work on the case. Dad says the times he isn't actually working are sometimes as important as the actual work."

"What case?"

"Yours."

"Of course."

"Naturally we don't believe that you hit Bubber on the head."

"We don't believe—and Daddy doesn't believe—and—"

"Shut up, Diane. You must try to remember everything you can about Glenn, Billyjean."

"Why?"

"He could be very important. Don't you see? Maybe it was Glenn who did it."

"Could he have?" Diane wailed.

I didn't think so, but I didn't like to disappoint Dione. His eyes were sending off sparks of excitement.

"He will be an important witness. We have to have witnesses, you know."

Diane pulled at his sleeve. "You can work on finding the key to the garage," he went on, "while we're gone. That will give you something to do. Diane says that GrandmaLoreen Doll must be in the garage. She wants to see her pencil eyes."

Mr. Campolini packed the car with the suitcases and garment bags, and with Mr. Campolini's camera equipment, and they went off to Disneyland and the San Diego Zoo. They would be gone for two weeks.

I missed the children. I picked up the throwaways, I checked the mailbox, I watered the lawn, once I mowed the lawn. Mr. Campolini didn't lock his garage, and I could take out the mower.

One day I was sitting in the garden thinking about them at Disneyland, not knowing what it would be like, and I felt someone looking at me, not from the Campolini side, and not Mrs. Bernhard, I was sure. I told myself that I would not look around, and he would have to go away. Even though I didn't turn around, I knew it was a man. I had not even been thinking about Max, but now though I didn't turn around, I thought Max. That made me jump up, and I ran into the house and locked the back door. He rang the doorbell, and I put my hands over my ears so I wouldn't hear. On tiptoe I went to the front of the house and there was the white convertible parked in front of next door. The next day, after Muriel went to work, he came again, and rang the doorbell again. The white convertible was still there. As he went away, I saw that he hardly limped at all. From the back, he didn't look like Max. He didn't have a crutch. His pants had two legs. He was dapper. It had to be Max. What had happened under the back porch?

The day after that, Muriel said she'd turn on the sprinklers low at the Campolinis' as she went to work, and I was to let them run a long time because the lawn was kind of yellow, but I was to be sure and turn it off. "It's my responsibility," I said. I was so mad at Muriel for taking my responsibility that I wasn't even thinking about Max, and I went out to turn the water higher, and I saw the white convertible, and I saw that he was there again. I saw his small feet in smooth shiny Italian boots. I saw his two legs.

"Hello, Billyjean."

I looked briefly. His eyes blinked rapidly. It had to be Max. He knew my name. He was between me and the front door. He jingled the money in his pants pockets, and then he began tossing two coins into the air and catching them again. He was good at it.

Everything in his face turned left. I didn't remember that. His long aristocratic nose curved to the left. The left corner of his mouth turned down. His left eye drooped. He held out the coins to me. "Do you want to try, Billyjean?"

I stared at his hands, not knowing if they had touched me. I guessed all my life I'd have to be wondering who had touched me.

"Go ahead, take them," he said. "It's easy. If you can do it with-

out dropping them, they're yours. Excuse me, I am forgetting that you're a grown-up young lady now, a very pretty one."

My eyes jerked and bumped into his that were crowded up too close against the bridge of his nose.

He kept tossing the coins in the air and catching them. "Do you still have the good-luck dollar I gave you? It didn't bring you good luck, did it? I'm awfully sorry, Billyjean." He stuffed the money into his pants pocket. My eyes kept trying to fly out of the corners, like robins drunk on too many pyrocanthus berries. "Billyjean, I never believed—you couldn't hurt any thing—" He took the coins out of his pants pocket again and this time when he tossed them, he dropped one. As he bent to pick it up from the lawn, I leaped around him and gained the side of the house. He was behind me calling my name, asking me to wait, to talk to him, to listen for a minute. It was like the nightmare where I was always being chased and never getting away and never caught either. He almost reached me. I closed the back door and leaned against it. His voice came through. The blood was pounding in my head making me deaf.

"Billyjean, don't be afraid. What did they do to you to make you so afraid? This is just Max. You know you don't have to be afraid of just Max. Didn't your doctor tell you that a little eight-year-old girl can't really be wicked? Whatever you did, you don't have to be afraid of it now."

Had I played house with Max? I couldn't be sure. I couldn't remember.

"Don't be ashamed. Whatever you did, you were just a child. You didn't deserve to be punished, not like that, and no more. It's over now. Take me—"

I shut my eyes, but I couldn't shut out his voice.

"I've done all sorts of things—"

What had he done? What had he done with me?

"Some of them I kind of wish now that I hadn't done—"

Had he played house with me? Was that one of the things he wished he hadn't done?

"No one punished me for those things. Talking to me might help you, Billyjean. This is just Max. Remember how we laughed over that? Billyjean, I know you're there. I can hear you breathing."

I shivered.

Do you want to see where my leg was cut off?

People need to touch. Shap said.

"I played, I gambled. I had girls. I made money, spent money. I wasn't always as honest as I should have been. I made mistakes. Why were you punished so cruelly and me not punished at all? Didn't you ever think about that?"

"You had your leg cut off," I said, and I crept away from the door. In the bedroom, I shut myself into the dark closet where the teddy bear sat with its shoe-button eyes, where the words couldn't get in.

When I came out of the closet, Max was gone. The phone was ringing. I looked at the clock. It would be Stuart phoning to say that he wasn't coming home for dinner. I was glad. I didn't want to see anyone. I'd go to bed before Muriel came home. I wouldn't tell anyone that Max had talked to me. Max had gone away. Max had never come. I didn't want to break my probation.

It was Shap on the phone. He said he had rung the doorbell. He had come to make his monthly visit with me. Had a whole month gone by? Time was different on the outside all right. "Why didn't you answer the door, Billyjean? Didn't you hear the bell? Were you taking a nap?"

"Yes, I was taking a nap." Shap always let me know what I was supposed to say.

Shap was phoning from the house next door, at the Bernhards'. When I had not answered the doorbell, he had gone first to the big house on the other side.

"The Campolinis are away on vacation," I said. "Did you forget? I'm taking care of their house for them."

"Yes, I did forget that, Billyjean. I said to myself those people have forgotten to turn off their sprinklers, so I turned them off for them."

"Thank you," I said. "But I wanted them on for a long time because the lawn was looking yellow."

"I believe they have had enough water for today."

Then Shap said he had rung Mrs. Bernhard's bell. She was sure that Billyjean was home. Shap didn't mention Max. I was glad that he didn't, and I was sorry. Glad ran away. Sorry remained.

Shap said he would like to come over and see me, if it was convenient.

"When?"

"Right away."

I said it was convenient. I watched him come across the lawns in front, across the line where the grass was growing taller between the two yards. It didn't look neat. Muriel didn't like it, but Stuart kept that line untouched as carefully as if it was something that they were cultivating together, something they were proud of.

Shap didn't look big enough or strong enough or old enough to be a doctor. I wished he was a very old wise man. Then maybe I could tell him about Stuart getting into my bed.

"May I take off my jacket, Billyjean?" He laid it across his knees and dropped ashes on it from his cigarette. He sat with his eyes almost closed. He said that the reports on me had been very favorable on the whole. He had had reports from the neighbors and from Muriel and from Stuart. He had talked to all of them. He said that I was looking very pretty, chic. He knew that I had made my dress. He said I should be given more liberty now. I should do the shopping alone for Muriel. It would help Muriel, and it would give me confidence. He also wanted me to go to church now, to join the Young People's group. He had already talked to the minister of Muriel's church. The minister knew everything about me that he should know. I did not have to be nervous or self-conscious. I was nervous. I was so nervous that I could hardly listen to him. I tried to tell him about Stuart. I couldn't say the words. My tongue was like tied.

"When I come back, I want to hear that you are making new friends," he said.

"I am making friends," I told him. "Diane and Dione are my friends. I suppose you know about them."

"I didn't fool you, did I?"

"No."

He picked very small pieces of tobacco from the sleeve of his jacket that lay across his knees. He moved the jacket and dropped ashes on the sofa between his legs. He brushed at them, dropping more. "It is good to have friends of your own age," he said. "Diane and Dione are much too young for you, and Mrs. Bernhard is old enough to be your grandmother."

"You said if I had a grandmother, I could visit with her."

"It is important for you to make friends of your own age."

"How old am I?"

"That's a joke, isn't it, Billyjean?"

I agreed that it was a joke.

"You must try to understand Stuart's position, Billyjean."

"What is his position?"

Shap brushed at his pants leg and dropped a long ash into his lap. "Billyjean, I've been frank with you. I told you that I have talked with Muriel and with Stuart. On the whole they gave you good reports."

I looked straight at the crotch of his pants where the ashes were dropping on the zipper that kept his thing in. I could not tell him. Maybe I could tell Mrs. Rose. But if I went back to tell her and ask what I should do, they would maybe keep me there. I had to tell someone. Someone had to help me.

"Stuart said that you and Mrs. Bernhard had laughed about how you confessed to me. He said that Mrs. Bernhard doesn't believe that you hit Bubber and that you were letting her influence you. Stuart is doing his duty in being concerned."

"What is he concerned about?"

"He doesn't want anything to go wrong for you."

"What can go wrong?"

"Stuart also says that you are acting strange."

"Is he afraid that I'll hit him?"

"Well, he said that is why he doesn't want you to make his breakfast. He didn't want to tell me, Billyjean. I asked him. I had to insist that he tell me. He said that he came to wake you one morning—"

"Did I hit him?"

"He said you accused him of trying to get in bed with you."

There was a buzzing silence like when I was back there.

"Did you accuse him?"

"No."

The buzzing was louder in the silence.

"Are you sure you don't want to tell me something, Billyjean?"

"I do."

"Good. I'm listening."

"You think I'm still loony, don't you?" I burst out.

"That's the wrong word, Billyjean." He closed his eyes like he was falling asleep.

"Don't close your eyes! Open them!" But when he opened them a crack, it was dark inside. "You do think I'm still a loony."

"I am trying to do what is best for you."

"It's a trick! You tricked me! You think I'm a loony."

"Don't you want to be home?"

"No. I don't know. You'd like to see me back in the cottage, wouldn't you? I would have turned off the sprinklers."

"Hush, Billyjean, don't get excited. You are doing very well. You have made great progress. No one wants to see you back at the cottage. You are so excited that you aren't listening to me." He stubbed out his cigarette and lit another. I clenched my jaws to hold back the black inside me. It kept roaring up into my throat. It shook me, like great hiccoughs of vomit.

"I'm going to confide in you, Billyjean." He opened his eyes again a slit. Let it be God! But there was only his own fear. What was he afraid of?

"I feel you can understand what I am going to tell you. You turned twenty-one while you were in the cottage."

He wasn't thinking about me at all. He wasn't even thinking about Stuart's lie.

"Are you afraid I will hit you over the head?"

"Of course not. I'm afraid you may not trust me again."

"What does being twenty-one have to do with anything?"

"You are thinking straight, Billyjean. You see, you do have a good mind. The cottage is a part of the facility maintained for minors. At twenty-one, you had to be transferred to the women's facility, or you had to be well enough to be released." He brushed at the ashes in his lap. "We didn't want you to go to the women's facility."

"Who is we?"

"The women's facility is very different from the cottage. There are women of all ages and all kinds. There are some women there who are very sick. Some are violent. Some are so sick that they want to make everyone as sick as they are. I expressed my concern to Muriel and she talked to Stuart and they agreed that we should make a big effort to effect your release. I am telling you this to show you that I believe you are almost well. I felt that the rules should be—well, not broken, but bent for you. I had to be able to report that you had faced the reality of that Saturday morning. It was a formality, but a necessary one. I felt that you had in fact faced reality, so this was merely a matter of saying the words. So I took the responsibility. If you said the words, I could report that you had said them, I could make my recommendations. I—in a certain sense perhaps I took advantage of you. If I gave you the

words, you would say them, you would do what I asked. It was for your sake. It wasn't so very bad, was it?"

"Am I real then?" The black was coming up again. I choked it back.

"The line between well and not well is not a real line. It is not always in the same place. It moves, Billyjean, according to circumstances."

"According to how the wind blows the grass."

"That is a poetic way of putting it."

"Did Stuart know that I was still sick?"

"I'm sure Muriel told him the circumstances of your probation."

It didn't matter what you did to a loony.

"Muriel felt, as I did, that it was right for you to have a chance now. If we had to transfer you into the women's facility, you might lose that chance. There are women there who are so sick they do very ugly things to other women who can't defend themselves."

He was talking about me. "Mrs. Rose would stop them," I said.

"There aren't enough Mrs. Roses to protect everyone all the time. You like Mrs. Rose, don't you? Shall I give her greetings from you?"

"Are you going to send me back?"

"No. No! Muriel thought as I did, that it was a risk you shouldn't have to take. I'm sure Stuart understood."

He understood that it was all right to come into the bed of a loony.

"Muriel bent," I said.

"Yes, if you want to put it that way. Stuart, too."

"She bent more."

"Mothers are like that, Billyjean."

"Stuart didn't want to be my baby-sitter." He wanted to get into my bed. "He said it was Muriel's job. I wasn't listening. They were shouting. I don't bring in any money."

"There will be time for that when your probation is over."

There was no way I could tell him.

"I'm not making any promises, but if conditions warrant, the probation time may be shortened."

"Can't the children be my friends any more?"

"When you have friends your own age, you won't have much time to spend with them. But of course the children can be your friends."

I didn't mention Mrs. Bernhard. "Was I part of the economy move?" I remembered.

He was writing in his notebook in his tiny script. He looked up, his glasses making his eyes very awake, like fishbowls. "What economy move?"

"When the government wants to cut spending, they don't cut the big subsidies, or the war budget, or money for space, they cut a few dollars from the poor and the sick and the loonies."

"I've told you what it was in your case, Billyjean. But you're right. Sometimes despite our best efforts, the cuts are made in the wrong places." He looked at his watch.

"Excuse me, please, it's time for me to start dinner. Stuart will be coming, or did he tell you that he wasn't coming?"

Shap smiled his turned-down sad smile on account of his bad teeth. "He told me that he wouldn't be home for dinner. Are you mad at me, Billyjean? I didn't intend to hide anything from you."

"I suppose he has to see about a remodeling job."

"Yes. He said to tell you that he'll pick up a bite to eat somewhere along the way. I agreed with him that you don't need a baby-sitter." He turned the fishbowls on my face. "Are you feeling all right, Billyjean? Not working too hard? How is your appetite? Be sure you get enough sleep."

"When I'm sleepy, I take a nap. You know that."

He smiled with his turned-down mouth. I watched him go down the sidewalk.

My face felt like a no-face. I went into the bathroom to look at it. I had begun to think it looked like a real face, but it was still a loony face. I turned on the water and scrubbed it as if I could scrub away the loony. I noticed my hands. I had never worn the ring that Shap had given me, except at night in the dark. Days I hid it in different places. But Shap hadn't noticed that I wasn't wearing his friendship ring. Maybe he didn't even remember giving it to me. I didn't have a friend. I couldn't have the children or Aunt Bessie. I was afraid of Max, afraid to ask him how he and Billyjean had played. But I had to have a friend. Everyone had someone. That was what made them real. . . . I would just have to set the alarm earlier.

14.

It was almost as bad as my first day home all over again. When it got dark I was glad, but I knew Muriel wouldn't like it if I didn't turn on the lights. I closed all the blinds tight. I didn't want anyone looking in to see the loony. I sat on the floor and wept for a long time until I was very tired. Maybe I even went to sleep. It seemed to me that I had told Muriel about Stuart coming into my bed, and Muriel said she'd kill him. Or maybe it was Mrs. Rose I told. I could hear the laughing. Mrs. Rose scolded them, saying that it wasn't a bit funny. Muriel had wanted me home, enough to take all the responsibility. Mothers were like that. I could tell a mother what had happened. But I couldn't tell if I didn't know the words.

As soon as Muriel opened the front door, her eyes ran around me to look into the room. They took in the whole room and even the whole house in one swallow. They reached into the kitchen and the bathroom, like they were on a long spring arm, to find Stuart. "I see your father isn't home," she said.

"Shap was here," I told her. "He surprised me."

"That's the whole point." She sounded cross. I could tell that she was tired. This wasn't a good time to tell her about Stuart. "Shap said he went to see you, Muriel. Did he go to see you?"

"If he said so, he did." She stepped out of her shoes with the

pointy heels and got a bottle from the kitchen cabinet. "For hevvins' sake, Billyjean, settle down."

I was too nervous to settle down. Who would believe such a thing, who could think such a thing?

"Shap said I could go to the store alone. That will help you, won't it? He said I should go to your church. He said the Young People want to be my friends. The minister, too."

"Your friends aren't the most important thing in the world, for hevvin's sake. If you have a good report for your Dr. Shap, it's because I've watched over you."

"Yes, Muriel. Thank you very much."

"What about my friends? What friends do I have? I've been tied to this house since you came home. I've been chained to you. I've been a jailer, and a jailer is just as much in jail as the one in jail. Did your father phone?"

"No, he told Shap to tell me."

"He isn't tied down, you notice. He's free as a bird."

"He told Shap it was about a remodeling job."

"I have to come straight home from work. Every single night I come straight home from work. A year is a long time."

"It's not as long as thirteen years."

"What's that supposed to mean?"

"Nothing. Honest, Muriel, it didn't mean nothing."

"Forget it. Oh for hevvins' sake, stop following me about. Stop staring. Go to bed. Leave me alone. Give me a little peace."

I would have thanked her for wanting me when I was still a loony. I would have told her I loved her. More than anyone. But I couldn't tell her about Stuart. Stuart slept in her bed. It came to me then that the only person in the whole world that I could tell was Stuart. I undressed and waited until the sounds of the bottle stopped from her bedroom. Then I put on my bathrobe and went into the front room to wait for Stuart. He rushed in through the front door a long time later, not noticing me or that the lamp was lit, he had to go so bad. Through the door of the bathroom that he left open, I heard the rush of his water into the bowl. It went on and on. I thought it would never stop. He thought he was alone. He thought everyone was asleep. He would be mad maybe when he saw me. I started to go into my room, but I sat down again. Finally he came out of the bathroom and then he saw that the lamp was on

and he came in to switch it out. "What the hell are you doing here?" he asked.

"I was waiting for you."

He frowned. "Were you here when I came in?"

"Yes."

The bone in his jaw began to get white and to pulse, then he burst into a roaring laugh. "You and Bubber always were impressed, weren't you? Muriel says you're not so bad at holding it yourself. You can chalk that up as one thing you got from me, not much, but it comes in handy sometimes."

"Where were you tonight?" I asked.

"What's the matter? Is something wrong?"

"Why didn't you come home?"

"What happened? Speak up, girl."

"Muriel was expecting you to be here. She doesn't like to go to bed alone."

"Don't you worry about us."

"I'm not eight years old now."

"Then act your age, and keep your nose out of what ain't your business. What's eating you? If you ask me, what you need is what Muriel wants. Even when you were a little thing—" He changed his mind about what he was going to say. What about when I was a little girl?

"Hang in there, Billyjean. You've got a few months to go."

"What did you tell Shap?" I demanded.

I caught him by surprise. He stammered. "You've got nothing to worry about. I want you off this probation, too."

"What do you care? You leave everything to Muriel. She has to come straight home from work every night. She hasn't had a night off since I've been home. You live it up. She's as much in jail as I am."

"She been crying to you about me?"

"She didn't cry. She just told me."

"Don't give me your lip. What she been saying? Speak up or I'll knock your block off."

"I hear you fighting at night when you come in late. It wakes me."

"Then go back to sleep again. It's none of your affair."

"It isn't safe to go to sleep."

As soon as I said it, I was scared. He grabbed my arm. Then he

gave me a push. He stood over me, his fingers tapping on his belt buckle. "By God, I'm beginning to think they shouldn't have let you out. You better watch yourself or when your doc comes next time, I'll have to tell him you need to be back there."

"You'd better tell him the truth," I said stubbornly. "Or I will."

"Who do you think you are to threaten me?" His big square face was full of red blood. "What kind of threat do you imagine you can get away with?"

I couldn't imagine. It was unimaginable. I'd have to make out some way until my year was up.

His jaw throbbed. His eyes were full of thoughts going lickety-split. "What did you tell your Dr. Shap? Speak up, girl, or I'll take my belt to you."

I stared into his eyes hard so he could see. There was a lot I could tell Shap if I wanted to, if I had to. I meant him to see. If I had to, I'd never sleep again.

"Hell," he said, "women are like buses. There's always another one coming along. I'm going to give you some advice and if you're smart you will take it. Don't forget that I'm the head of this house. It's my sweat and my money that keeps this roof over your head. Your mother understands that. You got to understand it, too."

I felt giddy, bold. "You should be nicer to my mother."

"You have no say about what I should do!"

"I thought if I stayed in that place all that time, I'd have some rights."

His hand caught the side of my head. I stumbled and fell.

"Get up," he roared. "Don't pretend you're hurt. A little knock like that don't do any damage. You don't have any rights whatsoever. Get that straight."

I raised my head and stared without blinking. "I didn't tell Shap anything."

"If you're smart, you'll keep it that way. You're no crybaby. I'll say that for you. You're tough, like me. But you are not me. Now, go to bed, and if you hear anything, just pull the covers over your head."

The next morning Muriel came to the kitchen for her first cup of coffee very late, wearing her robe, and looking soft and doughy. Her mouth had no shape. She eased herself on to a chair. "Oh sweet jeezus," she said, "I wish I didn't have to go to work today."

That was all, except she gave me a five-dollar bill. "It's from your

father. Stuart wanted you to have a little treat. He's a good man, your father." She told me that I could walk to the store when my work was done and buy anything I wanted for dinner.

After she was dressed in her pink uniform with the pink bow on her hair, and was gone to Henry's Fashion Restaurant, I went into their bedroom. She had made the beds. I lifted the bedspread. The sheets were fresh. In the laundry the hamper was full. I loaded the washing machine. After the sheets were washed and folded and the hems ironed the way she liked me to do, I changed into my new dress, and I went back into her bedroom. I examined the cosmetics on her dressing table. Then I examined myself. My hair was shaggy, like a child's cut, too short to do anything with. I touched the tip of my finger to the green eye shadow and smeared it on my upper lids. I lengthened my lashes with mascara. Now I looked older, almost twenty-one, I thought. Through the bedroom window I saw the white convertible swing around in a U-turn and disappear down the street. I drew a moist mouth with Muriel's lipstick. I sprayed cologne around my head. Then I took my purse and went next door to Mrs. Bernhard.

"The door's open," she called out. She was lying on the sofa, crocheting. Her needle stopped, her forefinger wrapped with the thread, curved in the air.

"Do they know you've come here?" Her bare legs were stretched out straight in front of her. They were the color of cement and pocked with encrusted craters. Her feet were thick, the toenails painted the same purplish red of her fingernails.

"Shap says if I had a grandmother I could visit her. He says I can go to the store by myself now."

"I should hope so. I liked your Dr. Shap better than I expected to, but I don't like snoopers. Pretending he needed to use my phone. I guess it is his job though."

"I didn't hear the doorbell. I was taking a nap."

"Where were you taking a nap, little sweetheart? In the closet?"

I hung my head.

"Max was upset because you wouldn't talk to him. He cares about you, Billyjean. We all care about you."

"I came to see if I could bring you anything from the store."

She sighed and her crochet hook flew. "Thank you just the same, Billyjean. I appreciate the thought. Max left the house not five min-

utes ago with my list. He'll be at the Coop. Look for him and he'll give you a lift home with your bags."

I walked rapidly, straight past the Coop where I wasn't supposed to shop because commies shopped there. Jews were commies. I didn't see the white convertible. I crossed the street to the Normandy Village and went into the supermarket. For a time I walked up and down the aisles just looking at all the things. One of the clerks who was straightening the shelves smiled at me. I was at the drug counter and examined the lipsticks, studying the colors. When the clerk moved to the next aisle, I picked out a real pretty red. I didn't have a basket and I carried the lipstick in my palm. At the fruit counter, I had to put it into my sweater pocket while I broke off three bananas from a bunch. I picked up a package of buns and some hot dogs. I went to the candy counter. A small boy was touching all the chocolate bars. He left suddenly, very fast. He did not go through the line at the cash register. I watched him disappear, running, through the parking lot.

"Is that everything for today?" the man at the cash register asked. I was glad it wasn't the lady that Muriel had introduced me to. I put down the bill, he gave me the change and bagged my purchases. On the street, I put my hand in my sweater pocket and was surprised to find the lipstick there. I knew I had done wrong, a silly wrong, but in the store it had seemed as if I was meant to take something. That little boy had certainly taken some candy bars. All those things were out on the counters to be picked up.

Someone was calling. I was sure it was the store clerk. I wanted to run, like the boy with the candy bars. A car stopped beside me. Max leaned across the opened door. "Get in, Billyjean, I'll give you a lift home with your bags."

The car seat was soft and deep and very wide. I was a long ways from Max. I sank into the leather which fitted me. The car moved down the street, gliding like a boat in water. Max didn't drive fast. He didn't go straight home. I had to get rid of the lipstick. Behind the groceries in my lap, I took it out of my pocket.

"Where'd you get that eye makeup, Billyjean?"

"I didn't steal it!"

"Of course not. I didn't say that. I didn't think that. I just asked where you got it, I meant why did you use it. I wasn't accusing you of anything. Anyway, thanks for talking to me today. Thanks for

letting me give you a lift. I wouldn't blame you if you did steal it. Billyjean, you know you can trust me, don't you?"

"It's Muriel's. Are you going to tell her?"

"Don't you believe I'm your friend? Didn't you listen to me yesterday? I'm on your side." He took his hand off the wheel and pulled a folded handkerchief from his breast pocket. The car steered itself. He handed the handkerchief to me. It smelled almost like a cocktail: lime. "What's that for?" I asked.

"Wipe off the eye shadow. Pull down the sun visor in front of you. There's a mirror on the back side. You can see what you're doing."

"I want to look my age," I said. "I can't go to a movie with Stuart and Muriel if I don't look my age. Everybody treats me as if I am still eight years old."

"You were never eight years old." He turned to me. The car drove itself. He had a kind of tick in one eye and a tight look around his nose as if he had a cold. "You don't need that stuff on your face. It's not your style."

"I don't know what my style is." I was scared.

"You're a stunner, Billyjean. I'd like a chance to show you to yourself. I could make you look like a million. I'd like to take you to Vegas and dress you like a queen."

"I'm not allowed to go anywhere with a man. I'm on probation." Suddenly I remembered the lipstick. I had taken a lipstick without paying for it, and I had broken my probation. I panicked. I let the lipstick slip out of my hand and fall to the floor. "I have to get home," I cried, catching my breath. I tried to open the car door.

"Stop it. You'll kill yourself! What in hell—!" Then he calmed down and almost like Shap he asked, "Do you have frozen stuff in the bag?"

"Yes."

He drove faster and didn't stop the car until he was on our driveway, right by the front door. When he opened the door for me, the lipstick rolled out. "You dropped your lipstick, Billyjean."

"It isn't mine."

"I sure don't have a lipstick," he said, smiling. His face was narrow, uneven. His smile turned down on the left side. His eye with the tick in it was lower than the other. I could see his beard growing even though it was only afternoon. His hair was straight and coarse and black.

"Maybe it belongs to your girl," I said.

"How do you know I have a girl?"

"Mrs. Bernhard said that you have gorgeous girls."

"When did she say that?"

"I've got a good memory. I've got a better than average IQ."

"Don't talk like that. No one cares about your IQ, a gorgeous girl like you." He opened the lipstick. His fingers curved, too. "It looks brand-new. You might as well have it, Billyjean."

I shook my head. "I don't want it."

"You're right. It isn't your color. You should only use a pale pink lipstick. Will you be going to the store tomorrow?"

I didn't answer. I had to get away from that lipstick. But even though I no longer had it, I couldn't get away from it. I couldn't settle down to start dinner. I didn't want to be alone. I wished that the children next door were home. The only other place was Mrs. Bernhard's but I couldn't go there, with Max knowing I had lied. The phone startled me like it was the police on my trail. It was Stuart saying he wouldn't be home for dinner. I asked him to come home, I begged him. At first he was kind of worried and wanted to know what had happened, but when I said I didn't want to be alone, he got mad and said I'd better start learning to be alone, and I lost control and screamed at him to come, and he hung up.

I was furious. I had the biggest blackest anger in me, bigger than anything that I had ever felt. I tried to think of some terrible thing to do, something hideous, like I was. But after a while I knew what I had to do. I had to go back to the supermarket and pay for the lipstick.

"I put in my pocket because it rolled out of the basket, and then I forgot to pay for it." I looked right into the man's eyes as I put down the money.

"You are a very honest person," he said. "Not many people would go to all this trouble for such a small mistake. But I do thank you very much because I have to make up any discrepancies in my cash."

I walked home feeling so good I wanted to cry, and I didn't notice that I was passing the Coop, until this man in the parking lot caught my attention because he was staring at me as if he wanted to speak to me. Almost I got scared again, but I knew I didn't have to be scared now. He smiled and started toward me. "Say, don't I know you from somewhere?"

He was good-looking, with a dark moustache that turned down at the corners and a nice mouth. I could see that he thought I was pretty. I was being picked up by a handsome young man, someone my own age, not too old like a grandmother, not too young like the children. I was pulled to him like he was a magnet, and I was one of those filings that can't stay away from magnets. I had to hold on to myself, to remember that I wasn't real yet, I wouldn't be real until my year of probation was over. It was so natural to turn to him and say, "I'm sure I've seen you somewhere, too." And then he'd say would I have a cup of coffee with him, and we would talk and then maybe we would find out where we had known each other from. He wouldn't be fresh. He didn't want to get off on the wrong foot with me. He could tell by looking at me that I was a nice girl. I wouldn't dream of doing anything like playing house—like Phil did—or those other boys—or even the way Michael played house, taking his family into the field—

The make-believer took me all the way home to the little house with the two small Doric columns. I took out my key and opened the front door and went in alone.

The following day as soon as I had finished the housework, I got ready to go to the store again. Again I rang Mrs. Bernhard's doorbell. This time she asked me to buy her a bottle of nail polish. She showed me the polish she was using, holding out her ugly naked foot. "Find me a new shade, Billyjean sweetheart. I need a change."

Most of the active things women spend their time on she couldn't do because of her bad legs. She crocheted, embroidered, knitted. She played solitaire. She played with her jewelry, changing earrings, necklaces, bracelets, rings. She spent a lot of time messing around with makeup. She had wigs and false eyelashes. She had every shade of lipstick and eye shadow, and a box filled with little nail polish bottles, every color, even black and opalescent. It was going to be hard to find her a new shade.

"Bernie says I've made enough doilies. I have to do something." She didn't mention Max.

In the store I chose a bright orange polish for her that the advertisement said was brand-new. At the meat counter I held the little bottle in my hand as I sorted through the packages.

"You need a basket, Billyjean." Max was beside me. He took the polish and the package of baloney from me.

"That polish is for Mrs. Bernhard," I said.

"I supposed it was. If you use any polish, it should be pink."

We went back past the cosmetic counter and he chose a bottle of the palest pink.

"You look great today, Billyjean. You look gorgeous." He added more cold cuts to the basket and some cheese. We went up and down the aisles together, choosing things. He would ask me about what size olives we should get, one can or two of anchovies, white crackers or wheat. At first I didn't know how to act. What else?

"Mayonnaise," I said.

"Right. What else?"

I couldn't think of anything else.

As we went to the cash register, he picked up a pack of Coke. He paid for everything. He carried the bags and led the way to his car. It was so natural that I couldn't feel frightened. Maybe we had never played house.

"Today you don't have any frozen stuff so you don't have to hurry home," he said, smiling. He drove slowly like before, the car meandering around corners like some big lumbering graceful butterfly. "The neighborhood has changed a lot, hasn't it, Billyjean, from when we used to play hide-and-seek."

"They took down the gate to Paradise," I said, troubled.

He laughed. The tick was going faster in his left eye.

"There really was a gate. It spelled out Paradise Valley in iron. You thought I was being a loony, didn't you?"

"Well, for a minute there, I confess I didn't know what to think."

"Aren't you nervous being seen with a loony?"

"No, I'm not nervous. You're not nervous today either, are you?"

"No."

"Mr. Bernhard gave me a pair of skates and I used to scoot on one foot pretending I was an angel with wings. Because we lived in Paradise," I explained.

"I get it," he said, grinning. "Do angels only have one foot?"

"I was scared to skate on two."

"I was, too, at first."

"I never learned."

"You didn't have a chance." He was silent for a time. I didn't know what he was thinking. And then he said, "Where should we drive?" and I was scared again.

"The woods are gone," I said quickly.

"No, they're still there."

"But I didn't see them when Muriel brought me home."

"She could have come by the new freeway. The freeway bypasses the woods. Some of the trees were cleared away to make room for new housing developments, but a lot of people in town didn't want

a single tree cut down, and they made a big fuss, so there was a compromise."

"Which side were you on, the side of the woods or the side of the houses?"

"Well, I have some money in the houses, but I like the trees, too. I guess it's right to have some room for houses and to keep some trees. That's the way it is now. You used to play in the woods, didn't you?"

"We weren't supposed to play there!" I said too quickly. Then I explained it was on account of the poison oak. "We played in the slaughterhouse. It's gone now."

"No, it's there, an eyesore. Every time I think it's coming down, some litigation in the estate comes up in court and stops the demolition or delays it."

I was very proud that he talked to me like I was grown up, using words like litigation and demolition. He didn't even ask me if I knew what they meant. "The slaughterhouse really was a slaughterhouse," I said.

"What else would a slaughterhouse be if it wasn't a slaughterhouse, eh, Billyjean?"

He laughed and I laughed.

"You've got a pretty laugh, Billyjean."

"When they killed the cattle there, the blood ran down the troughs. The troughs are still red. We found some real bones. The boys played war."

"It was realistic."

"Yes," I said gravely, "realistic. But the bones were important too for scientific reasons." I stole a look at him, and he was interested, so I went on to tell him about Michael who was going to be an anthropologist or a paleo—I was sorry that I started with that because I couldn't say the word right.

"Paleontologist," Max supplied. "I always have trouble with that word."

"I do, too." I was glad I had thought about Michael. Michael Colby. He was one of the good memories. "Michael collected bones to study them. We played field trips, and once I found an important bone." I smiled to show that I was funning. He smiled back showing he understood me. "Michael said Bubber could come along on the field trips because when he was a real paleontologist" —this time I didn't stumble—"he was going to take his family into the field with him."

"I'm glad you can talk about Bubber, Billyjean."

"Shap told me it would be easier after I said I did it, and it was easier."

"Do you want to talk about how it happened?"

"I don't know how it happened."

"Then why did you say you did it?"

"Shap wanted me to. If I said it, I could come home, he said."

"Then I'm glad you said it."

"I'm glad, too. May I tell you something?"

"You can tell me anything, Billyjean."

"I'm not really well."

"Of course you are. Who's been telling you otherwise?"

"Shap told me. He bent the rules. You see, when I was twenty-one, I was old enough to go in with the women, but he didn't think it would be good for me. He wanted me to have my chance, and so he told me what he wanted me to say, and I said it. I said I picked up the wrench and hit Bubber. Muriel bent, too. She knows that I'm not all well, but she wants me to have my chance, too. She wanted me home with her even though it's not easy for her."

"Is it easy for you?"

"It's life."

"I'm proud of you, Billyjean."

The car kept going down one quiet wide street and around a corner and down another street. Boys played baseball, ladies watered the lawns, little girls wheeled doll buggies. They watched us go cruising by and I thought how they would be wondering who that gorgeous girl was in the big convertible with the handsome man.

"Shall we have our picnic in the woods, Billyjean?"

I had no idea that we were going to have a picnic.

"Do you like picnics, Billyjean? I love them."

"I love them too," I whispered.

He turned quickly to look at me and he laughed as if he was very happy. Mrs. Bernhard or someone had seen to his teeth so they didn't go bad, like Shap's. I didn't have to feel bad about Shap now, I had another friend. Maybe I'd wear the friendship ring and I could pretend that Max gave it to me. But I knew I wouldn't do that. Shap had given me that ring. I couldn't pretend he hadn't.

The car went faster. Before long we came to the woods and we had to get out of the car. When we walked into the trees I began to

get scared. All of a sudden I thought I recognized the place. It was the place where Phil had brought me. Phil wants to take you for a walk, Glenn said, and he said he'd watch Bubber for me in the slaughterhouse, and Phil gave him money, and Stuart chased Glenn out of the house. Where was the slaughterhouse? I shouldn't have gone with Phil. I shouldn't have done it even for Glenn.

"Are you cold, Billyjean? We can eat our lunch in the car if you're cold."

"No, I'm not cold."

"Some ghost walked over your grave," Max said. "I've heard that said when you shiver like that. You sit on this log. I'm going to get the robe from the car."

I really was shivering now, but I wouldn't say so. Max spread the car robe on a smooth place. I hoped he wouldn't ask me to lie down. I didn't want it to be like it was with Phil. I knew I didn't want to do it. I wanted Max to be my friend. If he asked me to lie down, I would.

But he didn't. He set out the food, and suddenly I was very hungry, and he said he was, too, but he really didn't eat as much as I ate.

"Warmer now?"

"Oh yes."

"I guess you were just hungry."

I laughed.

"Is that funny?" he asked. "I guess it is. But when I'm real hungry, I get cold. Crazy, huh?"

"Real crazy," I agreed.

Afterwards I helped pack the food away in the car.

"There's a lake somewhere around here," he said. "Want to go find it?"

"I don't remember any lake."

We held hands so he could help me over branches and guide me around marshy spots that still held water from the night, and just because we wanted to hold hands.

"It probably wasn't here before. It's man-made. You can take out boats. Would you like to take out a boat?"

"I don't know how to swim."

"I'll see that you don't fall in."

We found the lake and the little boats looked nice on the water. I was so happy to see them there with people in them. It looked easy too, like I could do it.

"Don't you trust me, Billyjean?"

"I don't trust those boats." We laughed. We laughed a lot.

"I guess we'd better get started back," Max said. I wasn't worried about it being late or about my probation. This wasn't a date. This was just Max, a kind of relative who had known me before I was born.

"We could drive by the slaughterhouse on the way back, but I guess that can wait. We had a nice time, didn't we, Billyjean?"

"The best time of my whole life. I want to pay my part of the food, please."

"Why, Billyjean, that was a present. You can't pay for a present."

I rushed at him, butting my face into his shirt front. I caught his smell, cigars and limes and just Max.

"Heh!" he said softly, and again, "Heh!" His fingers touched my cheek. "You're not crying, are you crying?" he touched my eyelashes. "You've got long lashes, Billyjean. Other girls are going to hate you for that. You've got beautiful eyes. Don't ever use eye makeup."

"I promise," I said solemnly.

He shook his head. "Billyjean, you shouldn't look at me like that."

I closed my eyes. "I forget."

"What do you forget?"

"Stuart says that I stare, he says I don't blink."

Max was silent.

"I've only been on one picnic before, when Stuart and Muriel and Bubber and I went, and Bubber all got poison oak."

"You're going to have a lot of picnics from now on."

"With you?"

"I hope some with me. But you'll make lots of new friends, too."

"I won't like them as much as I like you."

"What about—the scientist? Michael?"

I didn't know what had become of Michael. Perhaps he was a scientist now, off somewhere on a field trip, with his wife and family.

Max raised his arm and put it around my shoulders. I looked up, waiting, and he kissed me. Then he removed his arm and started the car, and we got out of there fast. "That was a kiss from your big brother, Billyjean."

"You aren't really my big brother. Was it wrong for me to kiss you back?"

"Not wrong to us. But it could be to your Dr. Shap. I wouldn't

want to do anything that would make trouble for you with your probation officer. I don't want anything to break your probation."

"I don't want anything to break my probation either. But I want to be real."

"You're real, Billyjean, don't ever doubt it." He hit the steering wheel. "Jeesus, you shouldn't be grateful for a little human kindness. You haven't had a chance to know love. You haven't even had a chance to talk to a man."

"I've talked to Dione."

"Dione, eh? So I do have a rival for your affections. You know I'm joking, Billyjean, don't you?"

"He is Diane's brother. He's twelve. Max, what if there isn't anybody who is just the right age for me?"

"There will be. Don't be in a hurry. You have to have a chance to find out. It's like you've been asleep for thirteen years, and you've just opened your eyes."

"And right in front of my eyes is the handsome prince and I fall in love with him just like in the fairy tale."

"Billyjean, be very careful while you're on probation. After that, you'll be safe."

"After that I'll go to Vegas and I can do all the things that everybody on the outside does and it's all right, but that puts you back inside if you're on probation."

"It isn't fair, I agree," Max said.

"Max, can we talk—about when I was eight and you were home from the Navy, and you played hide-and-seek with us kids?"

"If you want to, Billyjean."

"Don't interrupt me or maybe I won't be able to say all I want to say. I guess you knew, didn't you, that sometimes we played house."

"All kids do that kind of thing, experimenting. They're curious. Sure I guess I knew. Why?"

"Don't look at me or I can't say it."

"Are you sure you have to say it?"

"Yes, I know I have to ask you."

"OK. Shoot."

"Did I play house with you, Max? I can't remember. I have to know and make it real, or else I have to be sure it is all right for me to forget it."

He made a sound that wasn't speech, and he took my hand and squeezed it. "You can forget it, little Billyjean."

"Truly? Really?"

"Truly and really. You were a little temptress, you know. I thought to myself, if she was only ten years older. You knew I was attracted to you, didn't you? You see, whatever happens between two people, both people share the responsibility. You were so innocent and so knowing. You had so much love to give and you were always looking for someone to give it to—but you can take my word for it, Billyjean, and forget it."

I thought then that I might be able to tell Max about Stuart getting in bed with the loony. Did she have to share the responsibility, too?

But Mrs. Bernhard was watching for us from her front window. On the Campolinis' driveway, their car was parked.

"They're back from their vacation," I said. "They went to Disneyland and to the San Diego Zoo."

"Would you like to go to those places?"

"I'd rather go to Vegas."

The following day when I rang Mrs. Bernhard's doorbell to ask her if she needed anything from the store, she told me to come in and sit down. Then she told me that Max had gone back to Vegas. She told me what an important busy man he was. People were always after him. Every day he had long-distance telephone calls to keep track of his business deals. Every night girls phoned him. "I don't think that Maxie will ever get married. He'll never be satisfied with one girl. Those girls have spoiled him. He's used to playing the field. After that a man doesn't settle down and stick to a wife. He's my brother's boy and I love him like he was my child. He is like my child. His mother was so sick after he was born. She didn't have enough milk to nurse him. I gave him his bottles. But that's not the same as mother's milk. His little bones were weak. Even today his fingers are crooked. But I took care of him, I made him strong so he grew into a man. He's a good man, but where women are concerned, he can't be relied on. A girl would be crazy to trust him."

"You think I'm not gorgeous enough for him," I said. "You think I'm bad, a loony, not good enough for him."

"My darling Billyjean, you are too good for him. He's not good for you."

"I hate you," I said, grinding the words between my teeth. "I'll kill you. I'll hit you on your legs and break open your sores."

"Go ahead and yell at me, little Billyjean," Mrs. Bernhard said in a heavy hurting voice. "Kill me, little madonna. But don't hit my poor legs."

"You'd like me to hit you. You'd like me to get into trouble so that you could send me back to that place."

"Billyjean sweetheart, you are killing me, but go ahead and kill me if it will make it any easier for you."

"I could kill you. I could get the wrench and hit you over the head and make your hair turn red."

"God in heaven, what are we doing to you?" she moaned.

"He didn't go back to Vegas. You're lying, aren't you?"

"No, my poor Billyjean, I am not lying. He went back to Vegas."

"You sent him, then."

"No, I didn't send him, sweet Billyjean. No one sends Maxie. Not even me. Maxie does what he decides to do. He went."

"Go fuck yourself, you dirty kike!"

"Where did you learn to say such ugly words, you poor child?"

"In that place! Where else?"

"Be careful, sweetheart, be careful so they won't send you back. A second time you might not be lucky again and come out."

"You'd like that, wouldn't you?"

"Not me. But someone might like it. I am afraid. I am afraid for you, little sweetheart."

"You're lying. There is no one but you who wants me back there."

"I pray to God you are right. If no one wishes more harm to you than I do, you will be safe, little madonna."

"Who are you talking about? Tell me, or I'll squeeze your legs and open your sores."

"Who is it who finds you a burden, little Billyjean?" Her head nodded all by itself.

"That's a lie!"

"I hope you are right and I am wrong."

"I can prove it is a lie." I told her then what Shap had told me. He had bent the rules to get me released, so I wouldn't have to go to the women's facility, and Muriel and Stuart had bent, too. They would take me even knowing that. "It isn't easy for them, but they wanted me." I said.

Mrs. Bernhard sat nodding her head like one of those silly dolls with bobbing heads.

"They could get into trouble over me, but they wanted me to come home to them."

The bobbing went on.

"Muriel hasn't had a night off since I came home. She's been as much in jail as me." I watched the head, bobbing and bobbing. "It's an added expense to take care of me, to dress me, and feed me, and even to take me to the movies. I don't bring in any money. When Glenn didn't bring in money, Stuart sent him away. Glenn had to pay his way or get out. But he wants me. Stop bobbing your head at me!"

The head was still at last. I was triumphant. I had proved it to her. "You see? You were wrong. Admit it. Go on, admit it. They've had to make adjustments because I'm back. It costs. Even if they have to do without some things, they want to give me my chance."

"Billyjean, God help me, I am going to tell you something, not to make you blame your mama and papa, but because I love you, and I fear for you. Muriel and Stuart want you to have your chance, yes. And they have to make adjustments, yes. It is not easy, that is true. But they are not out money because you are back."

"I suppose it doesn't cost with another person in the house?" I sneered. "Stuart even gives me spending money. Just the other day he gave me five dollars."

"It costs," she agreed. "But they don't pay. The county pays for you. The county sends a monthly check to cover your keep. Even for a spending allowance for you. Billyjean, he gave you your own money."

"That's not true."

"It is, child."

"You are lying!"

"God strike me dead, if I am. Muriel and Stuart get a check every month for keeping you, like they were a foster home."

That day at the store, I filled my purse with candy bars and I kept only one in my hand.

"One?" the lady at the cash register said. She was the one Muriel had introduced me to. "Is that everything?"

I put down the money and stared at her without blinking.

"It's a real tasty bar, isn't it?" she said. "I love 'em, but I can't eat 'em. I could when I was your age, but now I put on pounds just looking at 'em."

I picked up my change.

"Have a nice day now," she said.

16.

Mr. Campolini owned a single-lens reflex camera with inter-changeable lenses. "It's an f1.2 with matched needle," he said. "Before our next trip I'm going to have an f1/4 automatic exposure." He also owned an automatic-load super 8 nonfocusing zoom lens movie camera. To show his slides, he had a projector with remote control and automatic focusing, and he also had a projector for his movie film, but there was a new one on the market that he wanted to buy which allowed you to stop and frame at any point, to back up, slow down, or speed up.

"He's always buying new equipment," Mrs. Campolini said, not disturbing her regular features with any expression so that you couldn't see if she was pleased or not.

"You're lucky I'm such a clever lawyer fellow and can afford to indulge a hobby," he said. He exuded confidence. His ugly face was better than handsome.

"I am very lucky," Mrs. Campolini said, and this time I saw into her eyes. She was thin and white, and he was not fat but he looked soft and rich. His complexion was like butter and he always looked as if he had just shaved and patted on talcum powder not caring how much he used. His fingernails were manicured and white around the cuticles.

On weekends it was easy to hear him talking, calling to the chil-

dren as he posed them for pictures. "When that cloud moves," he'd
say. Or, "A little to the right so you are framed by that bush." It
was harder to hear Mrs. Campolini, but I caught words like "your
dress," or "don't squint." Then likely Mr. Campolini would shout,
"No, hold that smile. I want a closeup of you all mouth."

When they came back from their trip to Disneyland and the San
Diego Zoo, Mr. Campolini had to wait while his slides were
processed, and then he had to sort them. It was a big job because
he had hundreds. "It's really immoral," Mrs. Campolini said in that
expressionless way that now I was beginning to understand. "When
he gets them down to a respectable number, we want you to come
over and see them."

Muriel bought a new dress especially, with a scoop neck that
shower her pushed-up breasts. "Proud of your boobs, aren't you,"
Stuart said, but he snapped his finger at the right one in the old
way. She tossed her head, then noticing me, she said, "What's the
matter with you?"

What was the matter with me was that Max was gone. "Nothing,"
I said.

As it turned out, we were the only ones at the Campolinis' show.
"We like to show our slides to small groups," she said.

"When they're good they are 'our' slides," he joked, winking so
that you knew he wasn't in earnest.

He talked a lot about how hard he worked to get his shots, study-
ing to frame the pictures just right, figuring the exposure, waiting
for the right light, for a cloud to shift, for people to get out of the
way. The way he described it, it didn't seem much fun. Sometimes
he even climbed to some dangerous place to get an unusual angle.
"Claudia was saying her beads while I got this one, weren't you,
Claudia?" He meant because she was Catholic.

"One of these days he will fall," she said without expression.

"I have faith in your prayers. You see, I wanted to shoot down, so
I had to climb on some construction for this one. By the time I was
finished, there was a whole line of fellow photographers waiting to
take my place."

Before the show started, Mrs. Campolini said that Diane had a
present for me, because I had kept such good care of their house
while they were gone. Her sister, Mrs. Logan, had driven by several
times and reported that I was doing a fine job.

"She didn't have to check on me," I said. "Who checked on her?"

"Good question," Mr. Campolini said. "You'd make a fine lawyer, Billyjean."

"It wasn't out of Isabel's way at all," Mrs. Campolini said. "She just drove by on her way home from work."

The present was a small doll, dressed in a costume. "It's from Italy," Mrs. Campolini said, "to start your doll collection. Diane chose it. I knew I couldn't offer money to a neighbor. It's hand-made, of course, and it is authentic, the costume of northern Italy where my family came from. A doll collection has an educational and cultural value."

"Are you finished?" Mr. Campolini asked, pretending to be very patient. "I didn't know these good people came here to talk about dolls. I thought they came to look at slides." On the whole, though, he was very polite to Mrs. Campolini. I wondered if they talked to each other in that polite way when they were alone.

He did most of the talking because he was the expert photographer, but once in a while he sat back, saying, "Now, this is Claudia's story," and then Mrs. Campolini would give a little talk about the slide, something educational—history, or art, or science.

Muriel responded at frequent intervals with nervous little bursts of enthusiasm, and Mr. Campolini acknowledged her praise each time with great formality saying, "I appreciate that, Muriel," or "I value your opinion." Stuart didn't say a word. I was afraid he would fall asleep in the dark and maybe snore or worse. I loved the slides, especially the ones of the animals.

"The children will sit on the floor," Mrs. Campolini had said, and Mr. Campolini added, "And leave the comfortable chairs for old bones." He winked at me and I understood that I was to be considered that evening a child to sit on the floor. I didn't mind, but I was embarrassed by the doll. Didn't they know that I was too old to start a doll collection? I didn't want the doll from Italy, and in the dark I pushed it under the sofa beside me.

"Diane didn't choose it," Dione whispered. "We wanted her to give you money. You're going to need money. Even Dad said the doll seemed inappropriate, but Mom was sure you'd like it."

"I didn't choose it," Diane explained anxiously.

When the last slide was shown and the lights put on, Mrs. Campolini served a real dinner, a ham with pineapple and potato salad, a green molded salad, and plates of cookies. There was lem-

onade for the children, and small glasses of sherry for the old bones. "I was beginning to get worried," Stuart quipped.

When we left, the men stepped outside, Mr. Campolini still talking about cameras, and Mrs. Campolini whispered to Muriel. She avoided looking at me and I was sure that she was suggesting that next time they went to Disneyland they would like to take me with them, since I had enjoyed the pictures so much. Muriel took my arm and held it tightly against her as we crossed to our house, and I felt very happy and forgiving. What did it matter if they got paid for taking me home? What did it matter if the county sent them a check each month, even with an allowance of spending money for me? What did it matter if Max was gone?

We were hardly to the house when Muriel screamed at me: "So that's what you do when I'm not here to watch you!"

"For crissake, Muriel, wait until you close the door."

"Leave it open. I don't care who hears."

"Do you mean about the doll, that I pushed it under the sofa?"

"I thought they were going to pay Billyjean for watching the house," Stuart said. "That doll couldn't have cost much."

Muriel slapped my face.

"Hold it, Muriel," Stuart said, "give her a chance to explain."

"Claudia knows. Probably the whole street knows. Everyone knew except me."

Then I understood that Mrs. Campolini had told Muriel about seeing me come home in Max's car. "I was at the store and he was there and he said he'd drive me home because I was carrying the groceries."

"You knew all along what I was talking about!"

"No, not at first I didn't know."

"You did know. Admit it!"

"Yes, I knew."

She slapped me again.

"That's not fair!" I cried. "You told me to say it, and I did what you said."

"Your father and I told you you were not to have anything to do with those kikes next door. Getting out of his car right in front of my house! Don't you have any shame?"

"Would it have been all right around the corner?"

Muriel sprang at me, but Stuart caught her.

"I'll kill her," she screamed. I knew it wasn't a threat. I knew it wasn't even a plan.

"You don't have to worry," I said. "He's gone back to Vegas. Mrs. Bernhard told me. It won't happen again."

"If it does, I'll send you back to that place, and you'll stay there."

"Why did Bessie send him away?" Stuart asked. "What did he do to you?"

"She didn't send him. He went. No one tells Max what to do."

Stuart was grinning.

"Go to him, go to Las Vegas with him, if that's what you are." Muriel stared at Stuart's grinning face. "Like father, like daughter. You both make me sick."

"Max doesn't have to be true to one girl," I said. "He isn't married. He's not cheating on his wife."

Then everything happened at once. Stuart started toward me. I stumbled, knocking down the floor lamp. The reflector bowl crashed. Stuart was swearing that he was my father and by God he was going to teach me to show respect. Muriel was crying over what I had done to the lamp and how much it cost. I saw blood on my arm and I began to scream. We were making so much noise we didn't know that Mrs. Campolini was on the porch. We didn't know that she was there until she hammered on the door. Her voice was high and screeching like we had done something to her. We got very quiet. In the quiet, her voice was a shriek. "Muriel! Muriel!" Muriel looked at Stuart and he turned away. Finally Muriel opened the door. Mrs. Campolini's pale face was very flushed. For the first time there was color in her skin. Her features were disturbed.

"What have you done to her? She's bleeding!"

"She'll do more than bleed," Stuart threatened.

"Her father wants her to understand that she is never to ride with a strange man again."

"He wasn't exactly a stranger, was he?" Mrs. Campolini asked apologetically. "He's practically living in the neighborhood. I only thought—well, I knew she wasn't supposed to have dates. I worried about it being a probation violation. I thought it was my duty. I didn't mean—I didn't want you to punish her—not to hit her— Billyjean, you left your doll, you forgot to take your collection doll. Diane found it under the sofa."

I lay awake for a long time planning how I could get to Vegas to Max. I knew I'd have to wait until my probation was finished, but

Shap said that sometimes probation was shortened. Besides, I would need a lot of money. I couldn't trust anyone here. They were all against me. Even Diane was against me, or why would she tell her mother about the doll. But Diane was just a child, perhaps she thought I really had forgotten it.

From the other bedroom on the other side of the dark closet came the familiar sequence of recriminations and reconciliation. "I hate them," I said to myself, "I'll kill them," but it wasn't a project. It just meant that I felt trapped. Everything was backing up in my throat. It was too large to get out of my mouth. I twisted and gagged. It was a nausea that I couldn't hold back, and I couldn't let it go. It was a great column of filth filling my throat. It would burst me.

"You are having a nightmare, Billyjean," Muriel said in a scared voice beside my bed. "Wake up, Billyjean, you are having a bad dream."

I wondered if this would mean that Mrs. Campolini would not let the children come to visit me. But on Tuesday after Muriel went to work and I was in the garden, they came through the hedge.

"How are you?" Dione asked.

"Mama said Stuart knocked you down," Diane squeaked. "Mama said he made you bleed." She was staring at the Band-Aid on my arm.

"It was the lamp that cut me," I said. "It wasn't bad."

"Mama said he would have killed you if she hadn't come in time."

"You talk too much, Diane. Don't mind her, Billyjean."

Dione sat cross-legged on the path, his feet curled on to his legs. "He sure has a terrible temper," he said.

"I have a terrible temper too," I said. "I have his temper. I got it from him."

"Mom said she felt it was her duty to tell about you and Max," Dione said.

"Don't be mad at her, Billyjean," Diane pleaded. "Please don't be mad at her."

"I'm not mad at her. She was just getting even because I didn't take the doll she brought for me."

Their eyes consulted with each other.

"You tell, Dione," Diane begged.

"She's sorry now that she told. Dad said it's always better not to tell."

The sun was shining in a pale blue sky, cloudless. The air moved with a gentle breeze, not even lifting my hair from my forehead. The slightly unpleasant odor of fertilizer and the dying flowers made me want to breathe deeper. Dione picked up a twig and poked in the ground. Suddenly the earth erupted with life. Ants swarmed in all directions, hysterically preparing for a crisis that they couldn't understand.

"What are you going to do, Billyjean? You have to do something."

"Why does she? Dione?"

"Maybe I'll go to Vegas to be with Max."

"You going to marry Max?" Diane asked.

"You can't go until your probation is finished," Dione said flatly.

Diane crept to me and stuck her head under my arm for a hug. "You've got us, Billyjean. Hasn't she got us, Dione?"

I looked from one small triangular face to the other.

"I don't know where she'd be if she didn't have us," Dione said.

I didn't see how I had ever thought that they looked alike. They didn't even look related.

"We're going to be with you every single day, aren't we, Dione?"

"I said if Billyjean wanted us."

"I do want you. I don't know where I'd be without you."

"So now," Dione said, "you will get the key for the garage, won't you?"

I had known for some time that the key to the garage hung beside the back door in the rear entry.

"I'm not supposed to go into the garage," I said.

"Of course, there's not much for us to do every day, if we don't go into the garage," Dione said.

The children waited in the garden while I got the key. The big overhead garage door didn't open. Beside it was the smaller door, not as tall as an ordinary door, but as wide. It was padlocked. Even then I might not have gone in.

"Will her mother and father be very mad at her?" Diane asked, with that delicate pulling together of her fine eyebrows.

"They won't even know," Dione told her. "Anyway, we're just going to look for GrandmaLoreen Doll, aren't we? Heh! What did you think we were going to do in there?"

I had to laugh, and Diane clapped her hands happily. I took the padlock off the hasp and hung it on one side. The door swung in. We stepped over the high threshold, and the door swung back behind me. It was dark, like the closet. I whirled around to escape. Dione blocked the way. "Where's the light switch, Billyjean?"

"I don't remember," I said wildly.

The light went on. "Diane can see in the dark," Dione said. The lawn mower was right beside the door. Against the back wall were

cartons and barrels, each with a big number on the outside made with a black crayon. In the other half of the two-car garage was the workshop.

At first, nothing sat still long enough for me to see, then gradually things dropped into the order I remembered. Behind the heavy workbench, built high on thick legs for a big man to work comfortably, was a large wallboard dotted with holes and pegs. Tools were hung there. Beside the board and around the right-hand wall were shelves. Nails and screws and washers and all that small kind of thing you needed for making things and for making things work were sorted into bottles that you could see into, and so you didn't need to wonder what was in them. There was a section of the shelves for paint cans with the labels wiped clean so you could read the kinds and colors. There were other shelves filled with boxes, and these were labeled, because you couldn't see into them. The labels said "Canceled Checks," "Paid Bills," "Tax Receipts" with the "p" left out, et cetera. Against the front wall that was really the large overhead door were some bumpy things like furniture, stored under old blankets, which I didn't remember. Over all the neatness and care lay dust and neglect. It had been a long time since anyone had worked in here. It had been a long time since anyone had even walked in here farther than the garden tools right by the door. We left footprints on the dusty floor.

"What we have to do first is find the key to the big boxes," Dione said.

"Why do we need a key?" Diane asked.

"Not a real key, a code, a list of the things stored in which boxes. That's why the boxes and barrels are numbered. The numbers have to stand for something. No one would go to all that trouble and then not make a code for the numbers."

"You're awfully smart, Dione. Isn't he, Billyjean? He's going to be a criminal lawyer when he grows up. Daddy says he's got a lawyer's mind. You have to have a special kind of mind to be a lawyer. Dione's got it."

"You still have to practice. That's the hard part, finding something to practice on."

"You can practice on finding GrandmaLoreen Doll!"

"Sure, but missing persons isn't nearly as interesting a case as murder."

"The key is on the back of the workbench," I said.

" 'T' for 'Toys,' 'D' for 'Dolls'—" Dione studied the key.

"Maybe its under 'Children,'" Diane said.

But it wasn't there either. There was a number for "Dishes," for "Household Appliances," for "More Appliances," for "Fishing Equip," for "Old Curtains," for "Old Clothes," for "Christmas Decorations," for "Mason Jars," for "Empty Boxes." Standing behind the workbench Dione said, "Pretend you're Stuart, Billyjean. If you were Stuart, where would you put GrandmaLoreen Doll?" His voice trailed off. He was studying the floor. "Is this where you found Bubber?"

"Yes."

"He was hiding from you here behind the bench."

"Yes."

Dione examined the tool board. "Was it the big one?"

"Yes."

"Big what?" Diane quavered.

"You took the wrench off the board."

"I picked it up from the floor."

"Aren't we looking for GrandmaLoreen Doll?" Diane asked.

He studied some more, then he snapped his fingers. "I've got a keen idea."

"What keen idea, Dione?" his sister asked.

"Maybe you won't want to do it."

"I will. Of course I'll want to do it, Dione."

"You'd make excuses, like you didn't want to dirty your dress."

"No, I wouldn't, Dione. Honest I wouldn't."

"Well, then, we will reconstruct the scene of the crime!"

"What crime?" Diane asked hesitantly.

"The killing of Bubber, what else? Billyjean, you show her where to lie down."

"Why do I have to lie down?"

"You'll be Bubber."

"Will I get my dress dirty?"

"It will brush off, don't worry."

"I thought we were going to look for GrandmaLoreen Doll," I said.

"It's the same thing," Dione said.

"How is it the same thing?"

I could see Dione's mind going around so fast it made me dizzy.

"Whoever made GrandmaLoreen Doll's eyes drop down could be the same person who hit Bubber."

Diane sidled close to me and hid her face against my body. I could feel the warmth of her breath. "She's scared," I said. "She doesn't want to do it, Dione."

"Are you scared, dopey?" His eyes glittered.

"Only a teeny bit," Diane said, clinging to me.

"You want to help solve the case, don't you? You want to help me clear Billyjean, don't you? You don't want Billyjean to go back to that place, do you?"

Diane offered no more resistance, but she couldn't bend. Dione and I lowered her to the floor, and after a little adjustment I said she was about in the right position. "Except his feet should be under the bench."

"It's me, Billyjean," Diane said in a rigid hoarse whisper. "I'm Diane."

Dione took the big wrench from the tool board and handed it to me. "Put it where it was when you picked it up."

I put it down on the floor beside Diane's head. Her eyes rolled around and came back to my face.

"Now!" Dione said, fairly jumping with excitement. "Billyjean will go to the door and show us exactly what she did and what she said."

I went to the door, opened it, and stepped outside. Dione's voice came after me. "What are you doing, Billyjean?"

"I need to breathe," I said.

Our eyes met. "We were invited to a birthday party today, and we turned it down because we wanted to be with you."

"Is it too late for you to go to the party now?"

"Oh yes, but don't worry about spoiling our day. We've got plenty of other parties to go to. We have things to do every day. We have all sorts of invitations from our friends. We may also go away to the Y camp at the river."

"For a long time?"

"No. A week. Or maybe two weeks."

"When do you leave?"

"Oh, it isn't settled yet. We don't have to go. Only if we get bored staying around here."

"I hope you won't get bored staying around here."

"Have you breathed enough?" he asked politely.

I remembered to blink my eyes, I remembered to smile. He smiled back at me, and I felt his smile run through me like a warm liquid.

He went back to his place in the garage and called out, "Ready!" I stepped over the threshold. "Bubber?" I said. "Are you in here, Bubber?" I was getting good and mad at him. "Bubber, you come out right away, or I'll kill you."

"I want to get up now," Diane whispered hoarsely.

"In a minute," Dione said. "Go on, Billyjean."

"I see your shoes, Bubber. You come out this minute! You are not going to catch me back there."

"Just a minute, Billyjean," Dione interrupted. "Did you bend down?"

"Not yet."

"But if you were standing there, you couldn't see his shoes without bending down. Think hard. How was it?"

"I saw his feet. He had on his new Keds."

"But you can't see Diane now, can you? The judge will bring you in here and he will tell you to show how it was and then if you say you saw Bubber without bending down, he'll say you are not telling the truth. He won't believe your story."

"She is telling the truth, Judge," Diane's voice came from the floor. "When she was eight, she was little."

"Very good, Diane. When she was eight, she wasn't tall like now, she was short, and she could see Bubber's feet under the bench without bending down. Go on now."

"I hate you, I'll kill you."

"Why did you say that?"

"Because he wouldn't come out."

"Then what happened?"

"I picked up the wrench."

"Show me."

I picked it up and held it in both hands, staring down at Diane who stared back at me, waiting.

"Then Bubber got up to run away," Dione prodded.

"No, he wouldn't get up. I told him and told him but he wouldn't. His hair was turning red."

"But, Billyjean, if I don't get up," Diane said, without moving from her rigid position on the floor, "how can you hit him on the head?"

"You can get up now, Diane," her brother said.

"Billyjean won't hit me," Diane said.

"Of course not. She didn't hit Bubber either."

In the dust of the floor, Diane left a perfect outline of her body. It looked very real. I stared at what her body had drawn on the floor.

"We just proved that you didn't do it, Billyjean," Dione said. He was very excited. His eyes blazed. "If Bubber didn't get up from the floor when you told him to, you couldn't possibly have hit him on the back of his head."

Diane began to cry quietly.

"What's the matter with you?" Dione demanded. "We've just cleared Billyjean. Now all we have to do is find the one who did it."

Diane continued to weep. "Who would do it and let Billyjean be taken away and blamed for it?"

I removed the blanket from something that looked like a rocker and that moved like a rocker when I touched the blanket, and it was a rocker, and I sat down and pulled Diane on to my lap. It was the rocker where Stuart had sat that Saturday morning and rocked me on his lap.

"Did you think about Glenn, like I advised you?" Dione asked.

"Glenn wasn't here. Stuart told him to get, and he did."

"He could have come back. I bet he was mad at Stuart for sending him away."

Diane sobbed. She didn't want it to be Billyjean's Glenn, even if he was only a half brother.

"Could it have been Phil?" Dione asked. "He could have done it to silence Bubber. You said that Bubber was too smart for being only four."

"Why didn't Phil silence me?"

"That's what was worrying me."

Diane was upset and I didn't think we should talk about it any longer. I wanted to tell her a story she would like, a story that wasn't sad, and finally I remembered the two clowns at the school Christmas party. I taught the act to Dione while Diane rocked, going faster and faster until she almost tipped over the rocker. Then she wanted to play clown with Dione. "Go back," I said, "don't come out through his legs. Go out the way you went in."

Dione was bouncing lightly on Diane. "Why?" he asked.

"Because there is a right way and a wrong way," I said.

The next day Mrs. Campolini waited until Muriel went to work and then she rang the doorbell. I wasn't surprised to see her, but I couldn't have known that she would come. She said that the chil-

dren had done something that was not nice. They had done it in-
nocently, of course, but an older person like herself, or like me,
would know that it was ugly, dirty, obscene. "I know that you are
fond of the children," she said.

"I love them," I said.

"You must know that it wasn't right to teach them such a thing."

"What thing did I teach them?"

Mrs. Campolini said that I was forcing her to say things that she
found very difficult to say. I repeated that I didn't know what she
was talking about. So then she told me how the children had
played the clown act, and Diane had crawled between Dione's legs,
and he had bounced on her. "Of course the children are innocent
and they don't know the meaning of what they were doing," she
said, "but you know the meaning, don't you, Billyjean?"

"It must have been to make the people laugh," I said.

Her pale face grew pink. "You taught the children that game!"

"Why does it have to be me? Is it because I have been sick for so
long?"

"We have forgotten that, Billyjean. That is over, in the past. No
one is blaming you for that."

"You want to send me back there."

"No, no," she protested. Then she sighed. "Diane is not a tattler.
She didn't mean to tell tales. It was a matter of the—well, the tech-
nique."

I did not even blink.

"Of whether she should go through the legs or back out the way
she went in." Mrs. Campolini's whole face appeared unfamiliar. It
was changing. I couldn't tell what it would become. She was trying
to smile. "I told her to go back the way she came in. I'm afraid I got
rather excited and I frightened her. I really don't know why I made
such an issue of that. It was silly. But I did, and she said that you
had told her that was the right way, too. She wasn't telling on you.
She thought she was helping me—"

"Why did she have to go back the way she went in?" I asked.

"That isn't the question now."

But it was the question, I wanted to say.

She studied me and then she said, "Very well, Billyjean, I am
going to take your word. Now I will never mention that again, but
I want you to promise me that you will not play any games at all
with the children in your father's workshop."

"Of course I promise," I promised. "Anyway, I'm not allowed to go in there. It is kept locked, and I don't have a key."

The children didn't come to visit that afternoon. I didn't see a sign of either of them. The following morning, even though Muriel was still home, I rushed out to the back driveway when I heard Dione getting his bicycle from his garage. He was turned away from me, fussing with the chain of his bike, and he didn't turn around. His legs in skin-tight jeans curved like punctuation marks, like a pair of parentheses. "Why did you lie?" he asked me without raising up.

"I had to. I'm sorry if they punished you. Did they hit you?"

"They never hit us, they just talk."

"I would have been hit. They would have killed me. It would have been very bad for me. Your mother would have had to report it to Shap. I'd maybe have to go back to that place, and not to the cottage. This time I'd have to go to the women's facility which was a much worse place to be, where it would make me sick again."

"Why is it a worse place?" Curious, he forgot that he was being mad at me.

"There are very bad women there and there aren't enough Mrs. Roses to see that they don't hurt the others. I didn't want to lie and get you in trouble, but I had to."

"I thought it was something like that. Better us than you."

"Do you know why your mother was so upset by the clown act?"

"Sure."

"Do you know why she called it ugly? Do you know what obscene means?"

"Of course."

"Does Diane?"

"Sort of."

"She's too young, only eight years old," I said.

"When she was only about four she used to chase Dad around the bathroom or the bedroom when he was undressed, wanting to touch him. It was awfully funny."

"Your mother didn't think it was funny, did she?"

"We all did. We all laughed. She was so serious about it, but when we laughed, of course she thought she was smart and she did it to show off. Then Mom made her stop, of course. Mom told Dad that he should be careful, and Dad said he would. Diane always went into the bathroom with him to watch. She wanted to hold it

for him. When he said she couldn't come in with him any more, she sat outside the closed door and cried. She cries easily."

"Does she still cry about it?"

"Of course not. She outgrew it a long time ago. Mom said she would."

"Did he ever let her?"

"I wouldn't think so."

"It was obscene because I had been in that place."

"No, I don't think that was why. It gets worse, I guess, as you get older. Being adult makes it dirty. Diane feels terrible. She knew she shouldn't have tattled on you."

"She didn't mean to tattle."

"I'll tell her you said so."

"Your mother said so."

"It will make her feel better. She threw up all over the bed last night and she has a temperature. Mom phoned the doctor. I'm going to the drugstore now for the prescription. If it doesn't bring down the temperature, the doctor said to bring her in to see him."

In the afternoon Mr. Campolini came home and he carried Diane out to the car wrapped in a blanket so that I couldn't see her face. The prescription hadn't made her better. Mrs. Campolini hurried to get in front of them and jumped into the back seat of the car, and Mr. Campolini laid Diane on the seat beside her, and Mrs. Campolini held Diane's head against her. Muriel ran out in her robe.

"She has a very high fever," Muriel said when she came back.

"She is going to die," I cried.

"Don't get so excited. They're taking her to the doctor. He'll fix her."

"How do you get a high fever?"

"From a disease, what else? From a bug. They'll make tests and find out which bug. Then she'll be all right."

"Can you get a disease from lying on the floor?"

"No, of course not, Billyjean. Don't be silly."

"You could get a bug from lying on the floor," I said.

"What floor?"

I said that I didn't know. It was Mrs. Campolini told me her dress was dirty.

18.

"She's got a strep infection," Dione reported to me.

"How do you get that?"

"From a streptococcus."

"Don't you let your mother hear you say that word."

"You're a loony, Billyjean." We were good enough friends now that he could say things like that to me. I was ashamed that I didn't know what the word meant, and that it was all right to say it, even with that ugly sound in it.

"I shouldn't have let her lie on the garage floor. It was dirty."

"Billyjean, that had nothing to do with her being sick. She was already coming down with something. The cement floor probably wasn't the best place for her, being cold, more than being dirty. Anyway, I was as much to blame for that as you—"

He was more to blame than me.

"And then Mom upset her about the clown bit. But none of that made her sick. It's a germ."

But I was to blame. I was always to blame. This time I could see that I was to blame. I should not have let Diane lie down on the cement floor. Dione was to blame, too, but he was younger. I was older. I had known all along that I shouldn't let her lie on the cold cement floor. I had known that what we were doing was wrong. I could not let her die. There must be some way I could take the

blame. And then I remembered that Shap had told me to go to church. Diane did go to church every Sunday, but still she got a germ. Was Diane being punished because I didn't go to church?

On Sunday, Muriel was up early. It seemed like a sign. I asked her if she would go to church with me. "Shap said I should go. I have to go!"

"Now stop getting so excited."

"He said he had already talked to your minister, and the minister was expecting me and would be looking for me. If he looks and I'm not there, I'll get a bad report."

"All right, OK, I guess we can go."

The minister was standing in the lobby shaking hands with everybody, and he shook hands with Muriel and with me and welcomed us. I could tell Muriel was nervous, the way she was pulling at the neck of her dress. She thought everyone was looking at her. Maybe they were. The minister asked an usher to find us a pew, and he took Muriel's arm to walk down the aisle. I could feel people's heads turning toward us, but they turned when anyone walked down the aisle. I tried to tell Muriel that so she wouldn't be nervous, but she was nervous. I was nervous, too, but for a different reason. I wasn't sure God would listen to me. I asked him not to blame a little child like Diane for something that was my fault.

Every day Dione brought me a bulletin on Diane's progress. She was getting penicillin. Penicillin was a specific for a strep infection. The next Sunday I and Muriel went to church again. I told Muriel I was praying for Diane. "Will you pray for her, too?"

"Sure, why not?"

Then one day Diane was out of bed and Mrs. Campolini let her come to the bedroom window. I didn't want to look at first. I thought she would look like Bubber, her hair turned red. Mrs. Campolini stood behind her at the window, her long pale face very severe, like she was scared for Diane, too. Diane was wearing a pink quilted robe with a ruffle at the neck. I told Muriel that Diane was out of bed.

"Thank God," Stuart said. "Now I guess you can stop going to church."

I was surprised that he cared.

The first day that Diane was allowed out of the house, she came to visit me in the garden. There were blue shadows under her eyes,

and her eyes were bigger than her face. Mrs. Campolini accompanied her, carrying a sweater, and a head scarf for her.

"I'm relying on you, Billyjean," Mrs. Campolini said. "I'm asking you to see that she doesn't get overheated or excited. She must not run or play hard. I've spoken to her but she won't remember. You will have to watch her for me. If it gets windy or chilly, I want you to see that she wears her sweater. Tie this scarf over her head."

"I will, Mrs. Campolini. You can rely on me."

"We don't want anything else to happen to her."

"Could something else happen to her?"

"Her vitality is reduced. She's in a run-down condition. She must be careful. She doesn't have any reserve to fight off another infection, if she is exposed. She's vulnerable."

"I'll protect her with my life," I said.

"I'm not asking anything as drastic as that."

"I mean it."

"I think you do mean it. You are a good-hearted young woman."

I was proud that she called me a young woman. I almost confessed that I had had to lie to her about the clown game. I didn't because I didn't think she wanted to hear it. She hurried away into the house.

"Hi," Diane said shyly and leaned against me.

"You're nothing but skin and bones," I scolded, turning her fragile wrist in its silky skin.

"Daddy says he can spit through me," she boasted.

"We can't waste any time!" Dione announced. "While Diane was sick, I've been busy. I made a list of the things on the code that we could remember. One box was listed as 'B Things.' I thought it meant 'Business Things' from when Stuart was in partnership with Mr. Bernhard like you told us, but even sick as she was, Diane said it could just as well stand for 'Bubber Things.' She is almost always right about things like that. We have to get into that box."

I did not want to go into the garage. "I promised your mother that I would take good care of you."

"You didn't promise not to go into the garage."

"Yes, I did. I promised I wouldn't play games in Stuart's workshop."

"But we're not going to play games," Diane said.

"All that is hypothetical," Dione said. "You cannot keep your promise. You ought to know that you can't keep it. You have to look

out for yourself. Whatever you promised. If she made you promise, it doesn't count." He was quite patient and very grown-up, but firm. "Go get the key now, Billyjean."

"It is too cold in the garage for Diane," I said.

"She's got her sweater and her head scarf. We can wrap her in a blanket, and she can sit in the rocker with her feet off the floor. Hurry now. Time is of the essence. That's what Dad always says."

Diane's face was a small white triangle. "I feel sad for Grandma-Loreen Doll," she said. Her enormous eyes pleaded.

I tried one more inducement. I remembered the candy bars I had taken from the store. I hadn't felt like eating them. I had hidden them on the shelf in the bedroom closet. "I'll give you chocolate bars," I said.

"You're bribing us, aren't you?"

"I'll paint your fingernails pink," I said to Diane.

"If we can't go in the garage, I want to go to the slaughterhouse," Diane said.

"You know we can't do that either."

"Go get the candy," Dione said.

"And the nail polish," Diane added.

They accepted the candy with thanks. They were very well-mannered children. Dione put his into his mouth almost whole. Diane nibbled on hers, but her face was still sad. I painted her fingernails, so small they were like a doll's nails. She was still sad. She pressed close to me. I felt how thin she'd become. I gave in.

We had to move several cartons to find No. 9 which was the number on the list for "B Things." I wouldn't let Diane help because the boxes were heavy and dusty and might have germs. I put my hand on her forehead, like Mrs. Campolini did. "You are already perspiring." I made her sit in the rocker, but when we opened the box she was right there in front. She could always get into the smallest space, and now she hardly needed any space at all.

GrandmaLoreen Doll was right on top, not wrapped like the other things, like someone had put her in at the last moment, like they were going to throw her away maybe, but decided at the end to put her in. "She's lost her pencil eyes," Diane cried in distress.

Dione picked her up and shook her, and we could hear her eyes rattling somewhere inside her body. He turned her upside down and peered in. Diane had to peer, too. "I think I see them," she cried.

"They got caught in her neck," Dione said.

That was all we could do that first day because it was time to take Diane home. Mrs. Campolini had warned Dione to watch the time. He had a wristwatch, though he was only twelve years old. "It isn't a good one." He shrugged.

"When he's sixteen, he's going to get a really good one, maybe even a gold one—"

"Not a gold one, dopey."

"Anyway, I'm going to get this one. Hurry up and be sixteen, Dione."

We went to the garage every day after that. Mr. Campolini's secretary got sick, too. There was a lot of that sickness going around. And Mrs. Campolini had to go to the office with Mr. Campolini every day. She had used to be his secretary long ago before she married him. She looked the way a secretary should look. Mrs. Campolini was very glad that she had me to leave Diane with. She said she knew she could count on me to take good care of Diane. I intended to take very good care of Diane.

Diane found some blue crayons to put in the holes where GrandmaLoreen Doll's eyes had fallen down, and we all agreed that she looked very pretty now. Diane dimpled and hid her long tooth.

We found baby blankets in the box, and a baby cup and spoon. I was the mother and Diane was the big sister who was supposed to take care of baby. Dione was the father who went to work. Gradually we took other things from the box and we opened other boxes and found things we needed, like an old toaster, and a fry pan and some pots. We uncovered the furniture and there was the old table from the breakfast nook. We folded up blankets to make a bed on the floor. Soon we had a proper house. Dione opened the box of "Fishing Equip" and some days he went fishing and brough home fish for dinner. In that box he found my skates. "Don't touch them," he said, "they may be a clue." I told him Mr. Bernhard had given them to me. I demonstrated how I played angel on account of we lived in Paradise Valley. Diane wept and I said I was very sorry, but if I let her play angel she would get too hot, and with her vitality reduced, she could pick up another germ. I gave her another chocolate bar. Munching, she complained.

"I'll tell you a story instead," I said.

"I know all the stories," she complained, as she had never done before. It was because she had been sick.

Sometimes we went to a show where the clowns performed. I did it with Dione. Diane had to be the audience. I was strict about that, too. I would not allow Diane to be a clown. To make it up to her I said that GrandmaLoreen Doll could be her baby. She saw that I meant it then, and she stopped fussing. She said politely that she would rather that GrandmaLoreen Doll stayed my baby. I gave her the bottle of pink nail polish, and she colored her fingernails.

We had a new story now, about how it was in the women's facility which was where I would have to go if I got sent back. I told about the big strong women who did ugly things to the weaker women. Especially to the pretty women.

"What ugly things?" Diane asked in a whisper.

I looked at Dione, because I could only guess at those things myself.

"Do you know, Dione?" Diane asked.

"Sure. They're lesbians." As we waited with mouths open in astonishment, he told us how there were some women who did to other women what papas did to mamas.

"But also," I said quickly, because I didn't want Diane to ask what I wanted to ask, which was how could they be like papas if they were ladies, "they make the weak ones do their work for them, they take their food especially if the dessert is something good, and if they get any clothes or talcum powder from visitors, they take that, too. And they take the money, if someone sends them money to buy cigarettes or candy, or stuff like a lipstick or nail polish. And if they complain, they beat them up."

The father's job was being a private detective. He was investigating the killing of Bubber. Sometimes he investigated the case of GrandmaLoreen Doll who had been attacked viciously so that her eyes had dropped down. He worked on those two cases when he didn't go fishing. We went on picnics in the park, which was Muriel's garden, of course. Diane wanted us to go on a real picnic to the park, or we could even have a picnic in the slaughterhouse; that would be keen, she said, but I said that I couldn't go to the park, I couldn't go to the slaughterhouse.

The month of July was a long slow-moving procession of days, passed in the slow warmth of the garden, but more especially in the secrets of the garage. We crowded into those days all of the mean-

ing of childhood, as if after this month and perhaps the month of August, if we were lucky, there would be an end to childhood for all three of us. That would be when the children would go back to school.

When I came out of the garage after an afternoon of play, I felt that I had come out into the dream. Inside the garage was the reality. Outside was unreal, too bright to see clearly, too thin. I did my work in the house, I fixed dinner, I went to bed at night and set my alarm for early, but it was all at a distance. As unreal as a television program. I was just waiting for the time when I could go back into the real life of the garage. The life in the garage was more real than Max who had gone far away to Vegas. It was more real even than Shap who would be coming any day now for the next checkup.

It was a dreaming time between Muriel and Stuart, too. "Everything's shaking down," Stuart said. Sometimes they fought but like they were pretending almost. In the mornings Muriel slept late and got up looking shapeless, the outline of her body blurred, and her face like she had stopped in the middle of taking off her makeup with cold cream.

One night when I had to get up because I was starting my period, and I always had to get up in the middle of the night, I heard Stuart's bedroom door open. I hurried to lock the bathroom door. He went into my bedroom, and then he came to the bathroom door. He put his mouth by the crack and whispered, "Come out of there, girl!" He rattled the doorknob not caring how much noise he made. I had to do something. I let the bathroom glass fall against the edge of the basin. It splintered.

"What's going on here?" Muriel asked suspiciously. "My God, what is she doing in there? What are you doing in there?"

"The glass jumped out of my hand. Like a fish."

"Did it break?"

"I'm sorry." I came out of the bathroom.

"What are you doing here?" Muriel demanded, seeing Stuart like for the first time.

"Crissake, can't I take a leak without you making a fuss?"

"I've got my period," I whispered to Muriel.

"Hush up about that!" she said furiously.

The next time Stuart came looking for me I fought, but I was trapped in the lower bunk. Did I have to take some responsibility?

He had to use his fist on me before I would lie quiet. Afterwards I got up and walked right into the closet door.

The next morning Muriel said, "Where'd you get that, for hevvin's sake?" meaning my eye which was all colors.

"I ran into the door getting up in the dark." I thought she would remember the time she said it to me. Maybe she did, but she didn't know what to do any more than I did. I hated him. I'd kill him. I hated myself.

In the darkened garage Dione said, "Tell about the slaughterhouse again," or "Tell again about the woods." Diane would creep under my arm to be hugged. Always at the end she wanted to know why I wouldn't take them to the slaughterhouse.

"I've told you why. It isn't permitted on probation."

"Buckets of blood!" Dione shouted, and jumped up to put on the light and read the paint can labels.

"Billyjean and Bubber weren't allowed to touch Daddy's paint," I said.

"It's too late for that now," Dione said. "You weren't allowed to go into the boxes either."

He dipped a paint brush into the can of Ruby Red and colored the head of Bubber in the shadow on the floor. I didn't watch. We had been very careful not to walk on Bubber, and while all the other tracks on the dusty floor soon got mixed up and disappeared, his tracing in the dust was as clear and perfect as when Diane had first got up, leaving it there. The place behind the workbench was Dione's office. Diane said it could also be the cemetery, and she put the cuttings from Muriel's garden around it. I had to look at Bubber then. "Billyjean's really crying," she said.

"So are you," Dione said.

He painted the head of the wrench red, too, and dipped the handle into the can. Dione found some of Bubber's clothes in the box and laid them carefully on the tracing on the floor, like he was dressing Bubber—a pair of short pants, a shirt, suspenders because he couldn't keep his pants up. He put Bubber's new Keds where his feet would be, standing them up at the end of his legs. "We need some hair," Dione said, looking at Diane. Her eyes grew large with tears. "Not your hair, dopey," he said.

We considered the suspects. In the end Dione had to eliminate Glenn and Phil. We had already discarded Mr. and Mrs. Bernhard. There was a motive in that old business of the quarrel over the

partnership, but they just weren't the type, we all agreed. They were the type that was good to children. That left Max. Stuart had never liked him, and Max had lost his money in the partnership, too. Max had those Vegas connections, the gambling and worse. "What is worse?" Diane asked in a mew so weak I scarcely heard her. I told about the Mafia and about Murder, Inc. "I hate him, I'll kill him," I said. They thought it was Max I meant, and then they knew it was Stuart, but they thought it was because of Bubber. Somehow I had to get away from Stuart. I almost told them about his getting in bed with the loony. It was something I had to tell or bust. But I couldn't tell it.

"You will go to Max in Vegas," Dione said with authority.

Diane began to cry and I distracted her by planning how she and Dione would come to visit me in Vegas. That raised the question of how I could get there myself. "Bus is cheapest," Dione said. "I'll phone the depot and find out how much it costs. It's bad luck Mom gave Billyjean that doll instead of money."

"I have my penny bank," Diane said.

She sneaked her bank out of the house, and sitting on the blankets on the garage floor, we counted out the money into piles. The bank was like a little safe and opened by turning a round door on the front. There was a lot of money in it, coins, dollar bills, and one five-dollar bill.

"Auntie Isabel gave it to me when I stayed one night with her and didn't cry," she explained.

"Diane always thinks she wants to spend the night away from home and then she gets scared and she has to be brought home," Dione explained to me.

"Is it enough money to get to Vegas?" Diane asked.

"Nope. Not yet."

Diane's face got pinched.

"Doesn't Dione have a penny bank?" Billyjean asked.

"He puts his money into the bank downtown and gets interest," Diane said.

"Diane didn't trust the big bank. She likes to count her money. Bad luck I can't take out my money. Mom would sure notice that. But Billyjean can't go until her probation is over, anyway. We'll get enough by that time. There's our weekly allowance, and I can earn some extra mowing lawns and doing errands on my bike. What will you do?" he asked his sister.

"I'll put in my Sunday-school money. I'll say I lost it and Daddy will advance me more."

I saved what I could from the food money, and the allowance that Stuart gave me, which wasn't really an allowance because he didn't do it regular. I wished I knew what my allowance was supposed to be. Each time any of us had any money to add to what was in the bank, we would empty it and count all the money over again.

Our house in the garage grew more complete. We found an old radio. And some handmade doilies, probably made by Mrs. Bernhard. Dione added socks to Bubber on the floor behind the workbench. Diane contributed a doll's wig. "It came right off," she said. "It was glued on loose."

"Is it Diane Doll's hair?" I asked.

"She wanted us to have it for Bubber. She said that was more important. I've wrapped her in a blanket and no one can see that she's lost her hair. Anyway, she's in the hospital now. The doctors are making tests to see why she lost her hair."

Dione opened the can of red paint. "Don't!" I cried.

"But you said his hair turned red."

"Diane Doll doesn't mind. It's for a good cause, she says."

"We have to reconstruct the scene. That means to make it like it was. Then we'll have the answer. Dad says the answer is almost always right under your nose, but you can't see it until you reconstruct the scene."

The tracing in the dust became more than a tracing, more than a picture. It became Bubber. Over and over Dione made me act out again that morning when I came looking for Bubber.

"Billyjean's a good actress, isn't she, Dione?"

"She really lives the part." When the paint dried, he opened the can and poured more paint on the wig. He liked it shiny and running.

"Maybe his mother got mad and hit him," Diane said.

"That's a terrible thing to say," Dione scolded her. She began to cry.

"Don't cry," I said. "We know you didn't mean it."

"She can't do anything right," Dione said angrily.

"I can, too."

"Then do it."

"Maybe his father got mad and hit him! So there."

Dione stared at me with his golden eyes so wide apart they looked like two separate searchlights.

"He wouldn't do that and then blame Billyjean," I said.

Dione nudged Diane. She said, "He might."

We were talking in slow motion with long pauses between.

"He might think that no one would put a little girl in jail for an accident. Mightn't he think that, Billyjean?"

"Dad says a child under eight cannot legally be accused of a crime," Dione said, his voice throbbing. "A child under eight is not considered old enough to distinguish between right and wrong, or to know the consequences of a blow."

I knew then that he had talked about it with his father. He had asked questions and got answers from his father. He was letting me know that as gently as possible.

"A child doesn't know that she can kill by hitting," Dione said.

"Maybe it wasn't a killing," I said. "Maybe it was just a death."

Then Dione got very angry. I had never seen him angry before. He had a smile on his face, the smile that was too big, but that made it clearer that he was terribly angry. His face was bigger, so the smile was bigger. His face was too big. It would fill the garage. "First you say you aren't a loony any more. Then you say you don't know if you hit Bubber. Now you say that no one hit him. By the time you get through, you are going to spoil everything."

I didn't want to spoil everything. I didn't want them to go to camp. I could see that he wanted it to be a killing. "But I wasn't under eight, I was eight, and I knew I had done something bad."

Dione was thoughtful in an angry way.

"But you didn't hit Bubber on the head with the wrench. We proved that," Diane said anxiously. "Didn't we prove that?" She was shivering. Even when I wrapped her in the blanket and held her in my lap in the rocking chair, she couldn't stop shivering. I was worried about her. I said we must leave the garage at once and get Diane out into the sunshine.

Dione stood at the door, blocking the way. "Didn't we prove that, Billyjean?"

"Yes," I said, "we proved that."

In the sunshine Diane stopped shivering, and Dione's face was back to its right size, and his mouth was sweet. But I felt that I was back in the dark closet.

19.

It was Saturday morning again and Mr. Bernhard was running around behind his lawn mower, a cigar in his mouth. Muriel was out in back, still in her mules and bathrobe, walking up and down her garden paths. She had turned on the fountain. Stuart was watching the fountain, too, but when he heard Mr. Bernhard's mower, he went to get his own mower out of the garage. Stuart would be barreling his mower around the corner of the house any minute now.

I went to watch through the Venetian blinds. Mr. Bernhard's face within the wreathing circles of lines was worried. There was a wordless roar from Stuart in the garage. Mr. Bernhard raised his head and looked straight through the blinds at me. There was the familiar sharp tapping on glass, and I knew that Mrs. Bernhard was trying to get his attention with her diamond rings on the front window. He was listening to Stuart.

"MURIEL!" This time Stuart roared her name. Mr. Bernhard dropped the mower and began to run. He cut across his yard and ours, then his feet slapped in their sandals down the driveway to the garage. I knew that Stuart had found Bubber lying on the dirty floor behind the workbench, his wig red from the paint, but Mr. Bernhard couldn't know that. I went quickly into the bathroom, locked the door, and crouched down on the stool. The window was

open a crack behind the shade. Muriel always closed it, but Stuart opened it. "A bathroom needs air," he said.

"Because of the stink," I said.

"Where did you learn such vulgar talk?" Muriel said.

"Your mother is so refined, her shit doesn't stink, Billyjean," Stuart said.

"Where is Billyjean?" Mr. Bernhard shouted.

"What in hell are you doing here, Bernhard?"

"What have you done to her?"

"Ohmygod, ohmygod," Muriel moaned.

"What's going on?" Mr. Bernhard shouted. "What's in there?"

"Get off my property, Bernhard."

Under the bathroom window there was the sound of Muriel's retching. My nostrils flared.

"I'm going in there," Mr. Bernhard said, "and if anything has happened to Billyjean, you can bet your bottom dollar I'm going to get answers this time."

"You move one step closer and I'll let you have it right on that big schnozzle of yours. You're trespassing."

"That's right, I'm trespassing. What are you going to do about it?"

"First, I'm going to lock this door—"

"Not before I see what is in that garage that is making Muriel sick."

There was the sound of scuffling and grappling and breathing, and a heat in the air that dried my mouth.

"Stu, he's an old man, Stu."

"Don't let my age stop you," Mr. Bernhard gasped.

"Let him in, Stu, let him see."

"And let him send Billyjean back to that place?"

"It wasn't me that sent her there in the first place and it won't be me this time. Muriel, is Billyjean in there, is she in the garage?"

"She's in the house, Bernie."

"Do you swear to that?"

"She doesn't have to swear to it. Now get off my property!" Stuart said.

"Muriel—" Mr. Bernhard began.

"She's in the house, Bernie," Muriel said.

"And don't go across my lawn," Stuart yelled.

I sat on the stool and listened to Mr. Bernhard's sandals slapping

down the driveway. Down the corridor. On Fridays we were careful to put everything away. But yesterday because I was worried about Diane, had I forgotten that it was Friday? And that the next day was Saturday, and that Stuart would be home and maybe would go to the garage for the yard tools? Had I covered the rocking chair with the blanket? Had we closed the boxes? Where had we left GrandmaLoreen Doll? Where was Diane's penny bank? Had she remembered to take it home?

"Come out of there!" Stuart's voice reverberated through the bathroom door. Automatically I reached behind me and pushed the plunger. Water rushed into the stool beneath me, then began to trickle back into the tank.

"Come out, or I'll break down the door."

I tore off some paper from the roller. I peered out through the window at the house next door. Mr. and Mrs. Campolini were talking to each other at the dining-room window. Upstairs I met the eyes of the children who stared back without blinking.

"Billyjean, I'm warning you!"

I pushed the plunger again and opened the door. "I had to go."

"You'll go somewhere else if I don't get some answers."

"What do you want me to say?"

"I want the truth, goddammit. Who made that—that thing in the garage?"

"What thing?"

"You drew a picture of Bubber on the garage floor."

"A picture?"

"You took his clothes out of his box and made it look like Bubber lying there. You spilled red paint to look like blood. Only a sick crazy person could do a thing like that."

Muriel sobbed. "He was so proud of those new Keds."

"Why did you fix up that bloody mess to scare your mother? By God, it's almost like that other Saturday all over again." He slammed his fist into the framing of the door, making the toothbrushes rattle in the holder with the screw loose.

"Why can't you fix that screw, Stuart? Is that too much for you to do?"

"Shut up, Muriel!"

"I didn't do anything," I said.

"If you didn't, who did? It had to be you."

"Why does it always have to be me?"

"Stu, maybe she doesn't know."

"She's home all the time. If she didn't do it, she has to know who went into the garage."

"Sometimes I'm not home. I go to the store."

"You're supposed to lock the house when you leave."

"I do."

Stuart's eyes never left my face. "You saying someone broke in? No, that won't do. The padlock was not broken."

Muriel was crying again. The bone at the corner of Stuart's jaw was throbbing. "Come on, you're going to come with me and look at it. Maybe that will refresh your memory."

He grabbed my wrist. I had to trot to keep up with him, like when I was eight years old. My legs were loose. Muriel trailed behind. She stayed at a distance from the garage door, her hand at her mouth. Stuart took out his key ring.

"You've got the key," I said.

"Of course I've got my key. But I didn't make that thing. I'm not the loony around here."

"Don't talk like that, Stu," Muriel said. "You don't know when it was done. You haven't used your workshop for years. You haven't gone near the workbench."

"You're the one said pack up all his things, get everything out of sight, lock the door."

Muriel was sobbing. He switched on the light in the garage and pushed me in. I remembered to stumble on the high threshold. "I'll say this for you, you're a good actress."

Quickly my eyes checked. The boxes were repacked and closed. The rocker was covered by the blanket. Everything was put away. There was nothing to give us away.

"Don't bother acting any more," Stuart said. "He's over there behind the workbench. You know where."

"Who?"

"That thing you made, the thing you made on the floor to look like Bubber."

"I didn't make anything."

"It's right where I found him that Saturday when I came home for lunch with you standing over him," Muriel said from the doorway in a hushed voice.

"Better not come in, Muriel."

"I don't want to look at it," I said.

"You are going to and you are going to tell me why you made it."
He pushed me across the garage. "Look at it," he roared. "LOOK!"
He forced my head down. I shut my eyes.

"Open your eyes, goddammit!" I felt Stuart bend over to the
floor. I knew he was picking up the wrench. My eyes flew open. His
fingers wrapped around the handle of the wrench and overlapped.
"Admit that you made this sick bloody mess."

"No, I didn't do it."

His mouth pushed out in a snout. His nose flattened. His eyes
pinched together close like a lion's. "You've never given me any-
thing but trouble," he said. "All your life you've given me trouble."
I stared at him. He lowered his arm. I ran outside.

The stink of Muriel's vomit was strong and I bent over. I
strained. "Let it come out," she said. Tears streamed down my face.
"Put your finger down your throat." She seized me. I screamed,
"Mama, Mama!" It never did come out, but it was there a column
so big it hurt my neck.

Muriel left me and went to the door of the garage. "Stu? Stu!"
Her voice was a hoarse whisper. "What are you doing in there? The
neighbors across the street are watching. Bessie and Bernie are at
the breakfast-nook window."

He appeared, wiping at his hands with a rag. The smell of tur-
pentine made me gag again.

"Mr. Campolini is watching from behind the screen door, Stu,"
she whispered. "Or maybe it's Mrs. Campolini. Stu! What's on your
hands?" She stared like hypnotized.

"It's paint, for crissake. It ain't even dry."

"It looks like—"

"Get in the house, both of you. We're not putting on a show for
the neighbors."

Muriel gasped. "I have to go to work. How can I go to work?"
She began putting some food on the table for lunch, every once in a
while she started to cry again. Stuart opened a can of beer and
drank half of it in one gulp.

"The hair was from a doll," he said.

Muriel was pouring coffee and she went right on pouring until it
spilled over. "How do you know?"

"Because it didn't feel like real hair."

"How could you touch it?" Muriel wailed, and at the same time
she was swearing as she mopped at the coffee.

"Why shouldn't I touch it? I'm going to get to the bottom of this lousy trick. I'm going to find out who did it. Don't just stand there," he said to me, "help your mother."

I washed my hands and face at the sink and began to fix a tray of relishes. Muriel always liked pickles and stuff, especially assorted mustard pickles, with her sandwich. Stuart drank his beer and stared out the breakfast-nook window. "Someone has it in for me."

"You can't mean them, Stu." Her eyes were puffy, her lips swollen, as if she'd been crying all day. She had that kind of delicate skin.

"Did you ever let Max into this house?" Stuart turned on me. "Did you give him the key?"

"No, never, I swear it. I cross my heart to die."

He went on and on at me about the key and about Max and about the Bubber thing in the garage.

"You know where the garage key is, don't you?"

"You have it."

Muriel picked a piece of herring out of the jar with her fingers.

"For chrissake, who do you think wants to eat after you've touched everything," he yelled.

"Your fingers should be so clean." But she said it automatically. "It's just like Bubber was killed all over again." She cried with her mouth open, chewing while she cried, like Bubber used to.

"It's not their kind of attack," he said with a jerk of his head to the Bernhards' side. "They'd go after my money if they wanted to make me trouble, after my job."

Sobbing noisily Muriel went to Stuart. He put his arm around her. I saw how his fingers played with the roll of fat on her ribs, pinching it up and rolling it between his fingers. Maybe he didn't even know that he was doing it.

"I'm going to be sick," I gasped. I gagged dry into the lavatory. Over and over again I retched, until my throat was sore all the way down, raw. After a while the spasms stopped. I bathed my face. It would be nice to stay with my face in the water. I opened my eyes and watched the water spiraling down the drain. It would be nice to spiral down with the water, even into the dark of the drain, and not have to go back to the kitchen.

"Billyjean!" Stuart roared.

He studied me as he ate. "You know something. Come on, girl, admit you know something, even if you didn't do it. You're afraid

of something. Talk, girl. Say what you know. We're on your side, you know that."

"Leave her be, Stu. She wants to forget," Muriel said. "Her Dr. Shap said she had to remember so she could forget."

"Listen to yourself. You sound crazy to me."

"You wouldn't go to talk to him. If you had, you'd understand."

"No siree, I wasn't going to let him make me crazy, too. You been talking crazy ever since."

"Ohmygod, Stu, it's almost time for his next visit. What are we going to tell him when he comes? Look at the time. I've got to change and go to work." But she didn't go, she opened the refrigerator and stood looking inside. "I feel like I want something else, but I don't know what." She took the carton of ice cream from the freezer section and got a spoon and ate right out of the carton.

"You're a slob, Muriel," Stuart said.

"No one eats the ice cream but me. Anyway, my mouth's clean." She sucked the ice cream from the spoon. "Don't look at me if you don't like what you see. Ice cream makes my teeth shiver, you know that." She was sucking dry-eyed now. "I keep asking myself who could have done it."

"And what do you keep answering yourself?"

"I've got to go to work, Stu," she pleaded. "What about—will you clean up the garage?"

"Let it stay."

"I don't want it there." She turned out her lips in the way that showed the purple lining, starting to bawl again. He twitched at his belt.

"It's going to stay until Billyjean and I get to the bottom of this."

"We may be here for a long time," Stuart said to me, "and then again, we may get through fast. It all depends. Go on in. Find a place to sit down." He looked around at the stored things. He touched the blanket-wrapped shapes. One moved. "Do you know what this is?"

"I guess it must be a rocking chair."

He removed the blanket. "Recognize it?"

"It used to be in the front room."

"When did you see it last?"

"They took Muriel into the bedroom because she was feeling sick and she had to lie down. You came home and you shouted, 'What's going on here?' I ran to you and you sat down in the rocker with me on your lap."

"Why do you want to do this to me after all this time, Billyjean?"

"Do what?"

He began to fold the blanket. Suddenly he sniffed at it. He carried it to the door and examined it. I sat down in the rocker and began to rock. He shook the blanket in the sunlight, watching the air. He sneezed hard three times.

"It's the dust," I said. "Dust doesn't bother me. I'll shake the blanket for you."

"You'll stay where you are. You'll do nothing. I can see what

you're thinking. You're thinking that if you shake it, I won't see that there isn't enough dust for all these years." He sneezed again.

"Better tie something over your nose," I said.

"You remember that I used to do that, do you? You remember what you want to remember, don't you?"

"I remembered what you wanted me to remember. I remembered that I picked up the wrench. I remembered that I did it."

"It wasn't what I wanted, Billyjean." He was breathing hard through his nose. "It was what had to be."

"Why did it have to be?"

"You had to remember, or you couldn't get out of there. I'm not mad at you. I know you didn't mean to hit Bubber. You took the wrench from my toolboard to scare him. I can see how it could have happened. You were mad at him. Or maybe he took the wrench and you said he had to put it back. He fought you. He was too big for his britches, eh?"

"I don't know." I began to rock faster. I was going somewhere, but I didn't know where.

His jaw got square. "You found him in the garage where he wasn't allowed to be, and you took the wrench from my toolboard to scare him—"

"No. I picked it up from the floor."

"How did it get on the floor?"

"Someone put it there, I guess."

"If it wasn't Bubber, it had to be you."

"Billyjean and Bubber weren't allowed to touch Daddy's tools on the board."

"It doesn't make any difference if you took it off the board or picked it up from the floor," he roared. "You were holding it when your mother found you."

"Yes."

He bent over me, pushing his face close to mine. I felt a drop of moisture fall on my forehead. He face was shiny.

"How could you make a sick thing like that sick Bubber thing over there on the floor behind the workbench? Your mother always said she could never tell what was going on in your head. You weren't like other kids. I thought you'd grow out of it, but I don't know. You'd better be careful how you act and talk now, you know that, don't you? Your Shap will get reports on you from everyone. You could get into bad trouble. No one can ever cover their tracks

perfectly. They always leave some evidence. There'll be a trail." He turned suddenly pale at what he had said. "I'm going to find out who made that Bubber thing no matter how long it takes. Why just now? After all these years. Just now when you've come back."

I kept my eyes steady on him, watching the moisture on his face become drops.

"What do you have to say for yourself, goddammit? Don't you even care enough to defend yourself?"

"You should have waited for Bubber and Billyjean. You should not have gone to the woods without Bubber and Billyjean."

"Is that what you been thinking all this time?"

"I have a good memory."

He stared down at the floor behind the workbench. "Did you do this to get even?"

"To get even for what?"

"For letting them take you away, goddammit."

"Could you have stopped them?"

"Do you think I could?"

"No."

"You were sick, Billyjean. You know that, don't you? Maybe you're still sick. Where did you get his clothes, to make this thing, his shirt and pants, even suspenders, for crissake. His Keds and socks. Look at it, dammit," he roared, coming back to stand over me.

The rocker was getting out of control. Each time it swooped up I felt myself fly out over nothing. Each time I swooped down, I could see Bubber's Keds on the floor, standing up like they were his feet, toes pointing up.

"What is the meaning of this sick thing?" Stuart demanded.

"He was hiding from Billyjean. He wouldn't get up from the floor." Faster and faster went the rocker, higher and higher. I hung on, my fingers cramping. Everything was jumping, even Stuart's face.

"That's when you got the wrench. To make him get up."

"He wouldn't get up from the floor so Billyjean could hit him. I tell you, he wouldn't get up from the floor. Goddammit, are you deaf? Can't you hear, for crissake?" Everything was going up and down too fast.

"Watch your tongue, young lady." His face kept jumping. "Why are you talking about yourself like that, like Billyjean was someone else."

"It's easier."

"Don't do it. It sounds crazy."

"I am crazy. Shap bent and Muriel bent and Stuart bent."

"Listen, Billyjean, you admit that you made that thing, and I'll get rid of it, and we'll forget about it. I just want you to admit that you made it. I don't even want to know why. I don't care any more. It was you did it, wasn't it? Admit it and I won't tell your Dr. Shap about this. If I have to tell him, you know he'll put you back in that place. He'll have to. But not in the nice cottage with flower arrangements and the electric mixer, no, by God, you'll go to the big house where they put the hardened criminals, tough women, worse than men. You'll see how bad it can be then. You won't be able to defend yourself, a thin little thing like you. They'll use you and misuse you."

The rocker was going too fast. I couldn't hang on much longer. I was going to have to let go. There was going to be an accident!

"Stop that damn rocking," Stuart shouted. He grabbed the rocker and stopped it. I was still rocking, wanting him to touch me and quiet me, hoping he would sit down in the rocker and hold me on his lap like he did when I was eight years old. If he did that, maybe I could tell him that I had made that Bubber thing, I and the children.

He sneezed again violently and then a second time and a third time. He took out his handkerchief. "Tie this for me," he said. So then I had to stop rocking and stand up. He turned his back to me and I put it over his nose, and made a tight knot. "Now I'm a bandit," he said. "Remember you used to call me bandit and pretend that you were scared of me, and you'd run screeching at the top of your voice, but loving it. Now sit down and don't rock any more. I don't know what in hell set you off."

He began looking into the boxes, moving some to get at others. He didn't know which box was for "B Things." He didn't remember there was a key to the boxes written on the back of the workbench.

"I haven't been fishing for a long time," he said in a marveling voice as he looked into the box of "Fishing Equip." He pulled out my skates. "Where did these come from?"

"Mr. Bernhard gave them to me."

"They hardly look used."

"Mama said if I didn't skate on two I couldn't have the skates and she took them away. She said I'd grow lopsided."

"Your mother was always looking out for your good. She was a good mother."

At last he came to the box of "B Things." Right on top was GrandmaLoreen Doll, with Diane's blue crayons sticking in the holes where the eyes had fallen down. "I remember when you put those crayons in her eyes," he said. "Yes," I crooned with the rocking chair, "I put those crayons in the holes." "You were a funny little Moonface." He shook the doll, listening to the rattle within. "How did she lose her eyes?" he asked, squinting.

"She was bad, and someone threw her on the floor to punish her."

He squinted at me, but he didn't ask who.

"These crayons haven't faded in all these years. They don't make crayons like this any more. They don't make anything like they used to."

He didn't even remember it was yellow pencils. I could remember better.

He poked about in the box, absently moving some of the things. Then he dove in. I heard a jingle of coins. He had found Diane's bank with all our savings in it. He held up the bank curiously. "Look what I found." His voice coming through the handkerchief was disguised, unfamiliar. "Must have been Bubber's. It's just like Muriel to pack it away without taking out the money." He shook the bank close to his ear. "Must be quite a lot in there."

"Bubber and I both had little banks," I said.

He poked around in the box. "There's only this one here. Besides, yours were china piggy banks. You had to break them to get the money out. Bubber broke his and bought a bunch of junk candy, and you let him do it, so I broke your bank and took the money to teach you a lesson. This is a little safe. It opens. Whose is it?" He wasn't really asking me so I didn't answer. He went on studying about Bubber's clothes and about the bank. He noticed Grandma-Loreen Doll again and shook her to hear her eyes rattle. Then he put her back in the box. Then he put the bank back in the box.

"Are we finished now?" I asked.

"You think I've forgotten why we came in here, don't you?"

He gave me a sharp glance over the handkerchief. But finally he said, "Let's go."

"Shall I cover the rocker?"

"Leave it."

"Are we coming back?"

"Maybe."

Mr. Campolini hollered from the other side of the hedge in a loud commanding voice: "You there, what do you think you are doing in my neighbor's garage?" Then he burst out laughing. And Diane laughed, too. She was there beside him, cradling Diane Doll wrapped in a pink blanket. I remembered that Diane Doll had donated her wig to the cause. It made me nervous.

"My young daughter has sharp eyes. She said a masked bandit was breaking into your garage. She sent me to apprehend you." He brandished a pop gun, the kind with a cork on a string.

Stuart swore and pulled off the handkerchief. The gesture dislodged some dust and he sneezed violently several times in a row.

"You could get some help with that allergy, Reasoner. I can see that dust bothers you. With me it's wool, but I got shots and now I can even wear wool sweaters. This dry weather aggravates your kind of allergy. They have combination shots now, you know. One shot and you're finished. Bang!" He aimed and the cork popped out. Quick as a flash Diane had slipped around her father and into the garage. The bang made Stuart jump. He whirled around, but he couldn't rightly see because he had to sneeze again, three times. He wiped his streaming eyes. "What do you think you're doing?" he demanded.

"I wanted to see if there was a skeleton. Dione said there must be a skeleton or you wouldn't need to keep the garage locked all the time. But there isn't any skeleton, is there? Dione was funning me, wasn't he, Daddy?" She showed her long tooth, not covering her mouth.

"You get away from that box. Don't you touch anything. What have you got in that blanket? Where did you get that blanket?"

"It's Diane Doll's blanket."

"Show me!"

"She is sick and I can't show you."

He reached for the doll and Diane rushed to her father and leaped into his arms, clutching Diane Doll to her chest. "Daddy, Daddy!"

I'll climb him like a tree—

"Now, baby, no one's going to hurt you."

"But I can't uncover Diane Doll, Daddy, because she is sick and has to be kept warm."

"Hush, baby. No one's going to touch you or your doll. Calm down, Stuart. What are you accusing my daughter of?"

"Trespassing."

"Well, she isn't trespassing now. I'm sorry if she troubled you by going into your garage, but what harm did she do?"

"Snooping. You heard her. Maybe taking things."

"Baby, did you take anything that belongs to Stuart?"

"No, Daddy. Cross my heart and hope to die. Daddy, you've got to believe me. You've got to make him believe me."

"All right, all right," he said again, holding her close. "I believe you." Over her head he said, "Mr. Reasoner believes you, too."

"I'm not sure I believe her."

Mr. Campolini looked stern. "Seems to me you're making a big fuss, Reasoner, scaring a child, for a very small intrusion. I apologized for her intrusion, and I promise you she will never enter your garage again. Now I think you should apologize to her."

"If she didn't take anything, she has nothing to be scared of." Diane began to wail again. Mr. Campolini swatted her bottom lightly. "Stop that, baby. You aren't scared."

"So if she's not scared, there is nothing to apologize for." Swaggering, he padlocked the door, and taking me by the arm, escorted me through the garden and into the house. There his air of satisfaction disappeared. He scowled. He sat at the kitchen table waiting for me to serve him. He stared at me without talking all the time he was eating. Then he pushed back his chair and went out to the garage again. He stayed a long time and when he came in he was filled up with red. He still didn't talk.

Muriel came home from work; right away her mouth fixed open to cry, wanting to know if Stuart had found out anything about "you know what." He took her into the bedroom. "And what are we going to tell Dr. Shap?" she cried.

I went to stand in the closet in the dark. What I heard scared me. He had taken every single thing out of the box and the bank was missing.

"What bank?" I heard Muriel's voice loud and clear. Stuart shushed her and I didn't hear any more.

Now he had to suspect Diane. Now there were two things, the Bubber thing and the bank. Stuart would make a connection between them.

All night I worried between being safe and letting Diane take the blame. In the morning, which was Sunday, Muriel was up early. Usually she stayed in bed until noon. Before she could be after me,

I asked her if she would go to church with me again. I had made up my mind about that.

"You got something else to pray for now?" she asked.

"If I don't go, the minister will have to tell Shap. I don't want to go back to that place. It won't be the cottage. It'll be where the tough women beat you with a hose if you don't do their orders. They take your food when there is something good. They spit in your dish and make you eat it. They pee in your coffee and make you drink it." The girls in the cottage had said that was what they did, and I went on from one bad thing to the worse thing I could think of. And when I ran out of things I could imagine, I went on to the unimaginable. "They use you and misuse you," Stuart said, "they use you and misuse you—"

"For hevvin's sake," Muriel screamed, "stop saying that."

"What does it mean, Muriel?"

"You don't need to know. You'll just scare yourself."

"Are they really butchers?"

"Not butchers, butches. Come on, I'll go to church with you and you can pray for Diane again. The first time you prayed real good and she got better. You'd best pray good now."

"Why should I pray for Diane? Is she sick again?"

She looked like she had already said too much. "I'll go with you this once more. After this, you'll go by yourself. I'm not on probation. I earn my day of rest."

We were late because Stuart didn't want Muriel to go. He wanted her back in bed with him. On the way to the bathroom, pulling up his pajama bottoms, he glared at me.

The service had already started, and we sat in a back pew. I prayed for Diane to be safe—from what? And for me to be safe from the butches—who were they? I prayed to be able to take the blame for the Bubber thing if Stuart accused Diane.

After the service, the minister spoke to us. "You've brought her back again, praise the Lord." Muriel promised that I would come for Young People's service.

When we got home Mrs. Campolini was coming down our sidewalk, ours not hers, with Diane held by her hand tight so that Diane was raised up on tiptoe. Diane was wearing a terribly radiant and innocent smile. Mrs. Campolini tried to smile, but all that happened was that her lip raised like a sneer or a wound, and caught and stuck on her upper gums.

It gave me no comfort to think about Diane's radiant smile as her mother pulled her along the sidewalk. Diane loved me. I knew how an eight-year-old girl could love. Diane would let herself be put away if that would save me. I couldn't finish the thought. I was awkward and stumbling, like crippled.

Muriel was worried, too. She didn't even stop to step out of her shoes. She hurried right through the living room when Stuart wasn't there. Muriel worried a lot about what the neighbors thought. It was important to her to have Mrs. Campolini's good opinion. She'd been proud that she could call her Claudia. She held my hand like Mrs. Campolini had gripped Diane's, but because I was taller, it was like I was balancing Muriel on tiptoe. "Stuart, what's wrong? Why was she here—Claudia—Mrs. Campolini?" That showed how worried she was.

"Can't she come just to be sociable?"

"But I wasn't home—"

"Can't she be sociable with me?" He was holding some money in his hand, and he looked pleased, I thought.

"Where did that come from? Stuart! Do you hear me?"

Then I saw that the sheen on his face was sweat. It had kept me from recognizing what he was feeling. He wasn't pleased, he was

afraid. I knew him. Fear was making him sweat, and fear was making his mind work lickety-split like the bone in his jaw.

"This here is Billyjean's money," he said, his eyes pinning me down while his fear beamed searchlights into all the angles of his mind. I knew him because I had loved him. I had wanted to be him.

"I don't have any money," I said. He was afraid. I could smell it like my own sweat.

"Why did Claudia have Billyjean's money?"

"I don't have any money." Why was Stuart afraid?

"Your Claudia had it because she counted the money in Diane's bank and Diane had more money than she should have had."

"Why did she count the money in Diane's bank?" I asked.

"That's a good question."

No, it was a bad question. Diane couldn't have wanted her mother to know about our money.

"It's a long story," Stuart said. "I don't know if you want to hear it all. Claudia seemed to want to tell me all of it, so I would understand, she said. I'll make it as short as I can. It seems that Diane wanted to buy some toy, some new clothes for her doll, and her mother said she had to wait for her birthday, and Diane said in that case she'd use her own money, and she went to her daddy, and he said he guessed if it was her money, she had the right to spend it as she wanted to, and your Claudia finally agreed, and they counted the money, and there was too much."

"What do you mean too much, for hevvin's sake?"

"She could never have saved that much from her allowance, your Claudia said—"

"Quit calling her that, she isn't my Claudia."

"Excuse me, I thought she was. You're so concerned about what she'll think of you, more concerned than about your own family. Go ask her what's too much."

"No, Stuart, please, I want you to tell me."

"Your Claudia is no dumb Dora. She knows that too much money is as suspicious as not enough. Even counting money from her Aunt Isabel who is always giving her money for presents, Diane shouldn't have had as much as she did have. The long and the short of it was that Diane confessed that some of the money in her bank belonged to Billyjean. She confessed that she stole it from Billyjean's purse. Well, open your purse and see for yourself."

I couldn't think fast enough of a good reason to refuse. I had to open my purse. I didn't know how he had tricked me into that position.

"Diane stole Billyjean's money?" For a moment Muriel was diverted like by ice cream or pickles. "Sweet little perfect special Diane? Now think of that." Then she scowled, and I knew she was thinking of ugly big bad Billyjean. "I don't understand any of this," she burst out. "Where would Billyjean get that much money from?" Her eyes darted from me to Stuart and back. I could see some kind of understanding come into her and I worried how it would hurt Diane. "Billyjean?" It was almost like when Glenn had that money and she was trying to see into him to see where he could have got it. "Ohmygod, you've been taking money from men? Who was it? Who gave you money?" She was working herself up and now she was beside herself. "You've been opening your legs for money, you —you tramp! Is that what you learned in that place along with arranging flowers and baloney? Stuart, did you know? Why didn't you tell me?"

At first I was even relieved. When I could get a word in I said, "The only man I've taken money from is Stuart." My mind was working lickety-split, too. No matter how mad Stuart was, if I could surprise him, I could make him laugh. He liked boldness, and then he'd get over his mad. I had known that since forever, and Muriel had never learned it. This time was different. He tested what I had said. I could see that he actually was considering if I would tell Muriel that he had propositioned me with money, and if she would believe me. I laughed.

Muriel's hand caught me across the mouth. I licked my lip and tasted blood. I hated the taste of blood. When she raised her hand again, Stuart caught it. "Let me at her, I'll kill her," she screamed. "Let me free, you animal. You'd do it to your own mother, wouldn't you?"

Would he? Really? Could it happen?

"Never mind me. Think about yourself. If you rough her up, you'll have some explaining to do to Shap."

"Then get her away from me. Get her out of my sight. I don't want to look at her."

"You heard, Billyjean. Give your mother a chance to calm down. Go to your room."

"Can I have my money?" I asked.

"So it is yours."

"You said so."

"No, Diane said so. I'll just keep it until we clear up a few things, eh?"

"You stay in your room until I tell you to come out!" Muriel yelled at me.

I knew that Stuart would take Muriel to bed. That's the way it went, first the yelling and the banging about, and then bed. I sat hunched over on the lower bunk, uncomfortable because the upper kept me from straightening. I licked my lip that was cut by Muriel's ring. It had stopped bleeding but it felt swollen, and I couldn't keep my tongue away.

I listened to the sounds coming from their room, wanting them to be finished and to talk. They were having a little snort now. They were doing everything in order, not leaving anything out. Finally they began to talk.

"That Bubber thing in the garage is only part of it," Stuart said. "There's something bigger going on."

Muriel started crying again. Stuart shouted, "Listen to me!"

"I am. You said—"

"I said it was Billyjean's money, that's all I said."

Love died hard and even when it looked and felt dead, could come to life again. The minister said that love was resurrection. I had to stop thinking about Billyjean. To protect me, Diane had lied. The children never got hit, just talked to. Mrs. Campolini had brought Diane to confess to Stuart. What did Stuart think was going on? Something bigger. I didn't know what that could be. How bad was it to make the Bubber thing? Not as bad as killing Bubber the first time. Stuart said it had to be me. The children said it couldn't be me. I loved them. They were my friends. Stuart was Daddy. But I wasn't eight years old any more. I was twenty-one. Even if I took the blame, would the children give up on the case? The case! That was something bigger. But Stuart couldn't know that we played at opening the case, that we were reconstructing the scene. There was no answer to anything in my mind. I was thinking so hard my head ached, like someone had been hammering on it.

Without waiting for them to tell me I could come out, I came out. Had the closet door been open all the time? Why had I stayed in there, if all I had to do was turn the knob? I would have to think on that sometime, but not now. They were in the kitchen. Muriel

had the ice cream carton held against her grapefruits, sucking from a spoon. Stuart was drinking beer and belching. I had my sweater and purse.

"I'm going to Young People's meeting," I said.

"You haven't had anything to eat."

"You promised the minister I would come."

"You see you go straight there and come straight home." I knew then that I hadn't surprised them.

Stuart never took his eyes off me, studying me. "Maybe I'll go to Young People's with you. I'm not too old, am I?"

"Stuart, I think you are too old," Muriel said, worried.

"Oh, for crissake. Billyjean knows I'm joking."

"You're going to keep watch on me," I said.

"That's right, my girl. I'm your legal guardian and I have to see you toe the line."

All the way to church he talked about the way little girls could lie, even to their mother and father. He talked about how they can fool you, looking so sweet that sugar wouldn't melt in their mouth, and all the time planning things that a man wouldn't believe they could think up."

"What things?" I asked.

"That bank was in my box in my garage. You saw me find it, in the box of Bubber things—and then it wasn't there." He hit the steering wheel with the flat of his hand. "You've been taking the key from the nail by the back door and going into the garage with those kids, haven't you? Don't deny it. Her bank is the proof. She knew it was there and likely to make trouble if I found it first, so she maneuvered to get it. She's too big for her britches!" He hit the steering wheel with his fist. "Together you made that Bubber thing on the floor. You were saving your money together. I have the pieces, but I can't fit them together yet. I will, though, if I have to shake them out of you and her." He began all over again. "If she didn't steal that money, how did it get into her bank? Would you let that little girl take the blame by herself?"

"Someone has to take the blame," I said.

He pulled around the corner across the street from the church so suddenly that he jumped the curb and hit a city trash can, sending it sliding across the sidewalk, and me against the dashboard.

"I wouldn't have believed that this kid would steal. I still have to make myself believe it. Here's one kid who would never steal,

wouldn't need to, a little princess with her mother such a fine lady, and her father a big-shot lawyer. And yet, somehow I can believe it. Why were you saving your money together? What were you going to do with that money? Why did you need money, for what?" He pounded me with the questions, hitting the steering wheel each time, like he held a wrench or something hard in his hard. "What were you planning to do with that money?"

That was it. Of course! Her father. The lawyer. Stuart was afraid of the lawyer. Why?

"OK, if that's the way you want to play it, we'll leave it that way for now. But don't forget, it takes two to play at cat and mouse. You think about what I've been telling you, Billyjean. Better than that, pray for help. You're going to the right place. Pray for an answer that I can believe."

What could the lawyer father do to Stuart? Suppose he thought we were saving our money to open the case. Why would he be afraid of that? It was like a box within a box within a box. Every time I opened one, there was another one inside to be opened.

Stuart leaned across and opened the car door. I smelled his sweat. "Go to your prayer meeting," he said.

"Prayer meeting is Wednesday. This is Young People's."

"Don't get too big for your britches!" he roared.

Bubber got too big for his britches and look what happened to him. There were words that would open the box. *STUART HAD BEEN AFRAID OF BUBBER.* There was still another box inside. I knew those words, too. Why didn't I say them? *STUART WAS AFRAID OF BILLYJEAN!* The box blew up in my face.

"What makes you so cocky all of a sudden? Watch your step, Billyjean. You'd better pray good, even if it isn't prayer meeting, or you may be praying out of the other side of your mouth."

Stuart wasn't afraid of anything. No, that was wrong. Stuart had been afraid Bubber would talk. Stuart wanted to stop Bubber from talking. Stuart was afraid that Billyjean would talk. I knew what Bubber would say, if he had talked. He would have said what he saw in Muriel's bed. That opened the last box. It had to be the last box. But it wasn't.

"Don't I know you from somewhere?"

I was reading the church directory to see where to go for the Young People's meeting. It was the man from the Coop parking lot. How had he found me?

"Look, I'm not being fresh. I'm sure I've seen you."

"It was at the Coop parking lot."

He laughed. "You're cute."

Billyjean Reasoner. Cute.

"I spoke to you then because I was sure I knew you from somewhere," he went on.

He was more handsome up close. He had clear olive skin and thick almost black hair with a full springy moustache, and eyelashes so long and tangled that his eyes glinted through them, amber. Even when he wasn't teasing, they glinted. I'd follow that lamp through the trees, I thought. I had to stop thinking like that.

"I thought you just wanted to pick me up."

I watched the blush run into his skin and then run off. He was beautiful, glossy.

"Do you always come on strong like that?"

"Is it wrong?"

"I like it. Very much. Honest, I just wanted to talk to you, maybe

over a cup of coffee so we could figure out where we have met. I'm sorry you didn't like what you saw."

"Oh, I did like what I saw."

He blushed again and laughed. He had very white teeth, a little uneven. I thought that teeth a little uneven were handsomer.

"I've thought about you a lot since, wishing—well, never mind—"

"I do mind."

He laughed like I'd said something clever.

"Well, now, we've met again. Don't you think it was fate?"

"Muriel promised the minister that I would come to Young People's."

"Afterwards, I hope you won't run away. I hope we can have that cup of coffee and talk."

"I'm not allowed."

"You wouldn't kid me, would you?"

"It's the law."

"OK, well make it legal. I'll call your family. When can I come? This evening?"

Stuart didn't trust me to go to church alone. I had to be investigated every month by my probation officer, like a criminal. Like a loony. I hurried upstairs where the meeting was being held.

"Wait for me. I'm going up, too."

"You were coming down."

"I've changed my mind. Is it all right with you?"

"The stairs are free I suppose."

"You didn't tell me if I could call on your family. How about it?"

"No."

He put his hand on my arm to stop me, but removed it when I stared at it. "I've been going at this all wrong. I'm rushing you. You're right to put me down. I'll level with you. I know who you are. I've been working up courage to ring your doorbell."

"Why should it take courage? What do you want of me?"

He swallowed. I watched his Adam's apple go up and down. Strange as it sounded, he reminded me of Mrs. Bernhard. "I'm not allowed to have dates because I'm on probation. Dates are a violation."

"Billyjean, thank you for talking to me about your probation. I appreciate that. It must be hard for you. Are you surprised that I know your name?"

"I suppose everyone knows it."

"I have a very special reason for knowing it." He grinned, and I had a flash of recognition, but it was gone before I recognized what I recognized. "I was once married to you and we had a little boy—" He stopped teasing and turned very serious. "I'm sorry if you don't want to talk about him. I never believed what they said. I was so useless. Too young." He said the last word as if it made a bad taste in his mouth. "I went to see your father once. He told me to keep my—well, to keep my own nose clean, only he didn't say nose. I guess I can't blame him. I was a kid. Later I tried to visit you. They said you couldn't have visitors. I told them that you would never hurt Bubber. They said just about what your father said, even if their language was more polite. The dice were loaded against you. It made me so mad I wanted to kill someone. You see, Billyjean, everyone says that."

He was talking like he knew Billyjean and Bubber.

"He was a real pain in the neck a lot of the time, but you were good to him. You loved him, like a little mother. No one would listen to me. Did they listen to you, Billyjean? I'm Michael," he finished.

"I said it. I said I killed Bubber."

"Even if you tell me, I don't believe it. I don't know why you said it. You had your reasons, I'm sure, but I'm not convinced."

"You're still skeptical, aren't you?" I said. "You told me once that a good scientist is always skeptical."

He smiled with relief and pleasure. When he smiled like that I would do anything for him. I had to stop that kind of thinking. I had to stop loving someone just because they were kind.

"You remember me."

"Are you a paleontologist? Do you take your family with you when you go on field trips?"

"Well, I don't have a family, I'm not married." He nodded, shaking his head at himself. "I'm not a paleontologist. But I've got a pretty good job. I'm assistant manager at the Coop."

"Why aren't you a paleontologist? Did you stop wanting to be?"

"I didn't stop wanting, but I also like to eat." He flashed that grin again, and now I knew he was really Michael. "I figure I can always be an amateur paleontologist."

"That isn't the same thing."

"It's the best thing. It's a great hobby. Say, maybe we could go on a field trip together—again."

"It was wrong to give up your dreams."

"Dreams? Well, sure they were dreams. Dreams can be made true. It's nightmares that are false. Billyjean, I'm glad your nightmare is ended."

I could see he was moved. I wouldn't have been surprised to see him take out his handkerchief and blow his nose, like Shap. Oh, Shap. My heart squeezed. Then I remembered about Stuart waiting outside for me. Starting all over again, are you? What could I dream? First I had to see that Diane was safe. She was only a little girl. She was only eight years old. That was twice as old as four, but I was only a little girl, too. Stuart said once that I was crazy like a fox. I pictured the small pointed face and the big bushy tail. That was what I had to be now, crazy like a fox. Let Stuart think I was a mouse. A fox could outrun a cat. It could outrun a lion, I bet.

I continued up the stairs leaving Michael behind. I could dream later, wherever I was. Once we had been married. Michael, assistant manager. I said the word "dream" to the assistant manager, and he began to dream again. It was Shap's game.

The Reverend Mr. Stevens was looking for me, as he had promised. "Ah, I was—almost giving you up. It goes to show we must always have faith." First thing he did was to introduce me to Michael who was just behind me. Michael met my eyes and they glinted at me. Something came to life inside me. Was it bad? A fountain splashing. I was laughing.

The minister made sure that I was introduced to everyone, and they were all carefully not remembering what they had been told about me. I didn't care. I was years older than they were, centuries older, lives older. Some of the girls were developed. They wore makeup. They flirted with the boys who seemed younger than Michael. I and Michael were the right age. Some of the girls looked like they were getting it. That was how Muriel said it. Michael had tried to visit me in that place. Michael and I had played house in the slaughterhouse, but there was nothing there of shame. I sat with the girls.

I let myself think of Shap without hurting because he had tricked me. I had misssed him. I sat there not hearing what went on in the meeting. I would do exactly what Shap said. I was growing up fast to my age, I would tell him when he came for my next checkup. I wished I knew when he was coming. It would be a nice thing to look forward to. In no time at all, I'd tell him, I'd catch up with my-

self and be twenty-one. Maybe he would shorten my probation. Then I would get a job. Maybe I'd find an apartment of my own. I would visit Muriel and Stuart, of course. I'd give them part of my salary so they wouldn't miss the money they got for me. I would shop at the Coop, and Michael would wait on me. As assistant manager he probably didn't do that kind of work. I turned my head and met Michael's eyes. People were standing up. Young People's was over. They all smiled at me, that smile that was too clean. They trooped down the stairs going somewhere where I couldn't go.

"I watched you," Michael said as he came to my side. "The sunset came through the stained-glass window on the west side and colored you."

Color him black. Color him red when he was mad. Stuart was downstairs waiting for me. Stuart, who wasn't afraid of anything or anyone, was afraid of two little kids and a loony. The two little kids had a lawyer father. And the loony, what could she do? "What color did you color me?"

"Blue. They call it the blue window."

Blue was all right. Some day I'd make a blue dress. "They taught us to sew in the cottage. Muriel says I should say I've been away at a girls' school."

"It was a girls' school, wasn't it?"

"No."

"No. I was stupid to say that."

Through the open church doors downstairs I could see Stuart sitting in the car, his hand tapping on the wheel, listening to the radio? Or itching to get at his belt? He could come into the loony's bed any time. What could the loony do?

"When can I see you again, Billyjean?"

"You can't. Not until my probation is over. No one would wait that long."

"Try me."

I started across the street.

"Will you come to church next Sunday?" Michael called after me. "Will you come to the Coop to shop? I'm on the day shift all this month. Don't come on Monday because that's my day off, but if you want to come Monday, tell me and I'll be there. The prices are better than at the supermarket, and we've got a fair-employment-practice policy. We were the first to hire minorities. You should support us, Billyjean." He was grinning.

"Let's go," I said to Stuart.

"Who's that dude?"

"Nobody. One of the Young People."

"How was it?"

"I'm not going again."

"You know, Billyjean, if I had the say, I'd let you date. You need to live a normal life."

"I don't even like him." Cats have a keen sense of smell.

"You need to lead a normal life. If you lived a normal life—" He shot a look at me and I read it right. Oh God, sometime I would have to say it. It was one big scream that I would have to let out. But I couldn't let it out yet.

"If you lived a normal life, you wouldn't spend your time making sick things."

I hadn't even seen him get ready to pounce. I mustn't let that happen again.

"I've been sitting here thinking, Billyjean. I've been wrong about you. I've been treating you like a child. Seeing you with that fellow —flirting—"

I was alarmed. "I told him that I'm not allowed to date."

"A father never sees how his daughter has grown up. He's the last one to see it. He doesn't want to lose the girl child, so he doesn't let himself see it. Maybe I exaggerated that Bubber thing in the garage. I guess it was just a prank."

"What else could it be?"

"You did it, didn't you!" The cat pounced.

"What could it be if it wasn't a prank," the fox replied.

I was pleased by what he was saying about how I'd grown up, but I kept reminding myself that he was playing with me. Still, I couldn't stop from telling him how I felt older than those Young People upstairs.

"Sure, Billyjean. You've lived a lot more than they have."

"Shap said inside isn't life. He said life is outside."

"That's what I mean. Look how you talk, better than your old man, figuring things out about life. French and all those other subjects. A better than average IQ. I didn't really know what that stood for until Muriel told me how your doc explained it. And you had it all the time! I bet there isn't one of those young people upstairs who can think like you."

"Michael could," I said. "He always knew he wanted to be a paleontologist." I stopped with a squeak.

"You don't say."

I stared straight ahead and there in the windshield, without any body at all, was the smile of the cat.

"I suppose you know what that big word means. I suppose you can tell your old daddy."

I told him reluctantly.

"And is what's-his-name, Michael, did he become that?"

"No, he likes to eat."

Stuart laughed. "I'm glad to hear that. I was afraid he might be such a thinker that he wouldn't even be able to find his—"

I remembered then that Michael had gone to see Stuart.

"Bones, you said. I suppose he could find some at the slaughterhouse. I suppose you played house with him at the slaughterhouse." He laughed again. He was having a fine time. "Did you think I didn't know you played house? Why, you told me about it yourself. That's one thing you didn't remember, eh, Billyjean?"

Stuart had known, and he hadn't cared, he hadn't stopped it. Children didn't have any chance. The dice were loaded, like Michael said.

"So where does he earn enough money to eat?"

"He's assistant manager of—of one of the food stores." Even cornered, especially cornered, a fox is smarter than a cat. Look how the fox can lose a pack of dogs, and all those men in red coats on horses. It only gets caught when it gets too tired. Or when there are too many hunters.

"Easy enough to find out which store, that is, if you want to see him again," Stuart said, easy like a cat. "If it was up to me I'd say you could date this guy, Billyjean. I could tell even from here that he goes for you. Couldn't keep his feet still. Kept on picking them up and putting them down. If you play your cards right, you could get him to marry you. Just don't give him a piece before the knot is tied."

"A piece of what?"

"I'm disappointed in you, Billyjean. Maybe Shap knows best, and you're not ready to date yet. You can't date if you're just a dumb lay. On the other hand, what does Shap know? How would he know? If you went shopping where Michael works—at the supermarket?"

"No."

"Coop then." Stuart roared with laughter until people in the car next to us at the red light turned their heads curiously. When I was little and went out for a walk with Daddy, I used to pretend that people would think we were married. I wondered, could they see the cat and the fox, or did they see a mouse?

"You remind me of a little vixen I once cornered right here in our own woods. Those days you could hunt in these woods. She had your pointed chin and your unblinking eyes. Trouble was she forgot her bushy tail was showing. Heh! You didn't give it away. I heard him tell you. I would have had to be deaf not to hear." He had sobered quickly and now he was telling me something. What was it?

"Who would know if he waited on you in the store, talked to you, or maybe he was off duty and just hanging around, or he could take his coffee break." He paused, but I wouldn't open my mouth. "There's a lunch counter right there at the Coop. Did he tell you that? Or maybe he'd drive you home if you had a load to carry. Maybe he delivers for the Coop. What harm in any of that, eh? You couldn't call it a date. You can trust me to hold my tongue, and I can handle Muriel. Remember how you always said you could handle me?" He roared with laughter again. He was telling me something and I couldn't figure out what it was. Then he dropped the subject entirely.

There were too many things to watch. There were traps all around. How could I avoid them? A little girl like Diane certainly couldn't. The cat would get the mouse. Better for the cat to get the fox, and let them do what they wanted with me, even to throw me to the lion. If I was where I wouldn't be a threat to Stuart, he wouldn't have to be afraid of Diane. What was I saying? Where did the words come from? I was shivering so hard, my thoughts rattled and got mixed up. I held myself tight to stop the shivering.

"Cold?" Stuart asked.

I didn't know if it was safe to answer that.

Muriel was in a state when we got home. "Thank God! I almost went looking for you."

"What's wrong with you, Muriel?"

"I was afraid to leave and afraid to stay."

"Make sense, Muriel. What happened?"

"I'm trying to tell you. Just give me a chance. All the time you've been gone they've been going back and forth in front of our house. I guess they saw you and Billyjean leave together and they knew it was safe."

"Safe for what?"

"First the Campolinis went to the Bernhards'. They didn't stay long that time. Then they hadn't more than got back to their own house than the Bernhards came out of their house and went over to the Campolinis'. They just left. If you'd come a minute sooner you'd have seen for yourself. Stu, they're plotting something, I know they are."

"Something? What? Against who? For what reason?" He was getting madder and madder.

"Why are you getting mad at me? I didn't do anything. I'm just telling you what I saw. They didn't even turn their eyes in my direction."

"But I suppose you went out to see if you were invited."

"I certainly did not. I have too much pride. But I stood in the front window and let them see that they weren't putting anything over on me."

"Oh Christ, you're dumber than I thought. You did exactly what they wanted you to do."

"What did they want me to do?"

"How do I know? You're the one screaming your head off."

"I didn't do anything to them, Stu. Why should they leave me out this way. What'd I do?"

"I'm hungry. What's for dinner?"

"What does it mean, their getting chummy all of a sudden. Do you want to know what I think?"

"If it makes any sense."

"I think the Campolinis started it."

Stuart's whole face and body tightened like a wound spring. I thought he was going to give her one but good. Then he controlled himself and turned on me, grinding his teeth. "Well, what are you waiting for? Get into the kitchen and help your mother put the dinner on."

He brooded all through dinner, and even Muriel was quiet. After dinner he turned on the television, swearing because there were no sports. He left on a travelogue and he never watched travelogues, so I didn't think he was watching. Muriel, still crying about her hurt feelings, took the magazine section of the newspaper into the bathroom with her. When Stuart called for me, he had the money in his hands and he was staring at it as if he was reading it like a book. "That girl lied." Could he see it written there? "She lied, didn't she?" His voice rose.

Muriel came out of the bathroom rubbing hand lotion on the back of her arms. "Who lied? Lied about what, Stuart? About me?"

He couldn't hear her. He was studying so hard. "She is too smart for eight years old."

"Dione says she's got a genius IQ."

He wasn't hearing me either.

"Mrs. Campolini knew she couldn't have saved that much. She kept after the girl to tell her where the money came from and Diane said Billyjean gave it to her. So they came to give it back."

"But you said—Stu, you said—"

"Shut up and listen. I put myself on the line for Billyjean. I said that money wasn't Billyjean's. I said, no way. I said, Billyjean

wouldn't want what wasn't hers. I said, why did they want to make trouble for Billyjean? I said that little girl must have stolen the money and now was trying to put it on Billyjean. I accused my neighbor's child to protect Billyjean."

"But Diane confessed. What are you saying now, Stuart? You said—didn't you—ohmygod, Stuart, that's why they're running back and forth taunting me. You accused Claudia's child of stealing. Of course she'd get even. She wants revenge. Why did you do it? How could you do it? You're always spoiling everything for me." She beat on his arm and he raised it without even looking at her and threw her off. She fell and immediately jumped up and was at him again. He held her easily with one hand and closed her mouth with the other. She bit his hand and he slapped her hard.

It looked like some kind of grotesque comic act with Muriel in her short pink dress and the bow in her hair, ready to go to work. One Sunday a month, she worked the late late shift, and Henry Fashion drove her home.

"Keep still," Stuart told her in a terrible voice. She whimpered, but she was quiet. "All right, Billyjean, let's go over it again. First she says that you gave her the money. Then she confesses that she stole it. She didn't steal it from you, did she? She lied to protect you. Goddammit, answer me."

"Protect her from what, Stu?"

"Shuddup!"

"I suppose it don't concern me." But she was mumbling it to herself so Stuart could overlook it. Anyway, he was holding the mouse between his jaws now and he wouldn't let it go until he shook the truth out of it, not even to get mad at Muriel.

"What I haven't figured out yet is where the snoopy brother comes into the picture. But I'll get there. It all ties in with that Bubber thing in the garage. You've been going into the garage with those kids. You've been cooking up something with them. Why did you need money? You were all saving your money together. What for? That girl's mother said they gave Diane an allowance and yet Diane never had money for collection. Dione was running around killing himself doing odd jobs, working his ass off—"

"Claudia didn't say that, Stu!"

"I asked her why she was coming to tell me this, what did it have to do with me?"

I didn't say anything. I didn't even blink, but like I was inside him, he was inside me.

"I won't be able to hold up my head on the street," Muriel moaned.

"Shut up, Muriel. You sure can find a lot of things to keep you from holding up your head on the street."

"What am I going to say to Claudia? How am I going to look her in the face?"

"I don't want you even to look her in the butt."

"It's my life, too. You should have let me get it out of Billyjean when I wanted to. You shouldn't have stopped me. I would have handled it then, and this wouldn't have happened."

"Sure, you would have handled it, like you handled your son when he had money that didn't belong to him."

Her face flew apart as she understood he meant Glenn.

"Why are you talking about Glenn?" she screamed.

"I'm just trying putting two and two together, and maybe I've hit the jackpot. I chased your good-for-nothing son out of my house because he had money he wouldn't explain, and now it's your daughter."

"I'm your daughter, too," I said to him.

"You know she's your daughter. You know I never had anything to do with another man."

"Not even Henry Fashion? What's he paying you for besides wearing that cute little apron?"

"God, Stu, you've got a filthy mind."

"You, Muriel, you shut up, and you, Billyjean, you tell me what you meant by that crack."

I had to say it without stopping to think or I would never say it. "You have all that money that you get for me, and then you pretend I'm costing you, and you give me a treat with my own money, five dollars of my own money. Glenn got more money than that from Phil." I ran out of breath, I was squashed flat, stuck together, like an empty balloon.

Muriel's mouth opened and hung open. She managed to say, "How do you know about that?" And then Stuart caught her on the side of the head.

"Don't hit her," I said. "She didn't tell me. But I know it's true. You get money for me, like you're a foster home."

Muriel was crying and talking through her crying. "All right, so

it's true, but there's nothing wrong about that. If we didn't take you, they have to pay a foster home for you. We have more right to the money than strangers."

Stuart was wild, chewing his underlip, his jaw blazing white. He surely did hate it when Muriel cried and talked at the same time. Bubber used to cry the same way, until Stuart would threaten to take off his belt. "HonesttoGod, you're a slob, Muriel," Stuart said.

"She's right; you do have more right to the money than strangers."

He eyed me sharply. "Do you know where Glenn got that money?" If he was smart he would have known where Glenn got that.

"She was too little," Muriel said. "She can't even remember Glenn." Even I had figured that out.

"Sure she remembers him."

"What are you getting at? Why, you dirty low-down scum, you shit! You think Glenn had something to do with that thing in the garage. Somehow you always get at Glenn."

"It wasn't like him to disappear," Stuart said, reflecting now. "Not when he had such a soft touch in his mama. He's a sponger. You can't insult a sponger. A sponger takes anything you dish out so long as he can keep on sponging. I never expected that we'd seen the last of him, unless he's found someone else to sponge on." He watched Muriel. "It gets to you, don't it? Your firstborn. A firstborn is different from the others, perfect. So was that weak nelly, his father. I never thought he could even get it up. My children were the bad ones. You liked to throw that up to me. You took it too calm when I chased him out, the dirty sneak thief."

"Glen said he earned that money, Stu. He did something, a favor for someone. Someone named Phil, that's all I know, honest. But you, you sonofabitch, you wouldn't give him a chance to explain. You wanted an excuse to throw him out."

"At his age, I'd been on my own for—"

"I'm sick and tired of hearing about you at his age. He had no place to go, he was all alone."

"He had Phil."

"Who?"

"Who gave him that money, according to you."

"How long would that last? You didn't care what happened to him. All you care about is number one."

"That's right. Number one is the important number."

"He was sick and so thin—" She stopped.

"So you did see him?" His fingers tapped his belt buckle. "When did you see him? Tell me, Muriel."

"All right, he did come back. He had nowhere else to go. Where should he go if not to his mother?"

"You gave him money."

"You would have given him something, too."

"That wasn't the end, was it?"

"I didn't give him your money, Stu."

"That was when you went to work at Henry's—to keep your mind off what happened to Bubber."

"It was true."

"You've gone on seeing Glenn, haven't you?"

"Stu, I told him I'd help him out only if he showed he would help himself."

"Where did you see him? Did you let him in this house?"

"Stu, I swear he came here only that once."

Stuart's hands moved in slow motion to undo the buckle. The belt was out. It looked like a snake. Muriel backed off. Her face shifted. Her features slid around. Her voice slid, too, like when you run your finger up a violin string. It made my teeth on edge.

"Don't hit me, Stu. I saw him when I went to see Billyjean. I couldn't treat one child differently than the other. It was only fair, wasn't it?"

"Christalmighty!"

"Glenn's made something of himself." She talked fast now to get it in. "At your age, Glenn will be more than a laborer who works with his hands."

Stuart sucked in his belly. "At my age, what will he be? Come on, Muriel, tell me about his future. Maybe I can borrow from him this time. You saw him from the beginning and all along, and you kept it from me. When was the last time you saw him?"

Muriel tried to escape, but Stuart grabbed her and set her down hard on a chair with one hand. The air came out of the cushion. "Excuse me," she said nervously.

Stuart looked puzzled, then he laughed in a short spurt, like the backfire of a car. Another spurt of laughter, then he began to roar.

"Stu, I've got to go to work. Look at the time. This is my late late Sunday."

He wrapped the belt around his fist and twitched the length of it. She sat on the chair, her feet hardly reaching the floor. She had kicked off her shoes, her face was pinched and small, she looked like a child, an old child with big breasts.

"I just wish I could get some truth around here. Is that too much to ask?"

"I'll tell you the truth, Stu," Muriel promised, "if you put your belt away."

"You're not giving any orders."

"Will you listen without getting mad?"

Glenn was married now, she said, to a fine girl who had worked while he went back to school. He studied electronics and went right into a good job with a big company. They paid for some special courses for him, sent him back East somewhere to learn something special. "He has a fine future ahead of him."

"He can't have a future behind him, for crissake," Stu said, and I could see that it was going to be all right now.

"He says you did him a favor, Stu, when you put him out of the house. He says it was the best thing for him."

Stuart's lower lip pushed out petulantly. His nose sank between his cheekbones. His eyes were vague, unfocused. "What I don't like is that it was behind my back."

"I had to give him his chance, Stu. No matter how old a man gets, he still stays his mother's son. A girl grows up and gets a man to take care of her, but a boy stays a son, all he has is his mother. They have a little girl, Stu. Glenn and Linda. That's his wife's name, Linda. They've named the baby Natalie Muriel. After me. You're a grandfather, Stu."

"A stepgrandfather. That's what I get from life."

"They've taught baby Natalie Muriel to say Grandpa."

"What color is her hair?" I asked, to remind them that I was there.

"She's a little doll, Stu. A living doll."

They didn't even hear my voice.

Muriel could see that Stuart had softened toward the idea of a granddaughter who had learned to say his name. She hitched her skirt band around and inhaled to raise her boobs. Stuart flung out his hand and she rushed to him. His finger rolled the fat on her ribs. One hand slipped down over the sweet curve of her belly and rubbed in the crease of her thigh.

"Stu, let me be," she said, but not meaning it.

"Come into the bedroom with me."

Now Muriel remembered me. "We would have took you anyway, without the money."

After they went into the bedroom, I heard Stuart's electric razor. She always made him shave before because of her sensitive skin. I went into the garden.

The Campolinis' house looked deserted, like they had moved out. They were probably having dinner with Isabel Logan, Mrs. Campolini's sister who had lost her husband. But as it got dark and there was still no sign of life, I decided that they had gone away to keep their children safe from Billyjean, and I'd never see them again. One part of me was glad if they could go where they would be safe. Where would that be? If Stuart wanted, he would find the children wherever they were. It wasn't just the money. It wasn't even the Bubber thing on the garage floor. I guessed at what it was, but I couldn't go into that box just yet. I checked from my bedroom window every once in a while until at last I saw lights in their house. And then I wished I had never seen them.

All day Monday I had no chance to talk to the children. Muriel was home and she kept a watch on the street.

"It was like a parade all day long," she reported to Stuart in a whisper voice when he came home. "First Bessie walked down the sidewalk bold as life and didn't even turn her head. Where do you think she went?"

"How do I know where she went?" He was terribly alive.

"I'll tell you if you stop interrupting me. All right, all right, Stu, she went to the Campolinis'. What do you say to that?"

"They're welcome to each other."

"She's never been there before yesterday and now she goes again. That makes two days in a row."

"I know that makes two days in a row," Stuart bellowed.

"Why are they getting so friendly all of a sudden?"

"Maybe they're getting unfriendly—with us."

"And that was only the beginning." Muriel was talking with her mouth open all the time so she could cry.

I had watched the parade, too. Mrs. Bernhard stayed at the Campolinis' for almost an hour. Then she went home, looking straight ahead. I could even tell that she was wearing her false eyelashes. The sac in her neck was going in and out like a balloon. No sooner was she in the house than Mr. Bernhard came out,

though at this time of day he should have been making the rounds of his cigar stores collecting the money to take to the bank. He trotted over to the Campolinis' like he was pushing his lawn mower, only he was dressed in his dark gray suit. His tie was a pretty turquoise color. The next thing that happened was that Mr. Campolini, who never came home for lunch, came home. He slammed the brakes hard, rocking the car, and jumped out. The door of the house opened right away for him, and he went in. Then Mrs. Campolini, her back very straight and her lip caught up in that sneer or wound or whatever it was, came out and went over to the Bernhards' where Mrs. Bernhard let her in. Later Mr. Bernhard went home, and then Mrs. Campolini went home, and Mr. Campolini drove away in his car.

When our doorbell rang, I saw hope leap into Muriel's face. She thought they were coming to invite her to the party. Against all the evidence, that was the miracle she hoped for.

It was Shap.

Didn't he remember that Monday was Muriel's day home? "Are you still mad at me, Billyjean?" he asked. Muriel was suspicious as she always was when she didn't understand. But there was nothing I could say with her right there to hear. I couldn't ask about another foster home. I couldn't ask him how much allowance I had a right to.

Muriel was sending me signals not to talk about the Bubber thing in the garage. I wanted to laugh and I wanted to cry. Muriel didn't believe I had anything to do with that. Muriel was just too damned innocent or too dumb. She was giving me signals not to talk about the parade either.

What we talked about was church. Of course Shap already knew that I had gone to Young People's because he'd talked to the minister for a report. "You made a very good impression, Billyjean," Shap said. "I'm proud of you."

"I'm older than any of them, except Michael," I said.

"Who's Michael, Billyjean? I didn't hear about any Michael."

"He is the assistant manager at the Coop," Shap said.

"I've told you not to go there. We shop at the supermarket. Didn't I tell you?"

I saw that someone had told Shap about Michael. I wondered what it meant. Shap was writing in his little book, the writing so

small. He looked up and caught me watching. "How have you been?"

"She's always pale," Muriel said. "But she's strong. Hasn't even had a cold and with so much of that sickness going around."

"Moonface," Shap said, remembering. Then he took off his glasses. "How'd you get that bruise, Billyjean?"

"It's almost gone," I said.

"She walked into a door in her sleep," Muriel said.

"That's a dangerous habit, Billyjean."

"It runs in the family," I said. "Muriel walks in her sleep, too. She banged up her face something terrible last time. Stuart walks in his sleep, too."

"Your father?" Muriel asked.

"You saw him. He was trying to get into the bathroom when I was in there. Good thing I had locked the door." I felt I was shouting. I thought I was saying it plainly for anyone to see. But I was shouting in a foreign language that no one could speak. There wasn't anything else I could do. For a mother, Muriel was blind. For a psychologist, Shap was slow. "Are you going back to study with that professor in Europe?" I asked him. "I'm planning on it," he said. "Do you think I need to?"

"That's no way to talk to Dr. Shap," Muriel scolded, not understanding anything.

* * *

"What does it mean?" Muriel asked Stuart.

"What do you care? Jews and Catholics."

"I do care. I live here."

I could see that he cared, too. His hands were looking around for something to pick up and do some hitting with. He tramped up and down the room.

"Why am I left out?" Muriel insisted, following him.

"Maybe it's a surprise party." But even Muriel understood that he didn't think it was a surprise party. In the silence, I said that dinner was ready.

"Don't rush me!" he roared. "Hell, where's the beer?" He was inside the refrigerator and then he rose up without closing the door, letting the cold air out like Muriel hated. "This is the last can.

Where is the goddam beer?" He was glad to have something to be mad about.

"We couldn't go to the store today," Muriel said.

"You had to watch the neighbors," he roared.

"That's all I did all day long, except for when Dr. Shap was here."

"Dr. Shap was here today?" Stuart asked, suddenly very quiet.

"He didn't stay long. Stu, I didn't say anything about the neighbors, or about the Bubber thing. We just talked about church."

"He didn't come to me for my report," Stuart said. "Why didn't he come for my report?" He was scared, he was even scared of Shap.

"They're all against me," Muriel cried. "I can feel it."

"You and your fucking feelings!" He chewed his lip. "Now they're getting at me through my wife."

"I told you," Muriel shrieked.

"By God, my home isn't safe. In my own home, I'm being threatened."

"Stuart, is it a plot? Stuart, you shouldn't have chased Bernie out of our yard. You shouldn't have accused Claudia's Diane of stealing. You shouldn't have talked wild about calling the police."

"I've got a good mind to call the police right now."

"You'll make it worse, Stuart." She jumped up and hung on him. "Don't do anything else, Stuart. You insulted them and they're going to find a way to get even. If you do something else, they'll do something else and worse. I can feel it."

"Your fucking feelings." He found the words again. "Somehow your fucking feelings get around to me." He said the words like he liked the feel of them in his mouth. "It's a wonder your fucking feelings didn't blame me for Bubber."

Even the air was still now. Something was going to explode, something was going to crack wide open.

Muriel's features pulled together like gathered. "It was Saturday," she said. "You were home. I had to go to work. If you had gone to find Bubber, instead of—if you hadn't gone off to dump the trash just then, which is against the law anyway." She was talking just like the children. "Billyjean, why are you looking at your father like that?"

I made myself look away. I made myself move. My hand was shaking as I checked the pot of stew and dumplings, and the lid

dropped with a clatter. I jumped and knocked the pot. I tried to steady it. The boiling fatty liquid slopped over my hand and wrist. Muriel screamed.

Everything was very busy for a while. Muriel would forget what she had seen on my face. She wrapped my hand in a big awkward bandage of damp dressings. Stuart gave me a shot of whiskey to dull the pain. I sat at the kitchen table cradling my hand. The whiskey made my head feel light. Large, but light.

"Look what you do to your mother," he said.

"For hevvin's sake, Stu, she's the one got burned."

"You're the one who has to wait on her now."

"She didn't do it on purpose. That's it, you got to show the neighbors that you didn't say those things on purpose. You've got to show them that you're friendly."

"That's the same wrist you cut that time before you lived in the cottage, isn't it, Billyjean?" he asked.

"The dorm came in between solitary and the cottage," I said.

"Dammittohell, don't split hairs with me!"

"Stuart, why are you going back to that time? All I know is we've got to do something to show the neighbors that we want to be friendly."

Stuart had said it right out in the open: Muriel could have blamed him for Bubber.

"Go on and talk about Muriel's fucking feelings," I said.

"You'll get slapped, talking like that," she said.

"Could feelings blame Stuart for Bubber?"

"Now you shut up, you hear?" Muriel stood in front of me in an imitation of Stuart's tough legs-apart stance. "If you hadn't just burned yourself bad, I'd give you what for. Now shut up or you don't get dinner."

"I don't want dinner."

"Then go to your room."

At the door I said, "Why didn't you blame him for Bubber? Why did it have to be me?"

My legs could hardly take me to my room. I waited there in a kind of terror at what Stuart would do to me, but I felt good, too. He had to think on me now, he had to concentrate on me. He would leave Diane alone.

"Are you asleep, Billyjean?" It wasn't Stuart who came, it was Muriel. "You sleeping with the covers over your head?"

"I'm not asleep," I said.

"You have to breathe fresh air when you sleep," she said absently, and turned to leave the room. I got up so hurriedly that I banged my head.

"I just came in to tell you you better have some dinner."

"I'm not hungry."

I could hear her breath. "I came in to be nice to you. You don't make it easy for me." She sighed deeply. "Maybe I ought to have told you before, I don't know. What good would it have done?"

"What should you have told me before, Muriel?" Mama.

She came closer, but first she checked to see that the closet door was closed. "Sit down, Billyjean. You're too tall."

Touch me, Mama, touch me.

"I found you there with the wrench in your hands. I saw it all bloody. I'll never forget seeing it." Her voice was low. I had to strain to hear. "I can't get it out of my mind. I can't get it out of my mind how you could do it. It never seemed like you were big enough to do it, like you were strong enough."

"I was strong," I said, talking in the same dark smothered voice. "I was twice as old as Bubber."

"He was stronger. In a fight, he always beat you."

"I could have caught him by surprise."

"Bubber was too smart for that."

"Why didn't you say this before?"

"I always worried over it."

"Why didn't you say what worried you?" Why didn't you ever say something, even if you only said it to me? Mama! I cried out silently from the dark smothering.

"How could I? If it was true they'd find out, I thought. But they didn't find it out. I told what I saw. I had to."

"You should have told what you thought." I beat at it like I was beating my head against the wall.

"I was afraid, I tell you. Of what I was thinking. Can't you understand? I was ashamed, too. After I didn't say it, I was ashamed. It got harder and harder. I tried to make it up to you in other ways." Suddenly she flared out angrily. "I did what I had to do. Besides, I didn't know anything. I just had this feeling, this fucking feeling." She didn't realize that she was using Stuart's words. "I wasn't even conscious when they took you. I fainted dead from shock. Those doctors examined you over and over again. It was

their place to find the truth. They told me that you were sick, that you needed treatment. I didn't know. Did you do it, Billyjean?"

Bubber wouldn't get up. He wouldn't get up so I could hit him on the back of his head.

"I always wanted to ask you, Billyjean."

"I don't know," I answered.

"You see?" she said hopelessly. "Stuart was all that I had left. Glenn was gone. Bubber was gone."

Muriel was afraid. Stuart was afraid. Stuart was afraid of the loony. What could she do? She could talk, for one thing. What could she say, if she talked?

"Muriel," Stuart roared from the other side of the wall. Had he sent Muriel to find out if I would talk?

"Don't you tell your father what we've been talking about. He'd find some way of putting you back there. I'd have to say what I said the first time. What are feelings? Just fucking feelings." She went to the door. "I'm coming, for hevvin's sake," she shouted to Stuart.

"What if your mother sees GrandmaLoreen Doll?"

"Oh, she's seen her. I said you were just letting me play with her."

We were in Muriel's garden, sitting in the sunshine. The butterflies were doing loop-the-loops. In the hedge an insect or a bird was making a clacking sound like a castanet. The roses were finishing, dropping their petals like slow-falling snowflakes. Time was acting queer. If I looked in the mirror I might see wrinkles and white hair. I ought to gather up the snowflakes. Muriel likes the garden tidy. Some doves were tirelessly worrying in their throats. I was worrying, too.

"You took a big chance getting the key, Dione. Muriel could have heard you. The back screen squeaks."

"He would make a good thief, wouldn't he?" Diane cried.

Dione shrugged off her praise. "I knew nothing was going to get Muriel away from that front window. I knew you wouldn't tell even if you heard me. I really wasn't taking any chance at all. It was easy as pie." He paused and then continued. "Shall I go for the key now so we can get back to work?"

"No, Dione, it is too dangerous. You have to be able to say that you didn't ever take the key."

"Why is twice more dangerous than once?"

"This time I know. I can't let you."

"Then you take it."

"No, that isn't safe either. You are both taking too many chances. Diane took a big chance rescuing her bank."

"I had to get it, didn't I?" She was matter-of-fact. "Anyway, Dione planned it and taught me what to do."

"But why did you say that you stole my money?"

"It had to be someone's money. It was better to say I stole from you than from anyone else. You would forgive me." She crept under my arm for a hug, and it struck me right then to wonder why Diane wanted to buy new clothes for her doll—which doll—right at that time.

Diane reached up and pulled at my neck. "I was counting to see how much we had, and Mother saw me. So I had to make up that silly story. Am I awfully bad for letting her see me?"

"I've been afraid that you wouldn't be allowed to visit me any more."

"Oh, it's the other way around. Mother said she was sure you wouldn't hurt us, if only she could be sure that we wouldn't hurt you."

"Shut up, Diane, we're wasting time."

"Daddy says Dione is like a dog with a bone."

"I can't do it."

"All right, Billyjean. You're right, it could be dangerous, but I was willing to take that risk."

"I was willing, too."

"It isn't as if we weren't already involved up to our necks," Dione said.

"I've spoiled your whole summer vacation," I said.

"Not at all." Dione was very polite. "This has been the very best summer of my life. It's been super, up to now."

"Super. Up to now."

"It isn't over," I cried. "We can play here in the garden. I will tell you my stories."

"Billyjean, I can think better in the garage. It always helps to reconstruct the scene. If Diane hadn't been on her back on the floor of the garage, we would never have proved that you couldn't possibly have hit Bubber on the head. Now we have to do the same thing to find out who did it."

"It doesn't matter now that I'm out," I said.

"Of course it matters. Now that you are out it is even more important to clear your name of the stigma."

Diane's eyes filled. "I don't want you to have a stigma."

I could feel the worry of the doves full in my throat rubbing it raw.

"Stuart could have done it, couldn't he, Billyjean?"

"He went to the woods to dump the trash."

"He had to be somewhere else when you found Bubber."

"Why did I have to find him?"

It didn't seem possible that eyes could be so full and not overflow.

"You aren't listening good, Billyjean," Dione said, tightening his mouth just like his mother did.

"Stuart had to go away to the woods or he'd be blamed," Diane explained patiently.

There it was, the words to open the last box. Stuart was afraid of Billyjean because she could say that he could have done it. But when I looked in, there was another box. Was I so bad that I had to be blamed for something because the other thing was too bad even to be talked about?

Now the tears were running down her cheeks and she wiped them away on the blanket. I knew how serious this was. "Bubber was dead and someone had to be blamed, and you were the only other one. Better you than him."

"Diane is right," Dione jumped in talking fast. "A man could get the electric chair for what happened to Bubber. They had capital punishment in California then, Dad says. He says they don't give children the electric chair."

"How did your father happen to say that?"

Dione's mouth stretched into that smile that his face would have to grow into. "I brought up the subject. I didn't mention any names, of course. I was just talking generally."

"And now it's worse," Diane said.

"She heard them talking, saying that Stuart would find a way to put you back, and of course now you are not a child, you are twenty-one. That's an adult."

"They're trying to put back capital punishment now." In embarrassment, Diane worked at GrandmaLoreen Doll's eyes. She held her upside down shaking her patiently, convinced that little by little her eyes would drop back into her head where they belonged. "I

think they're getting a little closer," she said. "He has to put you back there so he'll be safe."

"Even Mom says that Diane is usually right about these kinds of feelings." He was very careful about grammar.

These fucking feelings.

"We're not going to do anything," I said. "This has been a summer game, children, and now summer is almost over. All that money you said was mine wasn't really mine, was it, Diane? I didn't put that much money in your bank. You gave back more than I put in, didn't you?"

"I thought it would be good for you to have it. Then if Mother checked my bank again there would be nothing to explain. You need the money to go to Max, don't you?"

"I'm not going to Max. I know that, you know that, Dione knows it. Tell her, Dione." I was using a stern voice I had never used before to him.

"I thought you'd both save harder if I said it was to go to Max. Diane is very sentimental and romantic."

"I am very—" Diane admitted.

"Max is—just Max," I said.

"What about, you know, Murder, Inc.?" Diane mewed.

"I don't even know if there is a Murder, Inc., and, anyway, I'm sure Max is not part of it. Now tell me what the money was going to be used for."

"Why, it was the defense fund, Billyjean. It was to reopen your case before Stuart can send you back there. We'll need quite a bit of money even though we don't need money for a lawyer. Dad wouldn't take a fee. I asked him about that."

"Speaking generally?" I asked.

Oh yes, Billyjean knew now how much danger there was for the children. Billyjean could feel Diane's small bones slipping in the silky skin of her arm. She remembered the feel of Bubber's head through his silky hair. Billyjean must not scare the children, but she must find a way to save them. She had to be alert all the time. She must never relax her vigil.

Mrs. Campolini was heard calling, and then there she was in the garden. Had she been there long? Listening? She was polite to Billyjean. How had Billyjean liked Young People's? Billyjean was very polite and foxy with her. Sometimes she would like to go to Mrs. Campolini's church, too, she said.

I knew that I was going to have to stop talking about myself as if I and Billyjean were two different people. I had to talk for myself. For me. I was outside now. That kind of talk belonged inside.

It was lonely in the garden with the children gone. The sky was higher, the sun was hotter, the garden was suffocatingly fragrant. I knew I shouldn't go to Michael. But Michael was the only real person I knew.

He was busy taking money out of the cash registers and putting it into the canvas sack. He saw me right away and called out, "I'll be with you in a minute, Billyjean."

That made me nervous. I couldn't wait for him. That would be like a date and I was not allowed to date. I got a basket and started up and down the aisles trying to think what I wanted to buy. I didn't see what I was looking at. I stood in front of shoe polish tying to decide brown or black. In a little while Michael caught up with me.

"Why didn't you wait for me, Billyjean?" He tried to take the basket, but I held on to it.

"Why should I?"

"Because I asked you to, that's why." He was so handsome when he was cocky this way.

"That's a good reason for you but not for me," I said.

"Excuse me, I don't think I get it. Let me try again. When I saw you coming through that door I said to myself, Billyjean has come because I asked her to. Billyjean has come to see me. That's right, isn't it?"

"No. I came to do my shopping. You told me that the prices were better here so I came to see."

"I can't believe it."

I saw that he didn't believe it.

"You're joking, aren't you, Billyjean?"

"Am I laughing?"

He looked like I had slapped him. "Well, then," and I could see he was mad or hurt so that he could hardly speak, "please don't let me interfere with your shopping. We are always glad to welcome new customers in the store."

"Thank you."

"Don't mention it."

It was over. I had done it. There was nothing more to be said. I

turned around in the aisle and walked in the opposite direction. I
had had to do it. There were spies everywhere. There was danger
everywhere.

"I still don't believe it," he hollered after me. And when I didn't
stop or turn, it angered him and he shouted after me. "You're
lying."

That stopped me, like I was dead.

"Do you hear me?" he asked. "I say you're lying."

Other people heard him, too. I was ashamed. I turned toward the
laden shelves as if I was searching for something. "You're making
them think I'm a thief. You're making them think I stole some-
thing."

He looked around then as if he had just waked up. "We can't talk
here," he said roughly. "Come with me to the locker room."

The locker room was in the rear of the store where the storeroom
was. The door was marked "For Employees Only." I wasn't an em-
ployee. I had no right to be there. It was a violation. I held back.

"What's wrong, Billyjean? What has happened since Sunday.
Something has changed you. This is me, Michael, the guy you talked
to about dreams. I haven't changed."

"I haven't changed, either."

"Then what's wrong? Don't you know me any more? Don't you
like me any more? Aren't you Billyjean?" He tried to smile, to coax
me, and that made my tears fall. He opened the door and tried to
lead me in. I struggled with him.

"This is stupid," he said, letting me go. "I've never had to fight a
girl to get her to talk to me."

"You may be stupid but I'm not. I'm not breaking my probation.
I'm not going back there."

He stared. I was having a hard time controlling myself. "OK,
Billyjean, let's start over, shall we? Will you please start over again
with me?"

I couldn't speak but I nodded.

He swallowed. "So, will you have a cup of coffee with me?"

"Is it a date?"

"Sure."

"Then I can't have it."

"Oh God, there we go again."

"I can't have coffee with you if it's a date! I tell you I can't have

coffee with you if it's a date! Why don't you listen, dammit? Are you deaf?"

He looked shocked. His voice was gone. "I must be deaf," he whispered.

"Then why don't you buy a hearing aid?"

"I'm sorry, Billyjean. I should have a hearing aid if I can't hear what you are trying to tell me."

"If I have a date, it's a violation." I continued to shout. He didn't even say calm down or not so loud. He let me shout and he listened, head bent, taking it.

"But if I happen to be sitting at a table having a cup of coffee and you just happen to sit down at the same table, how could I help that?" I was still shouting, but not so loud.

"Good idea." He was still whispering, but then he cleared his throat and said loudly, "Best idea I've heard all day."

I got my own cup of coffee, I wouldn't take his quarter, and I sat down at a table, and in a minute he came carrying a tray of coffee and some Danish, and he started to sit down. I looked up.

"Excuse me," he said, "is this chair taken?"

"No."

"It is now," he said and sat down.

He offered me a pastry and I ate and drank in silence. He stirred his coffee, but he didn't taste it.

"They've got no right to do this to you, Billyjean. You aren't guilty of anything, and they're treating you like a criminal."

"No, like a loony."

"It's enough to make anyone a loony."

"It's a stigma," I said before I thought.

"Yes, it is a stigma. I'd like to talk to a good lawyer and see if they have the right to do this to you."

"It's only for a year, not even a year now."

"If I had the right to protect you, I'd hire the best lawyer I could find. I'd take it right up to the Supreme Court." He stirred that coffee until I thought he was never going to drink it. His hands were clean, long-fingered.

"You've got nice hands, Michael."

"What good are they? They can't help you." He took my hands.

"I think I have to go now," I said, scared again.

"I like your hands, too, Billyjean."

"No." I pulled away.

"You have to trust, Billyjean. You have to begin to trust again. You can't rationalize trust. Any more than you can rationalize love. You either feel it or you don't. I feel it," he said.

"I'm late. I have to go."

"If I promise not to hold your hands, will you sit down again? I'll be careful what I say. I've been wanting to talk to you. Thank you," he said as I sat down. "I've thought a lot about the things you said to me last Sunday. For one thing, maybe I could get on the night shift regularly here. I'd have to go back to being a checker again. But that way I'd be free days and I could go to college."

"And study to be a paleontologist?"

"You're a funny sweet girl, Billyjean, the only girl I've met who can be seduced by the mention of courses in ancient skeletons. No, no, sit. That was a slip, but I'll be more careful. I won't use words like that."

He went on then about how it would work out. He talked about things I didn't understand and yet I loved them, like units and grade points and prerequisites. I listened like the children listened to my stories in the dark of the garage. But these were real.

"Tell me again about the degree. How long will it take?"

"A long time, maybe four years, maybe more."

I didn't think that was very long. "I was in there thirteen years." I saw his Adam's apple go up and down. It was a funny thing, an Adam's apple. I loved it.

"I can get off work now for a couple of hours," he said. "Ride with me and we'll go to the college and pick up some catalogs, and then I'll drive you home." I got nervous again, and he swore. "Dammit," he said.

"When you get the catalogs, will you show them to me?"

"I'll come by your house tonight with them."

"That wouldn't be a good idea right now," I said. "Stuart is having some kind of a feud with the neighbors and he's in a bad mood, and when he's in a bad mood, he's like a lion. I have to be alert all the time."

"Are you afraid of him, Billyjean?"

"Of Stuart? Because I said he was a lion? Of course not. When I was little I was scared when he roared, but I really loved it. I just played being scared."

"Billyjean, something else I've been thinking. I want to go to see your doctor, the one who is your probation officer. If I could talk to

him I know I can convince him that you are safe with me. I can convince him, I know I can, that there would be no violations."

This time I got up and I wouldn't sit down again.

"What'd I say this time to scare you, Billyjean?"

"I'm not scared," I whispered. "I have to go now—"

"When will you come again?"

"Michael, please, it is almost time for Shap's next visit, and I want him to see how I'm catching up with my age."

"Shap? Is that his name?"

"It's the way I heard his footsteps coming down the corridor when I was in the hospital, that was before I was promoted to the dorm, and after the dorm came the cottage. Shap-shap, his footsteps said as he came down the corridor."

Michael appeared to be listening and testing the sound. "I see what you mean, Billyjean. I believe you can tell a lot about people by the sound of their footsteps. I wonder how my footsteps would have sounded to you."

Stuart's car was on the driveway when I got home. He had beat me home.

I ran quickly around to the back and was careful to not let the screen door squeak. Right away I heard Stuart's voice and he was shouting. "That's all finished and over with!"

"She is on probation, neighbor. There's a difference." That was Mr. Campolini. I stayed quiet in the kitchen.

"If there is any chance that someone else could have done it, we must pursue that chance," Mr. Campolini went on.

"It happened," Stuart said. "She didn't know what she did, of course, but it happened, for crissake."

"But suppose she is innocent! She must be cleared."

"She was sick, she is better, in time she'll be well."

"Probation is itself a prison."

"She's on probation because she went off, she went crazy. That's the long and the short of it."

"Any child could go crazy under those circumstances."

"What circumstances are you talking about?"

"Being falsely accused of such a terrible thing."

"No one falsely accused her. Her own mother found her with the wrench in her hands standing over her little brother. It was thirteen years ago, for crissake. Why open it all up now?"

"It's never too late for justice."

"I don't have money for lawyers, Campolini."

"I'm not looking for a fee. The Bernhards came to talk to me, they wanted to hire me to reopen the case. I told them I wasn't for hire for that job, but that I'd like to do it for myself. My son thinks justice is a lawyer's business. I happen to care what my son thinks of me."

"Does your son know who did it?"

"He thinks we should find out."

"You take good care of those kids of yours, Campolini, they're some kids."

"Thanks, Stuart, and you know how we feel about Billyjean. We want what is best for her."

"She had the best care, she didn't lack."

"No one is saying different."

"She's my flesh and blood. If you get her worked up for nothing—! What are you trying to do to us? Do you think it's easy for me to keep saying that she did it? To keep remembering? It was bad enough for a child to go through all that. Now she's a woman. I don't want it opened up."

"Stuart, man, I'm sorry. It is open."

"She said she did it."

"That confession they got won't hold up in court."

"Court? This is your kid's doing!"

"Listen, Stuart, she says she picked up the wrench from the floor. From the floor! She says the little boy was lying on his back on the floor and wouldn't get up. Sure, she was mad at him, he was hiding from her. When she found him she said, 'I'll kill him.' That's what she said. And she told him to get up, but he wouldn't. Why? Because he was already dead. What does 'dead' mean to a young child?"

"If she didn't do it, who did?"

"A transient maybe? Was there ever an investigation? The Bernhards say they weren't questioned. My son tells me that there is a stepbrother."

"Does Billyjean say that Glenn did it?"

"Could he have?"

"Glenn wasn't even living in the house. I kicked him out long before because he was goofing off. I told him to earn his way or get out. When I was his age—"

"He could have come back, and finding the little boy alone, he saw his chance to get even with you for cracking down on him.

Supposing Billyjean took the rap for something she didn't do, a little girl, my Diane's age."

"You telling me? I'm her father! You can't know what I feel. I'm warning you, if you hurt her, if you give her hope only to snatch it away, if you make her afraid—"

"I'll do nothing to hurt her, Stuart. I promise solemnly. I'll just come forward as an amicus curiae. There'll be no big publicity, just an inquiry in the judge's chambers."

"You'll come forward as what? What in hell is that?"

"A friend of the court. Someone who acts for justice."

"You'll be a big man in your son's eyes, won't you?"

"I'm doing it first for Billyjean, Stuart."

"Don't mind me. It upsets me to talk about it. But like you say, if she was in that place for something she didn't do—dammit, Campolini, she was there because she was sick."

"That place made her sick. Her world fell apart. I suppose you know how she loves you, Stuart. My son says—"

"She was my favorite. Her mother held it against me, but I can't help my feelings. How will you go about this business?"

"First thing, I petition for the role. Then I get permission to introduce new evidence—"

Somewhere about then I stopped listening. It was like a great load had been lifted off my chest and I could breathe. I was floating. Stuart wanted the case opened. Stuart was willing. He didn't want to send me back there. He wanted justice for me. I loved everyone, but most of all I loved Stuart. I was sorry and ashamed that I had suspected him. And then, like someone hit me over the head with a bloody wrench, I remembered what I had tried so hard to forget, what I had tried to believe never happened, what happened in the dark in Billyjean's bed.

He came out to the kitchen when he heard me moving around. He got a beer from the frig and sat at the table. He caught me studying him and he barked at me, "Where in hell you been?"

Something had happened to him. He was all of a sudden grown old. His lower lip rolled over in a petulant old man's pout. His nose sagged. His eyes were suspicious and vague under his long gray eyebrows. A network of little red broken lines made a pattern on his cheeks. Yes, he was an old, old man. He was almost old enough to be dead. I was glad. I was all mixed up.

"I guess you've been listening to me and Campolini discussing about you."

I nodded. I was nervous.

He got up heavily. "Well, that calls for a celebration, doesn't it? Never mind starting dinner—"

"It's already started."

"Well, we can eat it tomorrow. Put it in the frig or put it in the garbage can. What the hell, we'll celebrate. We'll go out for dinner. How about it? You and me."

"I'd like to celebrate here at home," I said.

"Ashamed of your old father, are you? You wish I was a lawyer like Campolini who knows how to be a friend at court and find new evidence and get justice done."

"You want justice, too," I said hesitantly.

He gave me a sharp look, then shook himself. "Sure I want justice. For myself, too. I'd like a new car every two years and trips to Disneyland. You want to go to Disneyland?"

"I'm too old," I said.

"Are you, now? Well, you want to know something? I'm not too old. I'd like to go to Disneyland, by God. I'd like to go to the San Diego Zoo, too."

"I'd like to go the zoo," I said.

"Well then, that's it. We'll take off and go to the zoo. Muriel never wanted you and Bubber to have a pet. You used to collect anything alive. Would you like a dog, a cat?"

"I'd like a cat," I said.

"We'll get you a cat. It can catch the mice, eh? What kind of cat? Siamese, Persian, alley? Alley cats are the smartest. The special breeds have their wits bred out of them. Alley cats have to be smart or they don't survive. They learn young to make their own way. Take me. I'm an alley cat. An old tom." He chuckled. "When I was eight, my father walked out on us. At eight, I was a man bringing in money for my mother—"

What was the number eight? What did it mean? It looked like a child's drawing of a man—8. There were eight notes in an octave, eight rowers in a racing boat. There was magic in the number, black magic. The eighth year of life was a dangerous year.

"I haven't done bad for a man who never finished grade school. I've got my own house. I live next door to a fancy lawyer. I did it by myself. No one ever gave me anything, not even the time of day.

Everything I have, I've made." He held up his hands cupped in front of him and stared at them. They were the gnarled big-knuckled hands of an old man.

He talked and drank, and hardly touched any food. Once he got up and went to the bathroom and when he came back, I saw that he had forgotten to do up his zipper. He continued to talk about the things he had done and the things he hadn't been able to do. "Necessity," he said, "that's all there is. It's what I've had to live by. When the chips are down, it's all anyone lives by. Damn right! It's each man for himself."

Once he absently put his hand inside his fly and scratched. Realizing what he had done, he zipped himself up, grinning at me. "If you have an itch, you have to scratch," he said. "You and I know that, don't we, Billyjean? Everyone doesn't know it. You'd be surprised. Take my word for it. Only a few people know it. Your mother doesn't know it. But my mother knew it."

He had never talked about his mother before or his family. Now he told about his grandfather who had lived to be a very old man. "I've seen my mother put his dry shriveled balls back into his pants for him. In the end she had to keep him in diapers. Christ, before I get that way, I hope someone puts me out of my misery. Maybe Bubber was lucky. Life," he said, nodding at it, "it's a trap and a fraud. But it's all we got, eh? Don't throw away anything until you have something better, my mother taught me. I ain't never tried the alternative to life." He laughed. "You've got to laugh, Billyjean. You can't make it in this world otherwise. Something to laugh about, a beer to guzzle, a woman to fuck," he said heavily.

I had almost forgotten Muriel, but Stuart hadn't. He heard her key in the door and right away called out, "We've been waiting for you, Muriel. Billyjean has some news for you."

Muriel's expression was one of fear or hope.

"Tell your mother what you've been up to," Stuart said, and then didn't let me. "Billyjean's been very busy."

"Will someone please tell me what this is about?"

"Tell her, Billyjean."

"Does it have to do with that thing in the garage?"

"You're getting warm. Billyjean and the shyster's kids have been playing a game called 'reopening the case.'"

"What case?" Muriel whispered.

"That shitty scarecrow in the garage is called 'reconstructing the scene.' They've proved she couldn't have done it."

"Done what? What are you talking about?"

"Justice, for Billyjean."

"Is it good news or bad news, for hevvin's sake?"

"What's the matter with you? Don't you want the stigma erased from Billyjean's name? We didn't get a new car, we couldn't paint the house. You went to work, no fur coat for you, no vacation for us, not in all those years. All our savings poured into that place for her care. And now along comes the smart lawyer and he's going to get something for her that her mother and her father couldn't get, he's going to get justice for her."

"If you were me," I said slowly, "would you tell Mr. Campolini to reopen the case? If you don't want me to, I won't. I don't need it. I'm home. I'm out. Would you reopen the case?"

"Hell, yes. Now let's all go to bed. This has sure wore out your mother. And you don't look so good either, Billyjean, for someone who is going to get justice."

"Good night, Muriel." I bent down for the rubbery kiss.

"Good night, Billyjean," Muriel said.

"Good night, Stuart," I said.

"Don't I get a kiss?"

He didn't get up from the chair, and I bent down to him.

The following morning Stuart was up before me and very cheery. "I'll tell you what I want you to do today, just to show how grateful we are to our good neighbors for their efforts on your behalf," he said.

I wondered why he was being so formal.

"I want you to go over to the Campolinis' and invite her kids to the park for a picnic, your treat. How's that?"

I had hardly slept, swinging between crazy joy that Stuart wanted me cleared, and a kind of sickness. People did say crazy joy. I couldn't eat any breakfast.

"Best get over there early, it being Saturday," Stuart said, "they might plan to go somewhere else."

"Does it have to be today?"

"Don't you want it to be today?"

"Maybe they can't go today."

"If they can't, their bad luck. Go."

"Should I ask Muriel?"

"Dammitall, don't you want a picnic with your friends?"

"She might want me to do something else."

"It was her idea. Your mother wants us to fix things up with the neighbors, to show we're friendly. You take the kids on a picnic, and Muriel can hold up her head."

From their front door I could see Mr. Campolini and Dione sitting at the dining-room table. They even ate breakfast in the dining room. They turned around to look at me as Mrs. Campolini said, "Why, Billyjean, how nice!"

"Come on, come in," Mr. Campolini called.

Dione's eyes were brilliant with excitement as if he already knew. Diane came to the head of the stairs, her little bare feet showing out from a pink nightgown, a blanket around her shoulders, and under the blanket, GrandmaLoreen Doll.

I felt hot and cold at the same time. Clammy. My voice shook as I explained about the treat.

"What a shame," Mrs. Campolini said. "Dione is going to the office with his father."

Of course! To open the case. Somewhere in my head I could hear Mrs. Campolini telling Stuart that he and Dione would get busy right away the very next day. I hadn't really been listening. I had already been dreaming. But the words had registered, and now they were loud.

"But I can go, Billyjean," Diane called out. "Dione is having a treat with Daddy. I want a treat with Billyjean. Please, Mother, please, please?"

"We'll have to think about it," Mrs. Campolini said.

"But, Mother, I adore picnics!"

"You're not even dressed, Diane."

"I can be dressed real fast."

"There's no hurry," I said. "I have to go to the store to buy the things for the picnic. Stuart says I can shoot the works."

"Oh Mama, please!"

"Hush, Diane."

"Dad?" There was a blaze in Dione's eyes. "Could I go on the picnic and come to your office on Monday?"

Mr. Campolini grew very serious. "I asked the stenographer as a favor to come downtown today. It's her day off, and it's my day off. Can you give up a picnic?"

"Yes sir, I can give it up."

"Good. If we get through early, we may come by the picnic grounds later. That's a promise."

Diane clapped her hands. "I can go, I can go," she chanted. "I and Billyjean."

"You won't go on the lake, Billyjean."

"No ma'am. I don't like the boats."

"And you'll be home before it begins to grow dark."

"Of course. I have to or it's a violation."

I ran back to tell Stuart the good news. "She can go, she can go," I cried like a loony.

"What about him? Doesn't he want to go?" But Stuart knew. I could see it in his face.

"His father put it up to him to choose—he could go downtown with him to open the case, or he could have the picnic."

"He sure thinks a lot of you."

"Diane thinks a lot of me, too. She wants to go."

Stuart rubbed his hands together. "OK, let's go shopping. Where do you want to shop, Billyjean? The supermarket? Or the Coop?" I could feel the heat of his excitement.

"Muriel likes me to stop at the supermarket."

"But you like the Coop, eh? To see your boyfriend."

"He isn't my boyfriend."

"He's a boy and your friend, isn't he?"

"Is it a violation?"

"I'll be sitting right outside to keep an eye on you. So no monkey business, you hear?" He laughed uproariously. He gave me ten dollars and told me not to bring back any change.

I didn't look for Michael. If I didn't look, he would be there. I had filled my basket and stood in line. Right then he was beside saying, "Mmmm, that looks like a feast."

"It's a picnic," I said. My throat was tight.

"Great. I love picnics."

"I'm sorry, Michael."

"You mean I'm not invited?"

"It's for Diane. Dione can't come because he's going downtown with Mr. Campolini to give his statement to the stenographer. They're going to open the case. Mr. Campolini is a lawyer."

"Billyjean, that's the greatest!"

"Maybe it's hope that can be lost again."

"Don't say that. Don't think it! If a lawyer believes you've got a case, if there's a chance of new evidence—gosh, I don't see how you can be so calm about it. I'm crazy with joy."

"I'm crazy with joy, too." I said stiffly. "Stuart's happy too. He wants to show them we're grateful for their help, he wants to show them that we want to be friendly."

"Too bad the boy has to lose out on the picnic."

"His father said he had to choose."

"Never mind, Billyjean, there must be some reason why the picnic has to be today."

"I don't know the reason."

"There'll be another time to take the boy. Cheer up. This is one great day."

"Stop interfering with the customers, Mike," the checker said.

There was some change from the bill Stuart gave me. "Stuart said to shoot the works," I said, and I took another six-pack of pop.

"I got the catalogs from State," Michael said.

"There's still some change left over," I said. "Will it matter, do you think?"

"Billyjean, I think you really are crazy with joy. Didn't you hear me? I said I have the college catalogs."

The catalogs. "The catalogs!" I cried, coming to life. "Oh, Michael, let me see."

"They're in my locker. I don't carry them around with me."

"How awful. Stuart is waiting. But I've got to see them."

"It's all right. You can see them another time."

"No, no, I must see them now. I can't stand not knowing what you are going to study. Take me there quickly, Michael."

"Really, Billyjean, they'll keep."

"They won't keep! Why are you doing this to me? Let's go right now."

The locker room was a kind of lounge for the employees with a sofa and easy chairs and tables, and lockers along one wall where they put their personal belongings. I took the catalogs from Michael's hands like they would break if I didn't hold them carefully. There was something living there. Like one Easter in the cottage I had held a baby chick. I pored over the course descriptions. The words were so wonderful.

"You're the one should go to school, Billyjean."

"No, no, it's your dream coming true!"

"Billyjean, I have another dream. You are my dream."

"Don't say such things. You're going to be a scientist."

"I want to take care of you, I want to make you feel safe, I want to give you all the things and all the love you've never had. I want to love you and be with you—"

"Don't talk like that!"

"So you won't ever be afraid again. I think about you all the

time. You are everywhere. You come between me and whatever I'm doing. I'm nothing until you come, and then you are with me and I am real again."

I was a loony, and anyone could come into a loony's bed.

I struck out at him weakly. "Don't talk foolishness. You are a scientist, Michael. You are going to be someone important and valuable. You will do big things. The field trips, Michael, the diggings, the discoveries. That's the dream, that's your dream!"

"Yes, I know that dream, too. But I'm not sure I want to go for it now, if it means giving up my dream of you and me together. Don't you want to be with me?"

"Don't talk like that!"

"Don't you love me, Billyjean? I want to marry you. All right, not right away, if you have to wait for a little while. I won't rush you. But I want you to be my wife. I make pretty good money now. If the manager leaves, I'm in line for his job—ah, Billyjean, I love you so much." He touched the collar of my dress though it didn't need straightening. He must not touch me. He could catch a germ from me, he could get sick and die from me. I pushed his hand away.

"You are a fool, Michael Colby. You don't know what you are saying. You don't know anything."

He got white like I had hit him. He got white like Bubber on the floor—dead white. "I hate you," I cried.

I ran to the car, Michael's voice following me, calling my name. I was black as thunder. And there in the car was Stuart black as a crossed-out black square, black as a black crayon. He started the motor and the roar came out. I stomped on the floorboard. We were two of a kind. We were one. I would made so much noise that I would drown out Michael's white face.

"Look at you," Stuart roared. "You tramp. Where did you go with him when you left the check line? I saw you leave. You let that bum take you somewhere where I couldn't see you. Where'd you go? I got out of the car, and you were gone. I ought to smack your face hard—"

"And make my eyes fall down?"

"What in hell does that mean? I've a good mind to call off the picnic."

"Call it off. I don't care," I shouted back at him.

"You don't care! And what about me? I invite the neighbor's kid for a treat because they're going to so much trouble for you, and

you call it off. You are not going to call it off, do you hear? You—are—not—going—to—call—it—off." He spaced every word. "You went into that back room with him, didn't you?"

"Yes," I shouted, "I went into the back room with him. What do you think I did there? Do you think I killed him? Yes, that's what I did, I killed him."

"You're crazy," he repeated over and over again. I could see that he was very scared of me now. Scared and pushed to violence on the track of the mouse.

"You made that Bubber thing in the garage, didn't you?"

"Yes, I made it."

"You WHAT?"

"I made it. To reconstruct the scene. To solve the case. It's all right to admit it now, isn't it? You want the case reopened, don't you? You want the stigma removed, don't you? You said you did."

His foot was pushing down the accelerator. People were watching because of the noise, and a kid came to ask if Stuart wanted him to open the hood and take a look.

"Bug off," Stuart yelled and let off the brake. The car leaped, screeching and burning rubber. His hands gripped the wheel. It could have been a wrench. "There'll be no picnic," he said. "We're going home."

"Good," I said.

"And there I'll telephone your Shap."

"Go ahead."

"You want to go back to that place?"

"I don't care. I don't even like it outside. I like it better inside." They called me Little Miss Innocent there. But I wasn't little.

"You are trying to do something to me," Stuart cried, "you're plotting against your own father. Aren't you? Aren't you, dammit? You used to love me. You used to have a thing for me. I suppose you don't choose to remember that? You liked to get into bed with me when Muriel went to work early on Saturday morning. You tried to get between me and her when I had a hard on. Now you're hot for this Michael, and I don't count any more. You want to show that you don't need me."

It was true, all true, and it was better that Michael was dead for me. Far better that he'd never want to look at me again, better that he'd never want to remember me.

I cried out that I loved only Stuart in the whole world. I told him

when he got old I would take care of him like his mother took care of her father. I'd put his balls back in his pants for him and zip his fly when he forgot. I never wanted to leave him. I would do anything for him.

"I don't know what to think," he said pouting. "I don't believe you. You're acting mighty queer."

"You have to believe me!"

"I don't have to anything. Nothing will convince me. There's been too much. Well, maybe one thing would convince me."

"What is it? Try me. Test me, Daddy."

Then he told me he wanted me to go on the picnie with Diane. "Take her to the woods."

That was no test.

After we ate, I was to leave her. I would go to buy soda pop maybe. But I had bought a lot of soda pop. I was puzzled.

"Do you have any money left? Never mind, I'll give you more. She will get thirsty."

Maybe she wouldn't, I said.

"You'll tell her it is going to be a surprise."

"For what?" I cried.

"Remember how your mother used to scare you with stories about the animals in the woods? Well, you'll tell Diane those stories and when you're gone, she'll hear the animals."

"There aren't any animals in the woods," I said.

He winked and his eyes dropped down. His eyes were empty. "I'll be there in the woods," he went on. "I won't let her see me, of course. I'll roar like a lion, and I'll scare her. You used to love it. She'll love it."

"No, she'll be scared. She won't love it."

His face hardened into a square. "I want her to be scared. Then she'll keep her nose out of our affairs, out of your affairs. I'm doing this for you."

"Won't she ever be found?"

"Of course. I'll find her. I'll find her and bring her home safely, but she'll learn a lesson first."

"I promised Mrs. Campolini to protect her."

"What do you care about that old bitch?"

"Diane will say that Billyjean left her all alone!"

"And you'll say that you didn't leave her even for a minute. You'll say that she is lying. Her mother knows that she lies. She took sick,

Billyjean, she had a kind of fit. You couldn't leave her. It was lucky I came back early to help you. You do that, Billyjean, and I'll always remember that you love me."

I could die for love. I could die for Michael's love. But this wasn't me, this was Diane. I couldn't let her be hurt or scared. Or worse. "I can't do it," I said.

"You said you'd do anything I asked."

"Not this. Anything but this."

"You can't play a little game on a kid who means nothing to you, who wants to get you into trouble? Yes, she does want to get you into trouble. She told her mother about the money, didn't she? A real friend wouldn't have done that. And that brother of hers. Can't you see what they're doing to you? From the first I knew those kids were up to no good. They're trying to make you look crazy. They're trying to shame us all by reopening the case. What case? There is no case. Just when everyone is forgetting what you did and where you've been, they are opening up the whole can of worms again. Just when you've met a nice young fellow. You do this little game I'm talking about, and I'll see that you get your young man. He wouldn't want to marry a loony, and that's what you'll be if they open the case again."

"No," I shouted, "I don't want him. I don't want to marry him."

"What's got into you?"

"I don't want to see him ever again. I don't want to get married ever. I don't want it, do you hear, I won't have it."

"What did he do to you in there?"

"I hate him."

"Did he get fresh, try for a feel?"

"I'll kill him."

"You don't mean that."

"I do. I want him to keep his nose out of my affairs—"

"Like I want the girl to keep her nose out of my affairs, eh, Billyjean?"

I agreed to do it.

He wiped his face with his handkerchief. "Good girl. Now we'll take this stuff in and get it packed in the picnic basket. Don't forget napkins and paper plates. And a sharp knife to cut the salami. Be quiet, Billyjean. No sense in waking Muriel. Between the two of us, she didn't get much sleep last night. OK, all set? Well, let's pick up your little friend and put this picnic on the road."

It all went as planned. It all went too easily. Mrs. Campolini was kind of surprised that Stuart was going to drive us to the park, but she accepted his explanation. "They've got this picnic basket to carry," he said. "I'll pick them up and get them home before dark. I'd stay with them, I like picnics myself, but I've got some business to attend to. Some day we two families should go together on a picnic, eh, Claudia?"

There were too many people in the picnic area, Diane said. She didn't want to sit at a table. A real picnic had to be on the ground. We carried the stuff farther into the woods, where we couldn't even hear the people at the tables, and Stuart spread out an old car blanket. Diane ran around finding acorns, and wild flowers, and a chipmunk. Stuart unpacked.

"Billyjean could get them to come right up and eat out of her hand. She had a way with animals, remember, Billyjean?"

I was very nervous wondering how he would work it about the soda pop.

"Heh, you only got one pack of pop, that's not going to be enough," Stuart said.

I said I thought it would be enough.

"No sweat," he said, "you can buy more at the stand in the picnic

area." He gave me money. "If you don't need it for soda pop, spend it on anything you want. Get Diane a surprise," he said.

"One pack is enough for me," Diane said with a grin that bubbled her dimples.

"You drink six bottles and you'd burst," Stuart said, grinning back at her. "Whatever you want, Billyjean can walk back to the stand and buy. Diane can walk back with you," Stuart said.

"I don't want to," Diane said. "Do I have to?"

Billyjean said not now, later.

"Billyjean used to like to scare herself that there were wild animals in these woods, lions and tigers and elephants," Stuart said.

"Are there lions? Really?" Diane asked. She wanted there to be. She wanted to be scared by a lion.

"We'll see if we can round up a lion or two," Stuart said winking at Billyjean, and then he said good-bye.

Diane ate a lot for a skinny little girl that you could almost spit through, and she drank a lot. Then she had to go to the bathroom. I said I'd walk with her to the lavatories. She said there was no use in that. She'd go right there behind a tree. No one would see. I could watch and holler if anyone came.

"Don't you have to go, Billyjean?"

I told her I preferred to go to the lavatories.

"Buy me something while you're near the stand, Billyjean."

"Don't you want to come with me and choose?"

"Stuart said you should buy me a surprise."

It was as if she wanted me to leave her. "Won't you be scared staying here alone?"

"Of course not."

"What will you do?"

"I'm trying to get this old chipmunk to eat from my hand, can't you see? He won't come so long as you are here and keep talking."

I went slowly. I stopped at a short distance to see if she wouldn't call me to come back, but she didn't even notice that I was gone. I bought her a box of chocolate-covered nuts for her surprise. Then I wandered. I didn't know where I went. I didn't have a watch to know what time it was. How long was long enough for Diane to be scared? How scared should she be? I had done it, I had killed love. I found myself back at the lavatories. You are hopeless. You might as well flush yourself down the toilet. Push the plunger and go down.

When I returned to the lavatories once more, the lady attendant looked at me suspiciously. Did she know what I had done? Did she know I was bad? I would have to go in with the bad women. I was too old for the cottage.

I did it. I killed love. And for that Diane must be scared, taught a lesson. But a child is important too, too important to die. What was my responsibility? We were only going to scare Diane. Would she be too scared? Would she be scared to death? No, it was just a game. Stuart would find her and bring her home safely. He just wanted to teach her a lesson. He was doing it for me. No, I was doing it for him!

The door is open. Come out. You can come out whenever you want. I'll put on my new dress and walk with Daddy, and everyone will think I and Daddy are married. You can't be married to Daddy. It is an ugly obscene game. Go back the way you went in. Daddy to married be can't you. I can talk backwards as good as forwards. That's because I have a better than average IQ. What does IQ have to do with anything?

First I have to buy some blue crayons and color my dress blue, like the blue window. There aren't any blue crayons any more. They don't make crayons like that any more. They don't make anything like they used to. It was a perfect plan. Billyjean did it. There will be a giant gasp, a wind of wonder when I step out, turning round and round making my skirt into a fan. See how loose I am, Stuart? See how I can rotate? Come on, Stuart, rotate with me. You did it, you know you did it.

"Taxi, miss?"

I was no longer in the park. I didn't know how I had got where I was.

"Are you Max?"

"Sure. Why not?"

I got in.

"Where to, miss?"

"What?"

"Where do you want to go?"

"I really don't want to go back there. But the woods are still there. The slaughterhouse is still there."

"You all right, miss?"

I stared at him. The pieces are coming together. The slaughterhouse. The woods. Stuart, Billyjean—not Michael. It was too late

for Michael. Michael was dead white. I had killed him. I, you, and he.

"Where do you live, miss? I'll take you home. What's your name?"

DIANE! How long had I been gone? How scared would she be? I had to get back to her. I jumped out of the cab.

"Wait!" the driver called.

"Here!" I gave him all the money I had.

"You don't owe me anything. I didn't take you anywhere."

I was running and he was driving along beside the sidewalk, keeping up with me. "I'll take you where you want to go. Where do you want to go? I don't think you should be alone."

Alone! Diane should not be left alone. Now I could see the park and I knew where to go.

"You got friends there?" the driver called. "You going to meet someone?"

I could hear his voice, honest and kind, behind me as I ran. No matter what Stuart said, scared or not, free or not, here I come. Someone dropped a glass jar and all the butterflies flew out. I wanted to tell the driver that I appreciated his kindness, but I couldn't stop then. It was a pity that I would never see him again.

I think I knew all along that Diane would not be where I had left her. Just the same I made for that place. There were the empty pop bottles, and the chipmunk who froze when he saw me, then ran away. The food was gone, the blanket was gone, Diane was gone. I ran around uselessly looking for her. I ran around like crazy. I knew I had to stop that. There was only one explanation: Stuart had come for her. I had to think about that and decide what it meant. Why didn't they wait for me? How long had I been gone?

It scared me that I had lost time, I didn't know how much. I had gone crazy again for a little while and that frightened me.

I was running again even before I finished figuring it out, and without thinking where I was running, I was running in the right direction toward the slaughterhouse.

The slaughterhouse was on the edge of the woods. Once long ago it had all been woods out there and the slaughterhouse was right in the center of town. When the town grew and the people complained about the noise, and the stink of the cattle and of the blood, the company moved the slaughterhouse out to the edge of the town, cutting down some of the trees. I had never gone to the

slaughterhouse through the woods. The quickest way from our house was on the streets, which at that time weren't rightly streets yet all the way and hardly any houses. I knew the direction, but there was no real path to follow.

The ground was uneven. I couldn't go very fast. Fallen leaves, thick and squishy, hid roots and rocks that I stumbled over. My sweater caught on a spiney bush, the spines formed in little crosses, and when I couldn't pull it free, I tore the sweater off my arms and left it hanging there. I ran, marking the beat of my feet with the pounding of my heart, "on time . . . on time . . ."

Then I heard some voices and that threw off the beat. The voices came from my right side. They were not coming from the slaughterhouse or else I was not going toward the slaughterhouse. I didn't recognize the voices, but they all sounded like a child. I couldn't see anything, but I switched directions with hardly a pause, and crashed through the brush not caring when I was scratched. With unexpected suddenness, because I had no idea how near I was, the brush thinned and dwindled, and I jumped out into the clearing where the cattle had once been penned. The voices ceased at my appearance. I saw right away that it wasn't Diane. There were three boys and I had startled them.

I couldn't speak at first, my lungs were burning and raw. The boys were older than Bubber, not as old as Phil, about as old as Michael, who was only two years older than Billyjean. I shook my head to empty it of the memories. "Police," I gasped to the boys, "police!"

The boys looked at each other and began to edge away. "Don't go," I cried. "Listen to me. Get the police. Don't be afraid. I'm not going to hurt you. Just please tell the park policeman to come to the slaughterhouse."

Before I had finished, the boys were running. I had to make them understand. "I need help," I shouted. "Tell someone to bring help to a little girl in the slaughterhouse." I was crying with desperation. They didn't even look back, but one shouted as he ran, "You aren't a little girl, you're crazy."

No one was going to come. That thought dropped to the bottom of my mind like a rock. OK, no one would come. But I was there. I would do what had to be done. I would not let anything happen to Diane, even if I died for it.

"Wait, wait up for me, Benjie!" Someone—a little girl—came

around the corner of the slaughterhouse, a fat, ugly little girl not more than seven or eight years old. She came to a sudden stop when she saw me, then she bent her head and scuffed along sullenly. She did not raise her eyes until she was past me, and then she ran as if she ran for shame, for guilt, for life. Run, run, I whispered, run fast.

I didn't run now. I went cautiously, trying to think like Stuart. The slaughterhouse was a huge two-storied structure. It looked exactly as I remembered it, gray, weathered, splintered, with empty windows. The windows on the upper floor were larger than those on the first floor; they went to the floor all the way from the ceiling. The cement loading platform was as I remembered it. The door we had used to enter by was boarded up, but someone small could slip under the boards, or someone big could climb over. Anyone could climb in through an empty window frame. My heart was beating fast for Billyjean.

The fat little girl had come from around the building where there was a ramp that they drove the cattle up, bellowing as if they knew that they were destined to go up to be killed and then, dead, to go down the chute to the butchering room below. If the children had been in the slaughterhouse, Stuart would have taken Diane somewhere else. Where? I couldn't count on that either, even if I could think of another place. I couldn't leave until I had checked. I didn't want to, but I had to go into the slaughterhouse. It was like going back to being eight years old, and bad.

I started downstairs. The small rooms had been offices, the children had decided in that long-ago time. We had held endless discussions about how the slaughtering had been done, the killing upstairs, and the butchering and packaging downstairs. Besides the small rooms downstairs there was the big cutting room with the long tables and the trough for the blood when they cleaned out the insides of the cattle. I had seen Muriel put her hand deep inside a chicken and pull out its insides. There were the hooks to hang the empty carcasses on.

Now the corners of the rooms were filled with pop cans, beer cans, candy wrappers, gum papers, and something that I didn't want to look at, like torn balloons. The big doors where the trucks backed up to load the meat and take it into town were still shut with a rusty padlock. I went out through a back window to the ramp that led upstairs.

There was only one more place to look, that enormous vaulted hall where the cattle were driven to the slaughtering blocks, of which there had had to be five, for there were five blood troughs. There was the chute down which they sent each tied and skinned beast, docile now, to the butcher block. Only the boys had dared to slide down that chute. Now it was boarded over, but someone had pulled some of the boards free.

In that great hall there was no place to hide. Stuart and Diane were there, Stuart by the farthest trough, the one near the front windows. And across the cement floor that was still dust clean and corpse gray, there was Diane, backed against the wall. I took it all in slowly, checking. She was not lying down like Bubber. She was not pale with her hair turning red. They had brought the picnic basket in with them and the blanket; and the blanket was stretched out by the trough. I was on time! I felt a thrill of triumph even though I knew it wasn't over yet. I knew that it wasn't like going back to eight years old, or to eight going on twenty-one. I was Billyjean and I knew how old I was.

This upstairs room was where Michael had had his diggings. Diane was standing just about where I had found the round bone, the one Michael said was an important find. I was thinking that, and at the same time I was thinking that Stuart shouldn't have let Diane see his face. If he was going to scare her, he should have covered his face with his handkerchief, like when he was playing bandit to sweep out the garage. Now she could identify him. Why wasn't his face covered?

"Oh, Billyjean," Diane cried but not moving, "we thought you were those children who came to play downstairs."

"Did they see you?" I asked.

"No. I was being quiet as a mouse."

"Why did they leave?" It was unreal to be talking like this. But even now, I had to know about that ugly little girl.

"The boys said there didn't seem any point in staying when no girls were coming."

"There was one girl."

"They said she was too little. They laughed at how little she was. They didn't see me, Billyjean, honestly they didn't. They can't tell anyone. I wanted to come to the slaughterhouse. You never would bring me and Dione, so I asked Stuart to bring me."

"You heard her, Billyjean. She asked me to bring her."

What will you do when you see Stuart?

I will be cunning as a fox.

"She wanted to see where you used to play house, Billyjean."

"I wanted to see where you played house, Billyjean."

"She wants us to play house," Stuart said, grinning.

"Please, Billyjean, can we play house the way you used to?" She was echoing Stuart just the way she echoed Dione. She wasn't afraid of him. She liked him. But she was wrong. She wasn't a fox.

"Now let's see," Stuart said. "Who wants to be the mama? And who will be the baby? Naturally, I'm the daddy. Billyjean is the biggest. Don't cry, Baby Diane, your mama and your daddy will let you come into bed with us. DON'T CRY I SAID!" he roared suddenly at Diane.

"I'm not crying," she whispered.

"That's smart."

"If you hurt her, you'll have to hurt me," I said.

"Who in hell is hurting? It's a game. No one got hurt when you used to play house, did they, Billyjean?"

All that time I hadn't looked into his eyes. I had looked at his legs strong in that stance he took, apart. I had looked at his bulging belt buckle. I had looked at his shirt open at the neck with red zipper that was closed. I had looked at his fingers tapping on the hairs springing out. No, they were gray. I had looked at the white jaw bone, that important find, that was clicking lickety-split. But now I had to look at his eyes. There were no yellow pencils. No blue crayons. No color. They were empty. His eyes really had fallen down. In his empty eyes I read the truth.

He had never really been after Diane. Diane had got in the way so he had found a use for her. He was after Billyjean who for thirteen years could have talked, could have finally grown clever enough to tell someone that she had not hit Bubber with the wrench or with anything else. Stuart had been telling me ever since I got home how he had worried that I would talk, but I had not heard it. I had been listening for something else. For love. That need had deafened me to everything else. If I had listened with my ears open, I would have heard. Now the beat had changed from "on time, on time" to "too late, too late." After this, after he had brought Diane here to the slaughterhouse, he'd have to kill her, or Mr. Campolini would kill him. Then when Diane was dead and couldn't talk, Stuart wouldn't even have to kill me. All he'd have to

do was say how he came to pick us up at the picnic to take us home, and he had found me with the wrench in my hand. How would he find me this time? In the picnic basket was the big knife we had used to cut the cheese and salami. That would do fine.

"I loved you, Daddy," I said.

"You hear? I'm still your daddy and you still love me."

"I won't let you hurt Diane. A child is as important as a man."

"You didn't talk before, Billyjean, and you won't talk now." He was terribly sure of himself.

"I will talk now if you hurt her."

"It won't be your Dr. Shap this time, remember that. It will be real prison, real jailors. What about our trip to Disneyland? It won't be the dark closet, Billyjean, not this time. It will be the hole, solitary."

I was watching the lion crouched ready to spring. But I had one big advantage over that lion. He still thought I was Billyjean to be tempted by a trip to Disneyland, to be scared by a threat to go back to the dark closet or worse. I would be scared, but I would go if I had to, to save Diane. Right then, with all that was going on that I had to watch and take track of, I saw the dark closet clear and distinct, and I opened the door and I walked out. The dark closet was inside me, and I could walk out any time I decided to. That was the meaning.

"I don't want to tell on you, Daddy, but I will if you hurt Diane. Run, Diane, run!" I leaped on him and hung on with my hands clasped tight behind his head. "Let her go, Daddy. I'll be your little girl again. I'll go to Disneyland with you."

He shook me off. Diane had not moved. It was like she had frozen with fear. Or like she was fascinated, like at a show. That wasn't right either. Like she was hypnotized by a need to know. I knew about that. I didn't think she could. It didn't matter. Whatever she knew, she was only eight, and I was older and I would save her.

Stuart was watching her, too. "She's a lot like you were, Billyjean, when you were her age. Your mother used to say that you were born old, you'd never been a child."

"I was born old, too," Diane said. "I'm just like you, Billyjean." She smiled, showing that long tooth and not caring.

"Don't you say that, Diane! It's nothing to be proud of, and it

isn't true. You are a little girl. You are only eight." Diane crept close and pushed her head under my arm for a forgiving hug.

"Well, are we or aren't we going to play house," Stuart said. "I think Diane should be mama. How do you like that, Diane? I kind of get the idea that Billyjean is a wee bit jealous of you." His voice was thick and strange. I could feel that Diane was tightening.

She looked into my face. "Can I be mama, Billyjean?"

"You cannot. I'm the mama and you are the baby. Now mind me or I'll spank you good. Your daddy is going to be late for work if he doesn't leave this minute, so say good-bye to him."

"Good-bye, Daddy."

"Haven't you got a kiss for your daddy?" he asked.

She looked at me again to tell her what to do. If she gave him a kiss, maybe he'd play the game and go off to work. Then maybe we could play going to the store to shop. Maybe by then the boys would have found the park policeman. Maybe not.

"Come on now, climb your daddy and give him a big hug and kiss," Stuart said.

She dimpled and jumped into his arms. He turned her face and kissed her, holding her mouth. "Mama," she cried when she could catch her breath.

"Give her to me, Stuart dear," I cried, desperately trying to protect her and still placate Stuart within the game. He was sure of himself like he had lost all sense of reality, like he was one of the really bad loonies. "She always cries when you go away, but she'll be all right as soon as you're gone."

He roared with laughter, hugging her in his thick arms. "You didn't think I was going to fall for that, did you?"

"That's how we play house," I said. "Daddy goes to work in the morning and mama and baby go to the store to buy dinner."

"Dinner is right there in the basket."

"Put me down, Daddy, and I'll set the table."

"No tricks, now," he warned.

She hummed as she set out paper plates and napkins. I unwrapped the food. "What's for dinner?" Stuart sniffed around. "Ah, a nice big beef roast. Living in the slaughterhouse isn't the fanciest neighborhood, but one thing sure, we will always have enough beef to eat. I guess I'll sharpen the carving knife." I watched helplessly as he tested the edge with his thick finger.

Diane was poised like a deer, without breathing. Now she would run when I told her to, I thought.

"You there," Stuart pointed the knife at me, "let's stop fooling around. This isn't how you played house."

"It is," I insisted. "Michael would go off on a field trip to hunt for specimens and Bubber and I would go shopping."

"Don't lie to me!" he roared. His face got too red. His lips curled back from his teeth, and his teeth were too big. I didn't know him at all. The lion was loose. But every minute that I delayed him was another minute for help to come, for me to think how to outwit him, and if I couldn't outwit him and no help came, how to fight him. But I didn't feel so sure.

Diane pulled at my neck to whisper, the way she did.

"Tell your brat to speak up. No secrets from Daddy." He lunged pointing the knife at her. Then suddenly his voice and manner changed. "Tell Daddy how you played house and Daddy won't be mad at you."

"She's scared of the knife, Stuart dear," I said. "Put it down."

"So you can get it?" he roared. He stuck the handle in his belt. "Let's get the show on the road."

The word "show" gave me a clue and I said we'd play clown. "Diane can be the little clown and I'll be the big clown, to show Daddy how the game is played."

"I know how the game is played," Stuart said with a horrible wink.

"I don't want to play clown," Diane said.

Stuart laughed. "You see, she wants to play house, and so we will. You tell me how you played it, little Diane."

"When there was nothing else to do and Mom says to Dione, can't you play with your little sister once in a while, it won't hurt you to play with her once in a while, then Dione plays house with me sometimes."

There was a sheen on Stuart's face. He ran his tongue over his lips.

"Dione goes off to work and I fix dinner and he comes home and he kisses me, and I hold up baby so he can kiss her, and I ask him how his day was."

"Then what do you do?"

"That all," I said too quickly.

"Shut up, Billyjean."

"No, Billyjean, there's more, you know there is. He says I love you dear and I say I love him dear and we go to bed." Her big golden eyes were luminous.

"Now we're getting somewhere. Come to bed, Diane." His big hand reached for her wrist and swallowed it.

Diane stretched out on the blanket, straight and stiff. I saw the thin stick legs. Stuart's hand moved up and down her arm. I could feel the small smooth wrist bones move under the thin silky skin. She struggled to sit up. "Lie still," he ordered.

"Baby wants to come to bed with Mama and Daddy," I said.

"OK, Billyjean, you can lay down on the other side of me."

"I want baby right here between us." Diane's eyes were filling with tears.

"NO!" Stuart roared. "I'm the head of this here family and I say where she sleeps or she doesn't come in with us at all. She'll have to go into the dark closet."

I crept into my place. Somehow I must get the knife from his belt and if he wouldn't let Diane go, I must strike him with it until he did. I thought I could do it. He wasn't Daddy. He wasn't Stuart. His mind was going lickety-split but around and around in a cage.

"Now what do we do?" he asked in a dreamy kind of way.

"It's morning and we get up," Diane said.

"Not so fast. Billyjean remembers this part. You have an itch, and you put your hand down there and I say, what are you doing, Diane, and you say you have to scratch, and I say, I'll do it for you and then you can do it for me."

I saw the small triangular face, all golden eyes, looking up to read in the face above it if she was doing as good as a big girl, as a woman—no, I couldn't imagine it. Diane must not be a victim.

I grabbed for the knife and Stuart rolled over. I felt the clean satisfying way the blade sliced into my hand. The blood showed instantly and flowed. I stared at it, but even then I didn't let go of the knife. Stuart bellowed with rage. He bent my hands backwards. "Drop it or I'll break your wrist."

I knew he meant it. I let the knife fall to the floor. I'd have to get at him in another way. "Do it to me instead," I cried.

I lunged once more for the knife but he was faster. My hand was bleeding all over me, but I didn't feel any pain.

"I'll do it to you, all right, but first I'll do it to her."

With the point of the knife at my neck, he forced me to lie down

beside Diane. He kept the knife there just touching the skin so that I felt the point prick as he breathed. He opened her thin little legs carelessly like he would tear apart a chicken wing, and he mounted her. I couldn't stand it. I hurled myself at him wildly, catching him off balance so that his hand with the knife would have to be thrown out backwards to support himself as he rolled off her. Together we turned over again.

For once I was glad that I was the tallest girl for my age. I was his daughter and I had his frame. I didn't feel the pain as he wrenched my arms to free himself. I could roll with him to the window frame that reached to the floor. I could roll him over the edge and Diane would be safe. I could roll out with him. If I had to. He was not going to hurt Diane. I would stop him no matter what. We struggled with no sound but our breathing. I wasn't his daughter for nothing. But the fox was getting tired. There were too many men in the red coats, too many barking dogs. What could one fox do? The fox could be sly! Stuart wasn't smart; I was smarter. I could goad him into exerting the force that was needed to roll us over to the window edge.

I bit his ear. My stomach came up into my throat. He bellowed like a bull, not a lion. But he had to free one of my arms to swat my head. I brought up my knee into his groin hard. That made him roaring turn once more. I caught a glimpse of Diane stretched out on the blanket, frozen stiff like that day that she played Bubber lying on the floor, unable to bend. After that I could think only of hanging on, whatever he did to me, hoping that his own fury would take us over the edge together, two stories down to the cement landing platform below.

I heard a cry and wondered if it was me who had made it, and then I recognized a siren. I heard the roar of car motors. I heard shouts. Someone was coming. Were they coming too late? Not too late for Diane. But too late for me? Now, at the very end, I didn't want to die.

Stuart heard what I heard, too. In the instant that his attention was pulled from me, I freed myself, but he was after me before I was wholly erect, with the knife held ready to be thrown. Crouching I could go no way but backwards. How many steps before I would hit the window frame? Could I stop myself there? Which step would take me hurtling into space?

A police bullhorn ripped the air with a blast, and I jumped.

"Give yourself up, Reasoner, you don't have a chance unless you do." Instinctively I had jumped in the right direction and I was hanging on to the window frame while the rotted and weakened molding threatened to give way, as the words flung themselves back and forth against the air. Stuart, startled as I had been too, lunged forward, grabbed for me, but I wasn't where he expected me to be. He flew out as if he wanted to go. I was almost sure that he reached for me to steady himself, and not to take me with him. He flew out like a cry.

"Don't harm the girls," the voice commanded, "it will go better for you."

Better for you, better for you, the words echoed. Stuart's cry wove in and around the echo like a counterpoint.

I heard the dull flat slap as he hit. A second later, I heard another sound, a metal click that bothered me until I had identified it. He had held on to the knife all the time, only at the very end letting go.

"Hang on, Billyjean!"

"MICHAEL!" I screamed, unable to believe that he was there when I had killed his love. "MICHAEL?"

"Yes, it's Michael, Billyjean. Don't let go!"

"I'm up here, Michael. Can you come and get me?"

"I see you, I'm coming. But first, Billyjean, I want you to do something for me. Slide down to the floor and let go of the frame."

"I don't know how."

"Sure you do, Billyjean. You can. The frame isn't strong, it may not be strong enough to hold you. But you are strong. Slide down slowly. Don't look down. Slide down, that's it, all the way until you are sitting on the floor, now let go of the frame and push back along the floor away from the edge. That's it. That's my girl."

"I can't see you now, Michael," I wailed.

"I'm here and I'm coming up. Don't move now. Keep talking so I won't lose you and I'll answer so you won't lose me."

"Do you remember where I am, Michael?"

"You're at our old diggings, aren't you?"

"That's right, at our old diggings."

"Where's Diane?"

I turned my head. Diane and I looked at each other. We could see each other clearly. The summer was over. She would soon be nine years old. "She's here, she's all right," I answered.

"I'm here, I'm all right," Diane called.

"BABY!" Mrs. Campolini shrieked.

"I'm coming, I'm coming, Billyjean," Michael kept calling so I wouldn't lose him. Now I heard other feet running, too.

I felt a warm silky child's head pushing against my arm, and I raised my arm to enclose Diane. Michael's voice was getting louder and louder, closer. Then he was there, holding us both.

"Stuart—" I began and choked. I had said so many times to myself that I would kill him, not meaning it, not planning it. Then I had killed him.

"I couldn't stop him," I explained. "Not any other way."

"Hush, Billyjean."

A child was to be saved.

"I'm here, Billyjean," Michael crooned. "I'll never leave you."

30.

"Let me take her, Billyjean. Come, Diane."

I wasn't surprised that Mrs. Campolini was there. She had become suspicious and worried when we drove off in the car with Stuart. She began thinking that she should have found out exactly where we would picnic. She went to talk to Muriel, but Muriel didn't answer the door. That worried her. She went home, but she couldn't rest. She came back and this time Muriel answered her ring, looking as if she had been drugged or was drunk. "They're with Stuart, they're safe wherever they are." Mrs. Campolini was so upset that she went straight away to the picnic area in the park to look for us and when she didn't find us anywhere, thoroughly alarmed by then, she phoned Mr. Campolini. He and Dione came directly to the park where they met Mrs. Campolini.

"I told you I'd protect her even with my life," I said to Mrs. Campolini.

"It came too close to that, Billyjean, much too close. We will always be in your debt," Mr. Campolini said.

An ambulance arrived and the doctor fixed my hand and checked for other injuries. They took Stuart away under a blanket and then I could leave. They wanted to carry me on a stretcher, but I could walk with Michael on one side and Shap on the other.

"I went to see Shap as soon as I could arrange to leave work," Michael said. "I knew something was wrong."

"I said terrible things to you."

"I didn't believe you." His face was stern. "I went to the park and then I couldn't find you. I drove back to the house to see Muriel. She didn't know why everyone was worried. I asked her who else was worried. She said that Mrs. Campolini was worried."

Then Michael phoned Shap and Shap wasted no time getting there. "They are with Billyjean's father, Stuart will take care of them, there's no call for anyone to interfere," Muriel said. She was terribly disturbed.

It was Michael who thought of the slaughterhouse and Shap called the police. The sad little girl who had run after the three boys had given my call for help to the park policeman after her mother had got it out of her where she had gone with the boys. Seeking to distract her mother from punishing her, she remembered the funny lady crying for help.

"You did fine, Billyjean," Shap said, "just fine." He blew his nose not getting anything. "Didn't she, Michael?"

"I should have been here. I should have insisted on going on the picnic with you. I should have remembered sooner about the slaughterhouse. I should have been here to protect you," Michael said angrily.

"Are you sure you're all right?" Mr. Campolini asked me anxiously. "Are you sure there isn't something we can do for you?"

"Will you still give me a job when my probation is over?" I asked.

Shap cleared his throat. "I'd say that the probation is only a matter of formality now. You've proved yourself. It's just a matter now of getting an order signed."

"We don't have to talk about all that now," Michael said, taking charge loudly. "I'm taking Billyjean home."

Mrs. Campolini had carried Diane to their car. The police were still taking measurements. They had drawn a picture on the pavement where Stuart had fallen. It was just like the Bubber thing in the garage, just like he was still there.

"Don't look at it, Billyjean," Dione said, swiping at his nose with the back of his hand. I smiled at him.

Michael held my arm close against him. "It's just a chalk drawing. It can't hurt you."

"Who did it?" I asked.

"The police always draw a picture, Billyjean—I told you—remember—?" Dione's voice trailed off. He sniffled.

"Stuart did it," Michael answered me.

"I did it."

"I tell you he did it to himself." He put his jacket over my shoulders.

"Don't forget, Billyjean," Mr. Campolini said as he got ready to leave with his family, "any time you want a job or anything just come to me and Claudia." Dione hesitated. He was like the shadow of himself. I could see that it would be some time before his face would grow up into his grin.

"I'm sorry I got you and Diane into this terrible trouble. I'm very sorry, Billyjean—" His chin wobbled.

"I'm older," I said, "I should have known better."

"I'm the boy." Everybody laughed with shaky relief and tears. There was talk of where they should take Billyjean. Not there—meaning Stuart's house. Maybe the Bernhards'. There was Muriel to think of, she would need someone.

"I want to go home," I said.

"Right now," Michael said.

"Is it all right if Michael drives me home, Shap?"

"If he'll give me a lift to my car. It's at your house."

All the lights were on in the three houses, the Campolinis', the Bernhards', and Stuart's house with the two little Greek columns at the front door. The door opened and I went into Mr. Bernhard's arms. "Muriel is at our house. Your Aunt Bessie is looking after her, with Isabel's help. Diane's Aunt Isabel. The doctor just left, he gave her a sedative, but she may not be asleep yet. You don't have to see her tonight if you don't want to. You'll stay with us, Billyjean."

"I want to stay here at home, Uncle Bernie. If it's all right with you," I said to Shap.

"Are you sure? You've gone through a shocking experience. You shouldn't be alone."

"I could go to Uncle Bernie if I get scared, but I won't be scared, I don't think. This is my home. It's the only home I know except—"

"She can't go there," Michael said angrily.

"No," Shap agreed. "Maybe I can arrange for a nurse to stay with you."

"Why do I need a nurse? I'm not sick."

"I can stay with her," Michael said.

Everyone was silent.

"I can sleep on the sofa," Michael said.

Everyone was looking at everyone else and trying not to look.

"Are you worried because I'm still on probation, Shap? I'm not sick any more. I know I'm not. I was when I first came home. And I'll tell you something you don't know. I don't have to tell you, you'd never find out, but I will tell you. I went a little crazy in the park. I left Diane alone, and I lost some time. The lady at the lavatories might remember me. And there was a taxi driver, if you could find him. It frightened me that I had lost time. I had never done that before. It really was the craziest thing I had ever done—"

"Except to say that you hit Bubber," Michael interrupted.

"Yes. That was crazy, too. But I was only eight years old. And I thought Stuart was telling me that I should go to that place. But now I was twenty-one, and I had lost myself and I wasn't sure for how long. But with no one's help, I found myself and I think that shows that I am well. Is that crazy, Shap?"

"No. On the contrary, I've never heard it put better. Actually there is clinical support for such a diagnosis—the same phenomenon appears in purely physical disorders also—but we don't have to go into that now. I'll see you tomorrow. We'll have plenty of time to talk. Good night, Billyjean. Good night, Michael."

"Good night, Shap," Michael said. I was glad that he called him Shap.

Mr. Bernhard said there was a pot of soup in the kitchen, and coffee made. There was also some of his famous doughnut holes. I ate two right then and Michael ate four; then Michael went with me to see Muriel. "How is she, Aunt Bessie?"

"How is she, Aunt Bessie. How are you, little madonna? Always thinking of someone else." Her makeup was smeared.

Muriel was mumbling about not being able to hold up her head. She seemed to know me. She kept pulling at me, but her tongue was getting thick. I told her to sleep and not to worry. I'd make sure Henry Fashion knew why she hadn't been at work. I'd tell him he could come and see her, if she'd like that. Poor Muriel, maybe she could go away somewhere and hold up her head.

Aunt Bessie worried because we hadn't had dinner. She cried over my cut hand and the blood on my dress. She wanted me to stay with her.

"Stop it, Bessie," Mr. Bernhard told her. "Billyjean knows what she wants to do."

"Of course she does," Aunt Bessie argued.

We came back to the house with Stuart's rocker and all the other things that were Stuart's, to the front bedroom, to the dark closet. I walked right into Michael's shoulder and put my face into his neck. He held me tighter and tighter.

"Those terrible things I said, I didn't mean."

"Hush, I know."

After a while I knew something was happening to him, and I moved out of his arms.

"I love you, Billyjean, don't you love me?"

I couldn't answer right then. I needed some time, maybe a minute only. I didn't know. "Are you hungry?"

"No. Are you?"

"No."

"Don't be afraid, Billyjean."

"I want to show you the garden and the fountain."

"Tonight?"

"Yes. It won't take long." We watched the water coming out of the fish's mouth.

"Let's turn it off now and go in, Billyjean."

"Wait. I have to tell you something. I'm at the last box." I knew he couldn't know what I was talking about but maybe he could. . . . But after all that, I couldn't tell him. I had known what little girls were not supposed to know. I had felt a love that I was not permitted to feel. From that child's forbidden love, everything had flowed. I had caught a germ, maybe, lying on the floor somewhere, and I had infected everyone. I had loved Stuart. I had hated him. I had killed him. I had a responsibility. I was in pain. I could feel Michael's warm arms, but Stuart was very close still.

"Shall I turn off the fountain now?" Michael asked as if I had explained everything.

I shivered.

"Let's go in now, Billyjean. Come in with me, please."

There was another box.

"Please don't be afraid."

"I am and I'm not. It's like I'm going to give up my life—not to death—not to sleep—but I might get lost—"

"We are going to give ourselves up to each other," Michael said.

He was smiling now in a beautiful sure way. I turned away to look up at the house behind the hedge. The windows were dark. The curtains hung straight and still. Just the same, far back in the darkness through the curtains I thought I saw the golden eyes brimming to the rim with tears that never fell.

"I should have been there!" Michael burst out angrily.

"Have you done it before, Michael?" I asked. "I'm not jealous. I'm glad."

"I've never given myself before, I swear it."

"You are going back to school, aren't you?"

His hands were traveling over me. "Maybe. Probably. But I may keep my job and go to school at night."

"Oh no, Michael."

"Well, we don't have to settle it now."

His hands were insistent. "We do! Michael stop that. It's important."

"Why are you fighting me, Billyjean?"

"Don't let me kill your dream!"

"Look, are you so dedicated to knowledge, or are you putting me off? What does the last box mean? What are you really afraid of?"

"Oh, Michael, I'm afraid that I won't do good."

He laughed. I shrank back. He pulled me close. I evaded him. "Of course you will do good," he said, reaching out again. "I've never heard of anything so crazy."

I pulled away again. "Don't say that to me."

"I will say it. If you can seriously spout nonsense like that, then I say you're crazy."

"You're the crazy. You want to be an assistant manager when you can be a scientist. That's crazier than I ever was."

We glared at each other.

"Michael, why are we doing this?"

"I'm not doing anything. I suddenly get the idea that you don't love me, you just love a paleontologist or something."

"Oh, Michael. I'm afraid that the things that I have done have made me different, not like other girls, ugly."

"Just love me, Billyjean, love me and everything will be all right. You'll see. We'll open that box together and there will be nothing to frighten you. You are so beautiful!"

I searched his face. I had been in a box for thirteen years.

"What are you looking for?" he asked. "Are you finding what you want? Is it there?"

I shut my eyes and he kissed me.

He was wrong about that last box. He really didn't understand. He couldn't understand. And that was a box I would always have to stay in. Some people didn't have any uncertainty at all. Suddenly Michael was a stranger. I didn't know him at all. The only person I could have talked to about the boxes was Stuart. I wished I had talked to him about them. He probably would have said something about necessity. It wasn't necessity. It didn't have to be. I had always been different. Even those who loved me said I was different. I had never been a child. Stuart was the man of the house at eight. Stuart was dead. Diane was proud that she was like me. Diane was almost nine now. My boxes were mine and no one else's.

"I'll turn off the fountain now, shall I?" Michael said hoarsely.

"Leave it on," I said. I would do that for Stuart.

"I don't want to rush you, Billyjean." He kept picking up his feet and putting them down.

I saw now that there were boxes to be closed also. Stuart's box full to overflowing would be hard to close. I would put the loonies and Mrs. Rose in another box. There would have to be a box for the children including the little fat girl. I would close all the boxes and store them in the garage with numbers on them, as Stuart had done, and a key so that I would know what was in each if ever I needed to find something.

"I just want to hold you and keep you safe."

I watched his mouth as he talked. Always before I had had to stop myself from loving someone who was kind to me. Now all that was changed. Everything I had known or guessed or dreamed had to be wrong. Would it be the rocking chair out of control? Would it be the fountain jumping higher and higher? Stuart had made the fountain. He was so proud of it. I wouldn't keep Michael waiting too long. I did want to know.

"I'll just hold you in my arms until you fall asleep," he said. "If that's what you want." He covered my face with his kisses that melted me. My mouth was blind. Michael, stranger that I loved.

"Now, no more talk about boxes, do you hear?" Michael ordered.

I wondered if Shap knew about the boxes. He knew about the covers to the days, but I wondered if he knew about the boxes.